PHILIPPINES

TALAUD

SANGIHE
(Sangir)

Manado

Gorontalo

MOLUCC

CELEBES
(Sulawesi)

Ujung Pandang
(Macassar)

BUTUNG

N E S I

NEA

TANIMBAR

SUMBAWA

LOMBLEN

KISAR

Maumere

FLORES

SOLOR

Waingapu

TIMOR

SUMBA

SAVU

Kupang

NDAO

ROTI

SPLENDID SYMBOLS

TEXTILES AND TRADITION
IN INDONESIA

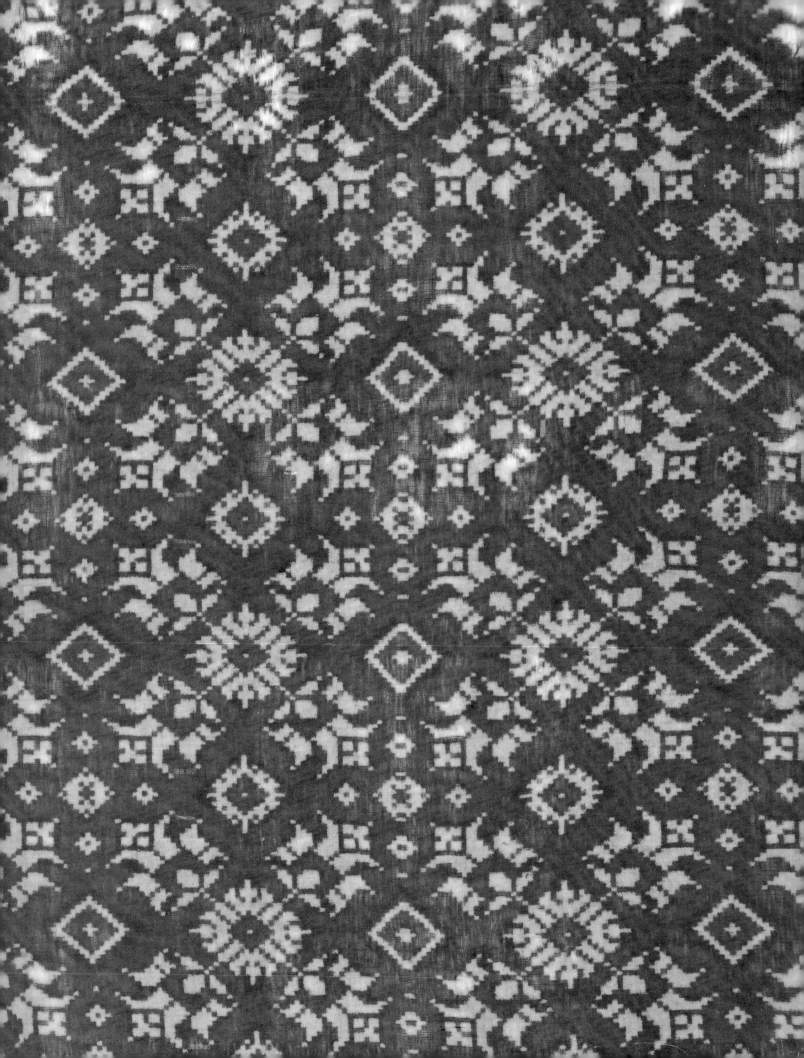

SPLENDID SYMBOLS

TEXTILES AND TRADITION IN INDONESIA

MATTIEBELLE GITTINGER

SINGAPORE
OXFORD UNIVERSITY PRESS
OXFORD NEW YORK
1985

Oxford University Press

Oxford London New York Toronto
Kuala Lumpur Singapore Hong Kong Tokyo
Delhi Bombay Calcutta Madras Karachi
Nairobi Dar es Salaam Cape Town
Melbourne Auckland

and associates in
Beirut Berlin Ibadan Mexico City

OXFORD is a trademark of Oxford University Press
© The Textile Museum, Washington, D.C., 1979
First published by The Textile Museum 1979
This reprint with additional illustrations
by Oxford University Press 1985
authorized by The Textile Museum, Washington, D.C.

ISBN 0 19 582630 2

Printed in Singapore by Dainippon Tien Wah Printing (Pte) Ltd.
Published by Oxford University Press,
10, New Industrial Road, Singapore 1953

Cover: *A young Balinese girl wears a*
sacred geringsing *fabric and dazzling*
crown of real and gold flowers. Such cos-
tume is a ritual requirement for certain
ceremonies in Tenganan Pageringsingan,
the single Balinese village where these
complex double ikat textiles are woven.
(Museum für Völkerkunde und Schwei-
zerisches Museum für Volkskunde Basel,
Basel. Peter Horner.)

Frontispiece *Figure 109*

PREFACE

The idea that textiles should be of interest to scholars other than those specializing in crafts was held by very few when this work was first published in 1979. That has changed. Indeed, textiles and their importance in traditional societies are now topics for doctoral dissertations in many disciplines and the subject for scholarly symposia.

The magnitude of this change is revealed in proposals advanced at a recent conference that 'Cloth traditions be given a place no less important than "agrarian regimes" in evolutionary and historical social theory'. Further, the suggestion was made that the study of cloth could become the arbitrator between the polarities of 'materialists' and 'idealists' within the anthropological world itself (Wenner-Gren, 1983).

Seminal to the evolution of this line of thought has been the complexity of the roles of Indonesian textiles in the social, economic and religious lives of the people of the archipelago. The importance of and the intellectual structures from which to view these textiles were established by early Dutch scholars. In more recent years scholarship, based largely on intensive field research in a closely defined region, has added significant details which are stimulating new ideas and giving rise to even more complex interpretations of textiles in insular Southeast Asia now and in the past. Numerous scholars should be mentioned, but the contributions of James Fox, from his work on the island triad of Roti-Ndao-Savu, and that of Susan Rogers among the Sipirok Batak of Sumatra, exemplify this new wealth of scholarship.

There have also been serious attempts to view the designs on some of the textiles of the archipelago in a context structured by complex philosophies. Danielle Geirnaert-Martin, Alit Veldhuisen-Djajasoebrata, and Rens Loedin-Heringa in works listed here and in forthcoming papers are authors bringing new insights into the familiar field of batik in this way.

Still other scholars have been and are looking at some of the less glamorous textiles, asking about the original function of *lurik* on Java, *kain Timor* in Irian Jaya or the specific role of local textiles in Halmahera and other parts of the Moluccas. This type of focus is bound to bring new surprises to this field and may well open questions of a broad historical nature.

The intervening years have also seen the publication of important books by

the late Alfred Bühler and Shinobu Yoshimoto. The latter has personally investigated many of the textile-producing areas in Indonesia and his work, hopefully to become available in English, promises to be increasingly important. Bühler's definitive work on the Indian *patola* is a mine of information, essential to an understanding of many of the textiles in Southeast Asia.

This is only a sampling of the explosion of material addressing the topic of Indonesian textiles, and if the economics of publishing permitted a great deal could now be added to chapters in this book that six years ago was unknown. Those interested in these specialized studies are invited to consult the Supplementary Bibliography. It contains many recent works and important older titles omitted from the original Bibliography because they had not been used directly as footnotes in the text. In an attempt to make this edition more helpful, these titles have been added.

The world of Indonesian textiles has not been invaded by scholars alone. An internationally-based, new aesthetic awareness of the beauty of Indonesian textiles and their legitimate claim to space on museum walls as Art is another of the changes of the recent past. Formerly, Sumatran silks had been admired, but now the artistic merit of handspun and, often, *ikat*-patterned cotton textiles has engaged the attention of art connoisseurs and, for better or worse, many types of Indonesian textiles are now 'collector's items'. The once unfamiliar terms, *ikat, tulis, tampan, palepai, hinggi,* and *pua,* have become common currency in the Asian art world.

Modern time abrades tradition in Indonesia and offers women different opportunities coupled with different rewards. Attempts to find a compromise with the weaving traditions have, to date, yielded textiles of pale substance, unworthy of past examples. A satisfactory resolution of this dilemma posed by modernization is not at all apparent, nor is the problem of how, or with what, handcrafted textiles, once basic to social reciprocity, will be replaced. In this very problem one can envision the outlines of research to come.

The Textile Museum, MATTIEBELLE GITTINGER
Washington, D.C.
1984

CONTENTS

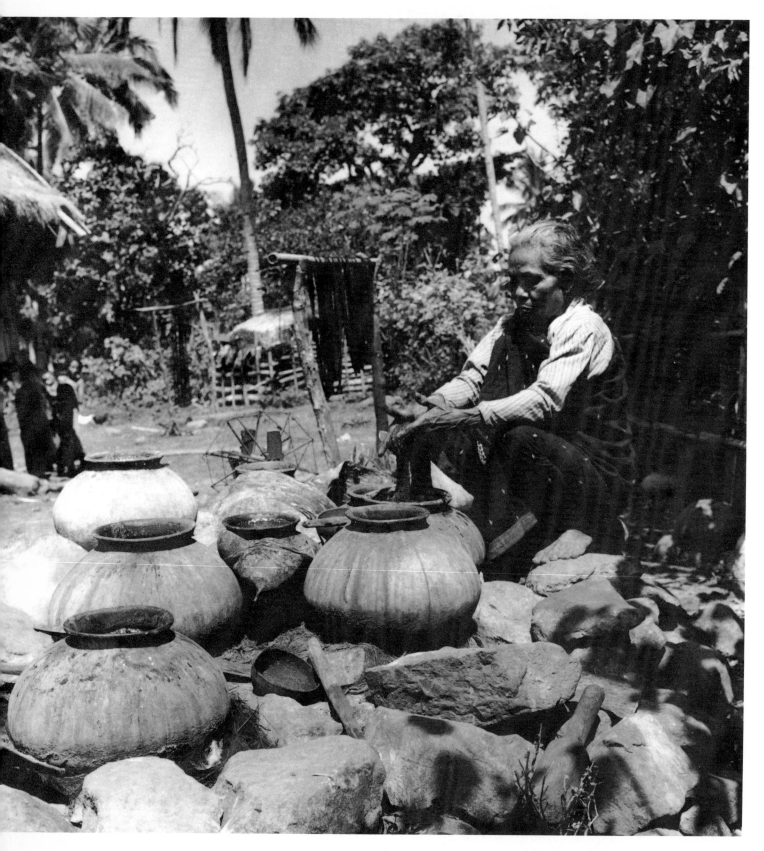

1a *A woman dyes cotton yarns indigo in Narang, West Flores. (Mattiebelle Gittinger, Washington, D.C.)*

FOREWORD

A principal aim of this book is to explore the role of textiles in the social customs and religion of Indonesia. At the same time, it serves as a catalogue, documenting a comprehensive exhibition of Indonesian textiles. A large selection of photographs illustrates the several essays that form the core of the book, and allows the reader to discover the range of technical skills and the varied taste of Indonesian weavers and patrons.

Upon coming to the Textile Museum three and a half years ago, I recognized the need to devote attention to the textiles of Southeast Asia and Indonesia. In December 1975 the Museum was fortunate to be able to persuade Dr. Mattiebelle Gittinger to accept the position of Research Associate for Southeast Asian Textiles. Dr. Gittinger's long experience in Indonesia and her wide-ranging knowledge of the textiles of that country assured a productive collaboration. We were not disappointed. Within a year, with Dr. Gittinger's interest and guidance, the Museum was able to propose an exhibition of Indonesian textiles.

A grant from the Charlotte Palmer Phillips Foundation, combined with a research grant from the National Endowment for the Arts, enabled Dr. Gittinger to visit collections and to speak with colleagues in England, Switzerland, Germany, and The Netherlands in preparation for the exhibition. A second grant from the National Endowment for the Arts provided funds for preparation of the exhibition and publication of this book.

The holdings of the Textile Museum form the nucleus of the exhibition, but we recognize that what has made both the exhibition and the catalogue extraordinary has been the collaboration of private collectors and museum colleagues in the United States and Western Europe, who arranged for photographs and generously agreed to lend some of the textiles in their care. Our gratitude to these many individuals is acknowledged elsewhere by Mattiebelle Gittinger.

In addition, owing to the interest of Allen Wardwell, it has been possible to present the exhibition at Asia House Gallery, New York, as well as at the Textile Museum, Washington, D.C.

As the exhibition matured, it also became evident that we should use it as the nucleus for a major discussion of Indonesian textiles, in the form of an international symposium. We were able to do this because of contributions from The Ford Foundation, The JDR 3rd Fund, and P.T. Caltex Pacific Indonesia. We are grateful for their support.

Special thanks go to the following for their extra contribution: Blenda Femenias for retyping the final edited version of this book; and Michael Monroe for offering valuable advice on the arrangement of the exhibition. The staff of the Textile Museum deserve thanks for their participation: Mary Lee Berger-Hughes and Mary Burgess for details concerning the loans of many pieces; Lilo Markrich for transatlantic telephone calls to Germany; Clarissa Palmai and Ann Craddock for preparing the textiles for exhibition; Sollie Lee Barnes and Richard Timpson for their help in installing the exhibition; and Patricia Fiske for her supervision of their work.

Eventually the exhibition will survive only in the memories of those who saw it and those who labored to ensure its success, but this book remains as a permanent record of their efforts.

Andrew Oliver, Jr.
Director, The Textile Museum
Washington, D.C.

ACKNOWLEDGMENTS

When I began work on this exhibition and the catalogue that describes it, a primary aim was to introduce viewers to the varied roles textiles play in Indonesia. I also wanted, however, to share my own delight in the broad variety of textiles once made in the archipelago. The catalogue thus had to serve not only as a guide to the exhibition, but also as a vehicle to present broader ideas. Further, I could not imagine a person reading the catalogue from start to finish; rather, I saw a reader sampling those parts that in some way appealed to him most. With this in mind, I have taken the liberty of repeating in the geographic listings certain material that appears first in the introductory essays, in order that a reader may gain a balanced view of the textiles and their uses whatever section he may be reading.

My own interest in Indonesian textiles began many years ago in a seminar at Columbia University. At that time there was very little awareness of Indonesian textiles beyond batik, and such an exhibition as this would have had no ready audience. In the past five years, however, there has been a surge of interest in Indonesian textiles, particularly those from islands other than Java, and within the past year there have been three large showings of these textiles in various parts of the country. The present exhibition was conceived two years ago around the Textile Museum's own collection, but quickly grew to draw upon virtually every major Indonesian collection in this country and Europe, including those of both institutions and private collectors. I personally have had enormous enjoyment in selecting the pieces, as well as pleasure in dealing with colleagues, and I owe much gratitude to the following people in Europe who welcomed me to their institutions and subsequently loaned textiles from their collections:

J. B. Avé, Rijksmuseum voor Volkenkunde, Leiden; Rita Bolland, Tropenmuseum, Amsterdam; H. Kelm and Gerda Kröber, Museum für Völkerkunde, Frankfurt; M.L. Nabholz-Kartaschoff and Urs Ramseyer, Museum für Völkerkunde und Schweizerisches Museum für Volkskunde Basel, Basel; D. A. Swallow, University Museum of Archaeology and Ethnology, Cambridge; A. Veldhuisen-Djajasoebrata, Museum voor

Land- en Volkenkunde, Rotterdam; and Rita Wassing-Visser, Volkenkundig Museum "Nusantara" Delft, Delft. Tine Cramer, Amsterdam, also deserves my thanks for kindness while I was in The Netherlands.

Many American institutions were generous. I wish to thank The American Museum of Natural History; the Museum of Fine Arts, Boston; The Brooklyn Museum; The Los Angeles County Museum of Art, and The Metropolitan Museum of Art.

A mark of the interest in Indonesian textiles is reflected in the number of pieces that come from private collections. My appreciation to Steven Alpert, Los Angeles; Howard and Bernice Beers, Lexington, Kentucky; Gordon Bishop, New York; Nigel Bullough, Pulborough, Sussex; James J. Fox, Canberra; Ruth Krulfeld, Washington, D.C.; Jack Lenor Larsen, New York; Mary Jane Leland, Los Angeles; Fred and Rita Richman, New York; and Kent Watters, Los Angeles. Special regards are due to Anita Spertus and Robert J. Holmgren, New York, not only for the loan of their textiles, but for their enthusiasm for the entire project.

Because a major aspect of the catalogue is the social and religious use of Indonesian textiles, I particularly wanted to illustrate these facets as well as the textiles themselves. Many archives were searched and appeals made to specialists around the world, and I am very grateful to the following: Trustees of The British Museum, James J. Fox; Robert J. Holmgren; Hedda Morrison; Koninklijk Instituut voor de Tropen; Koninklijk Instituut voor Taal-, Land- en Volkenkunde; Maimunah, Museum für Völkerkunde und Schweizerisches Museum für Volkskunde Basel; Sutan Badiaradja Sianipar; and Kent Watters. In particular I acknowledge the photographer Peter Horner of Basel for the splendid Balinese picture that we were allowed to use on the cover; and the artist Ann W. Hawkins of Washington, D.C., for her loom drawings.

I wish to express gratitude for the encouragement of the Director, Andrew Oliver, Jr., and the cooperation of my colleagues at the Textile Museum. Also there are special thanks to Corrian Atwell and Claire Polakoff who, as volunteers, gave me many hours of help as well as valuable consultation. And, of course, the help of my husband, Price, was immeasurable.

My greatest debt, however, is to the weavers and dyers of Indonesia, some known, but most not, whose work gave us these splendid symbols.

Mattiebelle Gittinger
Research Associate for
Southeast Asian Textiles

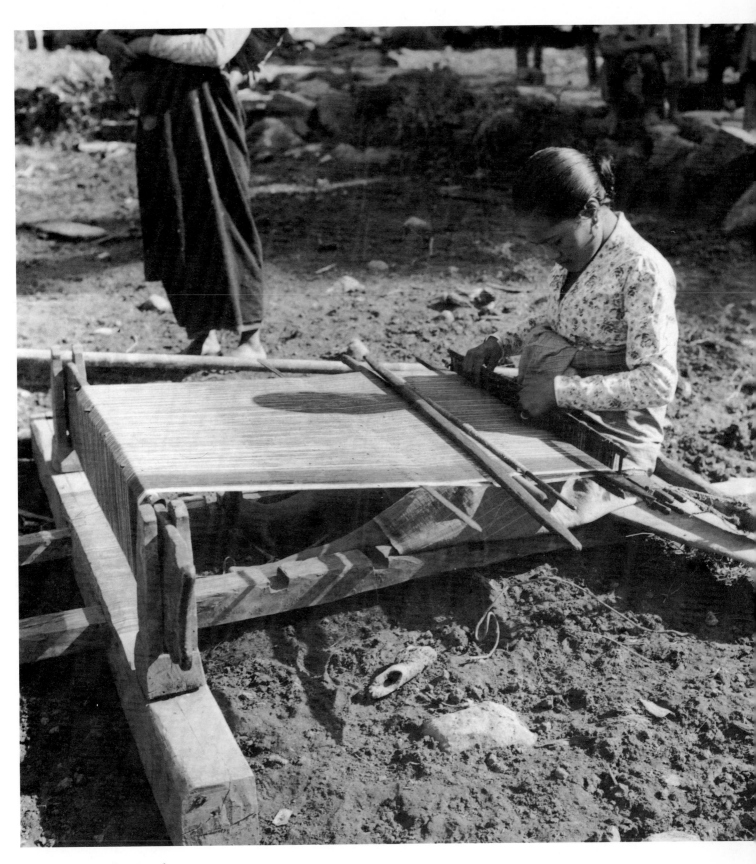

1b *A weaver in Todo, West Flores,
demonstrates her back-tension loom.
(Mattiebelle Gittinger, Washington, D.C.)*

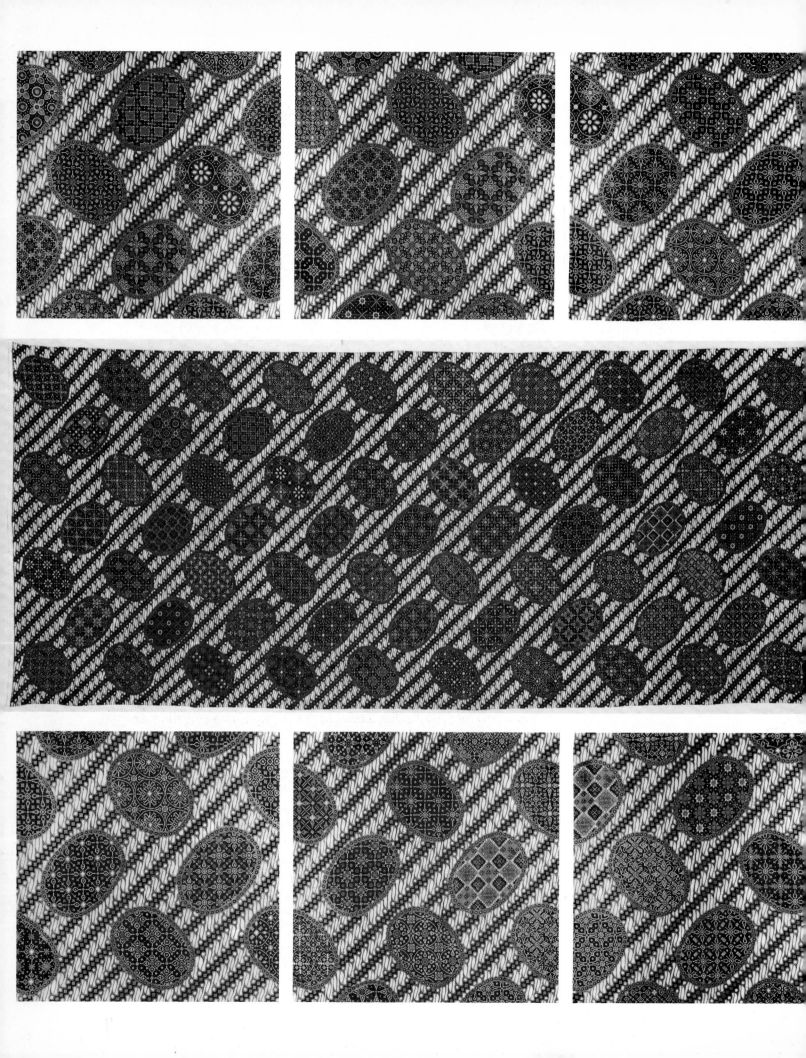

INTRODUCTION

Indonesia is an island state arching 3,500 miles across the underside of Asia. Like a vast net it has caught the migrations of peoples from the mainland, cultural influences from a multitude of sources, and the imagination of scholars, artists, fortune-hunters, and travelers from all over the world. Romantic musings about the region are hard to suppress, given a history linked to fortunes traded in cloves, pepper, nutmeg, and sandalwood. Closer inspection does not completely banish such mental structures, because Indonesia's greatest treasure, its more than 350 ethnic groups, gives a diversity of cultural expression and personality that remains a source of exotic fascination.

Nowhere is Indonesia's broad cultural spectrum more evident than in its textile arts, which range from luxurious silk and gold shoulder cloths to boldly patterned cotton mantles, from huge ceremonial wall hangings to simple working garments. Less well known, perhaps, is the role that textiles play as a symbolic medium, functioning on many levels of understanding and communication. They enter into all phases of social custom and religion, assuming unusual properties and attributes. It is this facet of Indonesian textiles that is examined here. The examples given are representative but by no means exhaustive of the great web of custom in which textiles are enmeshed in these islands. How this relationship of custom and textiles evolved is not clear; even the history of Indonesian weaving itself remains vague.

It seems probable that weaving first came to Indonesia with bronze and iron-using peoples, who brought with them a simple back-tension loom that used a continuous warp structure. This presumably ancient form of loom is still used by many ethnic groups, and even where other types of looms are known, the more primitive is retained to weave certain sacred textiles. This simple loom is associated primarily with cotton fibers and warp *ikat* patterning, although other types of fibers and designs, often of great complexity, are worked with this loom as well.[1] At some point another type of loom, one with discontinuous warp yarns, began to be used in certain parts of the islands. The warp yarns on this loom pass through a reed or comb. While the function of the

See Figure 86.

comb is disputed, one expert believes that it gained usage because it frees the weaver from closely aligned heavy warps that result in warp-faced patterning, and allows finer warp yarns to be more widely spaced so that the weft yarns can ride on the surface and act as pattern elements. On this type of loom the relationship between the weight and number of warp and weft can be balanced so that plain weave plaids are possible.[2] Whether or not this analysis is correct, there is an almost perfect coincidence of this loom with plaids, weft ikat, and silk fibers in Indonesia. Since these components are primarily found in coastal trade areas and high court centers, the loom and the textiles woven on it may have a different source, and their distribution in Indonesia may be due to causes other than just migration of peoples alone.[3]

Such insubstantial conjectures are necessary because historians have unkindly ignored the textile arts in these islands—not only in regard to the craft of weaving itself, but also the means used to decorate and design textiles. Thus in addition to the uncertainties about when weaving began there, questions remain about the entry of silk, and how such processes as *batik, plangi, tritik,* weft ikat, and warp ikat developed. Which techniques did the early mainland migrants bring with them, and which were introduced from China, India, or the Middle East?

Chinese records from 518 A.D., older than the first local references to textiles, mention weaving of cotton on Sumatra and note that a king in the northern part of this island wore silk.[4] Because of the long interval before silk is mentioned again, it is probable that this king wore imported fabrics, and that silk was not woven in either Sumatra or Java until the rise of the empire of Srivijaya or at least until 1000 A.D. For the Chinese, however, cotton was still an exotic fiber, so envoys from Sumatra, Java, and Bali who bore gifts of cotton textiles to the oriental court between the seventh and fifteenth centuries were duly noted.[5] Unfortunately, such terms as "variously colored silks and cottons" leave little impression about the appearance or construction of the fabrics they brought with them.

Some attempts have been made to use patterns on stone and metal antiquities from these early periods as evidence in dating, but they are not detailed enough to indicate textile technique. For instance, ninth- and tenth-century temple wall carvings in Indonesia have been identified as batik patterns,[6] but because such patterns may also be done in a supplementary weft technique, there is no assurance that batik is represented here. Indeed, the precise vertical and horizontal alignment and the complexity of the metrically repeated motifs argue for a source in weaving rather than in the dyer's art. Stone carvings from the thirteenth

century contain *gringsing* and *kawung* designs that subsequently became important batik motifs with both sacred and secular connotations. Here, too, doubts must be raised whether these are stone renderings of batik; one expert has proposed instead that they were executed in applied gold leaf.[7]

There are written Javanese records from the fourteenth century which, although not mentioning technique, do clearly indicate the importance of textiles in the social and religious life of the Javanese and name certain types of patterns and cloths. The gringsing motif is said to have been used by the king's entourage in the annual royal procession of hundreds of carts that passed through the kingdom.[8] During this journey the king gave textiles to loyal followers. "Probably the design and the colours of the pieces were highly significant to the receivers. By giving some persons pieces of textile with special designs, the king was able to do them special favors."[9] Probably the custom of proprietary rights to certain cloths and patterns was already well established, because the declaration of these royal reservations was a part of the New Year's Day celebration.[10] One scholar concludes that in the fourteenth century the Javanese may have used warp ikat textiles, and that bark cloth was still important to religious communities, but that there is no evidence for batik.[11] What is apparent from this early information is that textiles had a status beyond that of mere clothing, and that their socio-religious import, found today all over Indonesia, was firmly established in Java by that time. To some degree, this must have been the case in most of the islands.

With this in mind, it is not difficult to see how Arabs and other traders had made cloth the primary medium of exchange by the time the Portuguese arrived in search of trade in eastern Indonesia, early in the sixteenth century, nor how Duarte Barbosa could write in this period, regarding the spice-producing island of Ambon, "Cambaya cloths [Indian cloths] are held in great value here, and every man toils to hold a great pile of them that when they are folded and laid on the ground one on the other, they form a pile as high as himself. Who so possesses this holds himself to be free and alive, for if he be taken captive he cannot be ransomed save for so great a pile of cloth."[12] These cloths were probably similar to the plain colored cottons, simple plaids, and stamped cloths that were later traded in the area. Lists of items traded through the entrepôt of Malacca at this time include other Indian cloths, silks, damasks, brocades and colored satins as well.[13]

The price of imported cloth was high in the islands in these early days. In 1603, an average piece of cloth was worth 40 pounds of nutmeg on the island of Banda.[14] The imported goods had a great impact on local textile design, especially in the case of a group of Indian ikat cloths called *patola*. As will be discussed, both the schematic concepts and individual elements of these luxurious fabrics affected whole textile complexes. What cannot be discussed beyond a few sentences here is the immense impact of the simple cotton plaid, termed the Malay plaid. This type of textile, now found in the Malay Peninsula, coastal Sumatra, Java, Bali, Lombok, Sumbawa, coastal Borneo, the Celebes, the Moluccas and much of coastal eastern Indonesia, completely replaced

indigenous patterns and decorative techniques, whether in weaving or bark cloth processes. We have no idea what common textiles were produced in most of these areas before the advent of this plaid, which seems to have followed the general spread of Islam in Indonesia.

Neither batik nor tritik enters the historical records until the sixteenth century. Batik then appears on a *lontar* palm scroll in 1520 as *tulis,* which has been interpreted by the great batik scholar Rouffaer as a reference to cloth decorated by the wax resist process. Even today the finest batik work done entirely by hand is still called tulis or "writing" in Java. Mention was made in 1580 of a shipment of *kembangan,* or tritik-patterned fabrics from Java.[15] Thus, by the end of the sixteenth century at least two textiles were considered worthy of special note, and these used the same dye-resist processes on woven textiles as today have come to dominate Javanese textile arts.

The lontar palm scroll interpreted by Rouffaer called the people who did the tulis work *lukis,* meaning "painter." The term painter was used in the seventeenth century by a Dutch visitor to the Javanese court of Mataram, who wrote of seeing 4,000 women painting cloth.[16] Surely this must refer to batik, although it is hard not to question the number of "painters" he mentions. By 1641, however, the word "batick" appears on a bill of lading describing polychrome textiles shipped on a sailing vessel from Bataavia (Jakarta) to Bengkulen on Sumatra's west coast.[17]

With the exception of the detailed description of the plangi resist process given by the Dutch botanist Rumphius after he saw it done on Java and Bali in 1680,[18] there are few notable references to textiles until the writings of the remarkable Sir Stamford Raffles in 1817, which mark the real beginning of the textile history of Indonesia.[19] His work contains a flood of detail, including an enumeration of costume items, descriptions of batik, ikat, tritik and weaving processes, and detailed drawings of woven striped *lurik* cloth, kembangan cloth, batik patterns such as *udan riris, parang rusak, sawat,* and kawung, and the patola pattern known as *jelamprang.* After Raffles there was a long hiatus, then the great works of Rouffaer and Jasper appeared at the beginning of the twentieth century. These studies discuss batik and the other textile arts of Indonesia in great detail, and still stand as the major foundation for all writing on textiles in the archipelago.

The problem in speaking of the history of Indonesian textiles is that so little can be said with confidence of weaving done on islands other than Java. Conclusions can only cautiously be drawn from circumstantial evidence. It seems that warp ikat was the major means of

patterning where weaving was done, and was brought into the archipelago by bronze-using people. This evolved into distinctive styles reflecting each island's separate development and the various foreign infuences that touched otherwise isolated groups. Paired with this would have been twining used for straps, edgings, and warrior garments. Bark cloth must also have been widespread; among certain groups it continued in use well into this century. Evidence of the relative antiquity of weft ikat, the various supplementary weft processes, and certain types of warp patterning is not so clear, but their distribution among the islands raises provocative questions.

The strongest evidence for the antiquity of weaving in these outer islands is the importance of textiles and weaving in the social and religious life of the people. They are basic components of systems that control the societal structure and enter ceremony and ritual as symbols with a multitude of referents. It is the purpose of this catalogue to introduce the viewer to some of these less obvious aspects of Indonesian textiles both on Java and the outer islands, making possible a deeper appreciation of the great traditions of the weaver's and dyer's arts of Indonesia.

NOTES

1. Foreign and technical terms are explained in the glossary.
2. Goslings 1922-23:179, 252
3. The properties and distribution of loom types in the archipelago are discussed in Nevermann 1938, Ling Roth 1950, Pelras 1972, Bolland 1971, and Vollmer 1977.
4. Nevermann 1938:18
5. Ibid.:18, 19
6. Hoop 1949:84-87
7. Langewis and Wagner 1964:30
8. Pigeaud 1962:54
9. Ibid.:78
10. Ibid.:288-289
11. Ibid.:506
12. Dames 1921:199
13. Ibid.:172
14. Leur 1960:311
15. Bühler 1954:3747
16. Kat Angelino 1930-31:xiii
17. Loebèr 1926:85
18. Bühler 1954:3747
19. Raffles 1817

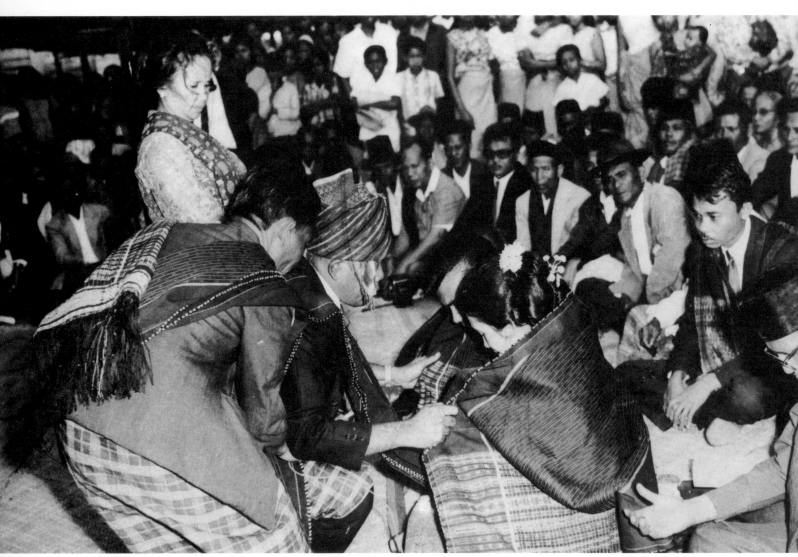

2 *The nexus of the traditional Batak wedding is the moment when the father of the bride wraps the bride and groom in one of the great* ulos, *here a* ragi hotang.
(Sutan Badiaradja Sianipar, Balige, North Sumatra)

TEXTILES AS GIFTS AND ITEMS OF PRESTIGE

We now present this garment which is the enrichment, upa-upa, of the soul force of our daughter. It brings coolness, upa dingin; it strengthens the stability of the soul, upa horus. It is a garment in which sons and daughters may be carried by her. . . .[1]

Thus in North Sumatra begins the presentation of the prestigious *ulos ni tondi*, soul cloth, to a Batak woman pregnant with her first child. The gift, coming from her family of origin, carries with it the superior soul force *(sahala)* of her lineage, and she will wrap herself in the cloth on occasions such as childbirth or sickness when her own powers are weakened or endangered. The beneficial and protective powers of the cloth extend to her children, who may be wrapped or carried in the textile in times of need. This is the most important textile Batak parents give their daughter, but it is only one of the many that her original lineage will give to her and to her husband's lineage in a system of gift exchange that permeates every aspect of their lives and continues even after death.

The way the Batak use their handcrafted textiles for purposes far more extensive than that of mere clothing exemplifies a clear pattern that underlies similar practices throughout Indonesia. Although traditions in many areas have not been fully documented, or have been altered by intrusive factors, knowledge of the rich Batak custom and metaphor allows us to understand the place of textiles in much of Indonesia.

The most important use of textiles is as gifts. This importance comes both from their real value and from their symbolic value as the product of women. For many Indonesian groups, textiles have sacred origins in myth and legend, and this aura is never completely lost. Their role as gifts, however, is rigidly controlled by customary rules and practices.

Among the Batak, all major gift exchange operates in a prescribed pattern between the lineages of wife and husband. Marriage automatically establishes the relationship between these groups, who are termed the "bride-givers" and the "bride-takers." All gifts from the bride-givers *Figure 61* or the maternal lineage are called *ulos*, the generic Batak term for handcrafted textiles. Gifts from the husband's lineage, the bride-takers, are called *piso*, meaning knife or sword. To some degree this term is metaphorical, in that knives are rarely given, but rather goods considered to be masculine, for example money, buffalo, and pigs. By contrast the

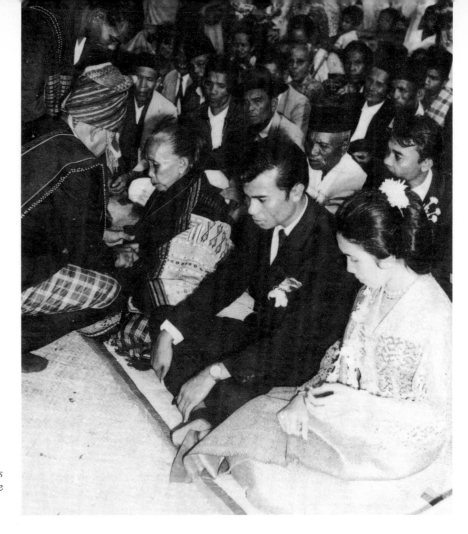

3 *The bride's father wraps the groom's mother in a* ragidup *in the course of the wedding ceremony. (Sutan Badiaradja Sianipar, Balige, North Sumatra)*

ulos category, while including other items, still demands the actual transfer of traditionally woven textiles.

Life-crisis periods such as marriage, birth, circumcision, and death are recognized times of exchange, and the ceremonies often center on the moment when textiles are transferred. In the marriage rites of the Batak, the act of *mangulosi,* or the enveloping of the bride and groom in a single textile amid blessings for fertility and a harmonious life, provides the emotional focal point. Just as this textile unites the couple, so another cloth wrapped around the shoulders of the groom's mother represents the union of the extended lineages. Ultimately, however, the gift of textiles symbolizes the sharing of the superior soul force of the bride-givers, who may be called upon to strengthen the soul force of the bride-takers any time they feel endangered or weakened by sickness or adversity. These demands may take the form of requests for the symbolically imbued *ulos na so ra buruk,* "the ulos that never wears out," a textile metaphor for arable land.[2]

Throughout Indonesia textile gift exchange has both symbolic and economic meaning. Originally large mantles, shoulder cloths, and *sarong* were products of the women of the family grouping by which they were given. Thus in marriage exchange, they symbolized the productive and fructifying qualities of the bride-givers, as well as having real value as the product of the labor invested in cultivating, spinning, dyeing, and weaving. Access to these economic factors of labor, materials, and skill was limited primarily to members of the extended family

Figure 2

Figure 3

in the traditional society. The textiles therefore represented both the ritual and economic wealth controlled by the family.

Patterns of gift exchange similar to that of the Batak, with its overtones of symbolism and economics, are found throughout Indonesia. On the hot, dry island of Sumba in the east, exchanges are made by clan segments called *kabihu*. Following patterns of exchange established by marriage, they give women's sarong, boldly patterned men's cloths, and beads in exchange for gold ornaments, buffalo, and horses.[3] In the past horses, sandalwood, and textiles were also sold to foreign traders, and this allowed certain local rulers to acquire great stores of goods such as metal gongs, gold, ivory, beads, and extraordinary numbers of locally crafted textiles. Thus they were able to extend the use of textiles beyond formalized exchanges between bride-givers and bride-takers to virtually all encounters. Sumba rulers often dressed their retainers in finery from their personal stores of textiles for special ceremonial occasions. As a mark of particular favor, the clothes might actually be presented to the wearer. Above all, the rich man collected textiles against the day of his own funeral when huge numbers of cloths would be required as gifts and still more to wrap the corpse into a gigantic, formless bundle. The wrappings would be buried with the dead man so that they could accompany him to the afterlife.[4]

Sumbanese marriages between families of great wealth and high social rank were marked by the exchange of many textiles. In a nineteenth-century account of a noble's wedding, it is recorded that the bride's kabihu gave valuable beads, seven slaves, forty men's ikat mantles, and forty women's sarong.[5]

The excesses of the Sumbanese are not unique; other Indonesian ethnic groups still incorporate enormous numbers of textiles into their ceremonies. Although customary law prescribes the direction in which these obligatory gifts will flow, local wealth and rivalries tend to govern the quantities. These exchanges can involve the extended family members in months of preparation, and the climax is often an extravaganza not unlike the potlatch of the Northwest Coast Indians.

The ruling nobility on the island of Timor once indulged in incredible displays of giving, and their funerals are often recalled in terms of the number of cloths buried with the corpse and the head of buffalo slaughtered.[6] The missionary Middlekoop reports a singular custom of competitive gift-giving at the final stage of a great man's funeral, but does not say how common it was. With his declaration of "wanting to sell meat, wanting to sell food," the widow's brother, acting as host, challenged the bride-takers to compete in gift-giving. No one was required to enter the contest, but refusal was an implicit admission of the challenger's superior status. The ceremony began with a "laying-out of the mats," in the course of which each of the guests asked for a "mat" from the host, who responded by giving each a woven textile. As he did this, he imitated the sound of an animal, usually a horse or buffalo, and the recipient then gave him the animal in return. If the brother scratched his neck, the textile recipient had to give him a string of beads; if he shook his *betel* bag, the recipient had to pay money.

Textiles could also be demanded from the host in the capacity of fines

Figures 122, 117

Figure 4

Figures 134, 136

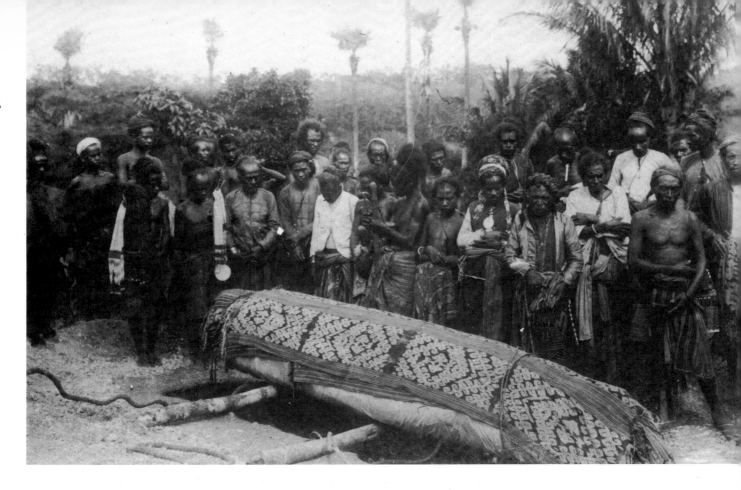

4 *Funerals on many islands are marked by the giving of extravagant numbers of textiles. Many of these are buried with the corpse, but in some areas the textiles may be given to retainers and extended family members or even saved for future exchanges. Here the body of the radja of Amanatun on Timor has become a formless bundle, lost in its textile wrappings. (Koninklijk Instituut voor de Tropen, Amsterdam)*

Figure 107

for real or imagined slights. Thus if the host served meat of questionable quality, he might be fined a cloth. If he served water instead of palm wine, a textile fine was imposed. A guest might declare her wine "dirty" and claim one sarong to cleanse it and a second to "dry her tears." Finally, as the guests prepared to leave they could keep the competition going by requesting a "basket," that is, another textile in which to carry home the excess food, and this would kindle the competitive exchange anew.[7]

The generally pervasive custom in Indonesia in which the bride-giver's textiles are exchanged for the bride-taker's animals or monetary wealth is commonly recognized. Less well known is the fairly widespread existence of what might be called "token" textiles. These are ritually significant cloths, often sacred in themselves, which are used for a variety of ceremonial functions. Physically these textiles share nothing in common except their nonutilitarian nature. They may be too small to serve as an item of clothing or too fragile and lightly woven to be used in any functional manner. Although their directional flow in gift exchange cannot always be predicted, they are always used as gifts or in a sacred capacity.

One group of token textiles from South Bali have physical properties that mark them as unusual. They are made of coarsely spun cotton yarns woven in a loose, balanced plain weave with a texture similar to cheesecloth. Most examples have designs dyed by weft ikat with overpainting applied to the surface of the finished cloth, but in a few examples it appears that the designs were painted rather than dyed on the weft yarns before weaving. Many of the known examples are of a nonfunctional size slightly over one meter long and half a meter wide;

others are the size of a normal shoulder cloth. Regardless of their
dimension, their fragility precludes practical use. The textiles seem to
have functioned as ritual surrogates for more functional textiles dur-
ing life-crisis ceremonies,[8] and to have had a sacred nature arising, per-
haps, from circumstances surrounding their weaving, such as the type
of loom and the rites of consecration. One example now in the Basel
collection was a ceremonial covering for a royal bed, and another
clothed the statue of a goddess. What little is known about the cloths
was collected, together with a few specimens, by the artist Theo Meier
in the 1930's and the textile expert Alfred Bühler in the 1950s. Neither
author was able to collect enough detail to clarify exactly how the
cloths were employed.

A different type of textile, also of a token nature, was the small *kain
kembangan* used in Central Java. This was a miniature rendering of the
large kain kembangan, recognizable by its tritik patterning of a large
central diamond shape. Such small cloths were used at wedding cere-
monies, where they were placed near focal points of ritual concern—
the bed-of-state, the rice pot, and the orchestra. At circumcision cere-
monies groups of seven of these small cloths, designated by pattern,
were given as offerings; other sets consisting of eight cloths were used
at ceremonies for pregnant women. The consecration of a new house
was another occasion requiring a set of eight of these textiles.[9]

A most interesting ritual quality that some token textiles may possess
is that they can run counter to the expected flow of bride-givers to
bride-takers. It is not always clear how this characteristic was rational-
ized except in certain instances. In these it seems the token textile was
an element of a larger symbolic expression whose referents encom-
passed a much greater realm than gift exchange alone.

One type of token textile that shows such multivalent properties
is a group of small cotton textiles once made in South Sumatra, called
Figure 54-59 *tampan*, that were used in virtually all rituals. They are about 70 to 100
centimeters square, with a variety of figurative and geometric designs.
In many respects they functioned as a ceremonial currency backed by
the *adat*, or customary law. Like any other currency, however, they were
only as strong as their supporting institutions, and once the customary
laws began to change, the weaving of these cloths first declined and
then ended, probably in the first quarter of this century.

The tampan were used in gift exchanges at all life-crisis ceremonies,
usually in conjunction with other objects of symbolic value. At funer-
als, a tampan tied around a small woven mat was a major obligatory
gift and at engagements, weddings, name-givings, and circumcisions the
cloths were used to wrap token foods. In engagement negotiations,
members of the groom's lineage presented tampan-wrapped packets of
ceremonial foods to the bride's parents and other members of her ex-
tended family grouping. When the couple's first child was born, the
same family members exchanged foods wrapped in tampan, but now
the wife's family was obliged to return a greater quantity of cloths and
food than the gifts of the husband's family. This was to be the pattern
of exchange involving the two families at all later ceremonies and could
involve quantities as high as 120 of the small textiles.[10]

In recent years the tampan used in most of these ceremonies have been returned to the original owners. This may be a response to their rarity and not necessarily a practice that would have occurred if the cloths were still being woven. Nevertheless, whether actually given or not, the cloths symbolize and enumerate the multiple ties established by the marriage.

It is not clear how this flow and counterflow of tampan textiles could be sanctioned given the proscriptions normal in the broader Indonesian context. Yet there are other occasions, even more dramatic, when this textile travels from the bride-takers to -givers. At these times it seems to be an element of a larger metaphor. In the more isolated mountain villages along the west coast of South Sumatra, only one tampan is still important in the ceremonial context. This cloth is theoretically the property of the groom's family; it is sent with meat, rice, and spices to the bride's family in the midst of the wedding ritual. Overtones of this same usage appear elsewhere in the south, where the adat demands that a young man leave a tampan at the house of a girl's parents if he elopes with her. Even today, this particular cloth is not returned. As noted in the essay on ceremony, the tampan is a part of a ritual tree of life. When separated from the other components of the symbol it carries the new connotation of the ritual destruction of that form. Hence in both the marriage and elopement, what seems to be a gift is more importantly a sign of transition.

This South Sumatran pattern of textile counterflow is repeated elsewhere in Indonesia. Unfortunately, not enough information remains to be able to analyze if these customs were once part of larger metaphors. On the far eastern island of Sangir, a red cloth called *talimbuku* was carried in procession by the elder female relatives of a prospective groom to the house of a girl at the time of the initial engagement consultations. This use of the cloth as a symbol of the intent to propose marriage has its roots in antiquity, for talimbuku are mentioned in a similar context in the myths of this island.[11] On the island of Roti a red cloth called *dela* was used by the groom's lineage to wrap the betel nut and other objects carried to the girl's home for the marriage negotiations,[12] yet the actual marriage gifts adhere strictly to the wider Indonesian pattern.[13] In Kupang, the major city on Timor, the groom at one time sent his engagement letter in a ritually folded and pinned cloth.[14] Similarly, among the Belu of this island a prospective groom took a headcloth and other token gifts to the home of a girl at the time of courting.[15]

A type of aged sarong, also of a token nature, but with immense ritual value, once circulated in parts of middle and eastern Celebes. These cloths were small (one of the largest cited was 80 x 35 centimeters) often striped, with a loose plain-weave structure of carelessly spun cotton. They were invested with magical properties and used primarily in exchange, particularly in marriage negotiations,[16] where they served as major gifts from the groom's family to the bride's. An instance is even cited of a family renting one of the cloths to go through a pro forma ceremony of giving, so necessary was it to a successful marriage.[17]

In the Bird's Head region of Irian Barat, the role of textiles in ceremonial exchanges was somewhat different, perhaps because of the in-

fluence of various Indonesian patterns of exchange on Melanesian trade traditions. No weaving was practiced on this extreme western tip of New Guinea, but imported cloths originally woven in eastern Indonesia, India, and elsewhere were important objects of wealth and were considered "male," as opposed to vegetables and other plant products, thought of as "female." Such textiles were gifts from both bride-takers and bride-givers, but mainly the former.[18] More importantly, they constituted the nexus of a ceremonial exchange cycle that was thought necessary to maintain the welfare of the people.[19] As many as twenty of these exchanges might take place in a man's lifetime. The textiles were given in exchange for taro, fish, meat, and palm wine. Four to six months later, those originally receiving the textiles had to return a similar number plus an "interest" of additional cloths. To acquire sufficient cloths for these exchanges men, in agreement with their female relatives (who actually owned the cloths), loaned textiles for a rental taken in additional cloths. A man's status depended on both the number of textiles he was able to circulate and the quantity he was wealthy enough to keep piled up at home. Although this custom of the Bird's Head people is an extreme variant of the usual role of textiles in Indonesia, it is still another manifestation of their importance.

Textiles are obviously central to the broader ritualized exchange of gifts throughout the whole of Indonesia. The traditional rules which direct this call for the bride-givers to furnish this portion of the gift equation. Given are the great kain, sarong, blankets and shoulder cloths that constitute the renowned products of the weaver's art. In addition there are enough examples to suggest that there existed at one time a tradition of token textiles and that these did not necessarily fall within the normally recognized dual classificatory structure of male and female goods that circulated in these exchanges. Both these types and the customs that govern their functions demonstrate the complex nature of textiles in these island societies.

NOTES

1. Vergouwen 1964:56, 86
2. Ibid.:84-85
3. Adams 1969:55
4. Nooteboom 1940:62-63
5. Roo van Alderwerelt 1890:574
6. Vroklage 1953 II:81-84; Kraijer van Aalst 1924-25
7. Middlekoop 1949:178-181
8. Notation regarding use of these textiles may be found in the accession records of the Museum für Völkerkunde und Schweizerisches Museum für Volkskunde Basel, Basel, Nos. IIc 7182, IIc 14008, IIc 14012 and IIc 14013.
9. Jasper and Pirngadie 1916:238
10. Gittinger 1976:211-213
11. Adriani 1894:18, 22
12. Wetering 1925:591
13. Ibid.: 625-627
14. Wetering 1927:355-356
15. Vroklage 1953:270
16. Kruyt 1933:8
17. Ibid.:4
18. Elmberg 1968:83
19. Ibid.:172

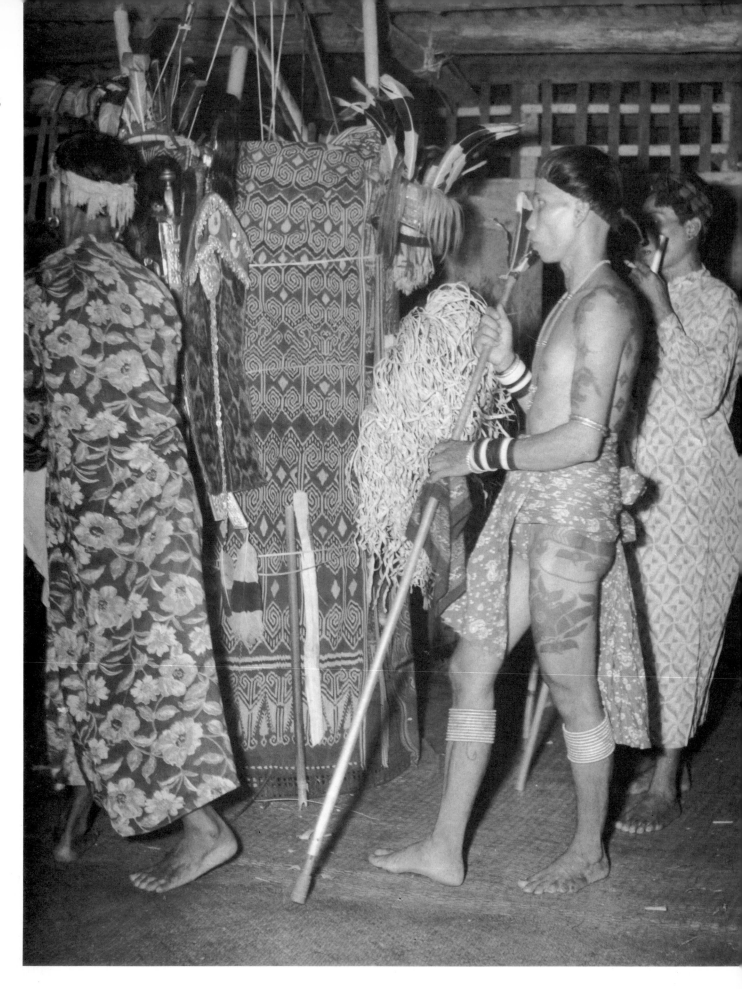

TEXTILES IN THEIR CEREMONIAL AND RITUAL CONTEXT

From the courts of Java to simple mountain villages in the outer islands, textiles fill complex roles in the ceremonial lives of the Indonesian people. They may appear as prescribed pieces of clothing, as wall hangings, as small squares, or large temple and house banners, and range from highly decorative accouterments to modest fragments. In physical details they are unique to specific groups, sharing only a transcendent nature in their roles within the ritual context. Unfortunately, many are no longer being made, and exist as heirlooms alone. Others, have disappeared entirely, except as notations in older writings.

While in detail the textiles are different, the physical form of a newly woven cloth offered a powerful symbolic instrument that many different groups recognized. This is the circular or tubular form the completed cloth has when it is woven on one type of loom. The shape results because the warp yarns are continuous, forming an uninterrupted circle between the two beams of the loom. When the cloth is finished only a small section of the warp yarns remain unwoven, and for normal use the textile is cut open across this area. It was the rich metaphorical potential of the continuous yarns in the uncut cloth that became obvious to diverse groups.

Certain Batak groups were among these, and they once made a circular cloth called *hijo marsitogutoguan,* which was used in birth rites. An early twentieth-century observer wrote, "The continuity of the warp across the gap where the woof had not been woven in was said to be magic to insure the continuity of life from the mother to the child, and 'the going on of the generations.' The birth of the child was represented by the beginning of the woof at one side of the uncut fringe. As one drew the cloth through the hands it represented the growing up of the child, and when the other side of the uncut fringe was reached, it represented the beginning of a new generation whose life would repeat that of the mother, and so on indefinitely." [1]

Other Batak groups employed a circular cloth, the *ulos lobu-lobu,* which was used to encircle the bridal pair while they ate the ritual

5 A pua *is wrapped around the whetstones central to the Iban ceremony of* gawai batu, *which precedes the clearing of the paddy fields in this part of Borneo. (Hedda Morrison, Canberra)*

meal consecrating their marriage.[2] Such textiles no longer exist among the Batak, but other groups still invoke the same symbolism.

Figures 111, 112

The Sasak of Lombok still use sacred *kombong* cloths of a circular shape. Three of these sacred cloths, made for the child at birth by the eldest woman weaver in the family, are stored in the sacred area of the house until needed.[3] In the course of hair cutting, circumcision, and marriage rites the warps of these textiles are cut. The fringes that result from the severed warps are dipped in water from a special spring, which is then sprinkled on the celebrant of the ceremony.[4] These personal kombong are apparently small imitations of even more highly venerated male and female pairs of cloths once kept by Sasak priests at sacred springs. On ritual occasions, families used these larger textiles to carry vessels of sacred spring water needed for purification. Also the aid of these cloths as well as that of the personal kombong was sought in times of illness, and offerings of rice, betel, incense, and coins were presented to them. When necessary the kombong was washed, and the sick person either drank or was bathed in water wrung from the cloth.[5] The Sasak also have a range of other types of textiles said to cure specific diseases. All of these cloths are modest weaves of striped cotton; yet they are endowed with ritual significance that makes them vital to major Sasak ceremonies as well as to the general well-being of individuals.

Other groups viewed the circular warp structure and the cutting of that continuous form as a metaphor for the passage into a new stage of existence. In the Molo region of Timor, an uncut *selimut* is the major gift for a dead person; when all the mourners are assembled, the yarns are cut through and the selimut is used to wrap the corpse.[6] On this island, too, the uncut selimut traditionally was used in the initiation rites for headhunters. After taking the first head and earning the title of *meo*, the new headhunter was ceremonially attired with headbands, ornaments, and a hip wrapper whose warps were cut immediately before being put on.[7]

Some of the most famous ritual cloths in Indonesia, the double ikat cloths of Bali, also remain uncut until used in a ceremonial context such as marriage or first hair cutting.[8] They are used as well in cut forms and carry with them concepts of protection from all harm, although their name, *geringsing*, refers to protection from illness alone. They are made by the intricate, laborious double ikat process, an art practiced only in the single Balinese village of Tenganan Pagering-

Cover

singan. Here they serve as prescribed clothing and ritual instruments in every life-crisis ceremony, from the first hair cutting at four to six years of age through death.[9] Elsewhere on Bali they are employed at third- and sixth-month ceremonies for children, tooth filing, marriage, in time of illness, and at death.[10] They also appear as temple hangings.

All the characteristics of the geringsing affect their ritual efficacy. Dye qualities in particular temper their worth, and inferior textiles are not permissible in ceremonies in Tenganan. Such cloths, as well as ones made impure by death rites, are traded out of the village to less demanding Balinese or sold to tourists.[11]

Ceremonies that turned on the ritual cutting of newly woven warp

yarns were probably performed in ancient Java. The *Nagarakertagama,* a fourteenth-century chronicle of court rules and religion, mentions "warp-cutting" as the name applied to the concluding ceremony observed in establishing religious areas. The term is also repeated in early charters.[12] This chronicle also mentions other textiles used in royal ceremonies. While a lack of precise descriptions prevents drawing analogies with cloths used in more recent times, it has been proposed that certain sacred textiles mentioned in association with processions would have been similar to more recent textiles.[13]

A custom which is both ancient and widespread in Indonesia is to use textiles to enclose or define an area of particular ritual significance. This use of textiles is one of the concepts shared through much of Indonesia that, in practice, is merely tucked under veneers of ethnic diversity. Examples abound of these ancient forms. On Roti, the bridal room was closed off by nine large textiles in imitation of a "room in the sky."[14] On this same island, a textile called "the broad cloth of heaven" was hung over the body of a dead person.[15] The Toradja in the Celebes still make a cloth enclosure in the house to serve as an area of seclusion for a widow during mourning rites.[16] The Iban of Borneo use their great *Figure 5* *pua* to form a sacred enclosure which acts as a focal point at ceremonies or encloses the dead at funerals.[17] Pua are also employed for a person awaiting a "spirit helper" in the "dream room" at the top of the house.[18] At all major ceremonies in South Sumatra the walls of the lineage heads' houses were hung with blanket-sized textiles in one area and smaller, more sacred textiles called *palepai* in an inner room, which was thus transformed into a ritual area.

A modern surrogate for the custom of enclosing ritual areas with *Figures 6, 7* textiles is the bed-of-state, with its high canopy and textile hangings, found on Java and Sumatra. On the latter island, the most lavish decorations may be found along the east and north coasts. Here rich gold and silk textiles are displayed on and around the bed as signs of opulence and prosperity.[19] In certain areas, embroidered and appliquéd square pillows are placed on the bed as well. While the number and designs of these pillows are jealously guarded prerogatives of particular social ranks,[20] the decoration of the bed and the display of heirloom textiles have a deeper meaning than mere ostentation. Concepts of fertility and well-being are a property of these textiles, and inherited cloths are specially imbued with these powers, which are invoked at life-crisis rituals.

Not just locally made textiles could acquire ceremonial status, but certain imported cloths as well. The most important of these to enter *Figure 19* the archipelago was the patola, a silk double ikat textile made in India. The patola and its imitations were bartered for sandalwood and spices by the sixteenth century and possibly as early as the fourteenth.[21] Originally these cloths must have been valued for their glowing colors, complex designs, and exotic silk material. When their status was augmented by time and use, they acquired a sacred character as well. They are treasured even today, and may be seen in ceremonies in Sumatra, Java, Bali, the Lesser Sunda Islands, and the Celebes. They also appear in the costume of certain dancers on Java, which is probably a reflec-

6 *Along the eastern, northern, and western coasts of Sumatra, it was customary to use a ritually decorated bed at life-crisis ceremonies such as weddings. This bed was usually hung with precious textiles and piled with embroidered cushions whose designs and number were indicative of the family's position. Here, in a scene from Aceh in the north, the bed to the right is piled high with these status symbols. In front of the bed is a seat for the groom, while to the side is a lower seat for the bride. (This subordination of the bride is a reflection of the Moslem traditions in the region.) In the rear may be seen other seats draped with textiles and a wall hung with a great striped cloth. (Koninklijk Instituut voor de Tropen, Amsterdam)*

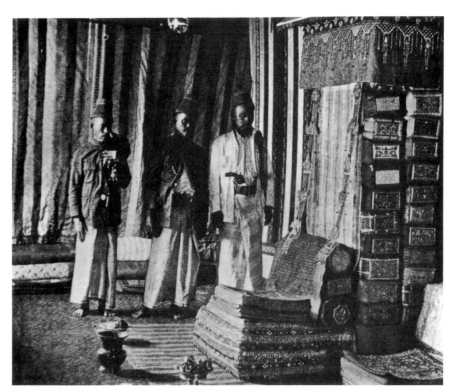

7 *A wedding scene from the Jambi area of Sumatra shows a multitude of textiles hung about the wedding room. These textiles are part of the family's treasure, and include both locally woven and imported cloth. The bride and groom sit on small thrones made of piles of mats, placed before a bed of state. In many areas, the number of mats was indicative of the family's social rank. (Koninklijk Instituut voor de Tropen, Amsterdam)*

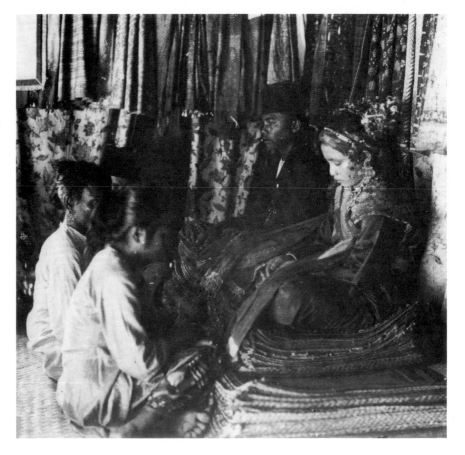

tion of the use of patola in the courts of the Central Javanese principalities of Jogjakarta and Surakarta. In these regions only the rulers, nobles, and high administrators could wear these cloths; an interesting exception, however, were the costumes allowed to the bride and groom, which by use of the patola equated the couple with nobility on their wedding day.

On Bali patola are still hung in temples on religious holidays and draped around temple sculptures. Small scraps or threads from the cloths may be burned and mixed with other ingredients in potions against lameness and insanity.[22] On the small islands to the east—Lomblen, Solor, and Adonare—patola were once given at marriage and used as burial shrouds and coffin covers. In the north of the Celebes, among the Minahassa, they were both used in ceremonies and carried by warriors as protection against their enemies. The garments of priestesses from this region include such textiles.

Figure 159-161

In the Central Celebes, patola and other imported textiles make up a group of sacred textiles called *Maa'* or *Mawa'*, which are ritually powerful accouterments of the lavish ceremonial cycle of the Toradja people.[23] They use textiles in every aspect of their personal and communal lives. In particular, textiles are employed in funerary display. They are hung on walls, displayed on lines, heaped in piles near the remains of the dead, layered as shrouds, and draped across the facades of houses.

Figure 158

Figure 8

Figure 155

The most unusual Toradja funerary textiles are the *sarita*, six- to seven-meter-long sacred banners flown from tall bamboo poles at funeral rites for important people. They may also be used in the shaman's headgear and sash, or as the head wrapper of a wooden effigy of the dead person. The Toradja say that originally these cloths were woven of "divine" yarns.[24] Some were patterned with a batik process by the Toradja themselves and others are block-printed imitations made by the Dutch in the nineteenth century.[25]

Figure 162

Other textiles displayed by the Toradja were made by joining similar batik bands to plain or plangi-decorated strips to form blanket-sized wall hangings used especially at funerals.[26] Huge warp ikat cotton textiles traditionally made in the Rongkong and Karataun valleys were also employed at these times.[27] Where they were woven, they were used solely as shrouds, but other Toradja purchase the cloths for display and costume at death and other life-crisis ceremonies.

Figures 179, 180

Textiles, headhunting, and fertility traditionally formed a symbolic triad in Indonesia. The great blanket-like textiles called pua of the Iban of Borneo were integral to their headhunting ceremonies. Heads newly taken by warriors were once received by the women and collected in pua or shoulder cloths and carried amid great ceremony through the longhouse. This ceremony is reflected in a ritual surrounding rice cultivation. In the center of each family's rice field is a group of rice plants which represent the fertility and wealth of the entire crop, as well as the general prosperity of the family. This rice is reaped with reverence in a special ceremony closely analogous to headhunting rituals. A pua is draped over the reaping basket, a cock is waved over the cut stalks in gestures of greeting and blessing, and libations are

32

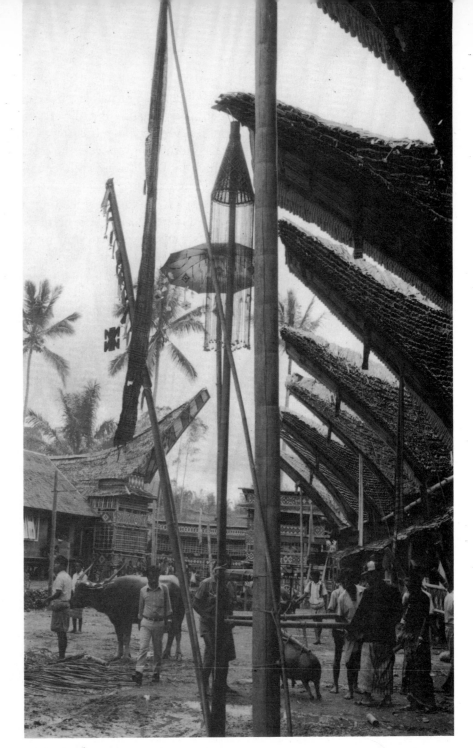

8 *The sacred symbols mounted on tall bamboo poles before the houses are an important part of the Toradja funeral ceremony. Here before a house in the village of Nanggala in Central Celebes a batik-decorated sarita, a great beaded ornament or kandaure, a parsol and a crab-like figure or bungkang indicate a funeral of the highest order. The antiquity of the sarita is suggested by its torn and frayed condition. Also in the photograph are the great tongkonan houses and horned buffalo central to these ceremonies, which are used as motifs in the sarita as well. (Koninklijk Instituut voor de Tropen, Amsterdam. C. H. M. Nooy-Palm)*

poured.[28] Headhunting was considered necessary to restore cosmic order, thus ensuring fertility, so it is not surprising that the rituals surrounding harvesting and headhunting were similar. In addition, just as men were required to become warriors and to take a head before marriage, women had to become proficient weavers before they wed. The creation of textiles and childbearing were seen as analogous to men's creative functions in headhunting and, indeed, certain steps in the preparation of the yarns were called the "warpath of the women."[29]

Among the Belu of Timor another illustration of the links between headhunting, fertility, and textiles is found. A new mother used to be confined to her home for one to two months after giving birth. On her first appearance after this seclusion, she was ceremonially carried from

Figure 9

9　*Among certain groups on Timor it was customary for a new mother to be secluded in the house for one or more months after childbirth. At the coming-out ceremony at the end of this period, she wore the accouterments of a head-hunter. Here she wears a man's selimut and a headhunter's ornaments. (Koninklijk Instituut voor de Tropen, Amsterdam)*

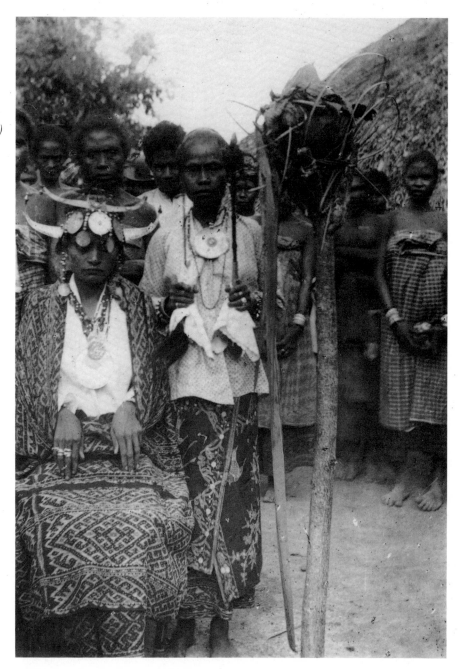

the house attired in the clothing and decorations of a headhunter.[30] For both mother and child, leaving the relative safety of the house was perilous; both had survived a potentially dangerous life-crisis and were now received anew into the community. The mother (the headhunter) returned bearing an appropriate contribution of new life, with prospects for prosperity and continued existence for the social group. The textiles and ornaments used in this ritual were invested with concepts of protection and fertility.

Complex and striking symbols frequently result when textiles are combined with other objects in the ceremonial context. One of the most spectacular is the tree of life. This symbol of totality, the cosmic whole, or the unity of upper and lower worlds, is seen in many groups,

10 and 11 *Among the Serawai people on the west coast of South Sumatra a tampan tied to a spear is a ceremonial instrument that accompanies all stages of a wedding. Here the groom, carrying the spear, leads the procession to the area where a buffalo is ritually killed. Later, when the animal is slaughtered, the tampan, tied to bamboo tubes filled with rice, together with coconuts, spices, and a leg of meat is sent to the bride's family. (Mattiebelle Gittinger, Washington, D.C.)*

among them the Ngaju of Borneo and the Serawai and Abung of southern Sumatra. Cloths joined to a pole or spear become the sacred tree. Renewal is dependent on the ritual destruction of the tree, just as the transition represented in life-crises is a form of death and rebirth. Concerning the Ngaju, Schärer writes, "The emblems of the supreme deities are the spear (Mahatala) and cloth (Jata). They are usually represented in their totality as the tree of life. The fruit and roots of the tree of life are the goods of the total godhead which have been bestowed upon mankind. Most of these fruits possess religious meanings and are used at every religious ceremony. These fruits are: cloth, agates, beads, gold ornaments, brass ornaments, sacred jars, gongs, and weapons." [31] In the most solemn ceremonies, the Ngaju ritually destroy the "fruits" of the tree and the tree itself so that the community can go on to a new stage of existence.[32]

Figures 10, 11

The same symbol is created and ritually destroyed in the Serawai and Abung marriage rites. The Serawai tie a tampan, a small cotton cloth once woven all over southern Sumatra, to the spear that accompanies the bride and groom through the various stages of the ceremony. Finally, when the ritual buffalo is killed, the tampan is removed from the spear and sent with a gift of meat and rice to the bride's family.[33] This represents the destruction of the tree and the entrance of the married pair into a new stage of life. Such simple acts, heavy with symbolic content, are performed even today in the mountains of Sumatra.

Figure 12

Another South Sumatra manifestation of the tree of life was the great *kayu ara,* set up for life-crisis ceremonies. This was a many-limbed, tall pole hung with textiles, mats, and baskets. In the course of the ceremonies, which might last three or more days, mock battles took place beneath it, and eligible maidens of the family, splendid in great gold headdresses and gold-embroidered skirts, had their ears symbolically pierced with a sacred *kris* (dagger). Beneath it too brides and grooms underwent ritual footwashing and ate the token foods solemnizing their union. When such occasions were over, small boys would swarm up the tree and, to the delight of the spectators, strip it of its "gifts." Thus plundered, the tree of life was destroyed, and existence could begin again. The kayu ara is still a feature of very grand ceremonies today.

Textiles complete the tree image because they are categorized as feminine items. This arises from work patterns which demand that all stages of the textile process, from the planting of the cotton through the actual weaving of cloth, be performed by women alone. As a consequence, in the dual classification that structures so many Indonesian concepts, textiles are bracketed with such entries as female, lower world, profane, night, moon, and blue-black. Opposed are male, upper world, sacred, day, sun, and red. A textile, then, is the perfect element to be united with a metal object such as a spear in a conceptualization and representation of totality.

Figures 48-52

Textiles often have symbolic value in both the religious and the social spheres. For example, large ceremonial textiles once woven in South Sumatra, the palepai (referred to as "ship cloths" in the West because ships form their dominant motif), were used as horizontal wall

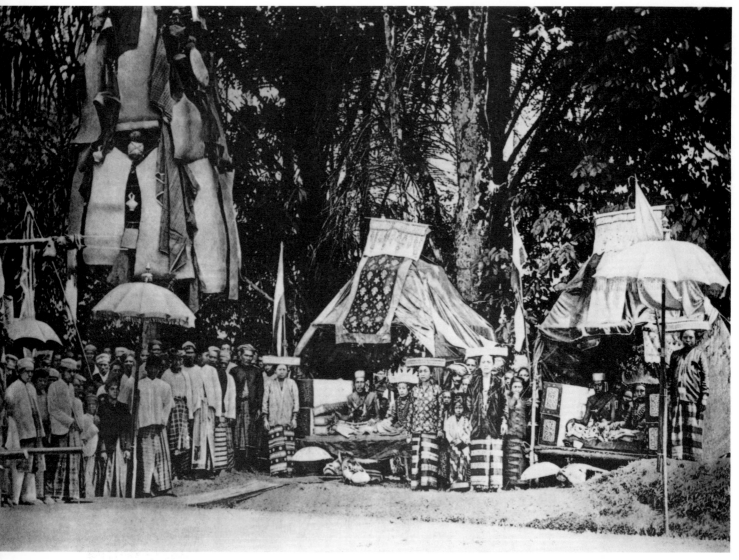

12 This early photograph preserves a moment in one of the elaborate wedding ceremonies of the Lampong area of South Sumatra. Here two pairs of brides and grooms sit on raised platforms beneath the towering form of the kayu ara (left). This manifestation of the tree of life is a bamboo structure hung with mats, baskets, and textiles. At the close of the ceremony, boys plunder it of these gifts, which represent the riches of the cosmic tree.

The photograph also records the great wealth used in these sumptuous displays. The brides wear great ship-shaped crowns, or siger, made of gilded metal, while the attendants standing in front wear kanduk liling, the straight headgear of married women. Their sarong are gold-embroidered tapis. Above the platforms are canopies hung with precious textiles, and to the right and left are large umbrellas that by their color and size are indicative of the high rank of the grooms. (Koninklijk Instituut voor Taal-, Land- en Volkenkunde, Leiden)

Figure 13 hangings, to be placed behind the principal subject of a life-crisis ceremony. This use was restricted, however, to the heads of patrilineal descent groups who carried the rank of *penyimbang*. These people formed an aristocratic class with many rights and prerogatives, including use of the palepai. Because the palepai is used and inherited only by such families, the textile itself has become a symbol of the aristocracy.

The very manner in which this cloth was hung was relevant in the context of the society. The penyimbang were the heads of patrilineal descent groups called *suku*, and four or more of these suku were

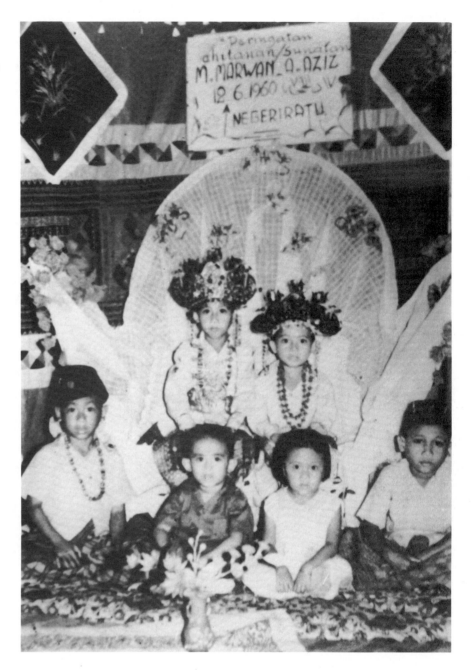

13 *Two cousins jointly celebrate a circumcision ceremony in the village of Negeri Ratu, South Sumatra. They are seated in a great bird chair placed before a panel-style palepai. (Amir Hamzah, Negeri Ratu, South Sumatra)*

affiliated into a larger grouping called a *marga,* which also had its penyimbang. Within the marga each suku had positional designations to the right or left, and was considered weak or strong. These classifications determined where people walked in processions or sat during ceremonies; they also controlled the display of the palepai. A penyimbang suku could flank his textile hanging with the palepai of the suku whose places were to his right and left, so that it was possible to hang three of these textiles at one time. A marga head, however, had the right to display the palepai of all the suku subordinate to him. These were, of course, arranged according to rank. Thus the ceremonial placement of the cloths constituted a schematic illustration of the relative positions of the aristocratic family and the suku, or among the suku themselves.

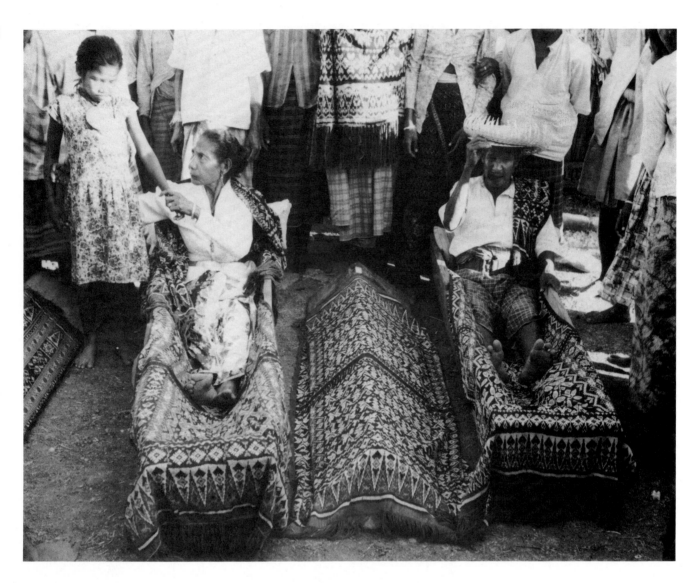

14 *For many people on Roti the initial funeral ceremony is well before death has occurred. Here an elderly couple prepare their coffins, lining them with the locally crafted textiles that will serve in the final burial ceremony. (James J. Fox, Canberra)*

Among many Indonesian ethnic groups some locally woven textiles are seen only on ritual occasions. The reasons for this are complex. In the nineteenth century, as the Dutch secured and expanded trade with many regions, large amounts of cotton goods were imported to Indonesia. In addition the development during that century of Javanese block-printed batik substantially increased its availability at modest prices. The absolute effect of this among certain groups was that they ceased weaving, bought what they needed for everyday use, and put their remaining woven textiles into the category of sacred heirlooms—a process that continues today.

For other groups, e.g., the Batak of Sumatra, the efficacy of ritual often turns on prescribed textiles made expressly for the occasion; therefore, by necessity, their manufacture continues. Even today most of these people cannot envision a time when there might be no weaving in their society, so necessary are particular cloths. The ragidup, ragi hotang, *ulos godang,* and others all are integral to ceremonies. How could the bride-givers greet their counterparts if they had no textiles laden with their sahala, or soul force, to bestow?

The use of textiles in ceremonial contexts in Indonesia is extensive and diverse. Many examples from other ethnic groups and in other rites could be cited. Underlying them all is a common conception of textiles as female goods in the male-female structural whole. They stand in association with fertility and are an expression in their own right of woman's creative essence. As such, textiles are transcendental wealth, but they are real wealth too, and their display affirms possession of both to the society as a whole.

NOTES

1. Bartlett 1973:138n
2. Gittinger 1975:23
3. Personal communication Ruth Krul-
 feld, George Washington University,
 Washington, D.C., 1978.
4. Pauw 1923:191
5. Ibid. 186, 191; personal communication
 Ruth Krulfeld, George Washington
 University, Washington, D.C., 1978.
6. Middlekoop 1949:56-61, 90
7. Middlekoop 1963 II:195
8. Pelras 1962:219
9. Ramseyer 1975:54
10. Korn 1933:14
11. Ibid.:13
12. Pigeaud 1962 IV:88
13. Ibid.:110
14. Wetering 1925:629
15. Fox 1973:359
16. Adriani and Kruijt 1912:342, 357, 365

17. Howell 1909a:75
18. Freeman 1975:284
19. Obdeyn 1929:109, 122
20. Ibid.:122
21. Bühler 1959:4, 5
22. Bühler 1976:17
23. Nooy-Palm 1975
24. Veen 1965:92-93
25. Nouhuys 1925-26:119-120
26. Nooy-Palm 1975:71
27. Nouhuys 1921-22:239; Spertus and
 Holmgren 1977:53
28. Freeman 1970:215
29. Howell 1912:63
30. Fiedler 1929:44
31. Schärer 1963:26
32. Ibid.:139-141
33. Gittinger 1972:40

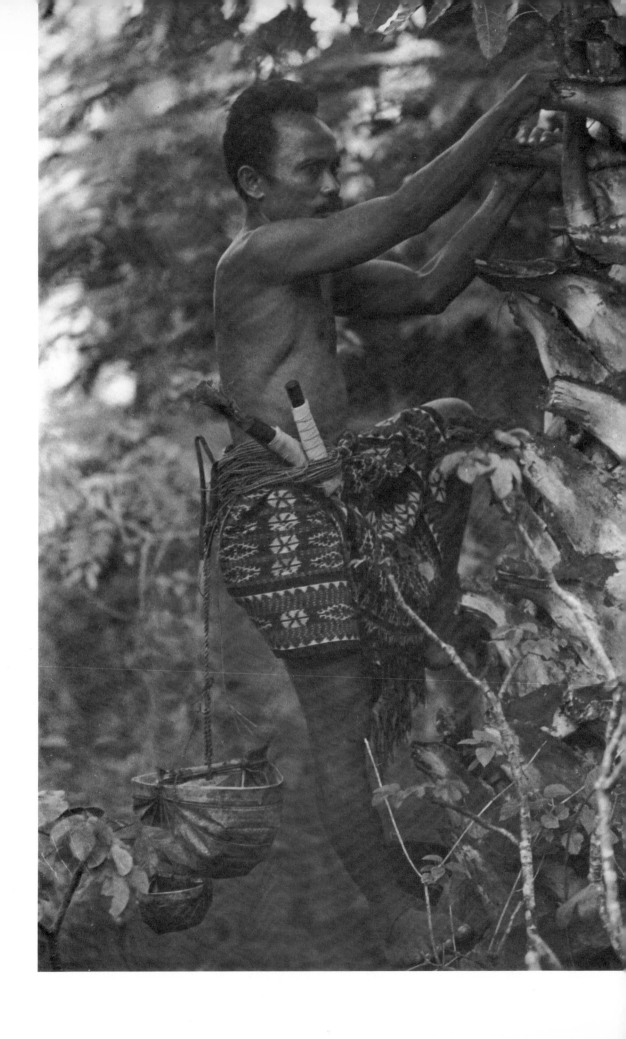

DESIGN AS MESSAGE

Designs often say what their owners can't." The reference is to a group of hereditary textile designs on the island of Savu.[1] It is also an observation to be extended to other textile designs in Indonesia that may bear witness to trade patterns, historical events, or cultural diffusion. For ethnic groups, however, the message they read in their designs is usually cast in a local idiom, virtually inexplicable to the casual observer. This may reflect social divisions or class distinctions. When investigation has made the design significance comprehensible, an entirely new level of understanding becomes possible.

Recent research on the island of Savu shows just how subtly and effectively design can function as a medium of communication.[2] One dimension of Savu society is that of the male descent groups. Another, which cuts across the male descent structure, is made up of two female aligned groups called "Greater Blossom" and "Lesser Blossom," which are further divided into sub-units called "Seeds." The function of these groups is the arranging and managing of life-crisis rituals. By customary law, membership in the blossom groups may not be discussed, yet it is revealed in the designs and composition of the textiles people wear which are specific to each blossom and seed group. Textiles with these designs must be worn on ceremonial occasions; at other times, non-significant but pleasing designs unrelated to group membership may be preferred.

Less well-documented examples suggest the similar customs were once common elsewhere in the Lesser Sunda Islands. On Solor, for example, certain textiles indicated descent groups, but here the various arrangements of design elements and divisions of the cloth surface, rather than the designs themselves, were reserved to different social groups. A weaver first learned from her mother the pattern of her mother's group, then from her paternal aunts the pattern of her father's. An individual could wear only his own descent group pattern. To do otherwise was to be classed as a "thief" and to risk having his clothes torn from his body.[3]

Figures 15, 16

Figures 145, 146

Figure 130

15 *A Savunese tapper ascends a lontar palm. The patterns of the cloth he wears identify him as a member of the group Hubi Iki, the "Lesser Blossom." (James J. Fox. First published in James J. Fox,* Harvest of the Palm, *Harvard University Press, 1977)*

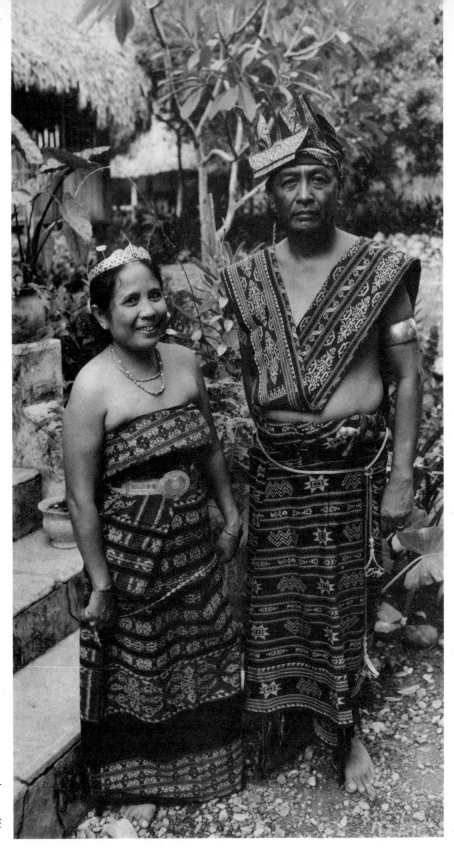

16 *D. D. Bireludji and his wife wear the royal regalia of the rulers of Seba on the island of Savu. The patterns of their textiles are those of the group* **Hubi Ae,** *the "Greater Blossom." He is a direct descendant of the ruler whom Captain Cook met on his visit to Savu in 1770. (James J. Fox. First published in James J. Fox,* Harvest of the Palm, *Harvard University Press, 1977)*

Designs may be the property of a particular family or weaver. In the Sika region of eastern Flores, ikat-patterned men's textiles were tied in an ordered sequence that reflected these rights. First came the designs that indicated the man's family, then a row associated with the ancestors. Only after these were worked could "imaginative" designs be added.[4] Among the Iban of Borneo, the weaver herself owned the

designs she wove and could sell them or pass them on to her daughter.[5]

There is evidence from other areas that locally handcrafted textiles were once part of larger ordering structures that are no longer recognized, although the particular textile or design elements may still occur. This seems to be the case on Timor and in South Sumatra.

Figures 134, 136 On Timor, each of the princedoms wove and used different textiles. "Every political community or important more or less independent sub-section of a community has its own pattern . . . often alternately red and indigo."[6] There also existed a well-honored tradition which forbade certain sub-groups to wear ikat-patterned textiles, assigning to these people the large mantles patterned by various weaving processes. In some instances, the paired opposition in the technique or the color category corresponds with historical patterns of social enmity. This suggests the textiles once were indicators of a broad social matrix. However, neither the opposition of blue-red nor that of weaving-dyeing consistently fits current social ordering. Consequently the larger scheme that once ordered these elements of complementary opposition is not completely apparent.

Figure 50 The message of design is often extremely complex even though local people cannot explain it today. This is true, for example, of the spectacular palepai of South Sumatra that were the exclusive right of lineage heads, who hung them during life-crisis ceremonies. At first glance their designs of ships and animals may seem nothing more than appropriate symbols of transition. On closer examination, however, their place in the larger cultural picture begins to reveal itself.

Figures 49, 48 With few exceptions the Sumatran palepai textiles fall into one of four design groups. The first has a single dominant blue ship. Another carries two large red ships, or in a few examples a single red ship. The *Figures 52, 51* third group has two or more rows of stylized human forms. Finally there is a group with a series of panels, each carrying a similar design. Within two of these groups specific design elements can be identified and shown to align according to a system. Birds, sacred ancestor shrines, and the color red are unique to one group. In another group are earthly houses, the color blue, and identifiable ship details. By comparison with other recognized design complexes in Indonesia, it may be shown that these groups represent the sacred versus the mundane realm, and together they form a complementary system based on antithetical elements. This ordering justifies only two of the four major groups; how the other palepai groups operated within this scheme is not clear, but it is evident that their designs are more than decoration or transition means alone.[7]

Figure 17 Designs such as those of the palepai tend to have a specific meaning for a particular ethnic group alone, and seldom does any design have the same significance in several places. A major exception is the checkerboard design, or its slightly altered form, the gyronny pattern. It appears that this pattern is associated with warriors or guardians in much of Indonesia.[8] This is the design worn by Bima, the warrior hero of the shadow puppets, to commemorate his mystical initiation at the bottom of the sea. Probably in emulation of Bima, real warriors of the central Javanese princedoms once used the pattern in their batik uniforms. In

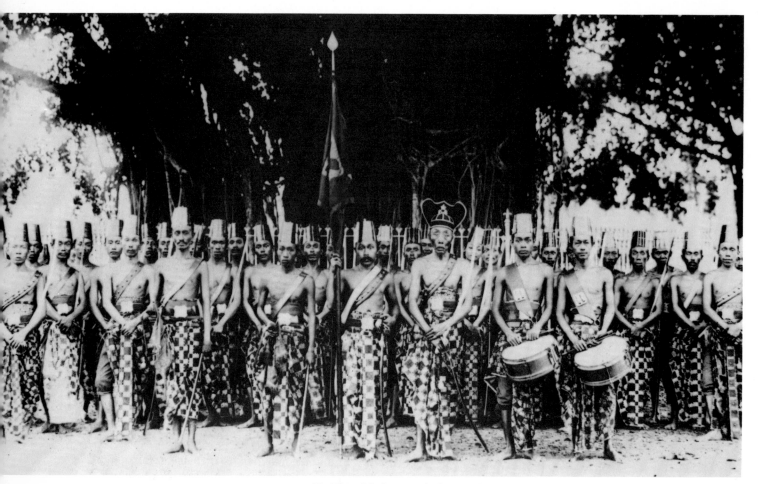

17 *This old photograph shows soldiers from Central Java in their uniforms of batik boldly patterned with a checkerboard motif. (Koninklijk Instituut voor de Tropen, Amsterdam)*

Bali, stone guardian figures flanking the temple entrances are draped with checkered or plain white cloths on high holidays. Here, too, the warrior followers of Barong, another figure in Balinese theater, wear checkered loincloths in their fight against evil. One writer has interpreted the Balinese checkerboard pattern as symbolic of dual elements such as white and black magic, fertility and death, good and evil, and positive and negative.[9] The motif also appears on some ceremonial Balinese geringsing double ikat cloths; here it has a protective meaning in keeping with the total nature of these ceremonial textiles.

The gyronny and the checkerboard occur in Celebes on the bark cloth head wrappers of warriors.[10] It is also seen in Borneo, on the war *Figure 178* jackets of the Dayak, which are thickly plied and twined, with these and other designs painted on the surface. The broad dispersal of these patterns points to an ancient origin.

Another very old design complex is the hooked diamond or rhomboid and key, which appears in textiles and other media throughout much of Indonesia. In some instances, for example in textiles from the Celebes, Borneo, and the Sangir and Talaud islands, this motif becomes a highly stylized human representation.[11] More frequently, however, it

appears as a more or less geometric form. This is the case on Timor, where it also serves as the basic element in lizard and crocodile forms.

Figure 18 It is also a major motif in twined borders on textiles made by the Batak of Sumatra, the Iban of Borneo, the Sumbanese, and the Timorese. These cloths share few other design properties, which suggests that this particular detail arises from a common source. It may date from Bronze Age migrations because other motifs found in twining, such as the rhomb, S-scroll, circle, and circle-and-tangent have been assigned to this early period also.[12]

The antiquity of such designs and techniques helps to explain their unusual associations. On Timor, twining is used to make the border on

Figure 140 men's mantles, entire betel bags, headhunter's costumes, and the bridle gear of the principal horse used in larger funeral processions. On Sumba it occurs as a border on especially luxurious men's mantles and as the sole ornament on pure white shrouds. These objects all have special ritual connotations.

Other legacies from the Bronze Age are thought to remain in the embroideries of ships and trees on traditional South Sumatran women's sarong. These, however, reveal slightly different influences. A much more decorative and curvilinear style is evident,[13] possibly a reflection of the designs found on bronze gongs or other metal forms. This is suggested by the stepped relief created by the flat satin stitches used in the major forms, in contrast to the simple running stitch used as a background filler element.

Needless to say, the antiquity of some sources makes it difficult to prove rather than speculate upon the ways in which design and technique transfer took place over time. But it is certainly evident that textile design reflects trading history. On virtually every major island in the archipelago, the influence of the Indian textile trade is evident. By 1500 routes were well established,[14] and many types of cloth were being imported. During the next 200 years and in some degree until

Figure 19 World War II, the prize trade textiles were the patola and its imitations. These were silk double ikat cloths made originally in Gujarat. Patola were brought by traders for use in bartering throughout Southeast Asia. The Dutch East India Trading Company, however, gave a special cachet to the patola by reserving it for selected trading partners. Thus these cloths and their designs carried status connotations that persisted when patola characteristics were incorporated into local fabrics.[15]

The reasons for this effect of the patola are more involved than mere Dutch sponsorship. Not least is the nature of the textiles themselves. They are diaphanous silks with finely wrought patterns in rich, glowing colors—red, green, purple, and yellow. The design elements of floral, animal, and geometric forms are often set in grids that cross the textile surface in dramatic diagonal patterns. There are strong framing elements on the vertical and lateral margins, and the fringe ends are marked by a row of triangles. The delicate fabrics and dazzling colors of these Indian textiles would have contrasted dramatically with the local cloths of heavy cotton and the somber blue that seems once to have been Indonesia's major dye.

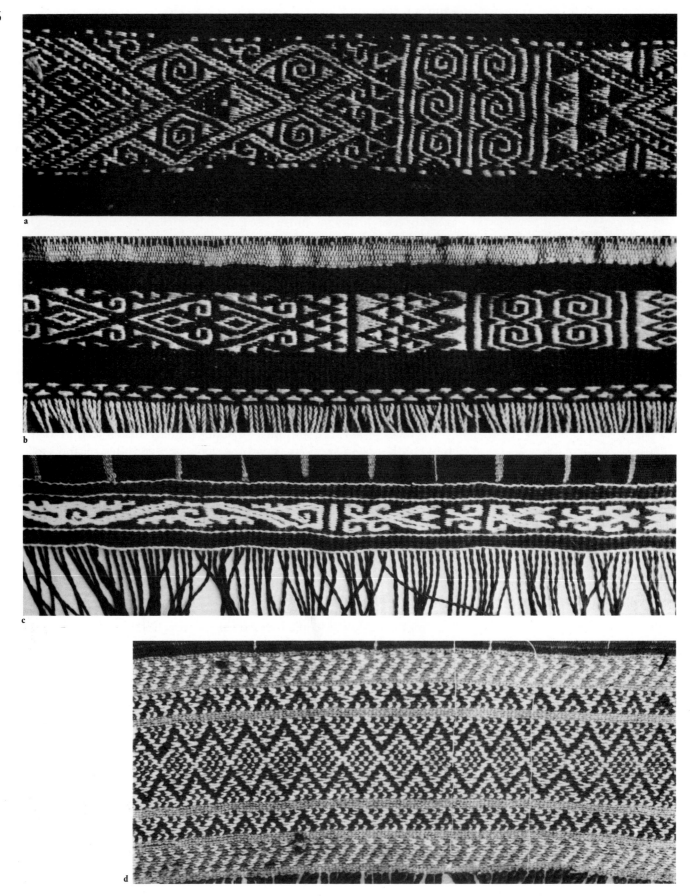

a

b

c

d

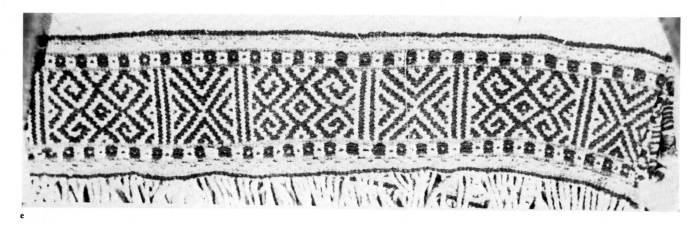

e

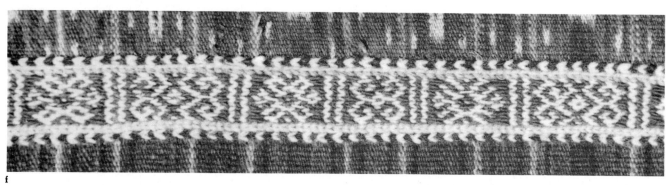

f

18 This is a collection of twined borders
showing variations of diamond and
hooked diamond motifs. Borders a, b, and
c are from the Toba Batak of Sumatra.
Borders d and e are from Sumba, and f is
from Timor. The last example, g, is also
from Timor but is a twined part of a
headhunter's costume. Twining is a very
basic and simple means of construction
known all around the world.[23] In Indo-
nesia it is used primarily as a border
element on large mantles, where it has a
decorative and functional purpose because
it binds the fringe ends securely. It is also
the technique found on betel purses, war
jackets and headhunter costumes. The
designs worked in these objects suggest
the technique was one of the earliest in
Indonesia. (Mattiebelle Gittinger,
Washington, D.C.)

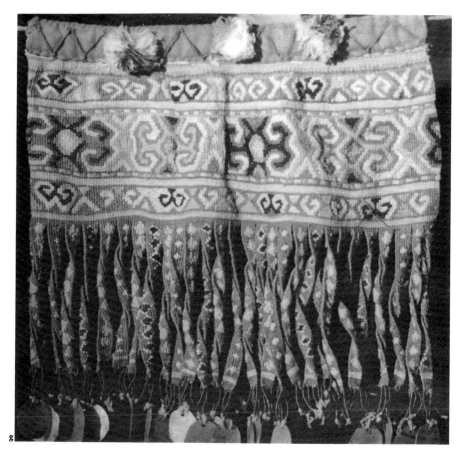

g

19 Patola
India, collected on Bali
Double ikat
Silk
Warp 450 cm, weft 102 cm
Museum für Völkerkunde und Schweizerisches Museum für Volkskunde Basel, Basel IIc 1415

Export textiles such as this double ikat from India, called patola, had a profound effect on the textile designs of many islands. This eight-rayed floral motif, locally termed jelamprang, was particularly prized and emulated. In addition to specific design elements, the compositional arrangement of these imported silks was adapted by many local weavers and dyers in Indonesia.[24]

The organization of many early Indonesian textiles was based on warp stripes only.[16] These were plain or contained woven or ikat designs that ran in the warp direction. The large center field and framing elements of Indian cloth introduced new spatial concepts which were quickly adopted by weavers and dyers.

The areas where the design correspondences between patola and local textiles are most striking are South Sumatra, Bali, and parts of the Lesser Sunda Islands. Many of the textiles in these regions incorporate *Figure 128* both specific design elements and compositional features. Elsewhere, patola elements have been borrowed in a selective fashion, for example, in the jelamprang design.[17] This eight-rayed flower form was highly prized on Java, where in 1769 it was reserved by the Sultan of Surakarta for his family's exclusive use.[18] It is much employed on eastern Flores, and on Savu; on Roti, it indicates the noble status of the *Frontispiece* wearer.[19] Double ikat cloths from Bali bear what may be expanded jelamprang motifs, and they appear as rayed floral forms in the center of east Sumba men's mantles.[20] Another Sumba design that seems patola-inspired is a network of lozenge or rectangular forms called *Figure 118* *patola ratu*. There are several variations, one of which was the property of a specific Sumbanese ruler alone, while the group of designs as a whole belonged to the highest class of people.[21]

Figure 130 Other design elements adopted from the patola include small interlocking hearts (Solor), and elephants and eight-pointed stars (Lomblen). The *tumpal*, or line of triangles that marks the fringe end of the patola, appears in many Indonesian cloths. However, this ancient motif is found in media such as bark cloth, stone carving, wood carving, and painting all over India and Southeast Asia, and its presence in Indonesia cannot be attributed directly to the influence of the patola.

Indonesia has felt the influence of many foreign designs. From the subcontinent came painted floral and resist-stamped cloths, whose intricate detail is suggested in the brush-finished batik of north coastal *Figures 95-98* Java. Chinese designs abound in the batik from this area—cloud patterns, phoenix forms, mythological animals, floral shapes, and the swastika symbol of good fortune which reappears also in Balinese weft ikat. Such designs came to Indonesia in the embroidery and ceramic wares that had been imported from the mainland for centuries. The China trade continued into relatively recent times, and pieces that may show pattern sources still exist today as sacred heirlooms in the archipelago.

Traditional Western symbols also entered the design repertoire. In the regions of Savu, east Flores, and Sumba the rampant lions of the Dutch coat of arms appear in local ikat textiles. This was adapted from the ship's flags and coins that the Dutch gave as tokens of favor and alliance.[22] On both Flores and Timor are designs reminiscent of the Hapsburg double-headed eagle. Early reports also recorded that gold pieces with a leaping horse motif were particularly prized on Flores. They may have inspired the *kain kudu*, a mantle made by the Ngada people in the center of the island that shows a faint horse design worked in warp ikat. Such eclectic sampling of design continues into the present, especially in commercially oriented areas like the region near the Sumba port of Waingapu.

Indonesia could scarcely avoid massive foreign impact on its art forms, including its textile arts. Many of these influences were adopted, but usually on terms that recast them to fit a local aesthetic. What has emerged is an Indonesian expression that is both artistically rich and culturally meaningful.

NOTES

1. Personal communication James J. Fox, Australian National University, Canberra, 1977.
2. All Savu material is derived from the work of James J. Fox. Some of this is found in Fox 1977a and 1977b.
3. Vatter 1932:223
4. Bühler 1943:108
5. Gill 1968:165
6. Schulte-Nordholt 1971:45
7. Gittinger 1976 discusses this in detail.
8. Professor Douglas Fraser of Columbia University first drew my attention to this association in 1962.
9. Swellengrebel 1960:40, 107
10. Kooijman 1963:23
11. Jager Gerlings 1952:110ff
12. Heine-Geldern 1966
13. Steinmann 1937, 1946; Heine Geldern 1966:195ff
14. Dames 1921:198
15. Bühler 1959, 1975
16. Bühler 1959:12
17. Jelamprang is discussed by Jasper and Pirngadie 1916:144.
18. Rouffaer 1900:163
19. Fox 1977b:100
20. Bühler 1959:18-19
21. Adams 1969:145-146
22. Ibid.:137
23. Emery 1966:200
24. An excellent discussion of patola is found in Bühler 1975.

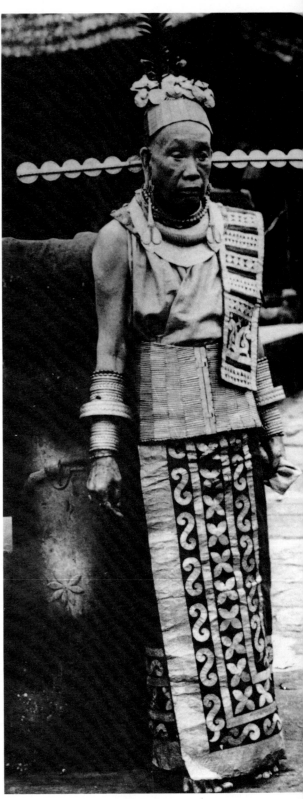

20 The representation of an evil spirit on the island of Buru. The costume is made from palm fibers. (Koninklijk Instituut voor de Tropen, Amsterdam)

21 A queen from Nias wears the elaborate headgear of her rank and the sacred shoulder cloth called lembe. This cloth, as well as her major garments, are appliquéd. (Koninklijk Instituut voor de Tropen, Amsterdam)

TEXTILES AS COSTUME

Figures 20, 21 **T**he mime of an evil spirit on the island of Buru portrays more than the myth of a small eastern Indonesian island. Here the structure of chaos is non-structure. Instead of cloth—the garb of order and custom—matted palm fibers swathe the figure. The costume disintegrates even as the figure moves. All is menacing, vague, impermanent. In contrast is the regal figure of a queen from Nias. Every element of her costume, from the sacred *lembe* over her shoulder to the precisely appliquéd skirt, is ordered precision—the epitome of control and superiority.

These contrasting examples capture a basic concept governing costume in Indonesia: man manipulates costume as a crucial element of life and ceremony. Clothing is much more than a mere adjunct to life.

Among many different groups, there are practices to show that costume identifies the self and new costume is the sign of transition and rebirth. For instance, on Roti the bride and groom change to new garments for the post-midnight portion of the wedding ceremony to signal their new life.[1] On the west coast of Sumatra, the bride and groom follow a similar custom, changing their clothes twice in the course of the evening as a mean of expressing their new identity.

No custom quite exemplifies this graphic symbolism as well as a tradition once practiced in parts of Java. This had to do with the ceremonial bath taken by the bride and groom before the wedding ceremony. The plain white cotton garments worn at this bath of purification and renewal were subsequently batikked with identical designs, and these *kain* were afterwards held in particular veneration by the married couple.[2] The parallel of the transition of bride and groom to the married state and of the cloths from unpatterned to a common pattern has a unique poetic quality. Only a society in which costume and textiles have a special role could evolve such a striking metaphor.

The ancient concept of new costume signaling a new start in life carried over into Moslem practice as Islam spread through Indonesia. At the time of Lebaran, the beginning of the religious new year, it is

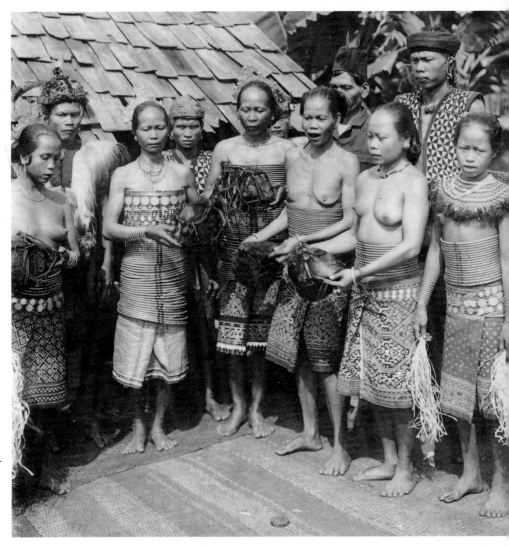

22 *Iban women display trophy heads from past times. They wear the short sarong called bidang, which may be decorated by a warp ikat or a supplementary weft. Around the waist are rattan hoops lined with metal rings. The men in the rear wear costumes appropriate to headhunting. (Trustees of the British Museum, London)*

virtually a universal practice to wear at least some new clothing. Even the poorest family strives to fulfill this custom lest its future well-being be jeopardized.

Considering the complexity of the customs that have evolved around textiles among Indonesians, it is surprising to discover the basic simplicity of their clothing components. The form from which all major Indonesian costume originates is a rectangle. This may be manipulated as a flat piece which is draped about the body, or it may be sewn into a tube to envelop the wearer like a sarong. Belts, breast wrappers, shoulder mantles, stoles, and head wrappers are additional rectangular pieces layered about the basic clothing elements. Such tailored items as jackets, blouses, and trousers are now common, having entered the area relatively recently from a variety of outside sources.

Figures 22, 23

Possibly the earliest use of the flat rectangle form was as the man's narrow loincloth and the woman's short tubular skirt. These may still be found occasionally among the Iban of Borneo, and until recently were seen among the Sa'dan Toradja of the Celebes[3] and in the small eastern islands of Aru, Tanimbar, Babar, Luang Sermata, Leti, and

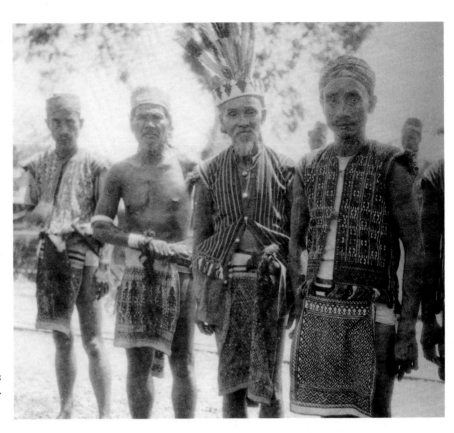

23 *A group of West Borneo or Kalimantan men wear the traditional loincloths and jackets. The designs on the loincloths have been worked by supplementary weft. (Koninklijk Instituut voor de Tropen, Amsterdam)*

Figure 24

Ceram. They may be worn with additional types of coverings. For instance, over the shoulder the Sa'dan men wear a *sambu'*, a tubular garment created from two lengths of cotton cloth joined like a woman's sarong. The piece has multiple functions—sometimes protecting against the elements, sometimes serving as a sarong. A like piece of cloth may serve as the Sa'dan woman's sarong, and then it bears the name *dodo*.[4] The short tubular skirt may be seen logically as a mere manifestation of the variable-length sarong worn by many women elsewhere in the archipelago. The man's loincloth, however, seems to bear no relationship to other forms of men's clothing, unless it be to certain decorative belts.

Far more representative of the main line of costume development are the garments worn on Timor. Here the basic man's wear is a large, flat, rectangular piece of cloth made by joining two or three woven panels at the selvage. It is worn wrapped about the hips and knotted at the waist, so that the fringe falls in front. A second similar cloth is worn over the shoulders to protect against the morning and evening chill in the mountains; but during the heat of the day, this is also knotted about the waist, over the first cloth. Etiquette demands that a man of lesser rank who is wearing his shoulder cloth immediately drop it to his waist when meeting a superior. This dates back to the times when a peaceful man would have to demonstrate he carried no concealed weapon. These heavy cotton textiles are cinched into place by a long, narrow cloth belt with carefully wrought tapestry and twined designs at the ends. Unfortunately, these local belts are being

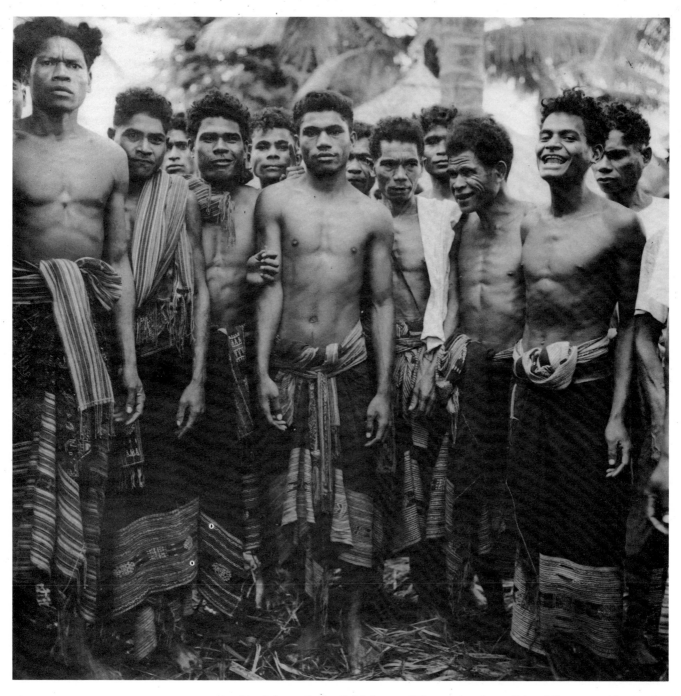

24 *Laborers in the Oelolok area of Timor wear the traditional flat rectangular textiles, knotted about the waist or held in place with a cloth belt. The designs, white on a dark indigo blue, are warp ikat patterns flanked by stripes. (Mattiebelle Gittinger, Washington, D.C.)*

replaced by leather imports. A betel bag, worked in a manner similar to the decorative part of the belt, is suspended from the shoulder or attached to the waist; this bag is such a vital element of a man's costume that it is used to represent the owner at his funeral.

For more important occasions today, Timor men wear Western-style shirts and jackets as an adjunct to the locally woven textiles. Men of wealth may wear a shoulder cloth, usually of extremely fine crafts-

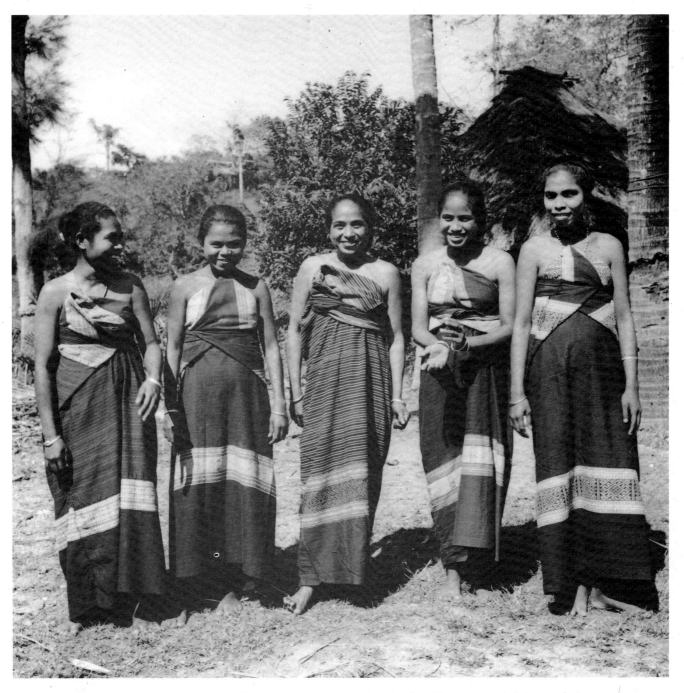

25 *A group of women near Oelolok in Timor model their long, tubular garments, which are worn knotted over the breast. The narrow bands of designs are either worked in warp ikat, as in the center example, or in a supplementary weft, as in the garment on the right. The major color of the sarong is a dark indigo blue, except that worn by the woman in the center, which is a brownish red. (Mattiebelle Gittinger, Washington, D.C.)*

manship, over the shirt; this cloth is folded into a narrow band and draped across the back and over both shoulders. Increasingly, this colorful and dignified costume is being replaced by Western-style trousers and shirts, which have become the garb of such people of authority as schoolteachers, government representatives, police, and members of the military.

Figure 25 The Timor woman's costume is a narrow tubular garment worn like a sheath. It is folded at the top and knotted over the breast. Two loom widths may be used, but longer garments of three and four loom widths, often making a tube as long as 2.5 meters, are used for formal occasions. The excess material is folded outward and down, and either knotted at the breast or folded so that pleats below the breast-line secure the tube in a decorative fashion. For everyday wear women in most areas have now adopted a blouse similar to that worn by the Javanese, which they combine with a local sarong or an inexpensive batik from Java. Women also use shoulder cloths for warmth and as an accouterment in dances, but this article of clothing is not as important a component of woman's costume on Timor as it is on the islands of Roti, Java, and Bali.

The way these garments are worn influences the technique chosen to weave them. Since both sides of a man's mantle are partially visible when it is folded and knotted on the body, decorative techniques that yield designs on both the front and reverse of the cloth have been employed. Warp ikat, tapestry weave areas, and small warp float structures, all of which produce designs on both faces of the cloth, are used. The same is true for the uppermost cloth panel of the woman's sarong, where the reverse side appears as the cloth is folded over and knotted. Conversely, among the Belu women and some other groups in central Timor, the bottom panel of the sarong, which is never seen reversed, is often worked in a supplementary weft patterning that has only one correct face. Interestingly, in these long, tubular sarong the lack of integration between the designs of the end panels—not only between themselves, but in relation to the two central panels of the woman's sarong—strongly suggests they were added to the basic two-loom-width sarong at a relatively recent date.

Figures 26-31 The elements of both men's and women's costume on Timor are characteristic of those of many ethnic groups in Indonesia. The draping of hip wraps, mantles, or sarong may differ slightly, but the basic properties remain much the same. Illustrations on the following pages present some of these variations and also demonstrate the effect of different types of designs on textiles of similar size and shape, although they are far from a comprehensive listing of costume in Indonesia.

Figure 32 On the island of Bali, there are other costume elements. Women's wear includes not only the closed tubular sarong but also, in contrast to styles in the far eastern islands, a flat textile that is wrapped snugly about the hips. There is also a supplemental layering of rectangular forms in both men's and women's dress that differentiates the ceremonial costume from that of everyday.

Basic dress for Balinese men is the garment called *kamben*. This is usually a simple piece of Javanese batik that reaches from the waist to below the knee. It is wrapped about the hips and knotted at the waist to produce a cascade of folds in front. The *udeng* or headcloth completes this costume. For ceremonial occasions, a man wears a kamben knotted at the waist or over the breast, with trailing ends falling in front, and over this a brocade textile called *saput*, wrapped about the body and tied over the breast with a silk scarf called *umpal*.[5] This ele-

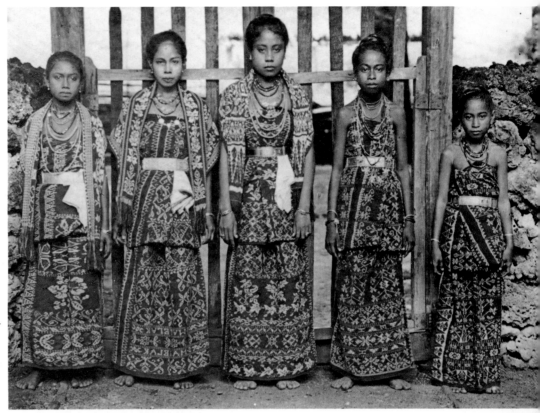

26 *Rotinese women tie their warp ikat tubular sarong around the waist with a cord, then let the excess material fall to form a flounce over the hips. The remaining upper part is pleated over the breast and the whole cinched with a belt at the waist. The shoulder cloth is an important element in the dress costume and also as an accouterment to dance. (Koninklijk Instituut voor Taal-, Land- en Volkenkunde, Leiden)*

gant costume is completed by a headcloth tied in jaunty folds and points, and a glittering kris tucked in the umpal at the back.

Balinese women commonly wear a flat rectangular kamben, or sarong, secured at the waist with a long sash called *bulang*. Over the breasts is an abbreviated camisole, or Javanese blouse. This is supplemented by a *kamben cerik*, a long, narrow cloth worn over the shoulder or wound on top of the head to act as a cushion to steady heavy loads. In the past, this narrow piece served as a breast covering, for while women traditionally wore no breast covering for everyday, it has always been a sign of reverential deference on the part of both men and women to cover the breast when visiting a temple or meeting a superior.

Women's ceremonial dress is made up of numerous layers. First there is a rectangular wrapping called tapis, of silk or a cotton-silk combination, which at one time elegantly trailed on the ground.[6] This garment is now largely omitted except when one is wearing very costly textiles.[7] Over this is wrapped the kamben, and on top of this goes the three-meter-long bulang, which encircles the torso from hip to armpit. Another strip, called sabuk, which is often of silk overlaid with gold leaf patterns, is wrapped over the bulang. Last of all comes the kamben cerik or shoulder cloth.

Although Balinese dress has been noted for its elegance, several other features set it off from the rest of Indonesian costume. The Balinese saw that the flat textile could be cut into pieces and these rejoined in

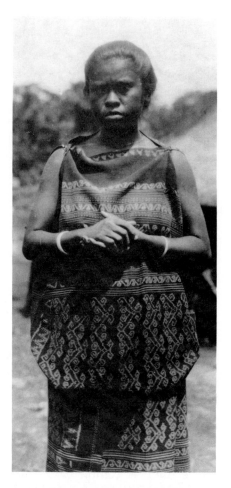

27 East Flores sarong for festive occasions are worn in a manner similar to those of Roti. Rather than being tightly pleated over the breast and belted, however, the front and back edges are merely pinned at the shoulder (traditionally, this was done with a thorn). The designs are worked by warp ikat. (Koninklijk Instituut voor de Tropen, Amsterdam)

28 These work sarong from eastern Flores are soiled with age and wear. Everyday garments are not usually worked with ikat designs, but in parts of east Flores, whether the ikat itself measured up to local standards of design and workmanship determined whether the sarong was used for festive occasions or relegated to daily use. On their heads the women are carrying large gourds filled with water. (Koninklijk Instituut voor de Tropen, Amsterdam)

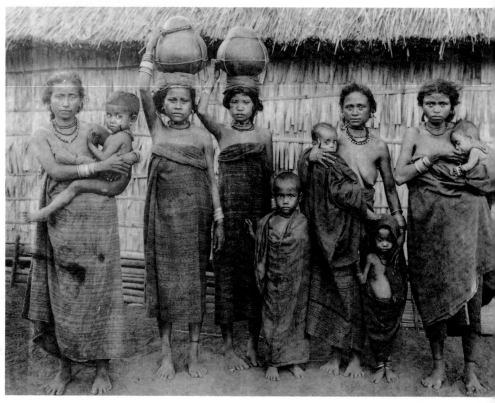

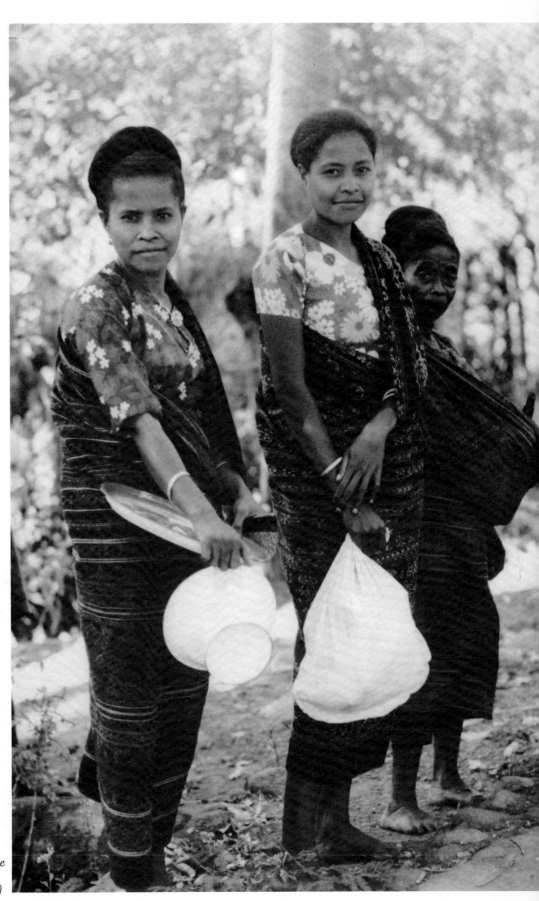

29 Women of the Sika region of Flores on their way to a festival. They wear large patterned warp ikat sarong and Western-style blouses. (Kent Watters, Los Angeles)

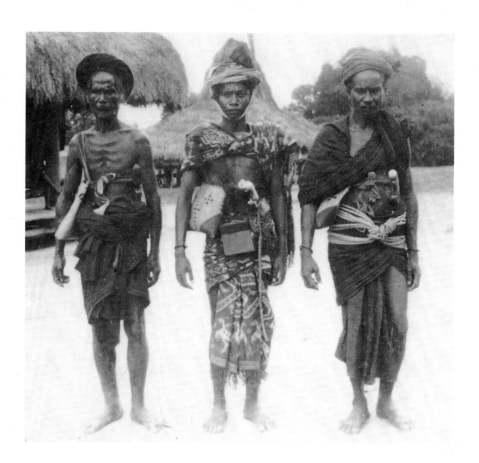

30 and 31 On Sumba, pairs of large rectangular mantles are the essential parts of the men's costume; the large knife tucked in the waist and the bag for carrying betel-chewing ingredients are also important. Probably the garments are so tightly wrapped because the men of this island ride horseback. The women wear tubular skirts folded into a pleat at the waist. Two have simple cloths draped over the breast and pierced turtleshell combs in their hair.

The legends originally accompanying these photographs state that the three people in each are representative of particular segments of Sumba society. On the left are slaves; in the middle, nobles; and on the right, commoners. The relative complexity of their costumes mirrors this ranking. The noblewoman's skirt has supplementary warp designs, and the mantles worn by the nobleman are of warp ikat. The others wear plain colored textiles; however, the figure of a deer, possibly done in beadwork, appears on the female commoner's skirt. (Koninklijk Instituut voor de Tropen, Amsterdam)

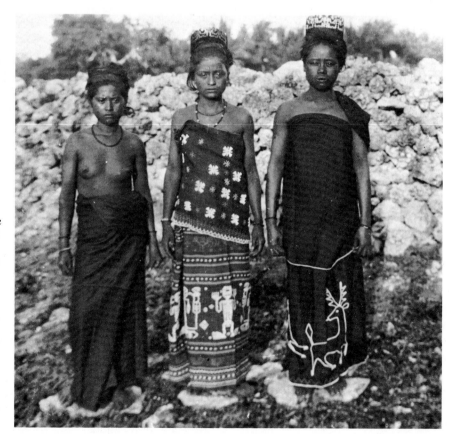

new ways or with other pieces to form a new flat, rectangular length.[8] The resulting piece had a blocky proportion and could be a visually more complex garment than the usual rectangle constructed merely by joining two identical loom widths. For instance, the tapis was made of a broad central band of cotton, with narrower top and bottom borders of silk, making use of the costlier material only in areas where it would be visible. Similar methods of joining textile sections to form the kamben allowed a relatively small area of cloth to be used to maximum effect.[9] Other novel details of traditional Balinese costume were the decorations on the margins of the man's saput. These were five-centimeter-wide strips of woven patterns of differing design that were called *tepi* when sewn on the narrow end of the cloth, and *eled* when attached to the wider side.[10] This is an extremely unusual addition; although many small straps were made in the archipelago, they were almost never sewn onto costumes as decoration.[11]

Figure 33

Javanese blouses, sarong, and Western shirts increasingly displace the local dress even on special occasions and temple visits. Fortunately, change has come slowly to the conservative mountain village of Tenganan Pageringsingan, where double ikat textiles can still be seen on ceremonial occasions and remain the prescribed garments for particular ceremonies.[12]

Figure 34

The dress of Java includes both the tubular sarong and the flat rectangular textile length wrapped about the hips. The latter is called *bebed* when worn by men and *tapih* when used by women, although the term *kain panjang*, meaning "long cloth," refers to both men's and women's flat garments.

The sarong seems to have been introduced along the north coast of Java and Madura, and there is still much debate about its early distribution elsewhere on Java. An 1876 report, for example, took particular note of its absence in the interior villages of central Java.[13] Whether the sarong was originally a man's or a woman's garment among the Javanese is also open to question. Today, however, this tubular style is popular with both sexes.[14]

As for the formal dress of Java, there is little doubt it begins with the rectangular kain panjang. This is simply wrapped about the hips or has one end creased into a series of graceful pleats that fall on the side of the front. The garment is held in place around the waist by a *stagen*, a stiff, plain colored band. Formerly women wrapped a long, narrow cloth around the torso, from the waist over the breast, and this is still used by a few for special occasions and in dance costumes. For the most part, however, it is replaced by a lightweight brassière and a blouse called *kebaya*. This garment, stylistically a hybrid between a blouse and a jacket, was popularized by Dutch and Dutch-Indonesian women in the nineteenth century. It is now worn not only by women in Java, but in many areas of the archipelago where Javanese influences have gained popularity. Completing the woman's costume is the *slendang*, a narrow strip of cloth normally draped over the shoulder. This may be nothing more than a decorative lace strip today, but it has honest antecedents that are still used in the original manner. Slendang made from sturdy cotton act as a sling to brace a basket of

32 *The festive garments worn by these Balinese women as they prepare to enter a temple are the Javanese kain, the torso-wrapping bulang, and, in one case, the sabuk breast covering. In addition, the woman at the top of the steps has a kamben cerik over her shoulder.*

Guardian statues are also clothed for special events. By tradition, their garb is the protective black-and-white check or a plain white textile. (Museum für Völkerkunde und Schweizerisches Museum für Volkskunde Basel, Basel)

produce or to hold a small child on the hip; the folds often serve as a purse for small items.

The standard woman's costume consisting of kain panjang or sarong, waistband, and kebaya is worn by the majority of women for all major activities outside their home, from working in the fields to attending festivals. The basic pieces vary only in the quality of the material. Western dress is increasingly seen on Java, however, and it is the usual costume of schoolgirls and most professional women.

Men on Java regularly wear shirts and either short or long trousers, depending on their occupation. Those who work in the fields or do physical labor wear short trousers and often carry a tubular cloth over the shoulder. This they use as a sarong, a shoulder wrap, a sleeping cover or a bathing garment, as required. In city shops and offices, long trousers with shirts are more common and jackets are occasionally worn. For formal occasions men may wear a kain panjang, often over *Figure 35* trousers, topped with a shirt and jacket. In central Java, the jacket may be a short, high-button style; here, too, the traditional square head-cloth remains a pride of costume. Each area of Java, and indeed many of the Indonesian coastal areas as well, once had its distinctive manner of folding the headcloth. Now the *pici,* a black velvet cap styled on the overseas cap, which was popularized by former President Sukarno as a sign of nationalism, has largely displaced this colorful sign of local pride.[15]

The symbolic communication inherent in Javanese clothing often involves elaborate choices of patterns and modes of folding the head-cloth and kain. These aspects and some of the more traditional pieces of Javanese costume are discussed elsewhere.

The local jackets, blouses, and trousers once common, and in certain cases still used, in Indonesia are not homogeneous types, nor do they seem to show logical evolutionary development. Rather, there is a range of types that probably derive from foreign sources, each having a number of variations. They seem to have been introduced or at least inspired by Moslem, Chinese, and recent European modes of tailoring. This extensive array of garments lies outside the scope of this study because most are made of imported textiles. However, some of the jackets and blouses that do appear in locally woven textiles are clever examples of the integration of design and tailoring concepts. These and a few other examples give a brief indication of the colorful variety of tailored garments.

The simplest of the upper body tailored coverings is the bark cloth "poncho" once found among such groups as the Kenyah of Borneo and the Toradja of the Celebes.[16] These are rectangles with holes or slits cut for the head. Slightly more complex are the garments in which the sides of this basic form have been sewn: for example, the embroidered *Figure 36* cotton blouses of the Gayo of Sumatra, the bark cloth jackets of the *Figure 176* Kayan of Borneo, and the *baju bodo* of South Sulawesi. The Dayak warrior's vest, with its open front, is a variant of this design.

The addition of sleeves is accomplished in two ways. In one method, the entire jacket, front and back, may be cut from a single piece of fabric that incorporates the sleeve forms. The piece is then folded at

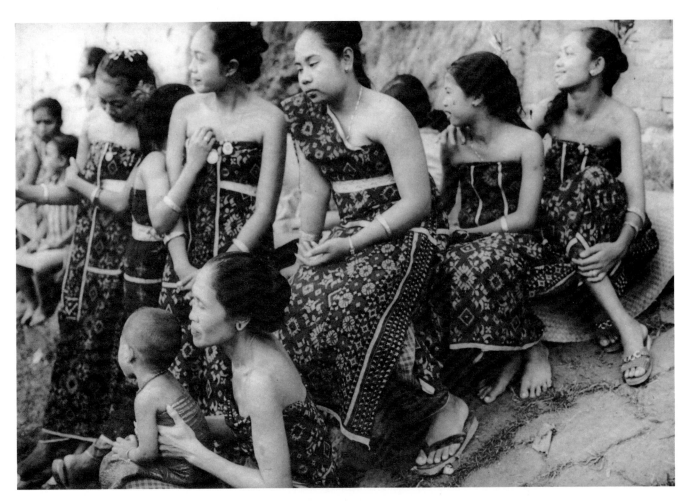

33 *The sacred double ikat costume is a ritual requirement at most religious ceremonies in Tenganan Pageringsingan, Bali, where they are made. One large textile formed by joining two lengths wraps the body. A second, narrower textile is bound over the breasts, with one end thrown over the shoulder. (Museum für Völkerkunde und Schweizerisches Museum für Volkskunde Basel, Basel)*

the shoulder line and sewn along the sides and lower sleeve seams. This method involves a single piece of material broad enough to accommodate the two arms and bodice. The bark cloth women's jackets called *lemba*, once made by the Toradja of the Celebes, were cut in this way, but included quite complex tailoring features. A gusset of bark cloth or imported textile was set into the arm hole to allow greater movement, the neckline was frequently accented by a ruffled collar, and the entire blouse was lined with a separate bark cloth fabric.

Figure 164a, b

Another method of adding sleeves is to join tubular pieces to the bodice. When these jackets are made from locally woven textiles, the process often involves interesting conceptual stages before weaving ever begins. This is exemplified by the jackets from Borneo and Sumatra in which the bodice is one continuous piece of fabric folded at the shoulder line, and the sleeves are cut from extra fabric woven at one end of the bodice textile. In other words, the entire jacket must be conceived at the earliest stages of preparation. In the Borneo jacket, which has identical ikat designs on the front and back, the warp yarns had first to be put on an ikat tying frame in such a manner that the

Figure 175

34 *The basic elements of the woman's costume on Java are the same, whether for work or holiday. These are the kain; the narrow cloth wrapping for the central torso, the stagen; and the blouse called a kebaya. For work the kain is simply wrapped about the hips and given a single fold at the waist, but for holiday wear, pleats are creased into the excess fabric and cascade down the front. Holding the kain in place is the stagen, and over this goes the kebaya. A shoulder cloth, the slendang, is also an important component, and may be a sturdy carrying cloth or a fragile costume detail. This woman is carrying recently harvested rice. (Mattiebelle Gittinger, Washington, D.C.)*

designs could be tied to form a mirror image about an axis located at the shoulder line. This would later cause the figures to be properly oriented on the front and rear of the jacket. In addition, lengths of warps without ikat patterns had to be calculated in the original warp length to allow for the fabric necessary for the sleeves and the area in which the tapestry-weave badge would appear. After the ikat and weaving were completed, two pieces were cut from the textile across the weft dimension to form the sleeves. These were further tailored by cutting a small wedge-shaped section from the wrist area in order to taper one end; then each piece was sewn into a tube. When the sleeves were joined to the bodice, a small length was left unsewn at the arm hole to allow greater freedom of movement.

Figures 46, 47 The preplanning necessary for the Kauer woman's jacket once woven in southwest Sumatra also called for a single warp length that would provide the bodice and sleeve elements. Here, however, the decorative features were executed in a supplementary weft patterning in the large block of designs that would appear on the back of the finished jacket, and in embroidery on the two smaller panels on the front. Mirrored metal disks were embroidered onto the two front panels, down the front, and along the lateral stripes. The entire jacket was designed and decorated before a cut was made or a stitch taken. To complete the jacket, two widths were cut to form the sleeves, which were slightly

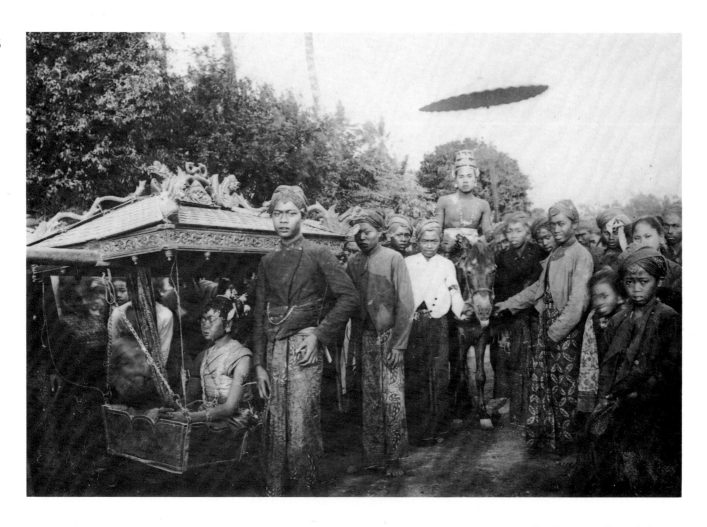

tapered at the wrist before being joined to the bodice. Neck and front openings were cut, and the whole jacket lined with a plain piece of imported cotton. In some cases, one or more lines of shells were added around the neck opening and back panel after the jacket was sewn.

These small jackets once made by the Kauer people are an integral part of a total costume and not merely an added element, as so many jackets and blouses appear to be. In the character of the cotton, dyes, decorative embroidery style, and striped patterning, the tapis and the jacket are totally integrated. The jacket is short-waisted and cut to allow the design panels in front and rear to ride above the top of the tapis skirt when it is tied above the breast.

Figure 45
Figure 37

The silk jacket from Palembang is slightly more complex. A narrow mandarin collar has been added to the bodice, and the collar, sleeve, and jacket edges are piped with gold trim. Here, too, the jacket is lined with an imported fabric. This style is found in those parts of the archipelago frequented by the early traders. It may incorporate a gusset, and is often made of velvet, silk, or satin. According to one report, this jacket was made also from indigo-dyed homespun cotton fabric in some parts of Indonesia until the early part of this century.[17]

Figure 38

The style of the *baju kurung* was probably introduced by Moslem traders. It represents more evolved tailoring concepts; supplementary rectangles of cloth are let into each side seam in the manner of a gore

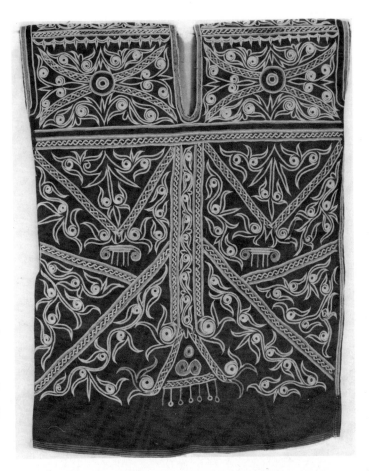

36 **Baju bungo bertabur** (blouse)
Sumatra, Gayo people
Embroidery on commercial cloth
Cotton
Width at shoulder 44.5 cm, height 59 cm
Volkenkundig Museum "Nusantara"
Delft, Delft S-451-261

*This simple woman's blouse was made by
folding a rectangle to form the shoulder
line and sewing up the sides, leaving the
armholes. It is embroidered with chain
stitching in soft cream and reddish brown
colors on an imported bluish-black com-
mercial cotton. This blouse was decorated
with true embroidery, but some are "em-
broidered" by means of a small hooked
needle device.*

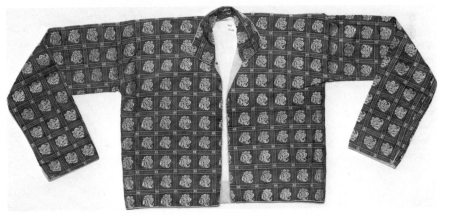

37 **Jacket**
Sumatra, Palembang region
Supplementary weft
Silk, metallic yarn
Width at shoulder 163.5 cm, height 46 cm
Rijksmuseum voor Volkenkunde, Leiden
300-134

*This jacket has both the simple basic
construction techniques used in other
Indonesian tailored garments, and some
finish details. The bodice is a simple rec-
tangle sewn up the sides and cut open at
the front. Untapered tubular sleeves and
a short standup collar are sewn to the
bodice. The whole is lined, and the edges
are piped with gold braid. A narrow band
of imported silk has been added around
the edge of the lining. The material itself
is a finely worked red silk plaid, with
discontinuous supplementary wefts of
metallic yarn worked as floral centers
within the plaid squares. The jacket was
shown at the World Exposition in Paris
in 1878, and entered the Rijksmuseum
collection shortly thereafter.*

38 **Baju kurung** (blouse)
Sumatra, Palembang region
Embroidery
Silk, imported velvet
Width at shoulder 138.5 cm, height 94 cm
Volkenkundig Museum "Nusantara"
Delft, Delft S-451-261

This is a multicolored silk and gold-embroidered green velvet blouse that was part of a dancer's costume. Other elements of the costume were an embroidered collar, a gold sarong, two plangi or gold shoulder cloths, a gilded belt, bracelets, long gold fingernails and a sparkling crown. This flashing assemblage was worn in the first years of this century by court dancers in Palembang at performances of welcome for honored guests.[22] Elements of the costume probably derive from Sumatra's early history. It is possible that embroidery came to Sumatra with early Chinese traders. Today many influences are evident in the designs, including Chinese, Indian, and European. The technique is used to decorate blouses, jackets, scarves, shoulder cloths, cushions, children's clothes, textiles used as food coverings, and hangings that serve as ceremonial room decorations.

39 *Palembang women demonstrate a traditional dance pose. They wear a silk and gold kain folded over the shoulder, another wrapped about the hips, and the long velvet blouse called baju kurung. (Museum für Völkerkunde und Schweizerisches Museum für Volkskunde Basel, Basel)*

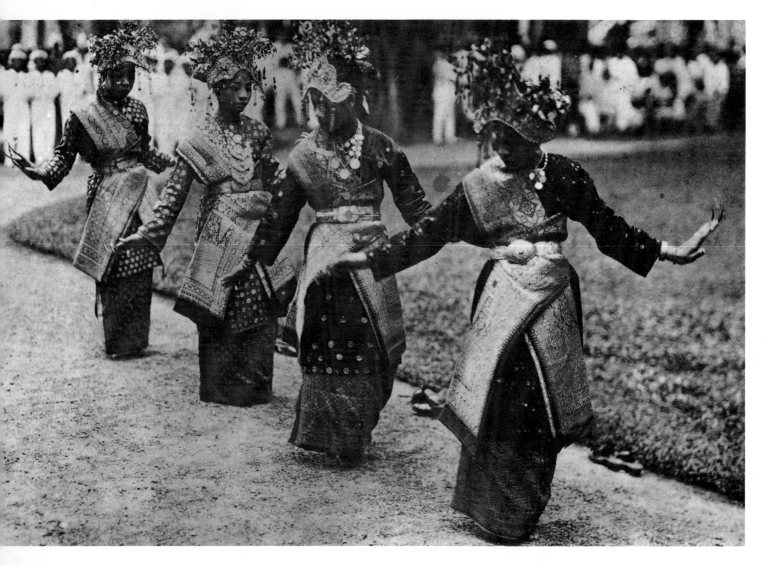

to allow for greater body movement. This blouse, with the addition of tailored sleeves and gussets, is a widely accepted piece of clothing and appears most commonly in imported fabrics. Variations of it are worn in West Sumatra, west and south Borneo, Gorontalo (north Celebes), Ujung Pandang (south Celebes), the Sangir and Talaud Islands, and the Moluccas.[18] The embroidered velvet example shown here is the principal piece of a dance costume from Palembang. It is worn over a glittering gold kain and layered with a large collar, belt, slendang, and jewelry.

Figure 39

Another long-sleeved garment found on the coast of Sumatra is the *baju panjang*. The bodice, created by a cloth folded at the shoulder, is increased in width by a supplementary band sewn around the neck opening and down both sides of the front closure. This loosely fitted, handsome garment is worn over a kain or sarong. It is probably the nineteenth-century antecedent of the Javanese kebaya.

The rules of customary usage or proscription that often surround the traditional flat woven textiles of the archipelago do not seem to be as numerous for tailored garments. Where they exist, they frequently align color with age or marital status. For instance, in the Moluccas red blouses are worn by single girls and brides, green by married women, and maroon or white by older women, while among the Bugis pink blouses are for brides.[19] Unlike locally crafted flat textiles, which so often carry a ceremonial significance, these tailored pieces are rarely invested with ritual functions.[20]

With few exceptions, tailored garments are relatively recent additions to Indonesian costume. Many were obviously urged on the population by traders and colonizers for reasons of propriety. Covarrubias, writing in the early 1930's, spoke only of a small region on Bali, but the effect applied to a broader area: "All women in North Bali have worn the Malay blouse [baju] for over half a century, since they were ordered to wear blouses by official decree 'to protect the morals of the Dutch soldiers.'"[21] The dictates of modesty, prestige, vanity, and status continue to extend the realm of tailored garments, to the extinction of older, often noble forms of dress.

NOTES

1. Wetering 1925:636
2. Poeroebojo 1939:326
3. Nooy-Palm 1969:169
4. Ibid.
5. Covarrubias 1965:112
6. Soekawati 1926:14
7. Ramseyer 1977:70
8. Soekawati 1926:14-15
9. The Minangkabau of Sumatra also cut and join textile sections in a different but related manner.
10. Soekawati 1926:6
11. The very narrow decorative borders found on a few Minangkabau and Celebes pieces are exceptions to this.
12. Ramseyer 1975
13. Poensen 1876-77:396
14. Veldhuisen-Djajasoebrata 1972:22-23
15. Ibid.:25
16. Kooijman 1963:Plates II, III, IV, XI
17. Achjadi 1976b:77
18. Achjadi 1976a:31
19. Ibid.:44
20. For an exception see Velhuisen-Djajasoebrata 1972:47 item 27.
21. Covarrubias 1965:111
22. Werff and Wassing-Visser 1974:Fig. 27: 64

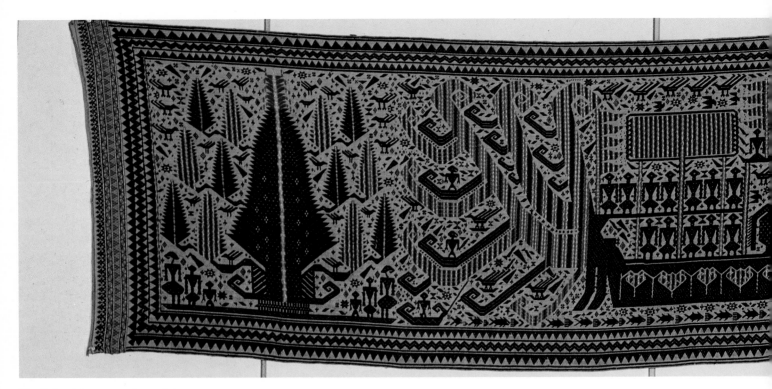

50 **Palepai** (ceremonial textile)

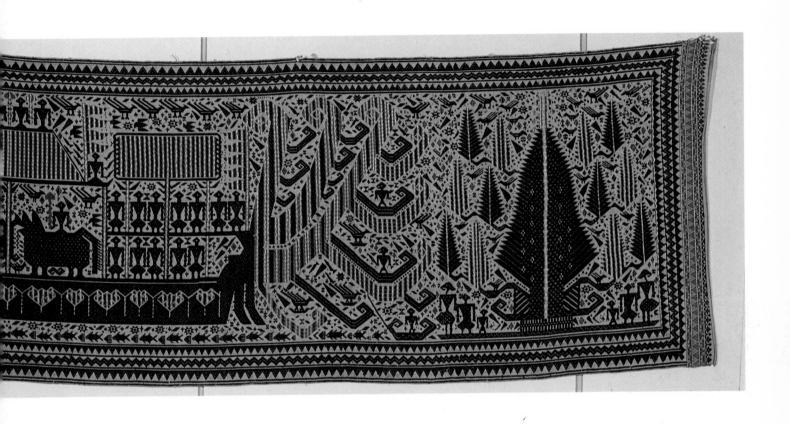

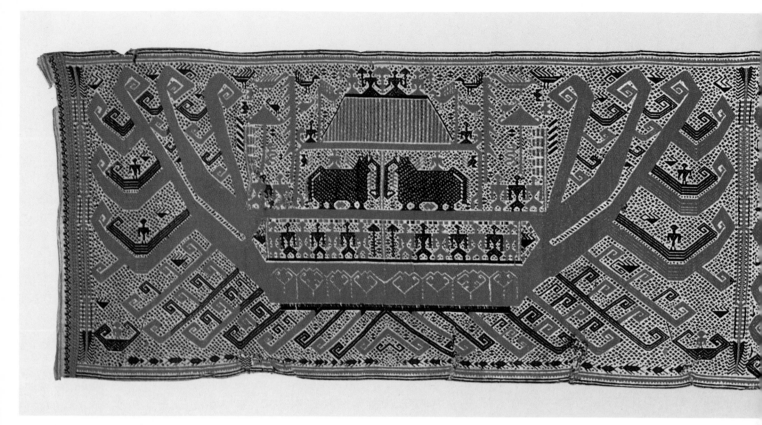

48 **Palepai** (ceremonial textile)

49 **Palepai** (ceremonial textile)

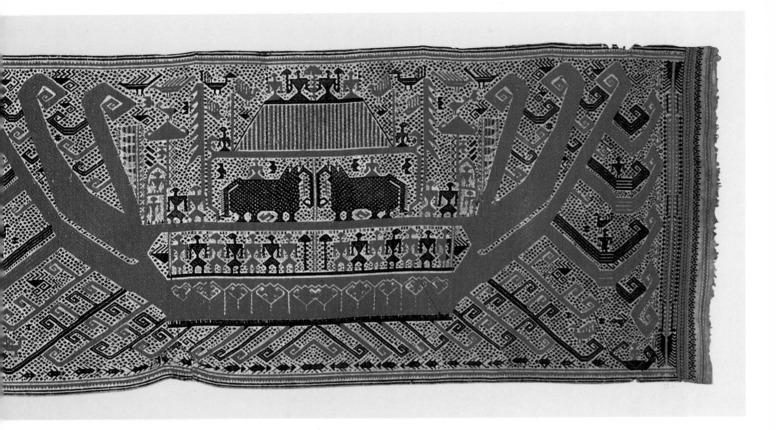

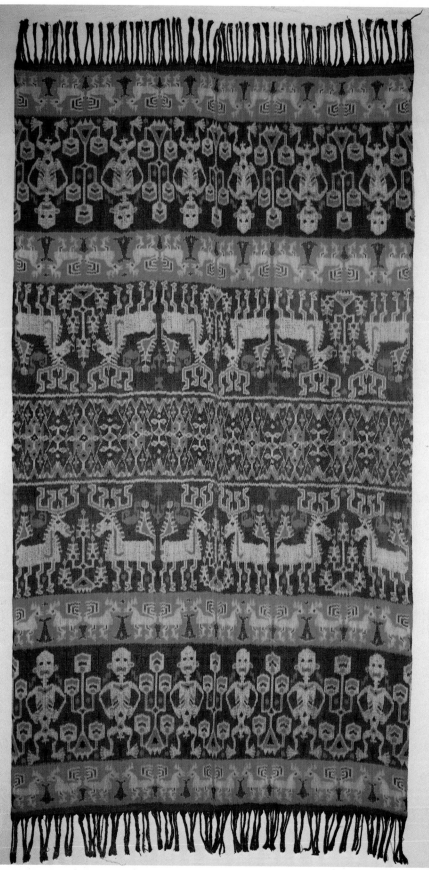

118 **Hinggi** (man's mantle)

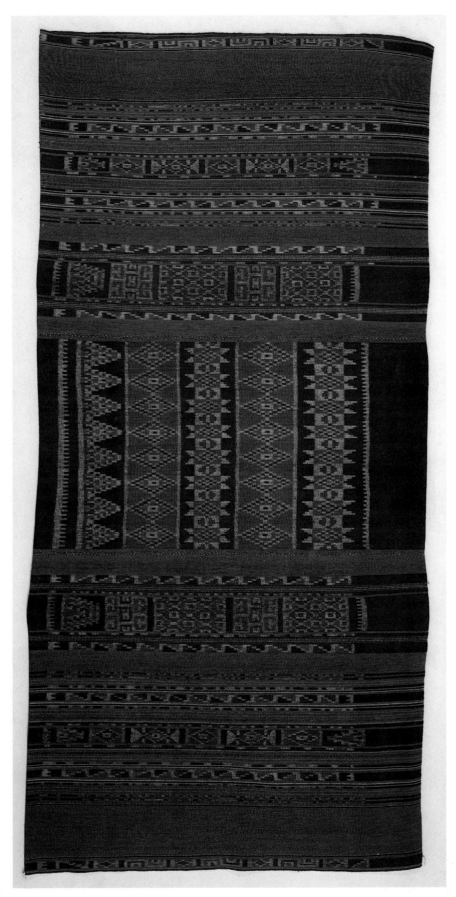

131 **Sarong**

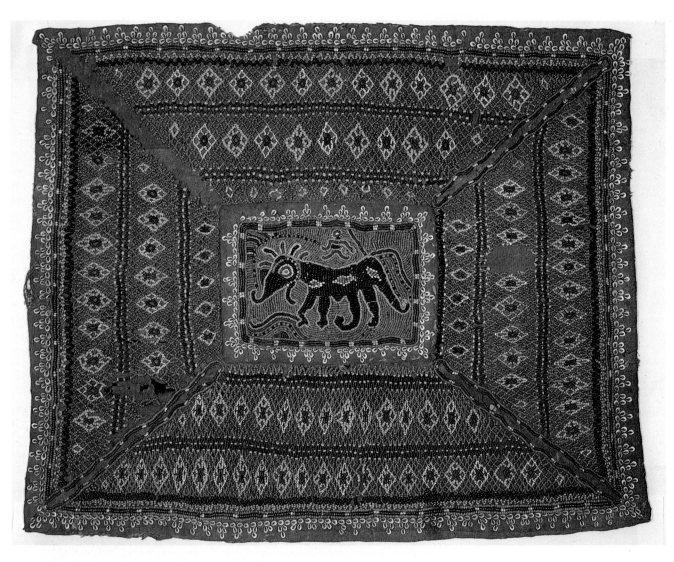

60 **Tampan maju** (beaded tampan)

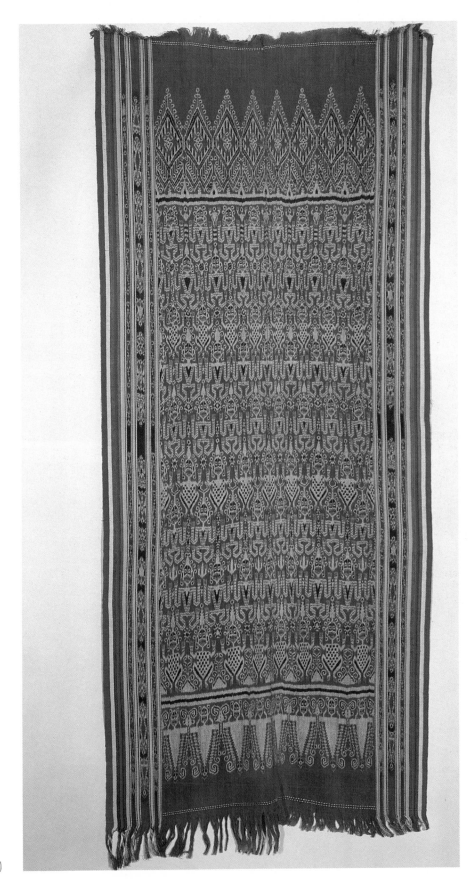

167 **Pua** (blanket)

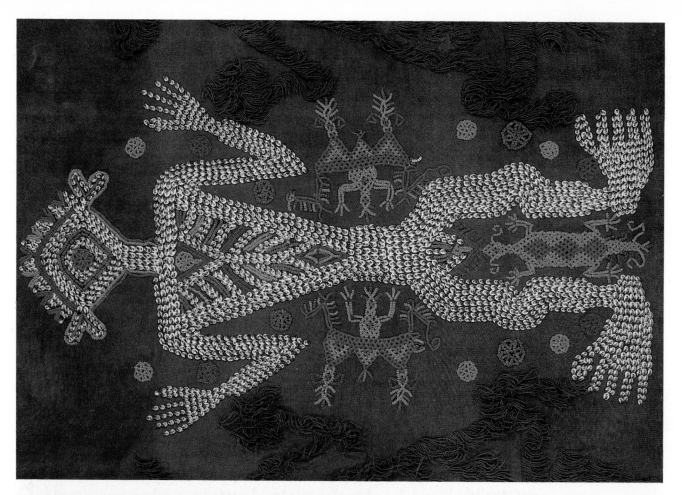

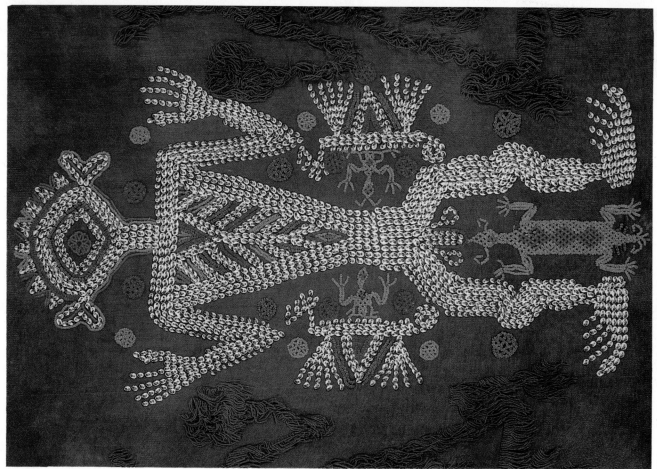

124 a and b **Lau hada** (woman's skirt)
Sumba

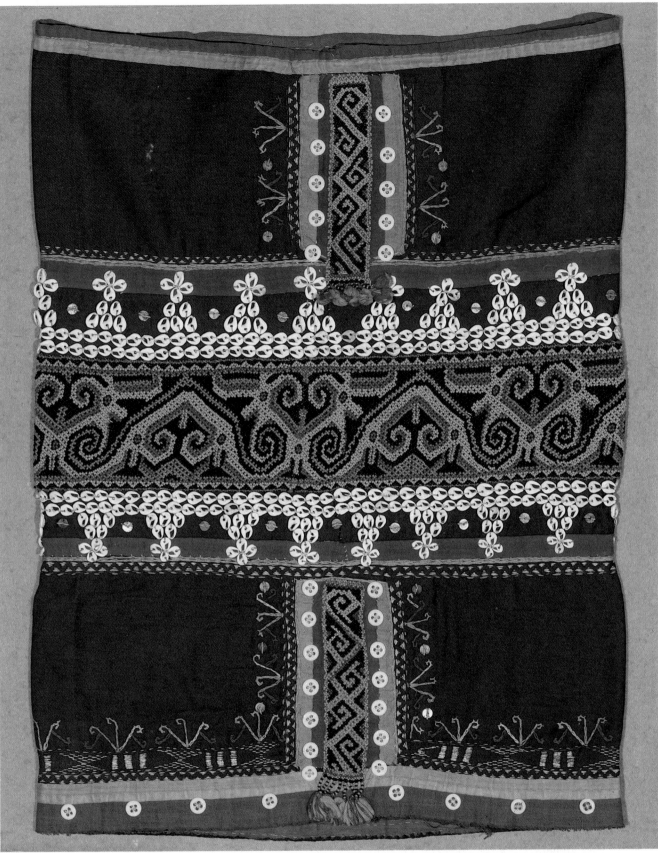

174 **Bidang** (woman's skirt)

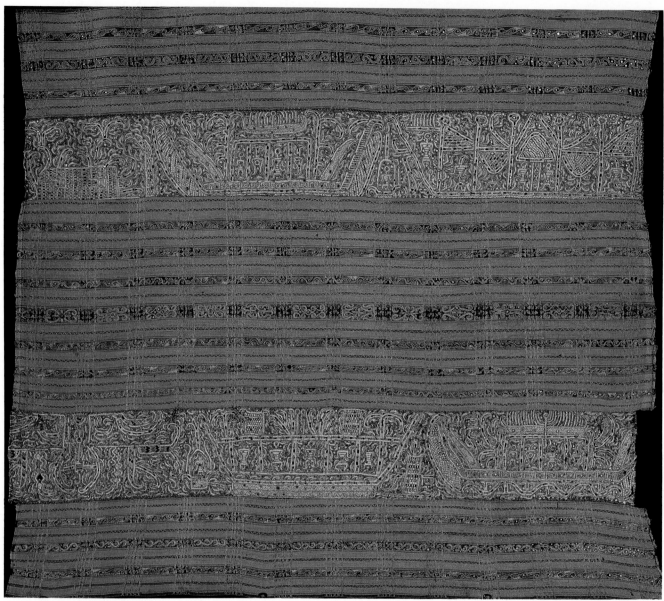

44 **Tapis** (woman's sarong)

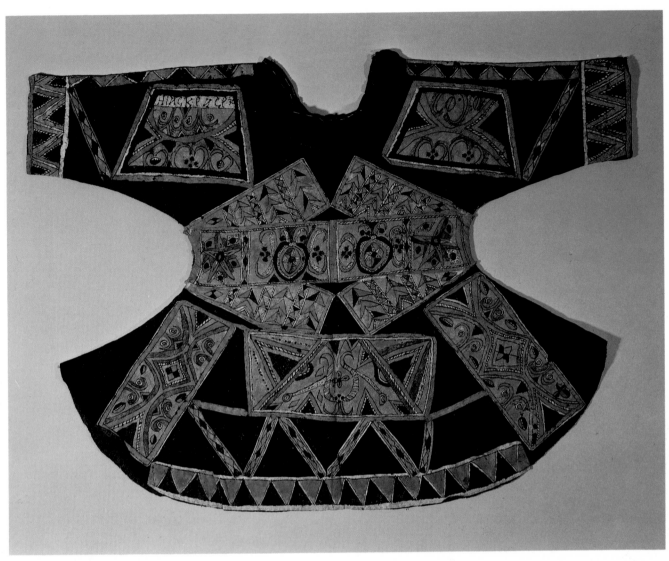

164 **Lemba** (woman's blouse)

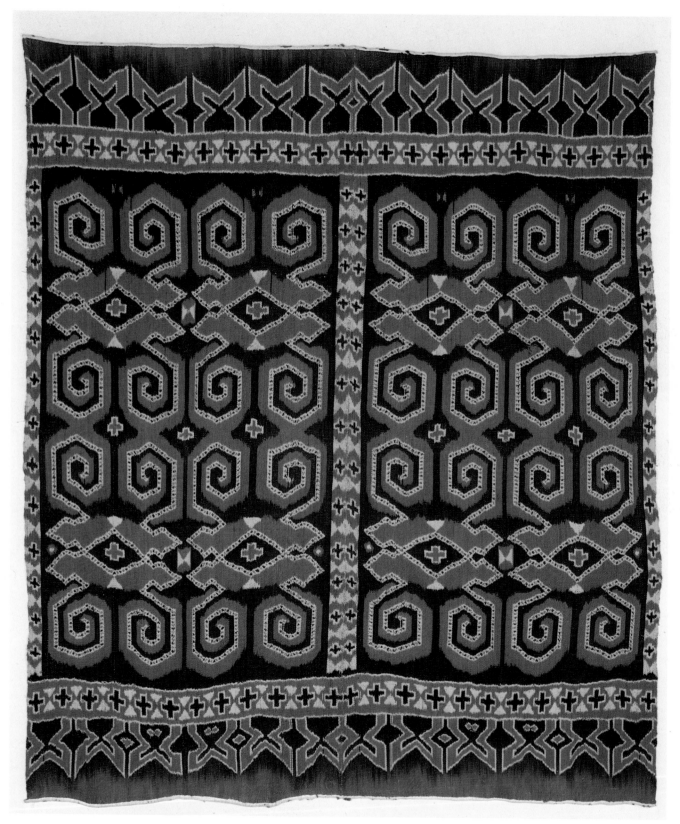

162　**Paporitonoling** (death shroud or hanging for ceremonies)

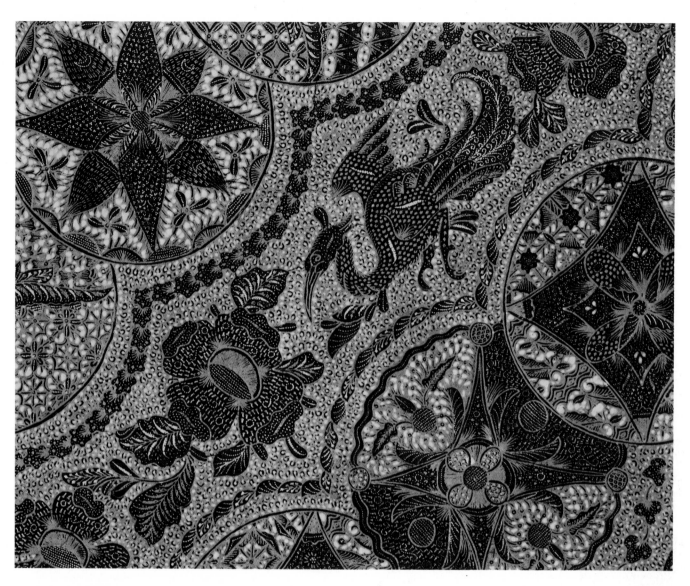

87 **Kain panjang**

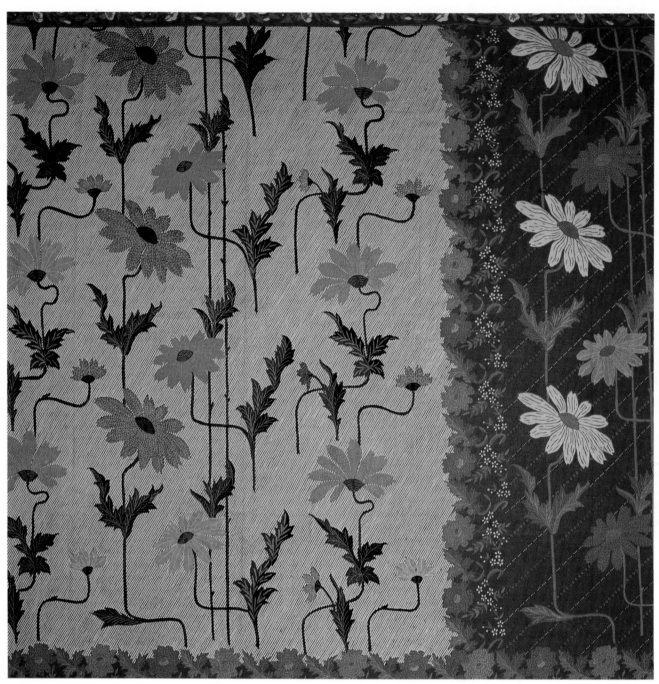

90 **Sarong**

97 **Sarong**

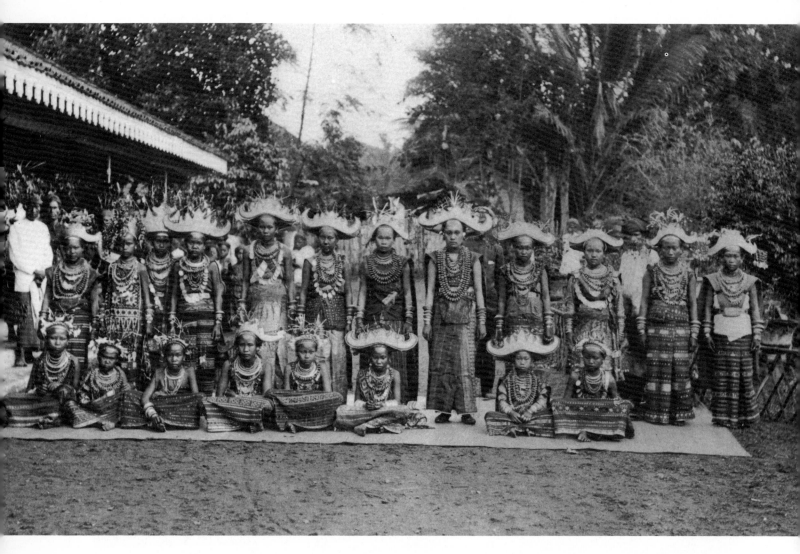

40 This remarkable photograph of a group of unmarried girls in their festival attire
was made in Tanjung Karang, South Sumatra, in 1893. Each wears the great headgear,
siger, which only the unmarried may use. Tapis embroidered with gold yarns and
mirror pieces, shoulder cloths of silk and gold, and numerous necklaces of beads and
gold coins make up the costume. It is not known if these women dressed up just for the
photograph, or if this was actually the occasion of a great wedding. At particular times
in these ceremonies, unmarried women who stood in a certain relationship to the bride
wore this regalia. (Koninklijk Instituut voor de Tropen, Amsterdam)

SUMATRA

Sumatra's position as guardian to the trade routes of Southeast Asia has been a major contributing factor to the great variety of its textiles. Set along the Strait of Malacca, its various coastal regions have sampled the influence of centuries of trade with Indians, Chinese, Javanese, Arabs, Portuguese, and Dutch. Traders brought exotic textiles that introduced new design elements and spatial arrangements, new materials such as silk, metallic yarns, beads, and mirrored metal, and new dye recipes. Initially this bounty proved a great stimulus to the textile arts and an amazing range of textiles arose including simple plaids, complex woven scenes, glowing silks and somber cottons. As social and religious customs altered with foreign incursions, however, the very contacts that had so enriched the weaver's art caused its demise in much of the island.[1]

The great variety of ethnic personalities found on Sumatra has been another important factor contributing to the different types of textiles once woven on this island. These cultural differences became accentuated in time by the isolation of certain groups and the exposure of others to foreign contact which was either direct, as in the Palembang region, or tangential, as in the case of the south. In this area, called Lampong, the world pepper trade injected wealth, but this was first filtered through the court of West Java, which maintained hegemony over the region. Foreign traders dealt with West Java, not with the Lampong lineage heads; the south therefore escaped for a time the direct impact of foreign cultures. The wealth that came from the pepper trade stimulated a system of ranks and titles with accompanying perquisites, bringing about a gross distortion of what had probably been a lesser system of feasts of merit. This manifested itself in portals of honor, special processional carts, and the final honor of sitting on a carved ceremonial bench. Each stage was reached through giving feasts accompanied by elaborate displays of food and other wealth, including textiles. These feasts were held in conjunction with life-crisis rites and even today are an aspect of the three- and four-day wedding celebrations of wealthy persons.

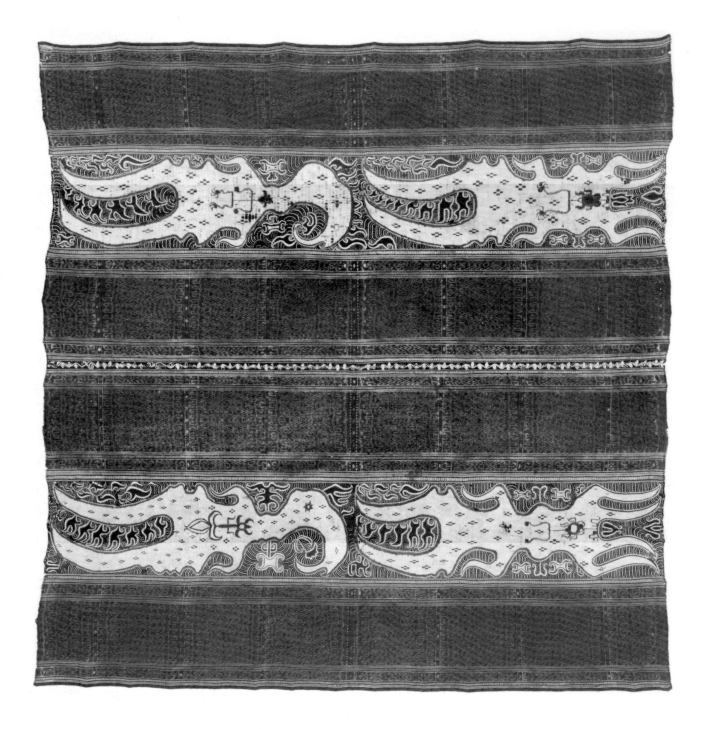

Figure 40 Adding to the splendor of these feasts were the women's heavily embroidered cotton sarong, called tapis. Together with luxurious silk shoulder cloths, gilded belts, strings of gold coins, and towering gilded ship-shaped head ornaments, the costumes were very tangible parts of these fabled occasions.

Figure 41 The tapis worn at these great feasts begins as a large rectangle composed of two or more locally woven cotton panels sewn together at the selvage and then elaborately embroidered. The piece is sewn into a tube and worn like a sarong. In the south and southeast, where display was especially important to social success, ostentatious cloths almost

41 **Tapis** (woman's sarong)
Sumatra, Lampong region
Embroidery, warp ikat
Cotton, silk
Warp 132 cm, weft 131 cm
The Metropolitan Museum of Art,
New York L. 1977.19.1.
Lent by Ernest Erickson

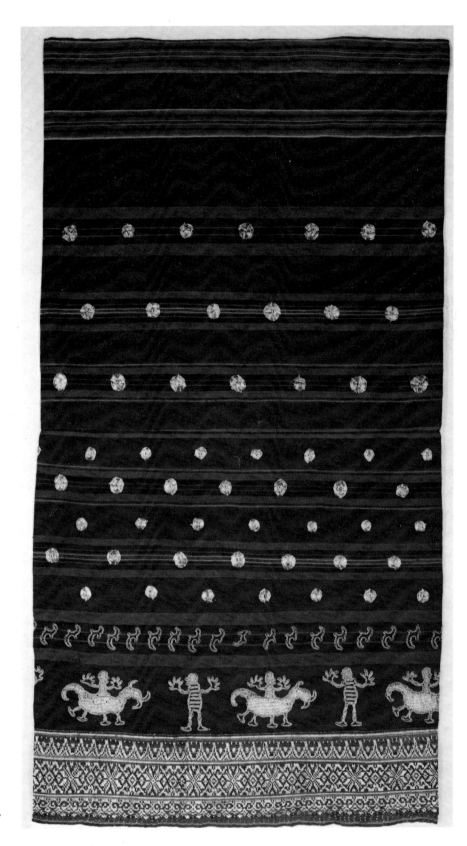

42 **Tapis** (woman's sarong)
Sumatra, Lampong region
Embroidery
Cotton, metallic yarns
Warp 124 cm, weft 114 cm
Friend of the Textile Museum,
Washington, D.C.

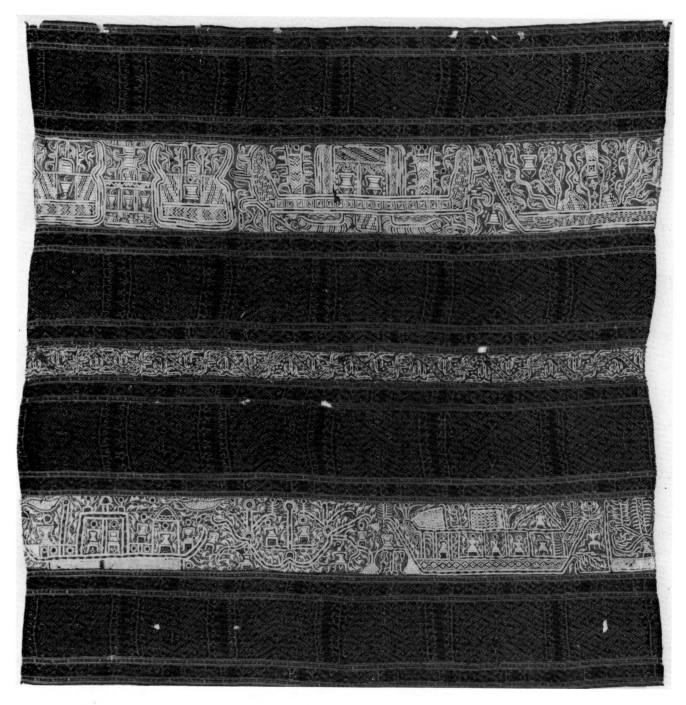

43 Tapis (woman's sarong)
Sumatra, Lampong region
Embroidery, warp ikat
Cotton, silk, mirror pieces
Warp 123 cm, weft 120.5 cm
Anita Spertus and Robert J. Holmgren,
New York

The woman's tapis that evolved in South Sumatra is surprisingly different from women's sarong elsewhere in Indonesia because it depends primarily on embroidery for its major design features. Originally this promoted a very sinuous style, greater detail, and more subtle coloring in the figures. The embroidery was always worked on a locally woven textile that utilized handspun yarns and rich natural dyes of deep blue, warm yellow, and subtle rust, which impart vitality to the design. Only in relatively recent times, when the desire for a more sumptuous

display of gold yarns prevailed, have these skirts degenerated into static forms

Several styles of tapis exist. One juxtaposes colorful blue, cream, and brown silk embroidered bands filled with curving forms with areas of angular scrolls, hooks, and rhombs worked in a brown warp ikat as in Figures 41 and 43. The contrast of the two elements is effective, but the sharp difference in style suggests the two designs originate in different traditions. It has been reported that the designs to be embroidered were presented by suitors to the girls of their choice.[20] Thus these

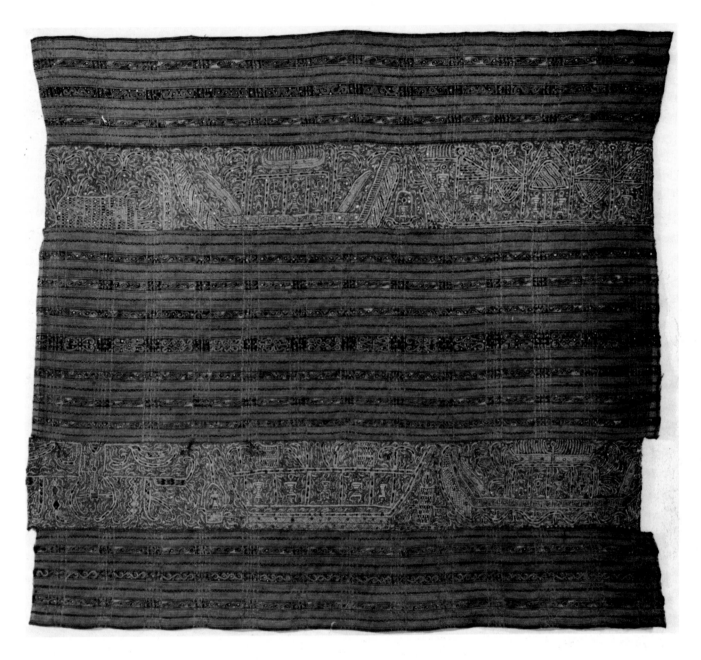

44 Tapis (woman's sarong)
Sumatra, Lampong region
Embroidery
Cotton, silk, mirror pieces
Warp 126 cm, weft 114 cm
Anita Spertus and Robert J. Holmgren,
New York

designs may derive from crafts practiced by men, while ikat patterns arise from women's weaving traditions.

The forms in the large embroidered bands are worked in a satin stitch and are of two types. One is of enigmatic amoeboid constructs, vaguely recalling human figures; the other is of ships bearing trees, shrines, and human-like shapes. These may be flanked by ikat bands, or, as in Figure 44, with stripes. The latter are deep yellow interspersed with rows of embroidered tendril-like figures. Sprinkled over the whole of the textile are pieces of mirror, applied to the surface of the cloth by embroidery, which add a sparkling detail to the swirling forms. As late as 1971 remnants of these three types of tapis were to be found in villages in the mountains of South Sumatra, and it is assumed that this particular style of embroidery as well as ikat work was once common in the interior.

To the south and east, along the coast, and among the Abung people embroidery was also used on locally woven cloth, but in this case to couch metal yarns to the surface. Often geometric shapes were created that visually interacted with the warm blue and rust dye tones of the foundation textile. As the taste for display increased, the entire surface might be covered with the gold yarns. Less frequently they were used to create whimsical figures of people and animals, as in Figure 42. This example also illustrates a rare use of metal yarns in the lower border. Here metallic supplementary wefts are laid-in with the foundation. The whole composition has a sprightly effect, with glittering gold yarns set on a deep blue ground crossed by rust-brown stripes.

Figure 42

entirely covered with imported gold yarns were produced. The yarns were couched on brown, blue-black, or deep yellow striped cotton in simple geometric patterns. A less common kind of tapis made in the same region had only a few gold silhouettes of people, boats, or horses on its lower section. Even less common are the examples in which gold designs have been created by supplementary wefts, which were laid-in to the foundation structure, rather than by embroidery.

Figures 43, 44

A quite different type of tapis was made in the mountainous interior region, where feasts of merit do not seem to have been a cultural component. Here large bands of complex embroidered designs alternated with areas of warp ikat or plain bands of contrasting brown and yellow stripes. Both the motifs and the style of the embroidered bands are unusual. Curving organic shapes emerge as ships carrying trees, people, and small houses, which all sprout tendrils that fill the band with a welter of sinuous forms. In some examples, the shapes go beyond recog-

Figure 41

nition, and dissolve into amoeba-like insubstantiality. The figures are worked in a satin stitch of one color and outlined in a contrasting color. The outlining accentuates the curvilinear quality and has given rise to speculation that the designs originated in painting on wood, bamboo, or metal. This is also suggested stylistically by the plain stitch that completely fills the background areas and gives a three-dimensional effect to the design surface.[2] These flowing designs are embroidered in soft tones of cream white, blue, and reddish brown silk on a dark indigo blue cotton ground, and provide a marked contrast to the angular rhombs and diamond patterns of the bordering brown cotton ikat bands.

Figure 45

Still a third style of tapis evolved on the far west coast in the south among the Kauer. Here hundreds of small mirror pieces called *cermuk* were embroidered onto the cloth surface, usually in conjunction with an embroidered scroll motif.[3] Other groups in Lampong used cermuk as a minor element, but the Kauer used them in great quantity, whether grouped in simple geometric designs or casually scattered across the textile surface. Some cermuk-decorated cloths took over a year to make, and there are examples weighing more than five kilograms.

Figure 46

Another element of the Kauer costume was an extremely short jacket designed specifically to complement the tapis. The textile woven to become this garment contained decorative panels that would ultimately appear on the back and upper front of the jacket. It also had to be long enough to allow for sleeve widths to be cut from one end. A tapis and jacket constituted the festival dress of young single women, who were required to make these garments before marriage. A suitor's inquiries often took the form of asking if the tapis were finished. The Kauer and the interior mountain people no longer make tapis, but as late as 1971 some tapis were still being woven and embroidered in the eastern region among the Abung people.

Also bearing ship designs are some of the most remarkable weavings ever made in the Indonesian archipelago. These textiles, requiring skills and patience which stagger the imagination, were once woven in the south where they had varied ceremonial functions. While ships are

45 *A young Kauer woman dressed in a tapis and jacket. Rather than using the large bands of embroidery found on the tapis of the interior, the Kauer layered their cloths with hundreds of small pieces of mirrored metal. In most cases it required more than a year to embroider these pieces onto such a cloth. The jackets are distinctive to the Kauer, where they were worn only by young unmarried women. Weaving ceased long ago in these areas, and very few such pieces are found today. (Mattiebelle Gittinger, Washington, D.C.)*

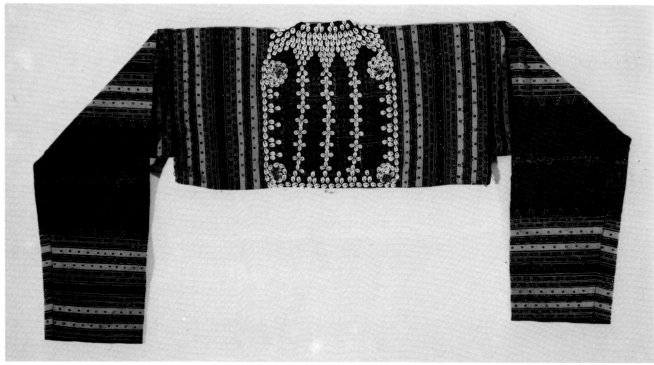

46 Jacket
Sumatra, Kauer people
Supplementary weft, embroidery
Cotton, metal yarn, mirror pieces, shells
Width at shoulder 123 cm, height 51 cm
Tropenmuseum, Amsterdam 1772-1574

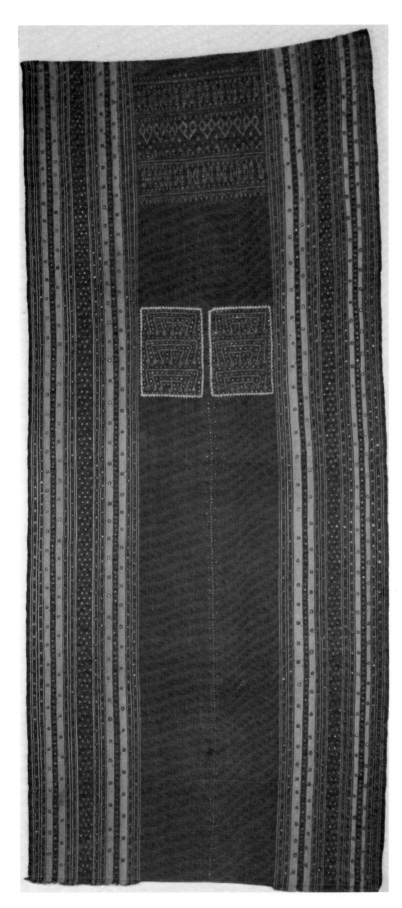

Sumatra, Kauer people
Supplementary weft, embroidery on
warp-faced plain weave, variable warp
floats in stripes
Cotton, metal yarn, cermuk
Warp 111 cm, weft 49 cm
Volkenkundig Museum "Nusantara"
Delft, Delft S-451-214

*In addition to making the embroidered
tapis the Kauer, a people of the far west
coast, also made a short jacket, to be
worn by young unmarried women, which
was totally conceived in the initial stages
of weaving. The weaving pattern included
the decorative panel that would appear
in the jacket back and the colorful stripes
for the bodice and sleeve decoration.*

*The back panel is a block of geometric
designs worked by supplementary wefts
laid-in with the foundation wefts so that
they do not show on the reverse face of
the textile. When the weaving was com-
pleted, the entire length was embroidered.
This included making the two badges on
the jacket front and applying several hun-
dred tiny mirror pieces. Two rectangular
pieces were cut from the end, tapered,
and sewn into tubes for the sleeves. After
being assembled the jacket was lined,
usually with imported cotton. Finally,
shells were sewn onto the neck opening
and around the back panel.*

*This jacket is a handsome blend of
local and imported elements. The cloth
itself is a heavy, handspun cotton dyed
warm shades of blue, reddish brown, and
deep yellow, capable of holding the sev-
eral kilograms of mirror pieces that stud
its surface.*

*Because of its very weight, this type of
jacket is unsuitable for the tropical cli-
mate of Sumatra's west coast. As a result,
young women traditionally carried their
jackets wrapped in tampan to the vicinity
of the celebration and donned them at
the last moment.*

the major design element, animals carrying riders, tree forms, birds, and small shrines may be present as well. As images suggesting transition, they are appropriate designs for textiles used in naming, circumcision, marriage, and death ceremonies. Earlier literature tended to label the ship motifs as "ships of the dead,"[4] but it is evident, as others have also noted, that the designs have greater significance than transition to death alone. The people of South Sumatra utilized the ship conformation as a major structuring principle, and it appears as the basic conceptual form for houses and ceremonial processions. The textiles, therefore, are another expression of this recurring theme. In addition, in one of their forms, the cloth designs came to indicate specific social segments, and as these cloths were hung at ceremonies they became a graphic representation of the hierarchical structure of the society.

Because of the predominance of the ship motif, these textiles are often called "ship cloths" in the West, but in Sumatra they have three names, given according to type. One is the palepai ("ship") or *sesai balak* ("big wall"), a narrow textile often more than three meters long. The second is called *tatibin*; it is also narrow, but rarely exceeds a meter in length. Both these types appear to have been woven only along the extreme south coast. The third type, called tampan, is about one meter square.[5]

Figures 48-52

Figure 53

Figures 54-59

Once the most numerous of the ship cloths, the tampan today exist in small numbers along the south and west coasts, where they are used only rarely in rituals. At one time, however, these textiles seem to have functioned as a symbolic textile par excellence, entering into all phases of the ceremonial life of the south.

A common use of the tampan was in the ceremonies surrounding marriage. Large numbers were included in the bride's dowry,[6] and they were used in gift exchange for such purposes as wrapping small presents of food which were exchanged between the lineages of a bride and groom. Similar exchanges subsequently occurred at all life-crisis ceremonies involving the same participants who had been initially linked by tampan exchanges at the time of marriage. The exchange of these cloths, which may still occur today in a token capacity, symbolizes the multiple bonds between lineages joined by marriage.[7]

Other uses for the tampan were quite varied. The elder who presided over the yearly law gathering sat on a tampan, and on other ceremonial occasions certain groups of elders gathered around a tampan to eat the festival meal. In the south, the handles of the funeral bier were wrapped with tampan, and in the traditional marriage ceremony the bride sits on one or more tampan at specific times in the ceremony. On the Krui coast, the head of a deceased person rested on one of the small cloths while the body was washed. At house consecration ceremonies, a tampan was tied to the ridgepole and stayed there for the life of the house.

Both the number of forms represented and the style in which the designs are rendered vary widely among tampan. In certain compositions ships carrying trees, shrines, and people fill an entire cloth, while in others simple geometric shapes are repeated in narrow rows.

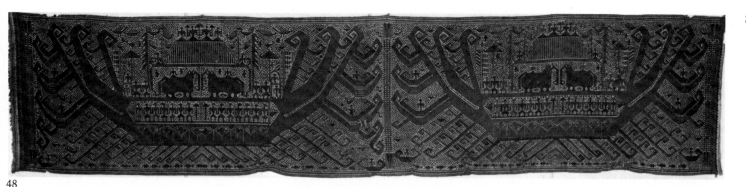

48

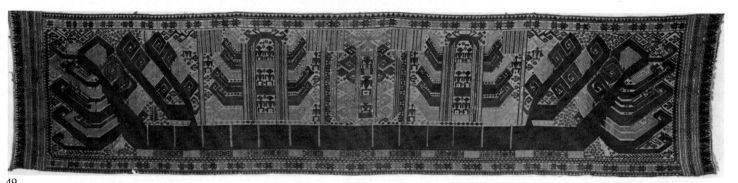

49

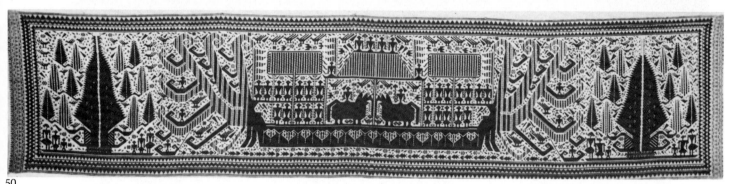

50

48 **Palepai** (ceremonial textile)
Sumatra, southern Lampong region
Supplementary weft
Cotton
Warp 295 cm, weft 64 cm
Tropenmuseum, Amsterdam 1772-1276

49 **Palepai** (ceremonial textile)
Sumatra, southern Lampong region
Supplementary weft
Cotton
Warp 292 cm, weft 65 cm
Tropenmuseum, Amsterdam 2125-3

50 **Palepai** (ceremonial textile)
Sumatra, southern Lampong region
Supplementary weft
Cotton, silk, metallic yarns
Warp 283 cm, weft 61 cm
Tropenmuseum, Amsterdam 1969-4
(Color plate)

These are fine examples of the long ship cloths woven on the south coast of Sumatra. They illustrate a mastery of the weaver's art and an understanding of iconography that was seldom matched. The dominant feature in each is a ship, or pair of ships, with a great arching bow and stern. They carry a host of forms: houses, shrines, umbrellas, flags, banners, animals with riders, and rows of people. The figures are set on a background crowded with scrolls, stars, small boats, and birds of various shapes and styles. All the central features are worked in discontinuous supplementary wefts, in earth

tones of dark blue, brownish red, and rich yellow. Occasionally a few metallic yarns or flat metal strips are used as highlights.

The designs on these textiles seem to have been an integral part of a symbolic system that reflected the structure of the large social unit called marga. The heads of the marga and its component parts, the suku, had the right to use these ceremonial textiles at life-crisis rituals. At such times the principal palepai was hung in a prescribed way in conjunction with those of other suku heads. The arrangement placed certain palepai to the left side and others to the right, in illustra-

tion of the internal structure of the marga.

In addition to this spatial structuring, the designs of each textile point to a precise classification that is only partially understood today. Examination of many examples reveals four or possibly five basic classes of textiles, each characterized by a particular design feature. Two of these classes are represented in Figures 48 and 49; their designs are two large red ships and a single large blue ship, respectively. Further analysis of major design elements convincingly places the red ships in a sacred realm and the blue

Still other compositions are so literal they seem to be graphic renderings of a story or myth that just eludes our understanding. When these are found along the south coast the style of the figures frequently recalls the *wayang* shadow puppets of Java, mirroring the strong influences that crossed the Straits of Sunda.

The size rather than the design of a tampan seems to have been what determined its function. Particularly large examples were used to cover great trays of ceremonial foods or served as cloths around which elders clustered to eat at a wedding.

Tampan were made and used by all levels of society, but this was not true of the palepai and tatibin. Only the senior representatives of patrilineal descent groups who carried the title penyimbang suku and penyimbang marga had the right to use these long cloths. They could, however, grant this right to others. It is probable that as the system of ranks and titles proliferated along the south coast, siblings or others gained access to these rights and had textiles made for their own ceremonies. Even so, use was essentially restricted to the aristocracy.

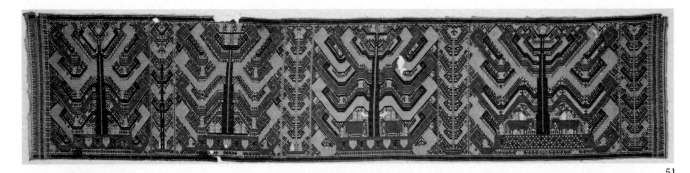

51

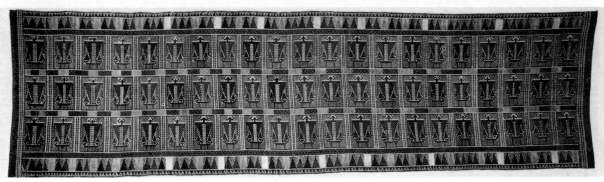

in an earthly context. The other two basic classes of palepai, shown in Figures 51 and 52, have features that are less easily recognized, yet there is no doubt that they were once symbols with profound significance for the society that produced them.

The rare textile in Figure 50 is an exception to the classification system, since it utilizes elements found in both sacred and mundane designs. There are less than six of these textiles in existence. What their relationship was within the total scheme can only be conjectured. For a tidy analysis, they might be dismissed as

51 **Palepai** (ceremonial textile)
Sumatra, southern Lampong region
Supplementary weft
Cotton
Warp 277 cm, weft 60 cm
Mattiebelle Gittinger, Washington, D.C.
(Not displayed)

an aberration, but their consistently superb craftsmanship suggests they were important textiles.[21]

52 **Palepai** (ceremonial textile)
Sumatra, southern Lampong region
Supplementary weft
Cotton, metal strips
Warp 302 cm, weft 82.5 cm
Friend of the Textile Museum,
Washington, D.C.
(Not displayed)

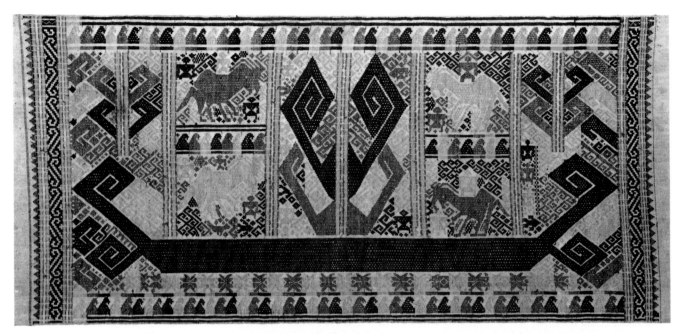

53 **Tatibin** (ceremonial textile)
Sumatra, south coast region
Supplementary weft
Cotton, silk
Warp 88 cm, weft 39 cm
Friends of the Textile Museum,
Washington, D.C.

The designs on the tatibin and their discontinuous supplementary weft structure seem to relate them to the palepai, rather than to the tampan. There are few of
these cloths in Western collections and often some of these are mislabeled as tampan. In recent times, tatibin have been found in Sumatra only in the peninsula between the two large southern bays and may have had a regional origin more circumscribed than other types of ship cloths. This example has a blue ship carrying figures in yellow, blue, and reddish brown.

In ceremonies the palepai was hung on the right wall in the inner room of the house as the backdrop to the central figure in the rite. In marriage rituals this traditionally was the bride, although in recent years the groom has joined her before the palepai at specific times. On the bride's first visit home after the wedding ceremony there might be a celebration, for which her parents would display one of the long cloths. Shortly after birth, the first child was presented to the maternal grandparents before a palepai to receive a name. This cloth also appeared at the celebration of a boy's circumcision. At one time the textiles were also hung when a man advanced in social rank, and at funerals.

In some southern areas of Sumatra, the palepai formed part of a tableau with other objects, including the tatibin. These arrangements generally included a pile of small, thin, mattress-like cushions and a group of hard bolsters, arranged as a couch that was set in front of the palepai. The bolsters were covered with tampan and the mattress pile with a tatibin. Another tatibin was wrapped around a wooden box set to the right of the bride's seat. Such boxes, now rarely seen, were lineage heirlooms, and during the ceremony they held festival cloths and jewelry.

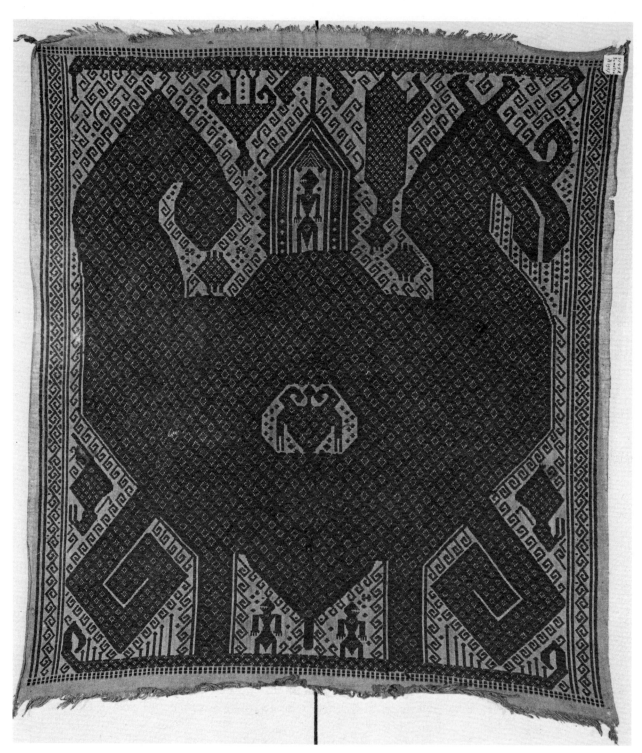

54 Tampan
Sumatra, Lampong region
Supplementary weft
Cotton
Warp 75 cm, weft 67 cm
Museum voor Land- en Volkenkunde,
Rotterdam 41452

The large curving protuberance from the bill of this bird probably identifies it as a member of the hornbill family, Bucerotidae. To the Ngaju of Borneo and the people of Nias, this bird represents their high god. Elsewhere in the archipelago birds in general are associated with creation myths, in the bipolar conflict between bird and snake, with omens for good and evil, and with concepts of death and

resurrection. Similar associations were probably made with birds in South Sumatra at one time, even though evidence of this is now lacking.

In this rendering, the bird is a reddish brown figure on a natural color cotton base. The diamond patterning within the body is characteristic of the manner in which supplementary wefts were used in the tampan. These decorative yarns run

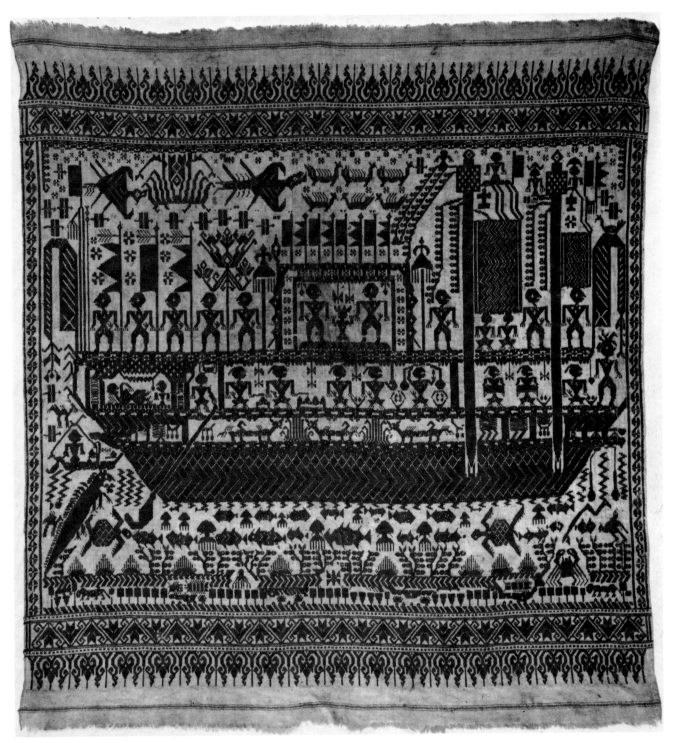

on the surface of the cloth, but to prevent them from tangling, the weaver periodically anchors them to the foundation yarns. Here the anchoring produces a pleasing network of diamonds. This type of structural patterning is common to all large forms in the ship cloths, and is one of their finest details.

55 **Tampan**
Sumatra, Lampong region
Supplementary weft
Cotton
Warp 78 cm, weft 71 cm
Anita Spertus and Robert J. Holmgren,
New York

This is one of a group of tampan whose designs seem to derive from a common source, possibly mythical. The scene cen-

ters on a sea voyage in which one person lies in a recumbent position in a small cabin at the stern of the ship. On a lower deck are men, identified by kris tucked into their clothes at the waist, who seem to play instruments of the Javanese orchestra, gamelan. *Above them on an upper deck are additional men and three small figures. The central positioning of one of these small figures in a cabin sug-*

gests a crucial element in the narrative. The figure stands on a raised platform with two men in attendance. Outside the cabin are umbrellas of rank, streamers, flags, banners, sails, and birds. The sea below teems with the forms of life that occur in Sumatran waters: jellyfish, coral, several types of fish, anemones, sea fans, turtles, and crabs. Other forms may be lizards, egg cases, and crab pens.[22]

The whole is a tantalizing scene, owing a large debt to Javanese culture and artistic insight. However, it frustratingly eludes further explanation.

The composition is worked in a reddish brown supplementary weft on a natural color cotton foundation.

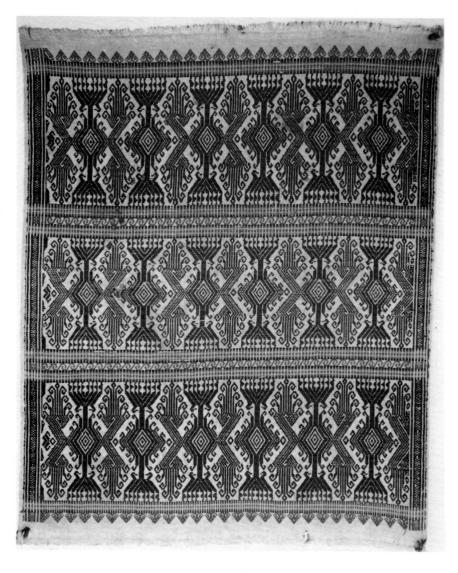

56 **Tampan**
Sumatra, Lampong region
Supplementary weft
Cotton
Warp 91 cm, weft 74 cm
Mary Jane Leland, Los Angeles

The great majority of tampan found in South Sumatra have geometric patterns, however, few are as striking as this example. Many show simple diamond and rosette patterns, hooked diamonds, interlocking scrolls, filled rectangles, or a pattern derived from the jelamprang. In 1970, in certain regions, such as the Rejang area north of Bengkulen, only geometric textiles were found. Here they were used in a variety of ways, but functioned as unsevered, paired tampan. Both halves carried the same design, but were worked in contrasting colors.

In this tampan, probably woven along the south coast, the designs of the center band are worked in reddish brown, and those in the top and bottom bands in indigo blue. Red is again repeated in the narrow end bands.

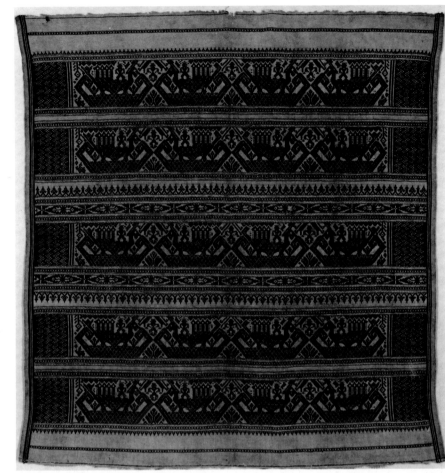

57 Tampan
Sumatra, Lampong region
Supplementary weft
Cotton
Warp 75 cm, weft 71 cm
Steven G. Alpert, Los Angeles
(Not displayed)

In this ship cloth, the exaggerated circular detail of the bird's highly stylized tail feathers suggests that the figure represents a peacock, although that particular bird is not known to have an outstanding role in the myths and legends of the area. It does indicate, however, that there was a desire to distinguish particular types of birds.

All figures are in a reddish brown cotton on a natural color cotton foundation.

The history of these ship cloths is obscure and the reasons for both their original use and their decline remain conjectural. The skills needed to produce them are now completely lost and apparently have been for three quarters of a century. The factors that are presumed to have caused this include the abolition of slavery in 1859, the decline of the pepper trade, and changing marriage traditions.[8] So many have appeared on Western markets in the past five years that it is doubtful any significant number remain in use in Sumatra today.

Far to the north, in the interior of Sumatra, ship imagery found expression among the Batak people, not in their textiles, but in the sweeping facades and bowed saddle roofs of their great painted and carved *Figure 61* houses, which loom like ships in a sea of rice paddies. The textiles are somber blue or deep maroon cottons relieved in their severity by occasional warp ikat patterning, warp stripes, or twined borders. In some textiles supplementary weft yarns are used to delineate simple geometric forms. Among the Batak there is a hierarchical structuring that determines the appropriateness of a certain type of gift textile relative to the age and social status of the receiver, and the occasion. The most *Figure 62* sacred and prestigious of all textiles is the ragidup, a dark cloth with white patterned end panels. This is the most important gift the bride's father bestows upon the groom's mother during the wedding ceremony. It is a statement of the bride-giver's superior status and protective and

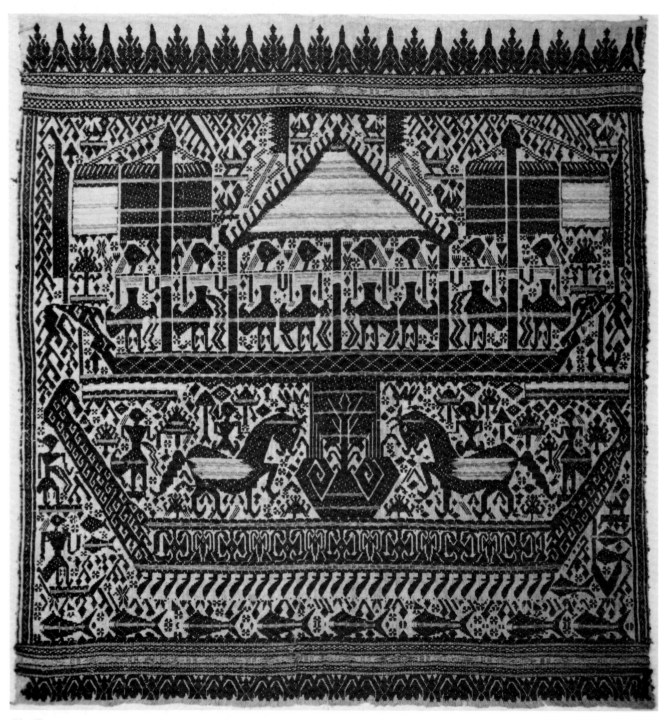

58 Tampan
Sumatra, Lampong region
Supplementary weft
Cotton, metallic yarns, silk
Warp 74 cm, weft 68 cm
Steven G. Alpert, Los Angeles

In this tampan the profile rendering of the head, broad shoulders viewed frontally, narrow waist, and exaggerated silhouette of the billowing court garment, the dodot, suggest the Javanese wayang puppets. This intrusive style, however, has been used to render themes familiar to the ship cloth repertoire: highly decorated ships bearing people, and horse and rider groupings. This represents a totally sympathetic blending of exotic features and local iconography. The designs appear in reddish brown with occasional highlights of yellow silk and metallic yarns in the flags, rooftop, figures, and horse's body.

59 Tampan
Sumatra, Lampong region
Supplementary weft
Cotton
Warp 85.5 cm, weft 76.7 cm
Textile Museum, Washington, D.C. 67.49

*The motifs of horse and rider, and human
in a boat in this tampan were inverted at
an axis at the bottom of the boat. The
mirror image that results probably de-
rives from technical factors inherent in
the weaving, rather than philosophical
considerations. It may be that the weaver
inserted a series of pattern sticks in the
warp above the regular loom parts that
were used to make the plain weave foun-
dation. After inserting one pattern stick,
raising that combination of yarns, and
throwing the supplementary weft
through, the weaver probably pushed the
stick to the top of the loom and in this
way "stored" that particular selection of
yarns. Each succeeding combination of
warps raised on a new pattern stick was
stored in a similar manner. The weaver
could then reuse these sticks, but in in-
verse order, thus rendering the design in
an inverted position. This could be used
to repeat either a small design element or
an entire cloth.[23]*

*All of the figures are blue on a natural
color cotton foundation.*

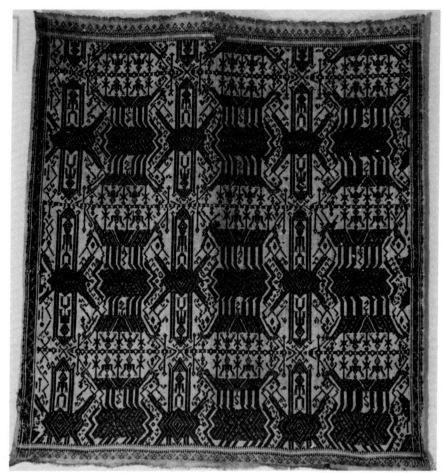

60 Tampan maju (beaded tampan)
Sumatra, Lampong region
Beadwork on cotton and rattan backing
Beads, shells, mirror pieces, commercial
cloth, rattan
Width 72 cm, height 59 cm
Anita Spertus and Robert J. Holmgren,
New York
(Color plate)

*This delightful ornament constructed
from beads and shell is one of the rarest
of all tampan forms. Possibly only three
others exist—two in the Jakarta Central
Museum, and another in the Tropen-
museum, Amsterdam. According to the
records that accompany one of the
Jakarta pieces collected before 1885, these
tampan were placed near the bride's seat
at the wedding ceremony.[24] There is also
a suggestion that such tampan were used
as gifts to the bride from the bridegroom.[25]*

*This example captures in beads a tradi-
tional ship cloth motif of horse and rider,
an expression of the basic transition
theme. The imaginative design is sur-
rounded by deep borders of evenly spaced
diamond forms and a final edging of
shells.*

61 Ulos padang rusak
Sumatra, Toba Batak people
Warp-faced plain weave, warp ikat,
twining
Cotton
Warp 213 cm, weft 81 cm
Museum voor Land- en Volkenkunde,
Rotterdam 2742

The advent of finely spun commercial
yarns and harsh aniline dyes has robbed
the plain textiles of the Batak of their
gentle sophistication. This example, col-
lected from the Toba Batak before 1884,
is evidence of that lost quality. Here sim-
ple ikat patterns of "arrowheads" appear
in dark stripes set against a reddish brown
field. The lateral margins are the same
brown, with an off-white selvage. Seven
rows of twining terminate the textile,
and the handspun cotton ends are plied
and twisted. The combination of natural
materials and the skills of an expert
weaver produced a textile of quiet dignity.

62 Ragidup
Sumatra, Batak people
Supplementary weft, supplementary warp,
twining
Cotton
Warp 227 cm, weft 98 cm
Howard and Bernice Beers, Lexington,
Kentucky

*The ragidup, whose name literally means
"pattern of life," is the most sacred of all
Batak textiles, and is used for important
gift exchange ceremonies. One of these
occurs when a woman is seven months
pregnant with her first child. On this
occasion, her parents present her with
one of these cloths, which becomes her
ulos ni tondi, or soul cloth. The designs
of the textile, which are thought to spell
out her future, are "read" by a knowl-
edgeable elder.*[26]

*This textile is composed of three bands
sewn together in the warp direction. The
lateral bands are warp-faced plain weave,
with narrow stripes of supplementary
warp patterning. The central band con-
tains white end panels woven by inter-
locking a new set of white warp yarns
with the center warps. This is done by
weaving the central area, then overlaying
the remaining dark warp yarns with the
white ones, and weaving a few wefts to
lock the new warps into place. The dark
warps are then cut away, and weaving
continues on the white yarns.*[27] *These
panels have supplementary weft patterns
on a warp-faced, plain weave foundation.
The ends are finished with twining.*

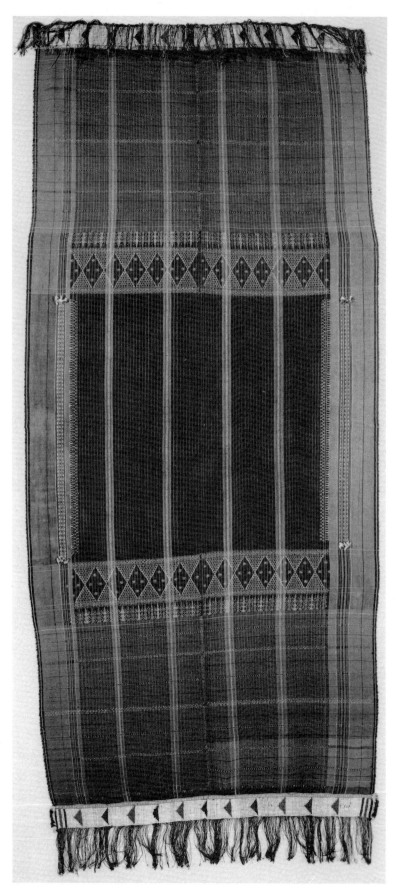

63 Ulos godang
Sumatra, Angkola Batak people
Warp faced plain weave, twill, supplementary weft, twining
Cotton, beads
Warp 217 cm, weft 99 cm
Museum of Fine Arts, Boston 30.827.
Maria Antoinette Evans Fund

The Angkola Batak are one of the few peoples in Indonesia who know how to make a twill weave on a simple back tension loom. They use twill as a decorative element in its own right, or as a foundation for decorative supplementary weft.

The twill appears on the two basic textiles of the Angkola people, which are distinguished from one another by their width. The size determines the function. A single panel cloth approximately 45 cm wide, called parompa sadum, *serves as a baby carrier. Two panels joined together create the larger wrapper, or shoulder cloth, called ulos godang. In addition to twill, the Angkola work may include supplementary wefts, tapestry weave, and twining, as well as beads which may appear on the body of the cloth and the borders.*

In this example the muted warp stripes of reddish brown and deep blue are highlighted by fine yellow stripes, and white beads in rows and patterned clusters. Four rows of simple geometric forms and an occasional stripe constitute the major designs in the weft. This elegant simplicity makes a strong contrast to today's popular textiles, with their continual series of designs or even words worked in harsh, synthetic dye colors.

Both the ulos godang and the parompa sadum are crucial to the ritual commitments involved in gift exchange. The latter textile in particular is used as a gift from maternal grandparents to the grandchild.

64 Bag

Sumatra, Batak people (?)
Double-faced complementary weft
Cotton
Width 13 cm, depth 9.5 cm, height 28 cm
Fred and Rita Richman, New York

The origin of this bag is obscure. No other examples are known, but because the motifs are virtually identical to those appearing in the twined borders of certain Batak ulos, a Sumatran origin is assigned here. The correspondence includes both the designs themselves and the use of alternating bands of color in the background. This bag is not twined, however. It is made of a double-faced complementary weft weave worked continuously around a warp structure that passes through the base.[28] How all the warps interlock in the base area is not understood, but the final product is a tightly woven seamless bag of superb craftsmanship.

fructifying role. The *sibolang*, a textile that goes to the father of the groom, has a similar significance. Paralleling these two in relative prestige, but imbued with a slightly different character, is the ragi hotang, which is the highest-ranked textile to be given to the bride and groom. If no child is born after a suitable time has elapsed, the young husband may return to his wife's family with a pig and demand the blessing of the bride-givers in the form of the ragidup.[9] In pregnancy and at the death of an elder the ragidup is once more the adat-sanctioned gift textile. The sibolang, a somber blue cloth with five bands of blue ikat patterns, also has a major role at funerals.[10] It is the major gift of the fathers of the son's wives and others who stand in the position of bride-givers to the dead person. It also serves as the chief mourning cloth a widow receives from her mother; in this case it is worn over the head, but in normal circumstances it is wrapped about the hips or folded over the shoulder.

Over two dozen types of Batak textiles have been identified. They are still made today, but few modern weavers are able to complete all the stages of production. This is especially true of the ikat textiles whose yarns are now ikatted by one woman and woven by another. More and more, the white panels interlocked in the end zones of the ragidup are woven separately and sewn onto the other segments of the cloth instead of being interlocked during the weaving process.[11] Nevertheless, the textile craft is still alive in the mountains of the northern interior, and the centuries-old system of gift exchange is still being practiced.

Figures 65, 66, 69

The contrast of the Batak textiles with those of the coast graphically illustrates the impact that foreign influences exerted on textile skills. From the eastern littoral and offshore islands come glowing red silks luxuriantly patterned with gold yarns, and soft blue, green, purple, and yellow dyes. These and various other types of silk textiles probably arose in the coastal areas of eastern Sumatra toward the end of the first millenium, as a result of Indian and Chinese traders who helped give rise in the seventh and eighth centuries to the kingdom of Srivijaya on the present site of Palembang. As a trading power, Srivijaya looked toward the sea and successfully maintained a hegemony over commerce in the straits for several centuries.[12] Caught in this trade flux between China and India, it would seem hard to believe that this was not the time when silk weaving was first introduced and flourished in Sumatra. The times provided both the trade structure to import the materials and a social class wealthy enough to support a luxury product. Silk culture was eventually established in parts of Sumatra, and at one time silk was even exported,[13] but the majority of the luxury weaving, here as elsewhere in Indonesia, was ultimately dependent on imports for a continual supply of its basic fiber. It therefore prospered along the coasts and in other areas that had ready access to imports.

Silk weaving was only one of the foreign influences on Sumatran weaving technology. Others were Turkey red, lac, and vegetable dye recipes as well as a host of decorative techniques. Of the latter, those that thrived were weft ikat, embroidery, plangi, and tritik. Even batik was known in a small area. Supplementary weft patterning, which may have been practiced earlier, was further developed in combination with silk.

The best-known textiles to emerge from this amalgamation are the red and gold silk textiles associated with Palembang, which are used for sarong, kain, shoulder cloths, and head wrappers. These have designs worked in weft ikat, or are entirely patterned with gold yarn in star and rosette forms identified by the names of flowers, vines, fruits, the sun, and stars.[14] Such designs occupy the center field of the textile, while near the end borders there may be narrow rows of *naga*, bird figures, or winged, lionlike creatures possibly taken from Middle Eastern iconography. The weft ikat motifs may be complex arrangements of ships and cosmic mountain images, naga, decorative rose-and-arabesque forms, or geometric patterns. Solid green, red, or yellow textiles were worn by widows who by custom could not use textiles with ikat in the center. The solid bright colors indicated their willingness to remarry.[15]

These gold and silk textiles are rarely seen today except on religious holidays and at weddings. Their manufacture does continue, however, as a cottage industry in villages adjoining Palembang. Aniline dyes and inferior metallic yarn are normally used, but fine textiles are woven on commission, using higher quality gold yarns unraveled from older cloths.

Figure 67

Immediately to the north and on the nearby islands of Bangka and the Riouw chain, textile traditions were virtually identical to those of Palembang, and only the most experienced observer can differentiate between these products. For example, the weft ikat fabrics from Mun-

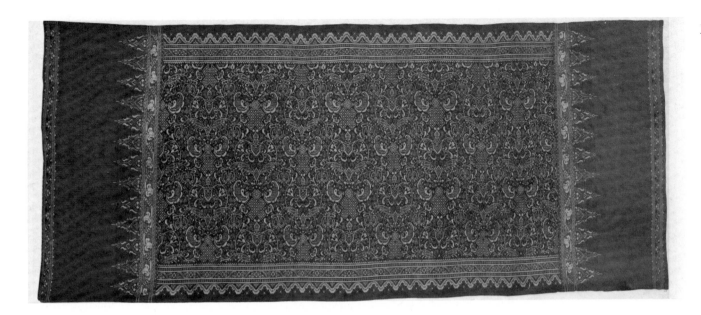

65 Slendang
Sumatra, Palembang region
Weft ikat
Silk
Warp 216 cm, weft 90 cm
Museum für Völkerkunde und Schweizer-
isches Museum für
Volkskunde Basel, Basel IIc 15704

*Fine patterning and complex interaction
of color make this a masterpiece of weft
ikat. Red, blue, yellow, and green are
brought together in elaborate interlocking
and overlapping forms that reflect the
many foreign influences that have formed
this dyer's art. The paired wings that
represent the mythical bird, garuda, are
basic to western Indonesian iconography.
Here some of the individual wings may
also be profiles of single birds. Below each
of the paired wings is a floral design, and
a patterned cross that is directly traceable
to Indian patola textiles. Also inspired by
textiles from the subcontinent, possibly
painted textiles from the Coromandel
coast, is the tracery of forms that arch
and curl like some organic growth. In
spite of these discernibly foreign aspects,
the textile expresses Indonesian aesthetic
values.*

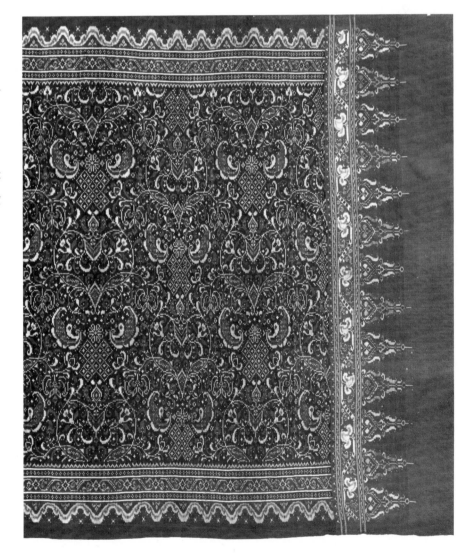

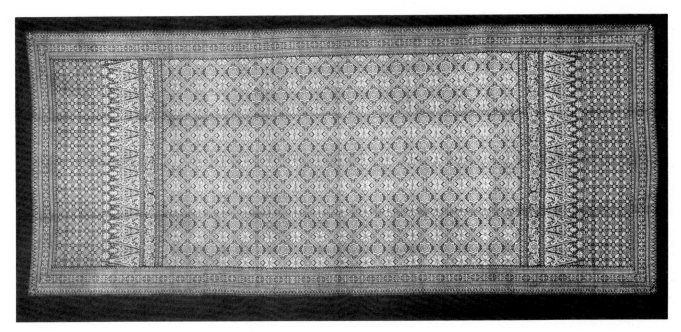

66 Kain songket
Sumatra, Palembang region
Supplementary weft, embroidery
Metallic yarn, silk
Warp 218 cm, weft 86 cm
Museum für Völkerkunde und Schweizer-
isches Museum für
Volkskunde Basel, Basel IIc 243

*This is a brilliant example of the Palem-
bang gold and red silk tradition that is
recognized throughout Indonesia. These
cloths are called kain songket, after the
technique of supplementary weft pattern-
ing. Additional names tell whether the
gold yarns cover the entire surface, if em-
broidery has been superimposed on the*
*supplementary weft, and what design
components are present. The name for
this particular textile made before 1903
could be kain songket lepus berakam
puncak rebung. Lepus indicates that the
entire surface is covered with gold yarns,
and berakam is the name of the technique
of covering the small designs in the end
borders with colored yarns. Puncak re-
bung refers to the rows of triangles near
the borders, here called "bamboo shoots."*

*Such textiles were worn over the shoul-
ders and cinched at the waist with a belt,
or wrapped about the waist as a skirt.
They are still made in the Palembang
area, but are rarely seen except in cos-
tumes at important life-crisis rites.*

tok on the island of Bangka, while being predominantly red, also give great precedence to a warm, rich yellow dye in the ikat patterns. In the textiles woven in the Siak area, the center field is divided into a very fine grid by supplementary gold yarns; within the squares of the grid are small rosettes or other floral forms. From Batu Bara and Lingga come changeable silks called *siang-malam* meaning "day-night," with different colored warps and wefts that respond to the angle of the light.

Figure 68

Figure 69

Embroidery, appliqué, plangi, and tritik are other decorative proc-esses used in these areas. The latter two in particular show Indian in-fluences. Their bright colors made them favored export items to Java, where they were used as shoulder cloths, belts, and breast wrappers. The embroidery seen on traditional jackets, dance costumes, bed hang-ings, pillows, food covers, wedding garments, and room ornaments owes much to Chinese and European sources.

Figure 72

In the Jambi region distinctive batiks were made, patterned with small geometric floral forms arranged in closely aligned vertical and horizontal rows. Some areas may be enhanced with gold leaf. Their

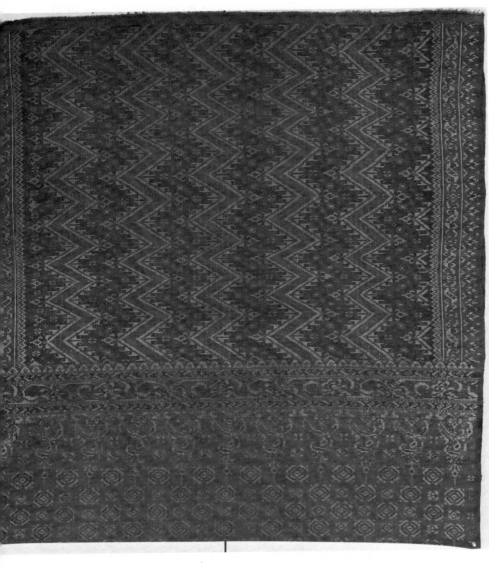

67 Sarong
Bangka, Muntok region
Weft ikat
Silk
Warp 209 cm, weft 106 cm
Museum voor Land- en Volkenkunde,
Rotterdam 19083

Muntok, on the island of Bangka, pro-
duces some of the most beautiful weft
ikat in Indonesia. It is even supposed
that silk fabrics of eastern Sumatra
had their source on this tin-rich island.
Muntok patterns are often richly detailed
and always colorful, with a spectrum of
blue, yellow, and red dyes. While a deep
red always predominates, the generous
use of warm yellow in the details is a
characteristic of Muntok weft ikat de-
signs. This textile shows the bold use of
yellow to outline the zigzags in the center
field, build arching scrolls in the framing
structure, and create floral squares in the
end borders.

muted reds and indigo blues, as well as their designs, seem closer to
Indian textile elements than to those of Javanese fabrics.

Figure 73 The textiles from the two other major silk weaving areas are less
well known. To the north, in the Aceh area, the brilliant colors of the
east coast give way to somber black, deep wine, and purple. Yellow,
orange, blue, and green occur rarely and are used in limited areas. The
dark tones are often combined with supplementary wefts of gold, and,
in older cloths, simple ikat designs of arrow points arranged in narrow
vertical stripes appear. This ikat, however, is in the warp, not the weft,
as is commonly applied to silk in Indonesia.[16]

Figures 75, 76 The fabrics of the Minangkabau in western Sumatra also represent a
distinctive textile style. This draws almost totally on supplementary
Figure 74 weft patterning with gold yarns, at times so heavily applied that very
little of the silk foundation remains visible. This ratio of gold to silk
in the composition, as well as other design factors, establishes stylistic
differences among these textiles. Each of the three nuclear districts—
Agam, Tanah Data, and Limo Pulueh Koto—produced textiles with

68 **Kain songket**
Sumatra, Siak region
Supplementary weft
Silk, metallic yarn
Warp 241 cm, weft 94 cm
Textile Museum, Washington, D.C.
1977.16. Gift of Mrs. Blake Middleton

All the textiles that come from Sumatra's east coast bear a close similarity. There are, however, substyles. Siak, on the coast north of Palembang, produced textiles with a finely patterned center field of small squares filled with round or diamond floral forms. These forms are worked in gold supplementary wefts on a red plaid silk foundation. The craftsmanship of such textiles is of the highest quality.

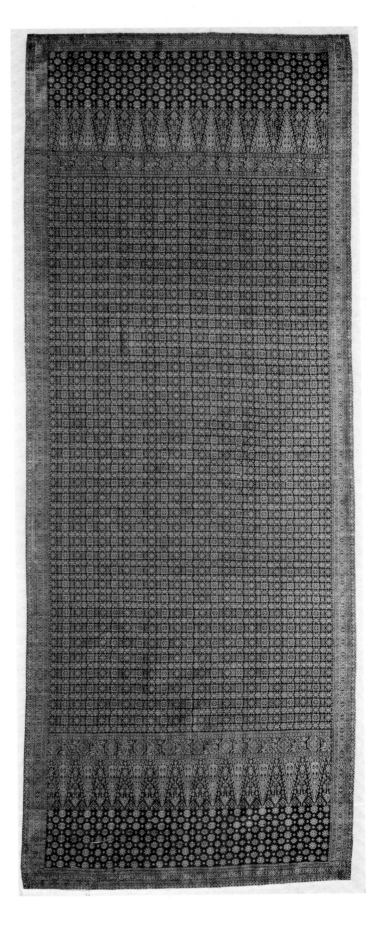

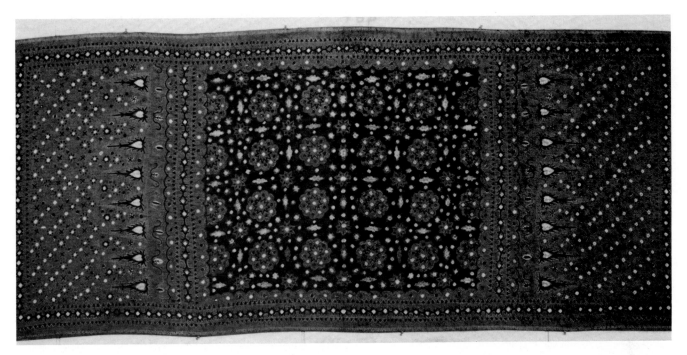

69 Slendang
Sumatra, Palembang region
Plangi and tritik
Silk
Warp 209 cm, weft 88 cm
Tropenmuseum, Amsterdam 1698-220

The plangi textiles of Palembang closely resemble their Indian prototypes in spatial arrangement, design elements, and color range. The subtle tones of the rich red border and deep purple center field suggest natural dyes were used to make this exceptionally fine example. Today the use of synthetic dyes produces a garish effect in the plangi-designed textiles.

Plangi has been known in South Asia for centuries, but the length of its presence in Indonesia is uncertain. Rarely do plangi textiles enter into sacred ritual, nor are they specific elements in gift exchange. This suggests they are not an extremely old type of textile in Indonesia.

distinctive features. Interestingly, Minangkabau silks seem not to have been influenced by the patola models in the same way as was textile design in so many other areas. The historical implications of this remain unexplained.

Commonly in Indonesia, as often noted elsewhere in these essays, textiles have traditionally been women's labor and used as bride-giver's gifts to express metaphorically woman's role. The counter-balancing gifts from bride-takers were metal items, money, and livestock. The very nature of gold and silk textiles makes them straddle these categories. They involve metal and they depend on materials available only by purchase. Frequently they were commissioned from commercial weavers, not produced by the women of the family. Although the phenomenon is not thoroughly understood, it seems that these contradictions have given rise to gift-exchange customs which vary markedly from the common Indonesian pattern. For instance, in the Palembang region, the groom supplies the bride with at least three types of cloth: one for everyday, one for formal wear and a gold and silk wedding costume.[17] At a child's first hair cutting, the paternal grandparents provide *Figure 70* a gold and silk *singep* and slendang. The former is a small square used to cover the child or as a head wrap, while the latter is a token carrier

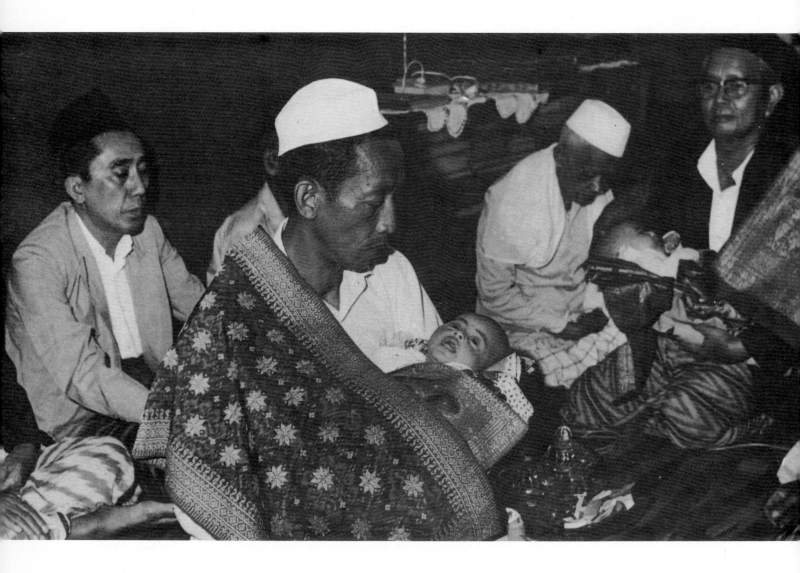

70 *In Palembang, the paternal grand-parents give the traditional textile gifts of a gold and silk singep and a slendang at the time of a child's first hair cutting. The former is a square cloth used as a covering for the child or as a head cloth, while the latter is a token carrying cloth. This photograph shows both textiles draped over the grandfather and the child. (Ny. Maimunah, Suro, Palembang)*

for the child. Unexpectedly, the textile gifts come from the bride-takers, not the bride-givers.

In this same region it is customary for the bride's family to give the groom a *kain blongsong*, in an echo of older gift-giving patterns. The blongsong cloth is probably of ancient origin because it is either all cotton or a textile with a cotton warp and a silk weft, with ikat patterns or simple plaids but no gold.

At one time there were mixed patterns of giving among the Minangkabau. The groom and his female relatives presented textiles to the bride and her family and later received two symbolic kain. One of these was a gold and silk textile, and the other an imported cloth. In this matrilocal society the textiles symbolized the groom's welcome into the bride's home. If the marriage was dissolved before there were children, however, the kain were returned.[18] Thus there is no consistent pattern of giving for these textiles. Although they seem now to have lost their original symbolic meaning, they continue to represent wealth.

There are no in-depth studies on the patterns of gift-giving in areas where gold and silk cloths are common, although mention was made

71 Slendang ?

Sumatra, Pasemah, Temalang Ulu region
Weft ikat, supplementary weft, tapestry
weave
Silk, metallic yarn
Warp 206 cm, weft 51 cm
Museum für Völkerkunde und Schweizer-
isches Museum für
Volkskunde Basel, Basel IIc 15888

*In Pasemah, on the upland plateau west
of Palembang, a special silk style arose,
influenced by the decorative techniques
of the coast but producing distinctively
different textiles. The greater part of the
cloth is covered with horizontal bands
containing weft ikat designs of diamond
shapes, a modified hooked diamond, or a
simple cross. These appear in the beige of
the silk against a reddish brown to wine
base. The ikat bands are regularly inter-
spersed with rows of simple geometric
patterns worked by a supplementary weft.*

*The singular trait of the cloths is the
double row of triangles placed base to
base or separated by a narrow row of geo-
metric designs. This example is unusual
in its use of five intervening rows, and for
having the center band worked in a tapes-
try weave. (Normally the entire area be-
tween the triangles would be worked by
supplementary wefts on a silk founda-
tion.) The design yarns were originally
wrapped in metal, which has disappeared,
leaving the silk or bast core.*

*Pasemah textiles may be identified also
by their narrow weft dimension, approxi-
mately 50 cm, considerably narrower
than that of textiles woven on the coast.
In the upland regions, two narrow textiles
would be joined to form a kain.*

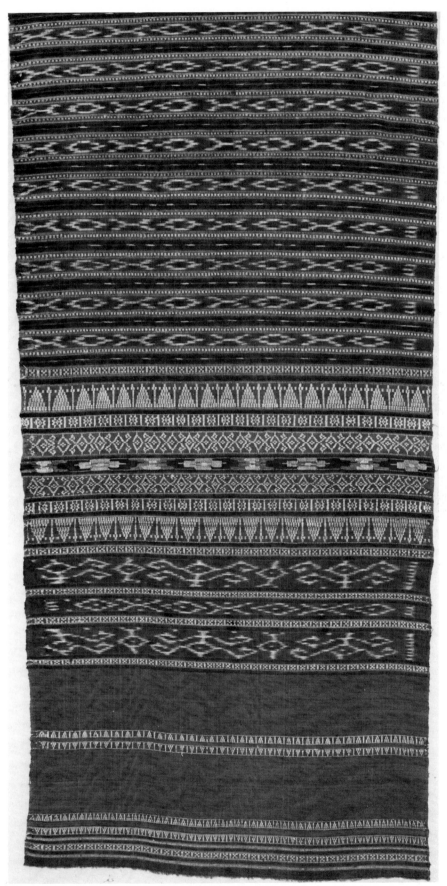

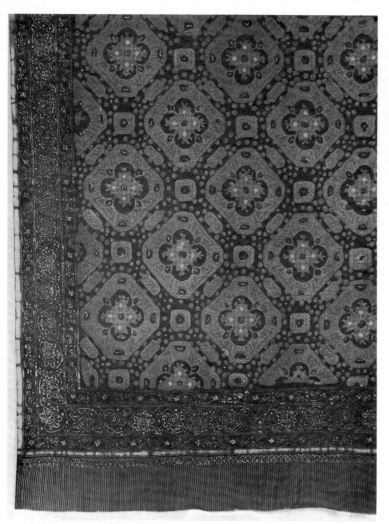

72 Slendang
Sumatra, Jambi region
Batik
Cotton
Warp 223 cm, weft 91 cm
Volkenkundig Museum "Nusantara"
Delft, Delft S-451-172

According to the Jambi people themselves, the skill of batik was brought to the east coast by Javanese immigrants in the last half of the nineteenth century, and soon adopted by local women.[29] *Batiks were made primarily for noble families, and reflect conservative tastes in designs and dyes. Muted red, light brown, and two shades of indigo are the basic colors here; some textiles were worked only in shades of blue. The designs display their Javanese heritage as well as strong influences from the batik traditions of India.*

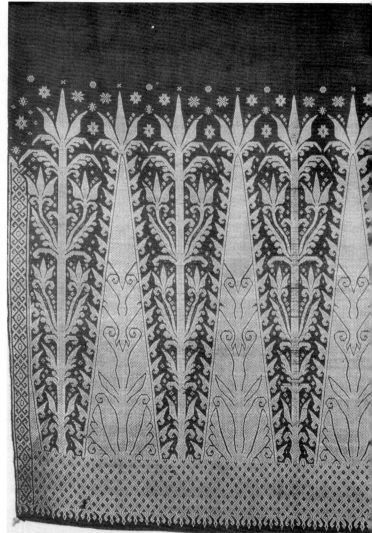

73 Slendang
Sumatra, Aceh region
Supplementary weft
Silk, metallic yarns
Warp 376 cm, weft 76 cm
Tropenmuseum, Amsterdam 1772-1269
(Details illustrated)

In spite of more than a thousand years of trade, the far northern coast of Sumatra has a surprisingly somber textile tradition of dark colors and static forms. There was a thriving silk industry at one time, and in the seventeenth century high quality raw silk was exported,[30] *but in later years the north coast depended on imported silk. The weaving from the region was known for its technical excellence, as expressed in fine silks, complex borders, tassels, and bands. The dark purple of this textile is a typical Aceh color derived from cochineal.*

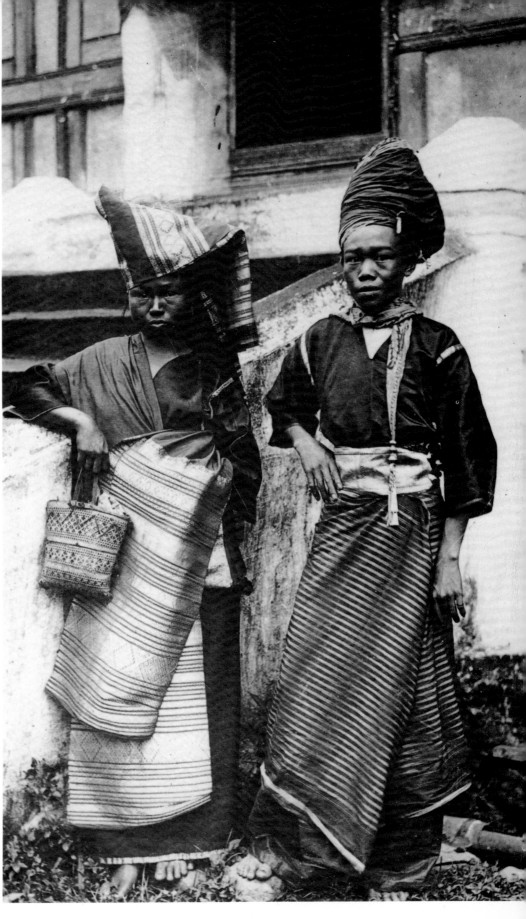

74 *A married couple from the uplands of Sumatra's western region wear the traditional dress of the Minangkabau people,* *rich silk and gold textiles similar to that shown in Figure 76. (Koninklijk Instituut voor de Tropen, Amsterdam)*

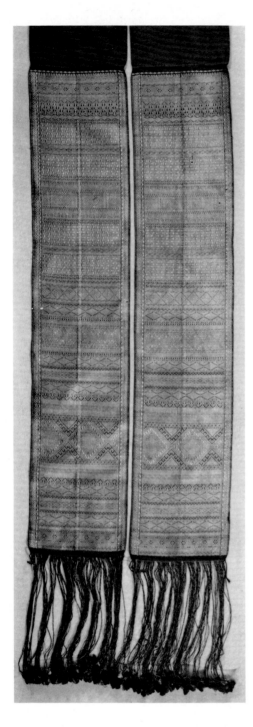

75 Waistband
Sumatra, Minangkabau people
Supplementary weft
Silk, metallic yarn, cotton
Warp 332 cm, weft 21 cm
Textile Museum, Washington, D.C.
Indefinite loan from Mrs. Huntington
Sheldon

A surprising variety of textiles was once woven by the Minangkabau: head cloths, shoulder cloths, kains, pieces for tailored blouses and trousers, and a wide range of belts and waistbands. They also combined different cloth segments to form a single large kain, which is unusual in the Indonesian context and probably reflects influences absorbed from mainland Southeast Asia.

The end pieces of this belt are decorated with gold supplementary wefts on a foundation of silk, with red, olive-green, and purple weft bands. Joining these end panels is a separate piece of plain weave red cotton. The fringes with their tasseled ends have been attached after weaving.

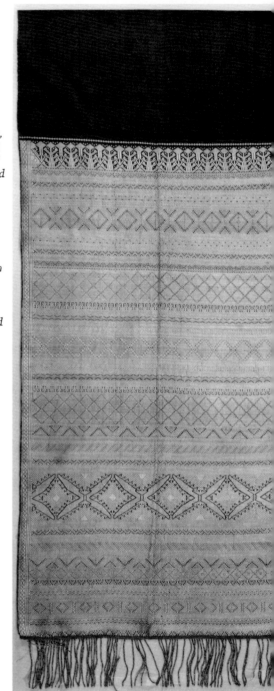

76 Tilakuang (headwrapper)
Sumatra, Minangkabau people
Supplementary weft
Silk, metallic yarns, metal fringes
Warp 274 cm, weft 48 cm
Textile Museum, Washington, D.C.
Indefinite loan from Mrs. Huntington
Sheldon

The centerpiece of the Minangkabau woman's costume is her headgear, which may be folded and wrapped in a variety of styles. The most startling styles soar in one or two points above the head. Usually the entire wrapping is made of a single heavy gold and silk woven textile such as this example, but on great occasions, no less than three separate pieces, as well as decorative strings, are used in the headdress.

The designs on this particular cloth suggest that it originated in the Agam district. The center of the cloth is a deep purple, and at the ends are supplementary wefts of gold metallic yarns. These overlie weft foundation stripes of red, deep olive-gray, and yellow. Like underpainting on a canvas, the colored bands lend a subtle nuance to the surface color.

of a few items of exchange in Palembang as early as 1843.[19] At that time certain textiles were a part of the bride-giver's portion, but these seem to have been imported or dyed textiles, not ones woven with gold. Closer investigation may show that textiles utilizing gold yarns functioned more as "metal" items than as women's textiles.

Sumatra provides a rich cross-section of Indonesian textiles. No other island can boast its wealth of textile arts nor such an astonishing variety of basic design complexes. This variety arises from the many diverse ethnic groups and from a continuing flow of foreign stimuli. Yet the variation is also witness to the vitality of the peoples of this island, who now increasingly turn their energies to skills other than those of creating textiles.

NOTES

1. Sections of this essay first appeared in Gittinger 1977
2. Steinmann 1946:1891
3. Gittinger 1977:13
4. Steinmann 1946:1889
5. The tampan were woven in long continuous strips and cut off as needed. Some of these tampan strips still exist in collections and should not be confused with the palepai. The designs in the palepai are correctly oriented when the cloth is hung horizontally. Designs among the tampan on a strip are varied in their orientation. There are also a few rare long textiles woven like a tampan which have a single continuous geometrical pattern. These were used to wrap house pillars or served as general decoration at ceremonies.
6. op't Land 1968-69:114
7. Gittinger 1972:21-29; 1976:211-214
8. op't Land 1968-69:115
9. Vergouwen 1964:58ff
10. Gittinger 1975:26
11. Ibid.:13
12. Coedès 1968:84
13. Veltman 1912
14. Jasper and Pirngadi 1912:239
15. Personal communication R. H. M. Akib, Palembang, 1975
16. Veltman 1912:53
17. Personal communication R. H. M. Akib, Palembang, 1975
18. Toorn 1881:213, 216, 217
19. Praetorius 1843:40-41
20. Jasper and Pirngadi 1912:303
21. Gittinger 1976
22. Speculative identifications were by David Pawson and Henry Roberts, Smithsonian Institution, Washington, D.C., 1972.
23. Technical suggestion made by Rita Bolland, Tropenmuseum, Amsterdam.
24. Jakarta Central Museum 577
25. Palm 1965:65
26. Vergouwen 1964:100; Gittinger 1975:19
27. Gittinger 1975:14
28. Technical suggestion made by Ann P. Rowe, Textile Museum, Washington, D.C.
29. Goslings 1929-30:143
30. Veltman 1912:18

JAVA

T

The story of Javanese textiles today is largely a story of batik, a technique that because of the excellence of the Javanese products, is now recognized and practiced in many countries by craftsmen and contemporary artists. Other types of textiles are made on this island, but they are mainly of historical interest.

Batik textiles as we know them are probably of relatively recent origin. Not only is there no mention of batik in the writings that come down from the fourteenth century,[1] but the finely detailed design elements of Java's great batik were only possible when the textiles to be worked with the wax resist had a tight, smooth surface. Because locally woven textiles did not possess these properties, imported cottons had to be available before the development of the more intricate forms could occur. Imports first came from India and later from Europe. Because of their foreign origin and high cost they were more available in commercial trading centers and in prosperous courts, and these were, in fact, the places where batik manufacture evolved.

The precursor of today's batik has been sought in a more primitive form of resist such as the sacred red textiles once made in parts of West Java and called *kain simbut*. These locally woven textiles had simple figures applied in rice paste, not wax, by means of a swab-like instrument or a flat nib of split bamboo. When the paste was dry, the cloth was dyed red by brushing or pouring a dye solution of *Morinda citrifolia* over it.[2] Repeated sequences of dyeing and drying finally gave the desired color. After the resist paste was washed away, the design—simple stick figures and geometric forms such as scrolls, swastikas, and triangles[3]—appeared in an off-white on the red ground. In some cases the resist may have been applied to the background to cause the colored designs to show on a white ground. These designs and the cloths as a whole seem a faint promise of today's complex fabrics, yet they were once a required part of a bride's trousseau and were sacred textiles used at birth, circumcision, and tooth-filing rites.[4]

A group of honored textiles from Central Java, however, suggests

77 **Textile length** (use unknown)
Java, Ceribon
Batik
Cotton (handspun and handwoven)
Warp 255 cm, weft 177 cm
Tropenmuseum, Amsterdam 807-2

This is an example of batik applied to a handwoven textile. Such pieces are uncommon and provide an interesting contrast to the usual batik on machine made fabric. On the handcrafted cloth the texture of the surface actively affects the design quality, resulting in an expression of great vigor and surprising freshness. These are properties often lost on the intricately worked finer batik textiles in their striving for perfect detail.

The composition of parallel rows of large circles or medallions has old antecedents in Java. It appears as a structuring device for designs carved on stone panels in eighth and ninth century temples. These have long been thought to imitate textile hangings.[39] Most of the stone examples show petal-lined roundels encircling an animal, but some, as at Candi Prambanan, are flat rayed disks that could easily have inspired the present textile or shared a similar design source.

The character of the lines in the design components suggests that the wax was not applied by the usual canting, but rather by a blunt instrument. Possibly a metal or bamboo nib was used.[40] Another unusual feature is the dimension of this cloth; the width is excessive for Javanese styles, indicating that the textile was not used as clothing.

another line of development that could have led to the batik of today. Some of Java's most revered textiles were the kain kembangan. This textile, which appears as headcloths, breast wrappers, waist cloths or the large ceremonial kain (dodot), is dyed by a tritik resist. The designs reserved in this process are a single central diamond area and a wavy margin around the cloth edges. These large designs do not involve small details, and could have been adequately rendered on coarsely woven textiles. Thus, their development need not have depended on large amounts of imported textiles. It was probably their early heritage that qualified them for their high social and religious roles. Certain types were reserved for titled persons, who could also bestow them as gifts of honor.[5] Some were for wear at certain stages of the wedding ceremony or were hung by the royal bed,[6] and still others were used as special offerings. The latter were token or miniature kain kembangan that were laid out ritually as offerings at marriage and circumcision rites. Eight kinds of token kain kembangan were once necessary as offerings at times of pregnancy and housebuilding, and certain kinds were among the offerings made to the goddess of the South Sea.[7]

Figure 80　　Another type of kain kembangan, also associated with the South Sea goddess, has designs applied in gold leaf. Following the usual pattern, these cloths have a large diamond shape in the center, reserved by a tritik process. In the remaining area, dyed either dark blue or green, designs are drawn by brush in a yellow clay, then covered with glue and finally with gold leaf.[8] This manner of decorating cloth does not depend on a highly evolved technical level of weaving or dyeing, and was probably one of the earliest decorative procedures used at centers that had access to gold, for example, the Javanese courts.

The design worked in these textiles in gold, or *prada* as it is called on Java, is the *alas-alasan*—a wooded mountain landscape. Its forms and structure are dependent solely on line and not on a combination of line and color, although it is now often rendered in batik in the traditional

Figures 78, 79　shades of cream, indigo, and *soga* brown. The scene may be symbolic of sacred mountain sanctuaries;[9] but whatever its original meaning, it is an important design in batik today.

These particular kembangan textiles were once required garments for the wedding ritual,[10] and they are still worn by court dancers at Surakarta for the Bedaja Ketawang dance, honoring the first meeting of the king of Mataram with the South Sea goddess.[11]

Both because of technical factors and because of the sacred character accorded these textiles in the very centers where batik became a dominant art, there is every reason to believe that the early development of batik on Java can be traced through them. It is possible that batik grew in response to the demand for imitations of the gold-worked designs. The actual technique of the resist process may have already existed in some other form, or may even have arisen through the imitation of clay painting. In any event, the special nature of these designs, the cloth form, and the sacred uses to which the textiles were put all suggest that the prada form of the kain kembangan was a textile considered worthy of emulation. While gold might be too precious for widespread use, the designs could be rendered in other media. These

imitative alternatives may have spurred the development of batik as it is known today.

There must have been many stages in the evolution of batik design and technique, but a major turning point was the development of the *canting*. This is a spouted copper or brass reservoir for holding small quantities of molten wax. A bamboo handle allows the tool to be held like a fountain pen, so that wax outlines can be drawn on the cloth surface. Spouts on the cup-like reservoir vary in size and style, permitting fine detail work, gross filling of areas, dots, or even parallel lines. This tool, unique to Javanese batik, allows the artist precise control of line and detail.

Figure 182

The batik process at its apogee evolved into a labor-intensive procedure that involved predyeing processes, repeated starching, and multiple applications of wax resists. The cotton piece was first washed, then rubbed and kneaded in vegetable oil to enable the fibers to accept the red and brown vegetable dyes.[12] Then the oil was removed in alkaline baths, and the cloth beaten with heavy wooden mallets to prepare the surface for the wax. The wax was a combination of resist materials such as beeswax, resins, and paraffin. These gave the substance greater viscosity in the molten state, which allowed finer control in the application and enabled the wax to seal but not penetrate the cloth surface.

The major outlines of a batik design were drawn in wax on the cloth first, then the smaller filling elements were added, and finally the areas to remain white and/or those to be dyed brown or red were filled in. Depending on the final color combination, there might be three applications of wax on both sides of the cloth before any dye was applied. Different colors of wax were used to distinguish the applications, so that they could later be scraped away as needed in the dye sequence. The textile was then dyed blue. Wax from the areas to be dyed brown was scraped away, and the blue areas were covered with wax. The next dye bath was brown or red, which not only gave that color, but also changed exposed areas of blue to violet or black. Additional wax was scraped away or applied for other colors, and extremely fine details achieved by actual brushwork. An alternative to scraping the wax was melting, but this required rewaxing both sides of the entire cloth again. In the final stage the wax was melted off, but a small residue remained. This gave the batik a distinctive texture which would last for many years if the cloth were washed in cold water only. Many of these stages are omitted or have been altered today, although the basic elements of the batik process remain.[13]

Batik dyes were made by complex and often secret recipes that were passed from one generation of dyers to another. Blue, probably the earliest of Indonesian dyes, was based on *Indigofera* species,[14] but might include such exotic items as sugar, cassava, banana, or shredded chicken.[15] Soga, the soft brown dye from a tree bark, *Pelthophorum ferrugineum*, often depended for its final shades and colorfastness on post-dye fixing baths.[16] The original dye solution, however, was tempered by several additional elements. One of these added to the soga was *Morinda citrifolia*, which was also used alone to produce rich red tones. These main dyes showed regional variations and could often be

78 Kain panjang
Central Java
Batik
Cotton
Warp 193 cm, weft 106 cm
Textile Museum, Washington, D.C.
1976.13.3. Gift of Gladys O. Visel

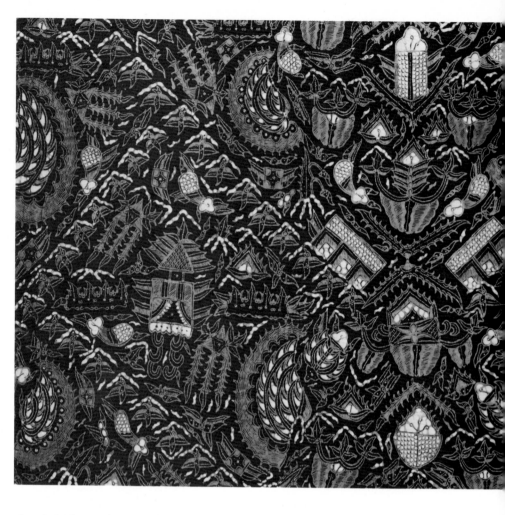

Each of these textiles utilizes a similar mountain scene as its major composition. These are formed by small, undulating peaks that accumulate into larger mountain forms. Technically each textile uses a form of dye resist, but to quite different effect. In the first example, the forms are drawn in wax, leaving the background to be dyed a deep blue and brown. In the second, wax was applied to the reciprocal areas, or the background, allowing the figures to appear in deep reddish brown and blue on the resulting cream surface. In the last textile, the large diamond shape in the center was reserved by a tritik process which was used to tie off this entire region. The edges were then dyed green, and after the resist was removed, the center was dyed red. When this was complete, the detailed designs were worked by gluing gold leaf to the surface of the cloth.

In all the compositions, a menagerie of birds and animals interlocked with plant forms fills the mountain scenery. The curling tendrils are called semen from the Javanese word semi, relating to the budding or unfolding of leaves,[41] and give to

the whole the connotation of fertility and productivity. Small shrines and the paired wings of the garuda bird are also frequent features of such landscapes. Initially interpreted as a sacred mountain scene [42] or a rendering of the sacred Mount Meru,[43] and later as a schematic rendering of the macrocosm,[44] the cloths provide a rich design inventory sufficient for numerous mutually compatible interpretations.

The elements of this type of textile composition, however, are not constant, nor is this variation totally understandable within the concepts of "artistic variation." Certain examples feature a dominant single wing, others a paired wing or wing-and-fanned-tail form of the garuda bird. In others, the garuda is absent, and stylized peacocks dominate the landscape (Textile Museum 67.6). In still other examples, the major form is a ship (Textile Museum 1965.34.1), or an exotic plant set in the mountain format.

It is possible that the mountain scenery format was a standard visual statement for the general concept of sacred shrine area. This may have been intended to encompass four "historic" sacred areas,[45] or

to include the entire concept of religious domains set aside by the king for the maintenance of temples, ancestral shrines, or religious orders of priests. Particular motifs were then enlarged and superimposed on this general scheme to indicate and identify more precisely the sacred area intended. For instance in records from the fourteenth century, ships were symbols of the Shivaite and Buddhist bishops, whereas particular species of trees represented the royal family.[46] At great celebrations, gifts were given in the form of mountains, ships, houses, or fish, which symbolized segments of this early society.[47] Thus, though many of these figures are time-honored symbols on one level, they could be adopted as a group or class of signs on a more limited plane. As grouped in this particular textile composition, their intended meaning may have been quite specific. It seems probable that the composition relates to a general sacred scene and that particular motifs, accentuated against this background, identified what type of sacred land was intended.

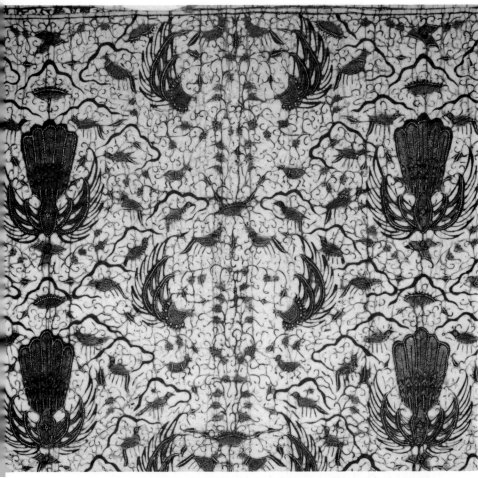

79 **Kain panjang**
Central Java, Surakarta
Batik
Cotton
Warp 252 cm, weft 105 cm
Tropenmuseum, Amsterdam 48-319

80 **Kemben**
Central Java
Prada and tritik
Silk
Warp 248 cm, weft 75 cm
Textile Museum, Washington, D.C. 67.19
(Not exhibited)

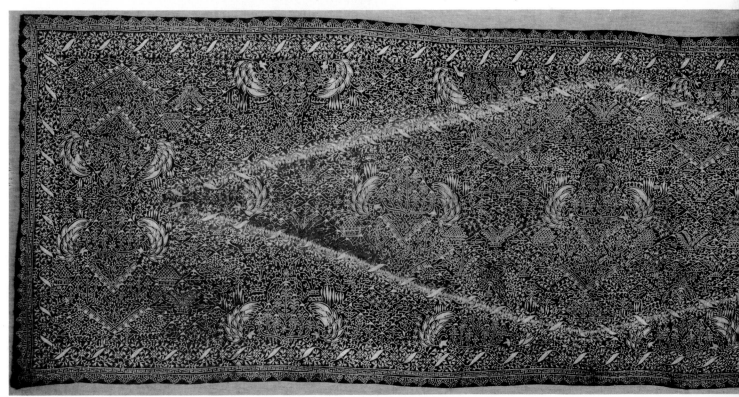

81 Slendang
Java, north coast region
Batik
Silk
Warp 315 cm, weft 52 cm
The Los Angeles County Museum of Art,
Los Angeles M74.18.5. Costume Council
Fund

*Normally batik silk slendang from Java
carry patterns of bird and floral forms
with a strong Chinese influence. This tex-
tile, worked totally with geometric forms,
is therefore an unusual example. Here
each design element has its own integrity,
but also exists as part of a larger design
unit. The brown outlines and shades of
blue further delineate planes, which cre-
ates the impression that several layers of
mosaic have been superimposed over the
beige ground. Because the usual silk slen-
dang has blue as its dominant color, the
name given to these cloths is* lokcan,
from lok *(blue) and* can *(silk).*

traced to individual steepers who gained fame for the brilliance or tone
of their colors. The indigo dyeing was frequently done by men, whereas
the soga dyes were handled by women. The exception to this was in
Surakarta, where some men specialized in soga. Dyeing with vegetable
substances demanded repeated cycles of immersing and drying to
achieve the desired intensity; up to 40 days were required for certain
reds. Now almost everywhere in the archipelago, synthetic dyes are
used, and as a result, the distinctive marks of regional or individual
dye qualities are fast disappearing.

For artistic expression, the canting wax applicator excelled, but it is

82 Kain panjang
Central Java, Jogjakarta
Batik
Cotton
Warp 276 cm, weft 105 cm
The Los Angeles County Museum of Art,
Los Angeles M77.97
Gift of Sylvia, Nanies, and Gordon Bishop

The two dominant features of this batik composition are the kawung and the sawat. The former, four petal-like ovals that share a nucleus, is an old Javanese pattern appearing on stone statuary of the thirteenth and fourteenth centuries. The textile medium represented in these early figures was probably not batik, but may have been gold leaf.[49] The sawat, a composition of paired wings and a fanned tail, now represents the garuda—the

mythical eagle. Here, however, separate heads are attached to each wing, making each the profile rendering of a separate bird. There are also birds, possibly phoenix, between the kawung.[50]

This batik may have been made for Sultan Hamengku Buwono VIII in the 1930's.[51] It is, therefore, not surprising to see the kawung and sawat, once patterns reserved for court use, joined on a single cloth.

Figure 183 obviously a labor-intensive tool. A copper stamp, termed a *cap*, invented in Java in the middle of the nineteenth century, allowed entire design units to be pressed in wax on the cloth surface. This eventually meant that a worker could wax twenty pieces a day rather than one in twenty or even forty-five days.[17] The cap technique had little effect on batik until after 1890, however, when a series of events combined to accelerate its use. From 1870 to 1880 the development of roads and railroads opened wide regions of Java to the importation of new goods. Among these were cheap European textiles, which began to replace handloomed products.[18] It was feared that the imports would cause the demise of batik as well, but the cap process gave rise to an industry that produced a much better product than its European competitors.[19] These industries not only depended on the canting patterns, but in some cases made textiles of combined cap and canting work. Although historians decry the effects of the metal stamps on batik, it is probable that this maligned form saved the art from extinction. By the 1920's the cap industry was producing imitation European woven sarong and printed fabrics.[20] Earlier, in 1917, Rouffaer [21] could write that after the iron industry on Java and Madura, the batik and dyeing industries were the largest employers.

83 Textile fragment from kain panjang
Java
Batik
Cotton
Warp 69.8 cm, weft 104 cm
Textile Museum, Washington, D.C. 67.1

*This textile's background motif of small
nucleated circles is thought to be one of
the oldest designs in batik. The name of
the design itself, gringsing, appears in a
fourteenth-century reference; however,
the precise meaning is not known. It may
derive from the word for fish scales, or
from another word that relates to decorat-
ing with metal.[52] It is used as a back-
ground element for other, larger motifs,
and almost always appears in a cream
color delineated by a rich soga brown.
Variations in the spacing of the small
forms make the design surface ripple like
a fine mosaic under water.*

By the early part of this century the inventory of batik designs was
said to number over a thousand,[22] which seems a modest calculation.
The total has certainly increased since then, and designs continue to
emerge from indigenous sources, Indian painted cottons, Chinese tex-
tiles and ceramics, and European textiles and pattern books. Such a
multiplicity of sources, even though filtered through Javanese eyes and
hands, makes the final renderings difficult to arrange in logical cate-
gories. Several attempts at organization have been made. The following
scheme, with a few exceptions, follows suggestions made in the batik
work of Tirtaamidjaja,[23] but in no way claims to be comprehensive.

Tirtaamidjaja's major categorial divisions are those of geometric and
non-geometric designs. Within the category of geometric batik a prime
Figure 81 classification is called *ceplok* or *ceplokan*. These are forms based on
squares, rectangles, circles, and stars which often become extremely
complex through the addition of fine details. In some, variations in
color intensity give an illusion of depth to the design, much like an
oriental carpet or tile pattern.

Of all the ceplokan the most famous may be the jelamprang, which
is an eight-rayed rosette set in a modified square, circle, or hexagon.
The motif imitates a pattern found on the double ikat textiles called
patola, imported from India. These textiles have been treasures of the
courts of Java since at least the sixteenth century, and continue in use
even today. Their designs were copied, not only in batik, but in the
silk weft ikat made in Gresik, East Java, and appear in many other

84 **Kain panjang**
Java, Jogjakarta region
Batik
Cotton
Warp 269 cm, weft 109 cm
Tropenmuseum, Amsterdam A5200
(Detail illustrated)

The tambal batik, a visual feast of patterns, is an assemblage of batik designs arranged in small geometric shapes over the whole of a cloth in imitation patchwork. The design is thought to emulate the patchwork garments worn by priests such as those shown in this rare 1902 photograph. In some instances, the tambal batik was adopted in lieu of tattered clothing by the priests themselves.

This may have been an outward expression of poverty vows, but there is also evidence that small fragments of cloth could be endowed with special properties. Certainly there is a magical quality attached to the patchwork jacket honored by the Sultan of Jogjakarta. This is an heirloom robe-of-state that by tradition descended from heaven.[53] If the tambal once shared any such special properties, they are not known today. Good examples of the tambal batik provide an excellent catalogue of traditional patterns, as this example made before 1881 suggests. (Koninklijk Instituut voor Taal-, Land- en Volkenkunde, Leiden)

85 *Javanese priests*

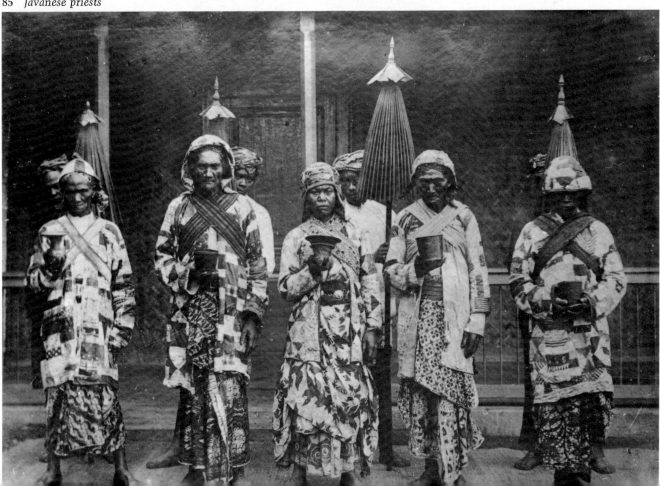

textile traditions of Indonesia. In the proprietary decrees of 1769, the jelamprang was reserved for the ruler of Surakarta and his family.

The patola pattern also appears in batik in a style that imitates a woven rendering of the design. In this small dots and bars imitate yarns as they would appear in a woven version. This is used for many other designs in addition to the jelamprang, and all these imitations of weaves are classified as *nitik* designs.

Figure 86

Figure 82

Another ceplok pattern is the kawung. It is formed from parallel rows of intersecting circles in which the resulting segments visually coalesce to form symmetrical four-petaled flowers. This pattern also may derive from Indian prototypes, for related forms appear on cloths from the Coromandel coast. However, if once foreign, it has been thoroughly assimilated, and is a favorite motif in Central Java, especially in the region of Jogjakarta, where it was once reserved for the use of the royal family. In the past the design was associated with the leaves or fruit of the aren palm,[24] or the oval fruit of the kapok tree.[25] More recently, it has been suggested that the word kawung refers to cotton.[26]

86 Kain panjang
Java, Jogjakarta region
Batik
Cotton
Warp 245 cm, weft 104 cm
Gordon Bishop, Gordon Bishop International, New York

This textile joins together two of Java's great patterns—the parang and the nitik. The parang, in particular the parang rusak variety, has been a favorite batik pattern for centuries. It may appear as a background element, as here, or as the dominant motif—on a diminutive scale, or in great curving forms. Within the palace compounds of Jogjakarta and Surakarta, it was reserved for the royal family, although elsewhere it was used by commoners as well. In one variation, used by the sultan on holy days, the pattern was rendered on a gigantic scale and had to be of flawless execution. No blemishes of dye could appear in the white areas, for this would indicate that the wax layer had been fractured; such an error would deprive the cloth of its magic power.[48] On

lesser cloths, to disclaim any pretension to nobility by too white a surface, the wax was cracked in the dye process to produce a network of hairlines across the surface.

Overlying the parang are ovals containing nitik patterns. These are designs utilizing dots and short lines to imitate woven patterns. Here each oval presents a different pattern, but rather than becoming chaotic, the pattern is sustained by the regularity of the ovals and their skillful placement within the textile field. In all respects, this is a superb example of the batik art.

87 Kain panjang

Java
Batik
Cotton
Warp 262 cm, weft 106 cm
Textile Museum, Washington, D.C.
1977.18
(Color plate, detail)

This is a batik composition with few peers. With a total mastery of design, the artist has combined a myriad of small individual motifs to form a remarkable unified whole. Diagonal rows of soft blue and brown patterned circles alternate with garlands of vines and flowers intertwined with birds, moths, and butterflies.

All is set on a lightly reticulated surface of beige and brown.

The circles at first appear similar, but in reality each is built of quadrants bearing classic batik patterns. The disciplined framework provided by the repetition of the basic circular shapes contains a vast catalogue of parts. Mocking the geometry of the circles are the undisciplined flowers, birds, and butterflies. The birds are delightful constructs with turned heads and flaunting tails, set among clusters of inventive floral forms.

This batik epitomizes the general name tulis. Tulis literally means "writing" or "painting" and is thought to be the original word used to designate the textile form now termed batik.[54] Data that closely align the skill of painting and batik, as well as the pictorial qualities of certain Ceribon batik, have led some researchers to suggest that batik may have begun in Indonesia as a kind of painting rather than as a textile art.[55]

This example shows the direction in which painting developed with the advent of Islam, which discourages the depiction of living beings. Few examples, however, involved this much detail in the elaboration of the geometric shapes. The waxing of this textile alone would have required several years of work.

These simple natural objects were important to the life of Java at one time. In Majapahit times (1293-1520) fermented sap from the aren palm was made into an alcoholic beverage that had an important role in the economy. The tree entered the mythology of the period, and was venerated much as the rice plant was.[27] Cotton, as Solyom explains, appears as a symbol for clothing on the coat of arms of the Jogjakarta and Surakarta courts—here, too, paralleling rice in symbolic importance.

Figure 83 According to the batik expert Rouffaer, the kawung derived from the gringsing. This design, usually used as a background or filler element, is composed of contiguous nucleated circles. Rouffaer believed it to be one of the oldest designs, dating back to the Majapahit period.[28] The name gringsing may derive from words that relate to decorating with gold or silver,[29] once more suggesting that the early batik patterns may have imitated designs that first appeared in metals.

Figures 86, 87, 88 When any of the ceplokan or other designs in Javanese batik appear in a diagonally arranged format, they fall within the category of designs called *garis miring*. As worn, these are visually arresting, in con-

88 Kain panjang
Java, Pekalongan region
Batik
Cotton
Warp 254 cm, weft 104 cm
The Metropolitan Museum of Art, New
York 65.38.1. Gift of Mrs. Delia Tyrwhitt

*One stream of batik design led to a
baroque process of layering or superim-
posing finely worked larger motifs on a
variety of patterned backgrounds. Particu-
larly favored were clusters of vivid, multi-
colored flowers. While more restrained in
color than some examples, this batik from
the 1920's exemplifies this trend. Here
large sprays of red, yellow, and purple
flowers are set on a background of diago-
nal lines created by parang and kawung
elements.*

*During World War II, because of a
critical shortage of imported cotton,
batik workers began to spend a great deal
of time on a single length of cloth and
built on this style of elaborate layering.
The wartime batik as a group are called
Jawa Hokokai after a political organiza-
tion established on Java during the
Japanese occupation.*[56]

Figures 78, 79

trast to the static compositions strictly aligned on the vertical and
horizontal. It is not surprising that one of the most beautiful was
claimed by the royalty of Java for their private use.[30] Although no
longer restricted, this pattern, called parang rusak, is still important to
court costume. It is one of the large group of parang designs, whose
origin and meaning are obscure, although there are many fanciful
analyses and romantic legends to explain them.[31] Even the translation
of the name parang rusak is disputed, although "broken knife' is gen-
erally used.[32] A more recent, extremely attractive concept proposes that
the terms relate to destroying an enemy.[33] The parang designs resemble
incomplete interlocking scrolls. There are other designs of great beauty
as well in the garis miring category. A favorite manner of using them
is as a surface on which larger design features are superimposed.

Non-geometric batik designs are difficult to sub-classify because of
their great number and variety. One large group is that of the textiles
with sacred mountain scenes built with the *semen,* or tendril forms,
as background filler. Subdivisions may be made based on the dominant
distinctive motif, for example, the *lar,* or wing; the peacock; or .the
ship design element. Paralleling this large class are groups consisting
of designs built of semen patterns alone and semen patterns with ani-
mals, all lacking the mountain infrastructure.

Other batik, especially those made along the north coast, draw more

89 Kain panjang
Java, Jogjakarta region
Batik
Cotton
Warp 251 cm, weft 106 cm
Tropenmuseum, Amsterdam 2160-48

The snake, or naga, is a motif that abounds in Indonesian art, appearing on the temples of Java from the very earliest periods, on metal work from Borneo, and wood carvings from the Celebes and elsewhere. While undeniably a part of Hindu mythology, the snake probably had a strong symbolic function among many ethnic groups of the archipelago before Indian influence arrived. The coincidence of forms merely assured the survival of the symbol. It is associated with the female division in a bilateral structure, sharing concepts of fecundity, rain, the ocean, dark colors, and the moon.

Here the naga appears as a crowned snake in a composition of stylized boats with high-rising bows and sterns. The scaled texture shared by snake and boat evokes their mutual association with water, while the sprouts and tendrils of the background express the concepts of fertility associated with the naga. The colors are indigo and soga brown.

heavily from foreign sources. These include a large number of textiles with floral subjects that show groupings similar to those on foreign textiles and may have been inspired by actual European textiles or pattern books used in Java. Other floral adaptations came from Indian sources, and these too were quickly assimilated into the Javanese aesthetic. European illustrations and stories served as the additional stimulus for a number of rather unfortunate examples with themes such as Bluebeard and Little Red Riding Hood, streetcars and cannons. Fortunately these patterns had little lasting impact and are now mostly confined to museum collections.

Figures 90, 92, 93

Chinese influences have been adapted by Javanese artistry to form an integral part of local textile patterns. Particularly excellent examples of this are the so-called *wadasan*, or rock motif, and *megamendung*, or cloud motif, made in Ceribon. Both the design elements and color gradations, from blue to light blue to white, copy conventions found in Chinese paintings, textiles, and rugs. Other batik contain motifs taken from Chinese porcelains, which were imported and valued as heirloom treasures in Indonesia for several centuries.[34]

Figure 98

Figures 95, 96, 97

Many batikking skills have now been adopted by modern Javanese artists who seek to use this ancient craft to create a contemporary art. The most interesting modern batik are those in which traditional styles are given fresh interpretations. It is still too early to know

90 Sarong
Java, Pekalongan region
Batik
Cotton
Warp 106 cm, weft 98 cm
Tropenmuseum, Amsterdam 1585-127

Javanese sarongs normally have a focal center created by two rows of facing triangles. This area is called the kepala, *head, as opposed to the remainder of the sarong called* badan, *or body. In place of the triangles, a kepala may be delineated by a contrasting color zone. Superimposed on this are motifs similar to those of the body or ones of a different character altogether. This example, signed "Lans," which was made in the north coastal city of Pekalongan, juxtaposes a wine-red kepala and a gray-green body. These act as backdrop to a lyric composition of arching stems and nodding flowers. The qualities of contrast between the gentle pinks and blues in the body and the abrupt wines and reds of the kepala are initially jarring; however the artist has tempered this contrast by a rain of background parallel lines that not only softens the boundary between the zones but stirs admiration for her technical virtuosity.*

whether this recent phenomenon will produce an art as durable as that on which it is founded.

The rise of batik and the importation of manufactured textiles has now ended almost all weaving on Java, that is, so far as the original craft was practiced on the back-tension loom. There are a few weavers

91 Sarong
Java, Indramaju region
Batik
Cotton
Warp 215 cm, weft 108 cm
Tropenmuseum, Amsterdam A5001

This finely worked sarong, made about 1887 on the north coast of Java, exemplifies the masterful manner in which batik workers could assimilate foreign influences. Each design element recalls a different source: birds whose ancestry is in Ming Dynasty porcelains, a garden built of flowers from Indian painted palempore textiles, European textiles, and possibly pattern books. The blossoms in the body of the sarong are said to be carnations, and by tradition exist on several continuous arching stems that, if successfully traced from selvage to selvage, bring the searcher good fortune.[52]

The blue and white color scheme is characteristic of Indramaju batik, which utilize a limited dye range with the greatest skill. Shading and texture are achieved by varying the width and character of line and lightly dotting the background. This is done by piercing the wax layer with fine pins. The strong, solid blue diamond shapes in the kepala of the sarong counterbalance the gentle quality of the body, giving a pleasing structure to the whole.

left in remote rural areas, but their work is not significant today. At one time, their major products were the conservatively striped dark cotton cloth called lurik, a simple cotton plaid, and plain cotton for shrouds. Particularly in Central and East Java, lurik has been the traditional textile of jackets, blouses and breast wrappers, and continues to be widely used even today, although now the textiles are woven on frame looms or machine looms in factories.

92 Sarong
Java, Tasik Malaya, and Pekalongan
Batik
Cotton
Warp 201 cm, weft 104 cm
Tropenmuseum, Amsterdam 1352-5

A particular type of batik evolved that carried the batik styles of two areas. As a reflection of this they were given the general name dua negeri, meaning "two countries". One section of the cloth would be completed in one region, then the fabric would be sent to another region to be finished. In this sarong the body was made in Tasik Malaya in West Java, and the kepala in Pekalongan, on Java's north coast. In the illustration the deep red kepala is on the right, and the body, with its European-inspired designs, is on the left.

93 Kain panjang
Java, Pekalongan region
Batik
Cotton
Warp 260 cm, weft 104 cm
Gordon Bishop, Gordon Bishop International, New York

One type of batik may have halves of distinctly different designs on a background patterned in two different ways. The contrast was usually created by making one half of the textile a light color and the other dark. This gave rise to the group name of pagi-sore, meaning "morning-evening"; the light half was to be worn outermost at night, and the dark half during the day. Some of the most sophisticated pagi-sore, however, do not have an abrupt color contrast, but, rather, a subtle variation in the background patterning distinguishes the halves. This was the technique used in this example from Java's north coast. Here bird and plant forms, heavily influenced by Western art styles, are set on a floral ground that varies in density and form between the two halves. The whole design has been treated in a gentle manner, with fluid lines rendered in soft pastel colors.

94 Sarong
Java, Semarang region
Batik
Cotton
Warp 114 cm, weft 110 cm
Tropenmuseum, Amsterdam 1585-4

Because batik making depended essentially on the import of cotton textiles, the infrastructure of trade and capital always stood between the batikker and the cloth. In addition, in the nineteenth century an individual had no easy means of selling his product in a larger market. As a response to this, foreign residents, primarily Chinese, Arabs, and Europeans, even before the advent of the wax stamp factories, functioned in the textile arts and trade in various ways. One of these people was a Carolina Josephina von Franquemont, an Indo-European who ran a batik "factory" from 1840 until 1867, first in Surabaja, where she had been born, and then in Semarang. She introduced new patterns from foreign sources, but was best known for her unique blue-green dye color, which proved a hallmark of her establishment and finally gave to all pieces with this shade of color the name kain prankemon. The secrets of this dye as well as those of an earthern yellow dye perished with the woman herself in an earthquake in June of 1867.[58]

This sarong is thought to be one of the Franquemont textiles. It shows a most imaginative rendering of a nutmeg tree at the moment the yellow pods—later to become the spice mace—burst to reveal the precious nutmeg. The leaves and stems carry patterns of their own, and small birds alight momentarily on the sinuous limbs. These are trees from the inner eye of fantasy, yet one pauses momentarily at the suggestion of irony. The jeweled wishing tree was a favored theme in classical Javanese sculpture. Just as this tree was to bestow riches and jewels, so the famous tree of the spice trade yielded similar abundance.

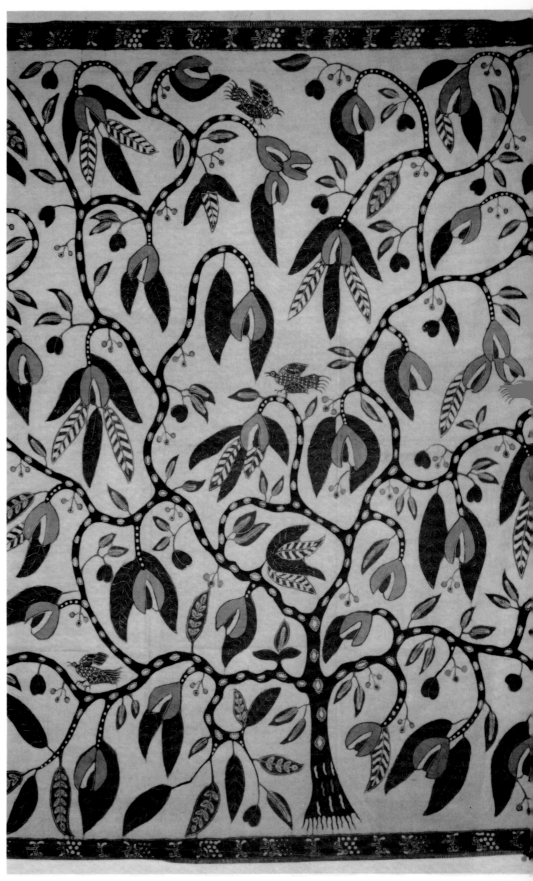

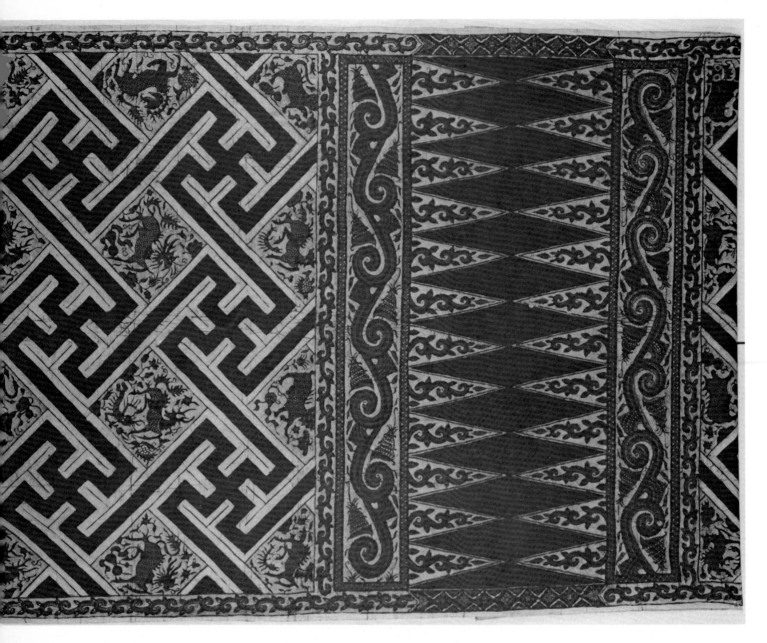

95 Sarong
Java, north coast region
Batik
Cotton
Warp 190 cm, weft 104 cm
Museum voor Land- en Volkenkunde,
Rotterdam 27833

The swastika, a motif symbolizing good fortune in many cultures of the world, frequently occurs in batik. It is called banji from the Chinese ban meaning "ten," and dzi meaning "thousand," which incorporates the concept of good luck. A delightful, if apocryphal, tale of its introduction to Java on a Chinese wedding bed is told by the early batik scholar Jasper. According to this story, all the surfaces of the wooden bed were carved with symbols for specific aspects of prosperity, but the canopy was covered with engraved banji to increase all the others by ten thousand times.[59]

In batik, the banji serves primarily as a background or filling device between major design components; therefore, use of the motif as a dominant element, as in this example, is unusual, but extremely effective in the daring pattern it creates. The arms are here extended and interlocked to form a heavy grid over the entire surface. Within this are delicately balanced figures of animals, which seem to be a group of mythological subjects drawn from Chinese iconography. The large scrolls flanking the kepala and their echoing shapes in the borders are also unusual for their size and placement. The whole is an exciting blend of geometric shapes and naturalistic forms.

There were also Javanese cotton textiles patterned in warp ikat. This technique survived into the present century in the form of textiles called *kain kasang* or *kain gubah,* the making of which was surrounded with certain customs and proscriptions. The dyes used were from *Morinda citrifolia* for red, and a dark earth combined with leaves for black. Considering the indigo heritage of the island, this latter dye was unusual. In view of the spotted pictures and examples that remain, it appears that the horses, ships, elephants, lions, snakes, leaves, fruits, and flowers that are said to make up the designs may have been more mental concepts than visual constructs. These textiles were used as wall hangings at ceremonies and life-crisis rituals, which argues for their antiquity.[35]

Silk ikat was also made in Java, but in recorded time only in a village near the East Javanese town of Gresik, and only as ikat on the weft. This was frequently combined with metallic supplementary weft yarns. Jasper reported in 1902 on the preparation and dyeing of these silks, which were worked in imitation of ikat textiles imported from India. They consisted of kain, sarong, slendang, and waist wrappers; surprisingly at that late date, natural dyes were still used. Twenty-four years later only synthetic dyes are mentioned, with a list of six patterns that were still made largely on commissioned orders from the palace in Surakarta.[36] One of the patterns was the jelamprang, whose imitations in ikat on Java can be traced back at least a century.

Silk, or more rarely cotton, plangi-worked slendang were also a product of the Gresik region, as well as Semarang, Kedu, and Banjumas.[37] This was an industry controlled largely by Arab traders, who supplied silk to local workers and then marketed the finished product, sending large numbers of the cloths to Palembang in Sumatra.[38] The interchange of silk textiles between East Java and Palembang led to a great similarity in the products of the two areas, which already resembled each other because of their common debt to Indian prototypes. These examples of the textile arts of Java are academically interesting, but have little of the creative vigor that was to be expressed in batik. Batik is today, and has been for at least two centuries, the most dynamic art of the island, growing and assimilating a host of inspirations, yet retaining its integrity.

96 Sarong
Java, Tegal or Ceribon region
Cotton
Batik
Warp 200 cm, weft 106 cm
Museum voor Land- en Volkenkunde,
Rotterdam 26918

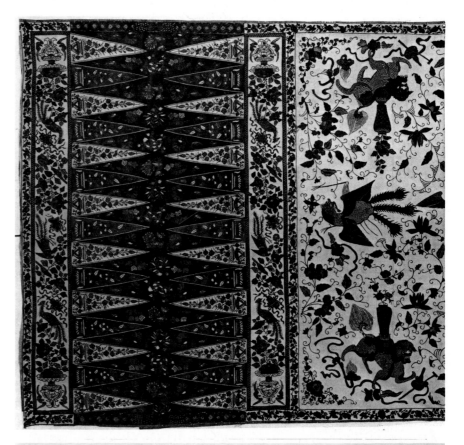

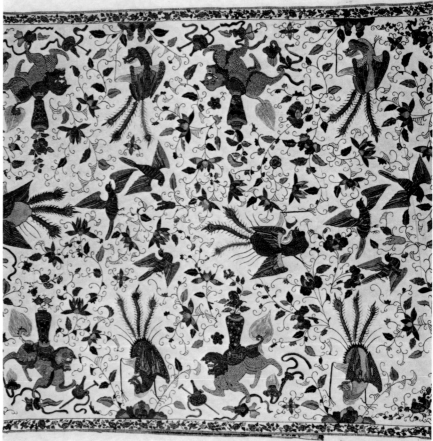

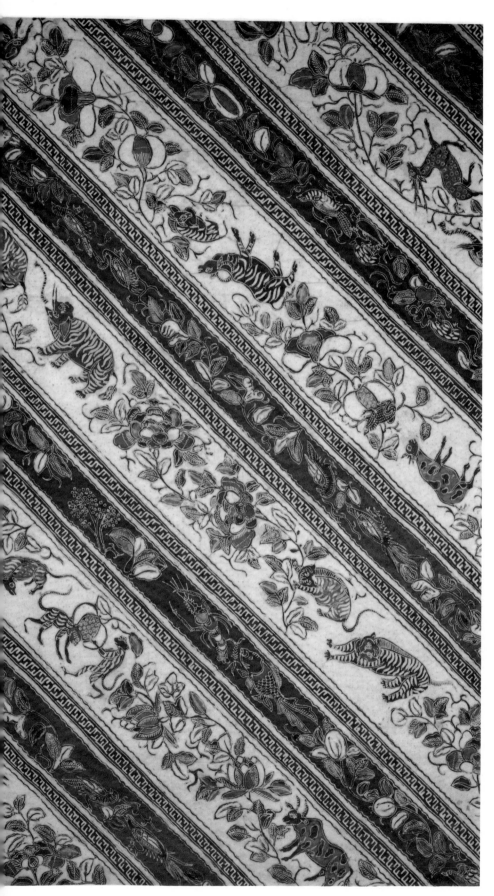

97 Sarong
Java, Lasem region
Batik
Cotton
Warp 199 cm, weft 112 cm
Tropenmuseum, Amsterdam 1772-1239

*Both of these textiles draw heavily on the
elements of Chinese art, yet each shows a
different way in which this influence has
been used within the format of the Java-
nese sarong. One uses the whole unre-
strained surface as an area to be decorated,
while the second confines the design ele-
ments within the matrix of the blabagan
arrangement which aligns designs on a
diagonal. A slight degree of difference in
adaptation is consistently reflected in
each detail. The first pattern remains close
to its origins, while the other filters its
motif through Javanese perceptions. Cen-
tral to the Rotterdam textile is the chi'lin
bearing a vase of flowers: this is the half-
dog, half-lion of Chinese mythology, who
here treads on symbols of prosperity that
vaguely resemble an Indonesian kris. In
the second textile, there is a veritable
menagerie of animals including deer,
water buffalo, cows, tigers, lions, monkeys,
and elephants.*

 *These Chinese influences largely result
from the history of the north coast region
of Java. It was sufficiently distant from
Central Java to escape the conservative
impact of the courts of Jogjakarta and
Surakarta, yet strategically located on the
exotic trade routes initially stimulated by
these authoritarian centers. Chinese, In-
dian, Arab, and finally European traders
all settled in the towns along this coast.
The Chinese brought painted and glazed
ceramics and embroidered and painted
textiles that would have carried many of
these designs. It has been proposed that
the designs of textile forms such as altar
cloths were quickly recast into batik for
the Chinese traders and immigrants,[60]
and in this way entered the motifs of the
batik art of Java.*

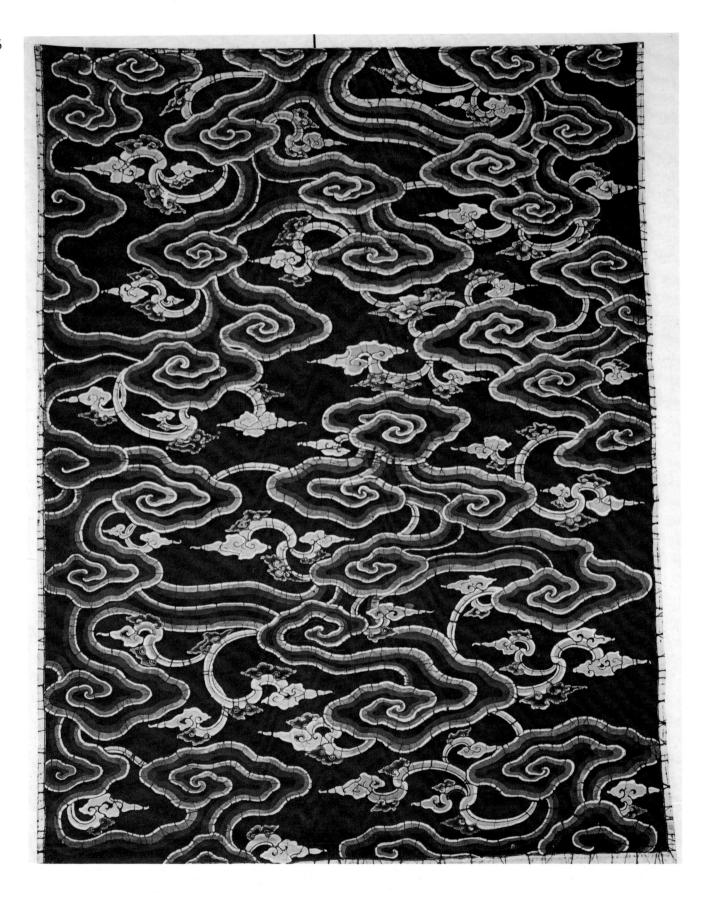

98 Kain panjang

Java, Ceribon region
Batik
Cotton
Warp 265 cm, weft 105 cm
Museum voor Land- en Volkenkunde,
Rotterdam 2051

*This batik is the most famous example of
the wadasan design ever made. It was
used by Rouffaer in the first major exhi-
bition of Indonesian textiles in Europe in
1902, and has since been regarded by con-
noisseurs as a stellar piece of the Museum
voor Land- en Volkenkunde. It was pur-
chased originally for ten guilders in Java,
and entered the Rotterdam museum col-
lection before 1878 as part of the now-
famous Ryckevorsel Collection. Older
records show, however, that its quality
was originally questioned because the de-
signs had been reserved in wax on only
one side, not on the front and back as is
customary in Javanese batik.*

*The design obviously owes a great deal
to Chinese influences, both in its use of
color gradations and in subject matter.
Visually the sinuous forms recall clouds,
but wadasan means rock-like. Contorted
rock formations are a part of Chinese art,
and appear as landscape effects in some
gardens in Java. The motif was particu-
larly favored in the batik of the Ceribon
region, becoming a distinctive, recognized
design type.*

99 Sarong

Java, north coast region
Batik and applied gold
Cotton
Warp 200 cm, weft 107 cm
Tropenmuseum, Amsterdam 1772-1249

*In most instances, when gold leaf is ap-
plied to a batik pattern it acts merely as
an adjunct to an already existing design.
Less commonly, as in this textile, the gold
serves as a significant component in
creating the structure of the design ele-
ments themselves. Here the gold is lightly
applied, enhancing each form with a
gentle coloration to produce a delicate
textile design. It helps create a fragile
tracery of limbs or vines that play coun-
terpoint to birds, flowers, and—strangely
—vicious animals like scorpions, centi-
pedes, and crabs.*

*Gluing gold leaf or gold dust to cloths
is called prada—hence the name* **kain
prada** *is given to such textiles. The tex-
tiles are now rarely seen, except on thea-
trical performers or an occasional princi-
pal at a wedding. The skills remain alive,
however, for prada work is used in
making some of the leather puppets used
in the shadow play, which remains a
culturally important art form in Java.*

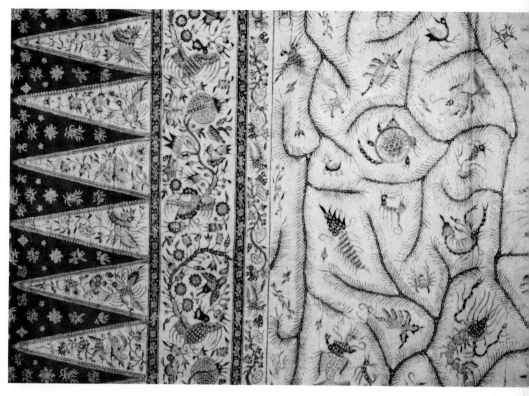

NOTES

1. Pigeaud 1962:506
2. Pleyte 1912:89-90
3. Steinmann 1958:Figures 12, 24
4. Pleyte 1912:90
5. Jasper and Pirngadie 1916:237
6. Pigeaud 1926:110
7. Jasper and Pirngadie 1916:237-239
8. Ibid.:79
9. Adams 1970:27ff
10. Jasper and Pirngadie 1916:237
11. Tirtaamidjaja 1967:32-33
12. Jasper and Pirngadie 1916:13-15
13. More detailed descriptions of the ba-
 tik process are given in Rouffaer
 1900, Jasper and Pirngadie 1916,
 Adam 1934 and Tirtaamidjaja 1966.
14. Lookeren Campagne 1899:80
15. Tirtaamidjaja 1966:23
16. Rouffaer 1917:195
17. Jasper and Pirngadie 1916:63, 79
18. Palmer 1972:15
19. Koperberg 1922:147
20. Kats 1922:95
21. Rouffaer 1917:198
22. Ibid.:202
23. Tirtaamidjaja 1966.
24. Jasper and Pirngadie 1916:152
25. Bolland 1960:4
26. Solyom 1977:67
27. Pigeaud 1962:506
28. Rouffaer 1917:200
29. Ibid.:77 fn 1
30. Jasper and Pirngadie 1916:227
31. Ibid.:154-155
32. Tirtaamidjaja 1966:26
33. Solyom 1977:69
34. Veldhuisen-Djajasoebrata 1972:50
 items 50-52
35. Jasper and Pirngadie 1912:166-169, 262
36. Kern 1926:194
37. Jasper and Pirngadie 1916:239
38. Kern 1926:194
39. Hoop 1949:86-90
40. Suggested by Rita Bolland, Tropen-
 museum, Amsterdam.
41. Jasper 1916:176
42. Adams 1970
43. Veldhuisen-Djajasoebrata 1972:37
44. Solyom 1977:72
45. Pigeaud 1962:197
46. Ibid.:192
47. Pigeaud 1962:193 also see Vol. III:77
48. Veldhuisen-Djajasoebrata 1972:19
49. Langewis and Wagner 1964:30
50. Solyom 1977:67
51. Ibid.
52. Rouffaer 1900:77 fn 1
53. Bolland 1960:4
54. Rouffaer 1917:199
55. Tirtaamidjaja 1966:19
56. Ibid.:20
57. Personal communication Rita Bol-
 land, Tropenmuseum, Amsterdam,
 November 1977.
58. Rouffaer 1917:197 and personal com-
 munication, Rita Bolland, Tropenmu-
 seum, Amsterdam, November 1977.
59. Jasper and Pirngadie 1916:116-117
60. Abdurrachman 1977:2

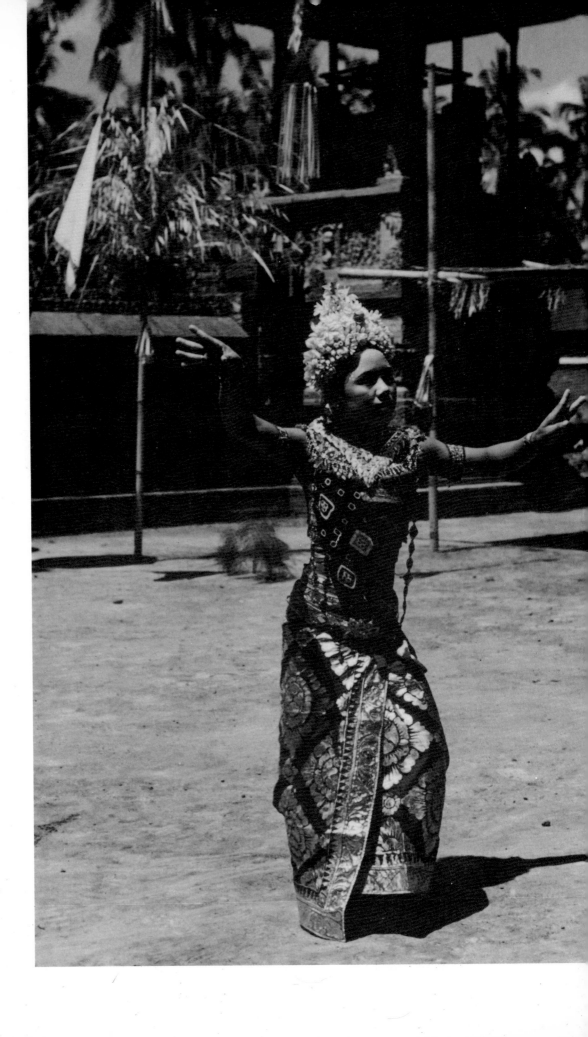

BALI

The gods taught the Balinese to dress,[1] and in the flickering light of a night dance or in the noon blaze of the temple yard, it is obvious they have not quite forgotten. There are brilliantly colored cottons and silks, textiles with applied gold leaf, and elaborately woven brocades. They may be assembled with batiks from Java or with imported fabrics, in the most improbable, incongruous, yet still charming combinations that only the Balinese can affect.

Figure 100

They also clothe their temples for special occasions, fly tall banners, bedeck cremation towers with precious cloths, and regularly gird up the loins of the stone temple guardians. In addition, they periodically return the sacred gift of textiles in the form of offerings at their temples, continually renewing the cycle of obligations and favors in which they and their gods participate.

Figure 32

Beyond this visual feast, there are other reasons to look carefully at the textiles of Bali. This small volcanic island, barely two miles from Java, has historically been subject to the major courts of Java since before the tenth century.[2] With a few intervals created by bloody warfare, the Javanese and Balinese shared a history until the fifteenth century, when the forces of Islam brought an end to the Hindu kingdoms of Java. A number of Javanese then fled to Bali, where today their descendants maintain at least a legendary identity, but in practice have been totally assimilated into the culture. Bali herself remained independent of Java and Islam, prospered, and sought to colonize Lombok and Sumbawa—the neighboring islands to the east—in the eighteenth century. This independence was terminated by the Dutch, who conquered Bali in the first quarter of this century.

Bali thus may be seen as a repository of not only its own arts, but those of Java as they existed in the pre-Islamic fifteenth century. Because of this, what is not there raises interesting questions—for example, how to explain the absence of batik? This resist patterning procedure has never been a part of the Balinese textile tradition, which suggests that it was not a prevailing decorative technique on Java until

100 *A Balinese dancer wears a cloth decorated with applied gold leaf, and about her torso, a plangi patterned textile. Such elaborate costume is now worn primarily by dancers and major participants of ceremonies. (Mattiebelle Gittinger, Washington, D.C.)*

140 101 **Kain prada**
Bali
Gold leaf
Silk
Warp 150 cm, weft 72 cm
Volkenkundig Museum "Nusantara"
Delft, Delft 371-1 (not exhibited)

*The art of decorating textiles with applied
gold leaf is still practiced in Bali, thanks
to the demands of sacred and secular cus-
tom. The craft extends beyond the textile
field, being practiced on leather as well.
Both these materials are decorated with
gold leaf to make objects used or burnt as
offerings in funeral rites. Certain dance
and theatrical costumes include gold-
worked leather collars and long bib-like
elements. The textiles are used at special
festivals, and at personal ceremonies such
as weddings and tooth filings, but are
most frequently seen as part of the
dancer's costume.*

*This particular cloth was made on Bali
for the administrator Kat Angelino. It is
one of a pair of textiles belonging to him
that were acquired by the Delft Museum.
The fabric displays a stark contrast of
gold on a black background. Today the
background colors are usually purple,
green, or red.*

after the strong relationship between the two islands ceased. The Balinese textiles that do exist include a range of other techniques.

Figure 101 Of potentially great interest are the cloths on which the designs are worked with gold leaf—the *kain prada*—but little study has been done on the designs of these textiles, possibly because their slight gaudiness inhibits scholastic enthusiasm. The technique, however, is a comparatively simple manner of patterning by gluing gold leaf to the surface of either textiles or leather. It probably has antecedents in stencils or cutout designs known elsewhere in the archipelago, as well as some relation to the largely ignored appliqué designs found on costume and ceremonial hangings in Nias, Sumatra, Borneo, and the Celebes. On Bali, the gold is applied in large, sinuous patterns to plain colored silks, or simply follows the patterns already found on Javanese batik. Items such as the woman's shoulder cloth, belt, and hip wrapper, and the man's wrapper and headcloth may be enhanced with gold. These

Figure 100 cloths, while most frequently associated with dancer's costumes, are still worn by important persons at tooth filing and wedding ceremonies. Others are hung on temple exteriors for special occasions, or burnt at cremations.[3]

In style, many of the gold flowers (principally lotus), vines, and scrolls recall the island's decorative woodcarving; and it is not surprising to learn that men are the principal, though not the sole, prada workers.[4] In the customary segregation of labor in Indonesia, textile work falls to women; but here the association with metal, traditionally aligned with men's labor, somewhat obscures the classification (stencils and cutout appliqués elsewhere also circumvent the work segregation pattern).

In addition to the floral elements of the prada, there are geometric shapes of diamonds, angular scrolls, and swastikas forming borders and decorative edges. These textiles quickly show wear from the creasing of the gold and, of course, cannot be cleaned.

Figures 102, 103 Of slightly more durable substance are the textiles patterned by supplementary wefts. These decorative wefts are of gold- and silver-wrapped yarns; they are woven on a foundation of brilliantly colored silk to make the cloths called kain songket. They show stylized floral and geometric patterns or, more rarely, complex figural compositions of wayang-styled forms.[5] The most admired examples of this technique have traditionally been made by women of the highest castes, and it is generally termed an aristocratic art.[6] Kain songket are still made today by a few women associated with former princely courts.[7] Balinese supplementary weft patterning was not all glitter. At least at one time, weavers dyed simple cotton yarns in rich somber tones and joined them with artistic skill to produce textiles with subtle visual movement and sophistication.

Figure 104 Control of color, density, and line to create motion on the surface of the cloth is also evident in certain textiles patterned by weft ikat. Such a form as the swastika could be made to pulse in the hands of a master. More commonly, however, the method was used to create simple bands of geometric designs that might alternate with woven patterns, or to imitate the designs worked in the more complex technique of double

102 Kain songket
Bali (?)
Supplementary weft
Silk, silver, gold metallic yarns
Warp 152 cm, weft 138 cm
The Metropolitan Museum of Art, New
York 65.13.2. Gift of Mrs. Morton Baum

*The contrast between these two textiles
is indicative of the range of variability
that the Balinese weavers could effect in
a single technique. The silk example from
The Metropolitan Museum of Art collec-
tion is typical of what is termed kain
songket. This is a supplementary weft, or*

*weft brocade, usually worked in metallic
yarns on a red silk base. The designs are
varied, ranging from networks of stylized
floral patterns to renderings of mythologi-
cal figures. These textiles are the gar-
ments most favored for ceremony and
dance.*

*In contrast is the similarly worked
cloth from the small offshore island of
Nusa Lembongan. Here blue and reddish
brown supplementary yarns interact with
the natural beige yarns of the foundation.
The colors alternate in horizontal bands,
resulting in a visual pulsation made elec-
tric by the more densely patterned zig-*

103 Cloth section (use unknown)
Nusa Lembongan
Supplementary weft
Cotton
Warp 131 cm, weft 91 cm
Museum voor Land- en Volkenkunde,
Rotterdam 25581 (Detail illustrated)

*zags. The textile shows a simple mastery
of the interrelationship of color and line.
It draws on completely different artistic
principles for its effects than the silk tex-
tiles, which rely almost entirely on the
splendor of the gold for bold-faced
patterning.*

104 Breast wrapper or shoulder cloth
Bali
Weft ikat
Silk
Warp 300 cm, weft 51 cm
The Brooklyn Museum, Brooklyn
45.183.91

The Balinese penchant for bold color and design motion appears again in this weft ikat. Here the red arms of swastikas are extended into pulsating lines reinforced by vibrant white margins. This creates a maze-like center zone that is held within bounds by the static, angular scrolls in the margins. The design exemplifies the Balinese talent for elaborating design within the confines of the weft ikat technique. The weaver does not allow the weft to dictate the design direction; rather, the designs flow visually in the warp direction—even in this medium, which lends itself to weft stripes.

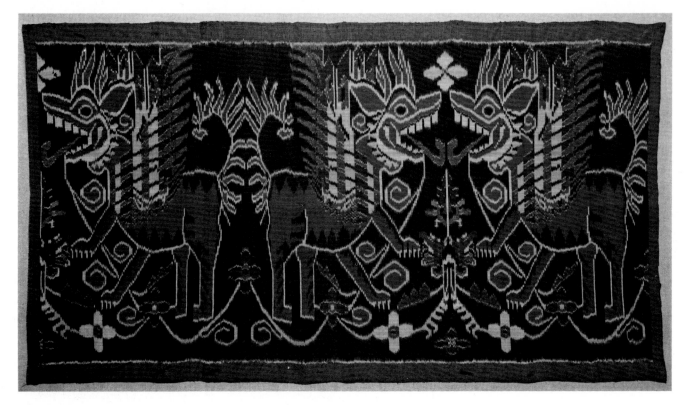

105 **Kamben** (wrapper)
Bali
Weft ikat
Silk
Warp 113 cm, weft 61 cm
Museum of Fine Arts, Boston 30.808.
Maria Antoinette Evans Fund

In addition to geometric and floral forms, there are lively figural compositions in the weft ikat of Bali. Most often these portray wayang-styled figures in paired confrontations. Here the singa, *the lion of Hindu mythology, is the subject. While this motif has become totally assimilated to Balinese design, the slightly raised stance of the front legs in this particular example suggests some design interbreeding with the rampant lions of Dutch heraldry. The animals are rendered in a brilliant red with blue and green detail on a dark reddish purple ground.*

Javanese batiks and other imported cloths now fill the Balinese markets, but locally crafted textiles still remain the essential garments of ceremony and dance.

Figure 105

Figure 106

Figure 107

ikat. It could also be turned to create striking figures drawn from Hindu mythology and the wayang theater. Executed in red, green, yellow, purple, and blue these are delightful and imaginative designs.

A completely different type of weft ikat was worked on cotton on the small offshore island of Nusa Penida. Called *kamben cepuk*, these textiles were used on Bali as special clothing, but now more commonly serve as temple decoration.[8] Their design and organization, including the dyes, which are a deep red, imitate the elements of Indian patola textiles.[9]

Most weft ikat pieces are used as clothing or as temple decoration and, with the exception of those from Nusa Penida, exist largely in the secular domain. There are, however, a small group of less well-known textiles that appear to have been completely sacred in function. *Bebali*, the name generally ascribed to them in museum records, are balanced plain weave cottons that have both weft ikat and some evidence of overpainting. The weave is broadly spaced, giving the textile a delicate gauze-like consistency. This gentle quality is matched by a dye palette built on pastel shades of blue, pink, and brown—all complemented by the natural beige of the unbleached cotton yarns themselves. The

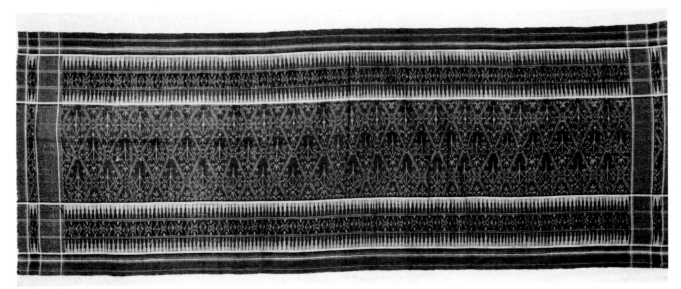

106 **Kamben** (wrapper)
Nusa Penida
Weft ikat
Cotton
Warp 220 cm, weft 79 cm
Textile Museum, Washington, D.C. 67.36

The weavers and dyers of the island of Nusa Penida are some of the few in Indonesia who make cotton weft ikat (normally weft ikat is paired with silk yarns, and cotton with warp ikat). On this small island off the shore of Bali, the technique is used to make textiles that are virtual imitations of Indian patola. They show the same framing elements and many corresponding design details, but lack the luxurious texture of the silk imports. Nevertheless, these somber cloths were held in great esteem by the Balinese, and were used as garments for royal audiences and temple decorations.[16]

This textile is predominantly a brick red, with small areas of blue and patterns in the natural beige of the cotton yarns. Often the dyes of the Nusa Penida textiles are somber, verging on a muddy brown.

designs in the borders are staggered or zigzag lines; in the center field, there are rows of interlocked hexagons that form a well-ordered honeycomb pattern, seldom seen in ikat. The color alignment among the hexagon designs is the same in the warp direction, which creates visual warp stripes rather than the expected weft stripes commonly found in weft ikat. These ambiguities accentuate the unusual nature of these textiles. What is known about them comes entirely from records in the Museum für Völkerkunde und Schweizerisches Museum für Volkskunde Basel. One example is described as an offering cloth used at death ceremonies, and others as offering cloths and clothing for one of the gods. This type of cloth, therefore, seems to be a token textile for ritual uses, without any mundane function.

Figure 108 Of a different technique, but even more rare than the bebali, is a small group of textiles called *lamak*. These long, narrow textiles, patterned by supplementary warp, are used as hangings before shrines.[10] They are in imitation of the long banners—often up to six meters— that are traditionally flown from gigantic bamboo poles before the gates of houses and temples at the Balinese festival of Galungan. These banners are made of lontar palm, but their designs are similar to those on the cloth lamak, in that both types show the stylized figure of a woman, possibly the goddess of rice and agriculture, followed by a long expanse of geometric designs.

Other groups of textiles once made on Bali are not so unusual. One group consists of cotton slendang-length pieces with openwork (ajouré).

107 **Bebali** (sacred cloth)
Bali
Weft ikat
Cotton
Warp 127 cm, weft 50 cm
Textile Museum, Washington, D.C. 67.8
Few of these textiles exist in Western col-
lections, and little is known about their
manufacture or use. Of those that are

available for inspection, most are too
small to function as clothing pieces,
whereas others are long enough to be
slendang or breast wrappers. Both large
and small textiles are too loosely woven
for practical use; they are probably token
textiles with symbolic functions. One
museum record says they were used as
offerings at funerals.

The soft dye tones are also a character-
istic of these textiles. Here there are two
shades of tan, cream white, light blue, and
black. Other bebali are worked in soft
browns and pinks. These colors are used
with weft ikat to form simple geometric
designs in a pattern network. Details are
often reinforced with surface painting.

Figures 109, 110, Cover

These, too, may have had a sacred connotation, for they were worn by women at cremation ceremonies,[11] but they also served as slendang and breast wrappers on other, less important occasions. The Balinese also make bright plangi textiles for their own use; but many of the modern fabrics are garish items intended for the tourist trade.[12]

The most renowned of Bali's textiles are the geringsing—double ikat patterned cloths made only in Tenganan Pageringsingan. Brought to the world's notice in the first part of this century,[13] the cloths have since tantalized ethnographers and historians, causing as much myth to be propagated outside of Bali as within. Some of the problem arises because these textiles, while made only in Tenganan Pageringsingan, are used elsewhere on Bali in connection with slightly different customs. Within their home village they are the most important of the pre-scribed cloths for rituals and ceremonies, and are worn by both men and women.

Although they have general names, the types of geringsing are also recognized according to the number of warp stripes.[14] The simplest and narrowest has fourteen stripes in the warp, but more complex examples have as many as forty-three. The completed textile has a circular form because it is made on a back-tension loom utilizing a continuous warp structure. For most uses, this tube is cut open to form a flat rectangle. Certain costumes—and even ceremonies—however, depend on the original form of the textile for ritual appropriateness. Thus the narrow fourteen-stripe cloth is worn by men and boys as a tubular belt or as a long wrapper hung around the neck. In a cut form textiles with the same design are employed by women and girls as breast cloths.

108 Lamak (temple hanging)
Bali
Supplementary warp
Cotton
Warp 163 cm, weft 36 cm
The American Museum of Natural History, New York L1978.18.4

Lamak are tall banners that are flown from high poles or suspended from shrine or altar fronts on important festivals. Great numbers of them are used, particularly at the Balinese New Year festival, Galungan. Most commonly they are constructed from cut-out and applied palm leaves, and are quite perishable. Only rarely do more permanent ones woven from cotton appear, as this example. Here the designs are worked by very thick bundles of white supplementary warp yarns on a finer blue foundation structure. Although the material and structure may differ, the designs on lamak are similar. A large hourglass figure appears at the top. Immediately below this is often a stylized figure of a woman, here represented only by the shape of her triangular skirt. Below this is a long field of geometric designs, ending in a row of tumpal.

109 Geringsing
Bali, Tenganan Pageringsingan
Double ikat, embroidery
Cotton
Warp 197 cm, weft 62 cm
Mattiebelle Gittinger, Washington, D.C.
(Frontispiece)

This floral geringsing pattern appears on textiles of variable widths, which could be worn as wrappers around the hip or breast. Like all double ikat, it is a rich, reddish purple with designs in beige. A more intense coloration outlines certain contours, optically projecting the figures forward in the design field. This lends a visual interest to the textile more complex than simple surface patterning alone.

The nuances and precision in color are crucial to the ritual value of these ceremonial textiles in the village where they were made. The subtle coloration is achieved by an incredibly long and complex dye process. First the yarns are soaked and kneaded in oil and ash solutions for forty-two days, then hung to dry for a similar period. This chemically prepares the yarns for later red dyeing, and also endows them with their rich beige or ecru tones. After careful measuring and tying of the warp and weft designs, the yarns are sent to the neighboring village of Bugbug to be dyed dark blue, because indigo dyeing is forbidden in Tenganan Pageringsingan. When they are returned, more of the resists are cut away and the yarns dyed red. This overdye process gives the reddish-purple colors with their shadowed accents. To obtain the deep tones demanded, however, the dyeing must be repeated in a cycle of immersions in the dye baths and drying, with exposure to the night dew—a process that continues for five to eight years.[17]

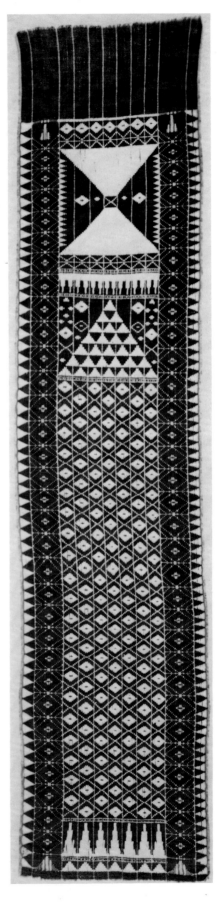

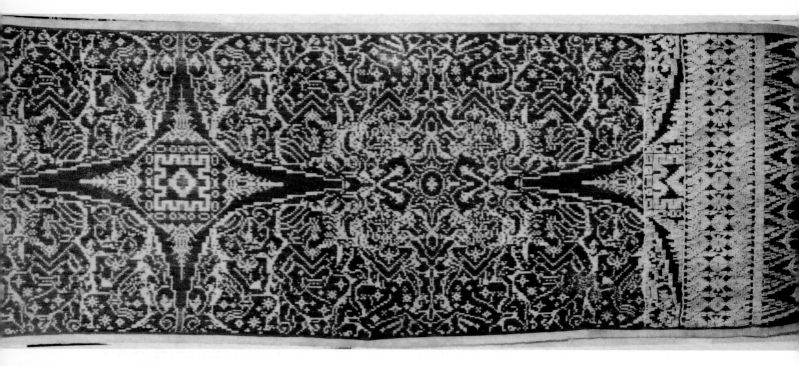

110 Geringsing wayang kebo
Bali, Tenganan Pageringsingan
Double ikat, embroidery
Cotton
Warp 226 cm, weft 56 cm
Textile Museum, Washington, D.C. 67.33
(Over one-half illustrated)

The correlation between certain designs on the double ikat of Bali and those on the similarly made patola of India points to an historical linkage between these two areas. Besides these derivative designs, however, there is a type of geringsing textile unique to the Balinese, called geringsing wayang kebo. This portrays human figures in a style resembling that of the traditional shadow puppets and

thirteenth- and fourteenth-century Javanese temple reliefs.[18] Through the artistic conventions of these other media, an attempt has been made to interpret the scene that appears on this textile.

Here, within the quadrants created by the four-pointed star, three people form groupings. In these a person with a large wrapped turban sits slightly higher than the others and places his hand on his hip in a traditional gesture of superior rank. He is thought to be a male priest because of his headgear. Seated somewhat lower are two women, one of whom raises her hands in reverence, while the other uses an arm position more frequently associated with portrayals of "noble ease." According to one expert, these attitudes

suggest an audience between a priest, his wife, and a devotee.[19] There are other geringsing with different arrangements of figures, but their significance too remains conjectural. All these textiles must have been intended for the sacred realm, however, for their manufacture was accompanied by a unique purification ritual.[20]

This textile is a dark, reddish purple with designs outlined and detailed by the tan color of the reserved yarns. Embroidery yarns are worked over the ikat designs in the end panels. In the village where these are made, they are prescribed clothing at religious rites, and are worn by women as breast wrappers or as shoulder cloths.

Twenty-four-, thirty-seven-, and forty-two-stripe textiles were usually sewn in pairs to make large body wrappers.

The designs on the textiles may identify certain groups, but apparently do not affect the ritual usage of the textiles as much as other qualities. Their efficacy is more strictly aligned with the quality of the dyes, and those not appropriate are sold out of the village. When properly executed, the cloth is considered a protection from illness and harm in general.

When they are used elsewhere on the island, geringsing are honored as the most sacred of all Balinese cloths. They form the head rest at tooth filing ceremonies, and encircle the bride and groom at weddings. Fragments are used in curing rituals, and entire textiles are hung from temples and cremation towers.

Visually, the cloths are immediately similar. They are all a natural tan cotton dyed somber earthen red and purplish black. On inspection, their differences become more apparent. Most have geometric or stylized floral designs arranged within a grid format. These, together with a few compositions with human figures, make a total of approximately twenty different basic designs. The style of the human figures has been compared to thirteenth- and fourteenth-century temple reliefs on Java, which suggests that these sacred and technically complex textiles may once have been woven on that island as well. One early writer records Balinese traditions that say these textiles were made in the Javanese kingdom of Majapahit.[15]

The origin of this technique as it is practiced on Bali is unknown. Certainly there is a strong relationship with the double ikat textiles made in Gujarat, India, not only in the complexity of the technique, but in certain design correspondences. By what means the knowledge might have been transferred to the Balinese, however, is not known.

To an outsider, Balinese life seems to be a celebration with intervals. This marvelous illusion is continually reinforced by chance encounters with a gift-laden procession, a decorated gate, or a small cluster of offerings by the side of the road. Costume for man, his gods, and his temples is part of this display. The Balinese once excelled in these arts to such an extent that they were famous for their export of red yarns, sarong, and slendang to other parts of the archipelago. There is still some suggestion of the ancient splendor, particularly in the costume of the dance, but it is evident that Bali's weaving and dyeing traditions have sadly declined.

NOTES

1. Soekawati 1926:5
2. Covarrubias 1965:26-28
3. Moerdowa 1973:52, 54, 60, 66, 78, 80
4. Loebèr 1914:48
5. Langewis 1964:113
6. Pelras 1962:230
7. Ramseyer 1977:71
8. Pelras 1962:219
9. Holt 1970:77-78 gives additional textiles woven on Nusa Penida.
10. Langewis 1956
11. Pelras 1962:228
12. Ramseyer 1977:71
13. Nieuwenkamp 1906-1910:206
14. Technical material derives from Ramseyer 1975:51
15. Nieuwenkamp 1906-1910:210
16. Pelras 1962:219
17. Ramseyer 1975:62
18. Ibid.:55
19. Ibid.:67-68
20. Ibid.:52

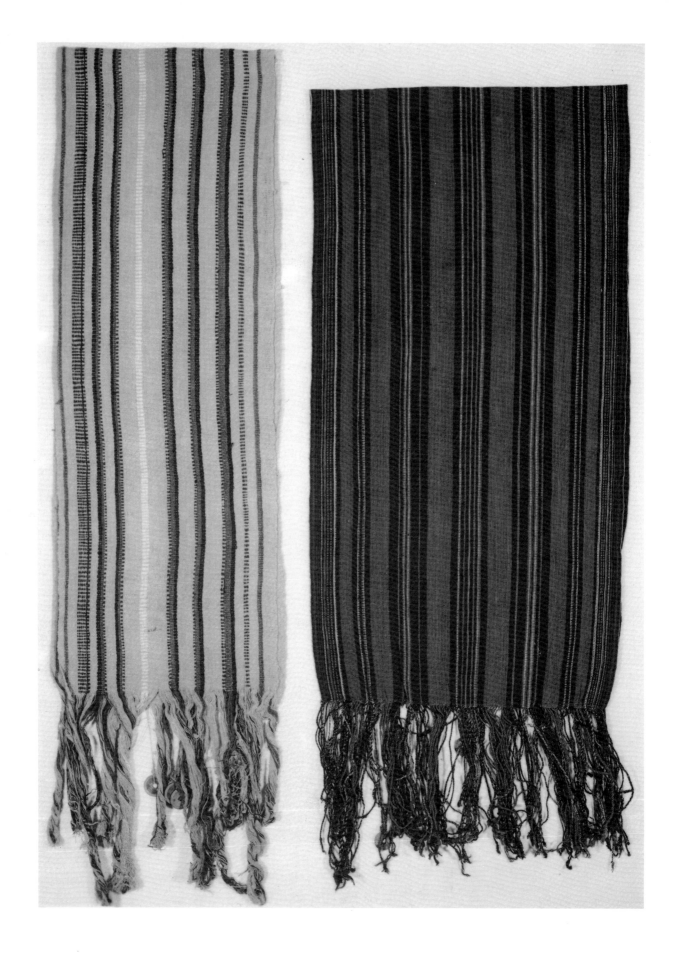

LOMBOK

The textile heritage of Lombok includes extremely modest cotton textiles that are sacred in nature. Visually they are unassuming, being made of coarsely spun fibers joined in a loose plain weave and bearing ornamentation of simple stripes. Some of these cloths were used in haircutting and naming ceremonies. In the course of these rites the circular warp yarns were severed, and the ends dipped in water to anoint the young boy or girl. Such textiles retained a sacred nature and were considered especially efficacious against illness.

Certain religious ceremonies accompanied the laying out of the warp, the weaving, and the first use of the cloth.[1] The work could only be begun on Mondays and Thursdays in certain months. Offerings were made to the warping frame, and at various stages until the circular form was finally cut by a religious functionary.[2] Other sacred cloths were made with similar ceremonies.

One textile shown here is red with black and white stripes, and the other is yellow with stripes in brown, black, and light yellow. In the fringes are old Chinese coins, which were worn by the boy or girl in the ritual and then tied into the warp yarns before they were cut through.

Lombok weavers using another type of loom—one with a discontinuous warp—also wove cotton sarong, slendang, and headcloths with stripes or plaids as decoration.[3]

111 **Kombong** (sacred cloth)
Lombok, Sasak people
Plain weave
Cotton
Warp 190.5 cm, weft 39 cm
Ruth Krulfeld, Washington, D.C.

112 **Kombong** (sacred cloth)
Lombok, Sasak people
Plain weave
Cotton
Warp 81 cm, weft 28 cm
Ruth Krulfeld, Washington, D.C.

NOTES

1. Bolland and Polak 1971:159
2. Ibid.:159ff
3. Bolland 1971:175

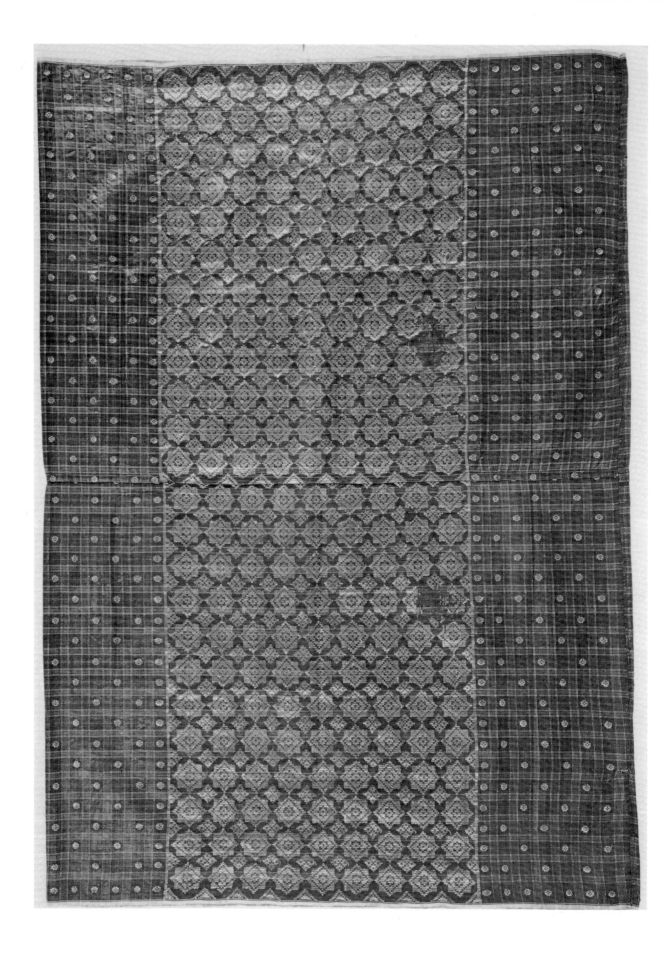

SUMBAWA

The island of Sumbawa was touched historically by Java in the Majapahit period, and in the early seventeenth century by conquerors from Makassar. The latter group are probably responsible for the sarong most commonly known here, called tembe or *kere*.[1] This is a cotton plaid of assorted bright colors that occasionally carries small patterns in supplementary yarns within the squares. It is constructed of two woven panels, which are joined and seamed to form a tube. The example shown here is exceptional, both for the high quality of the textile and for the quantity of metallic yarn used. These factors lend credence to the supposition that it was part of the Sultan's wardrobe about 1925.[2] It is a highly polished red and purple cotton plaid, with silver yarns forming supplementary weft patterns. Metallic yarn has also been used as a regular weft element, repeated about once every two centimeters, and this lends added glitter to the polished cloth surface, whose shine was created by rubbing the highly starched sarong with a seashell (a technique also practiced in Makassar).

The other two pieces from Sumbawa are shoulder cloths termed salampe or *pebasa*.[3] Their hallmark is the tapered point in each end of the center field, which is created by a tapestry weave. In this technique regular wefts of different colors meet, interlock, and reverse their direction to form solid color blocks. The margin between the two color areas in the shoulder cloths may be a precise, stepped motif or a more casual staggered line. Usually the tapestry technique is continued along the lateral margins of the center field to form a row of tumpal.

The first of these shoulder cloths, that from the Frankfurt collection, is a brilliant yellow and black textile in virtual mint condition. It was collected by J. Elbert on his scientific mission to the archipelago in the first decade of this century. In this example, the stripes in the framing borders have a repeated geometric figure formed by gold supplementary weft yarns. This is true even in the warp-directed stripes, where the metallic yarns are worked back and forth as decorative weft elements.

113 **Tembe** (sarong)
Sumbawa
Supplementary weft
Cotton, metallic yarn
Warp 164 cm, weft total 118 cm
Nigel Bullough, Sussex

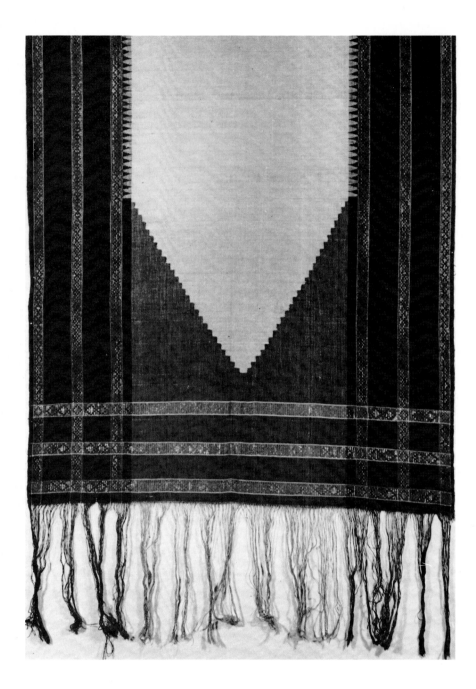

114 Salampe (shoulder cloth)
Sumbawa
Tapestry weave, supplementary weft
Cotton, metallic yarns
Warp 236 cm, weft 69 cm
Museum für Völkerkunde, Frankfurt
NS15382 (one-half illustrated)

The Metropolitan Museum of Art textile has a red center and blue-black flanking margins. The tapestry joins in the center field to create a zigzag line, and there are no tapestry-weave tumpal along the sides. Rather, silver supplementary weft yarns create the triangles along these borders, as well as the pattern of small floral forms that dot the surface.

Use of tapestry weave to form the large hexagonal shape in the center of the cloth is unique to Sumbawa. The technique is used infrequently elsewhere in Indonesia for small tumpal details. The hexagonal shape on this textile is strikingly similar in effect to the central lozenge found on the kain kembangan of Java. The Java cloths, whose larger center pattern is made by a tritik resist, are old and of a sacred

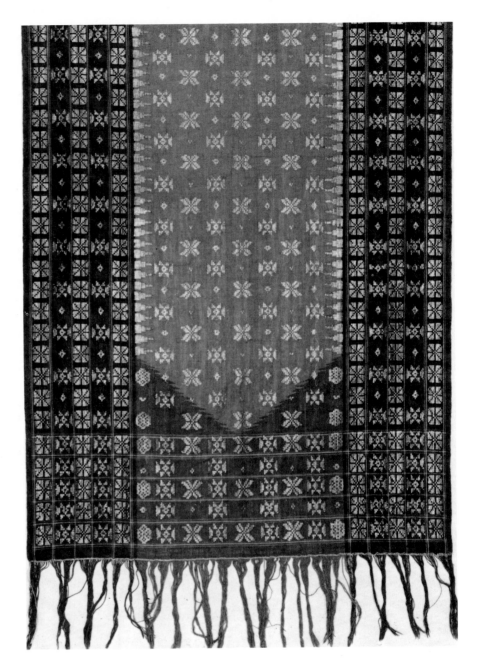

115 **Salampe** (shoulder cloth)
Sumbawa
Tapestry weave, supplementary weft
Cotton, metallic yarns
Warp 213 cm, weft 94.5 cm
The Metropolitan Museum of Art,
New York
65.38.6. Gift of Mrs. Delia Tyrwhitt.
(one-half illustrated)

character. It is conceivable that early contact between Sumbawa and Java gave rise to this type of patterning.

In Sumbawa the textiles are used as shoulder cloths and head wrappers by women, and as a wrapper worn about the waist by men.[4]

NOTES

1. Jasper and Pirngadie 1912:229
2. Personal communication Nigel Bullough, Pulborough, Sussex 1978
3. Jasper and Pirngadie 1912:229
4. Ibid.:230

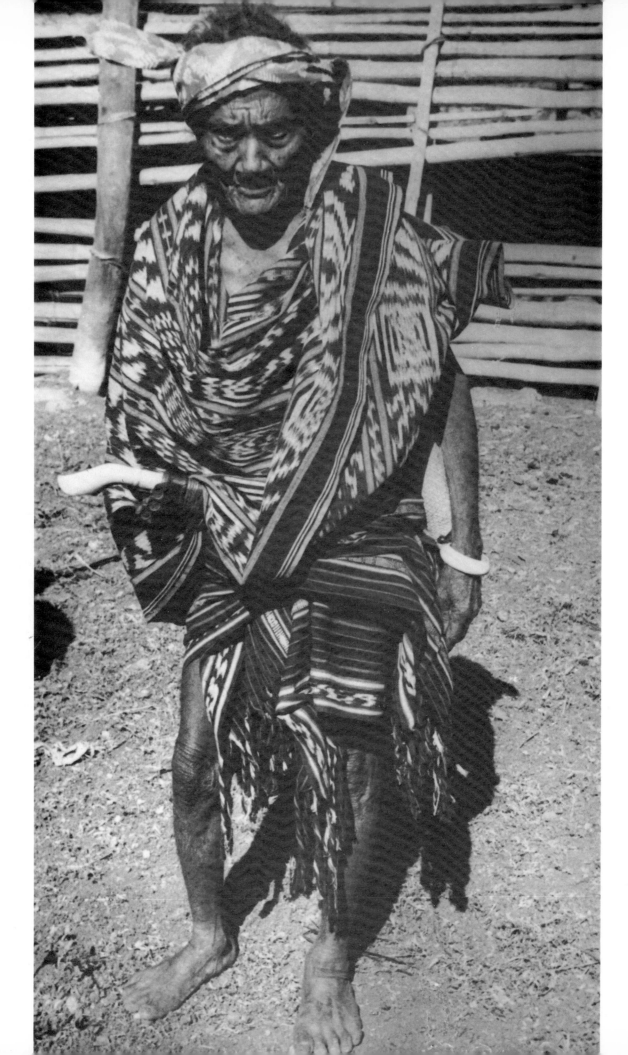

SUMBA

A hundred years ago the Dutch were already exporting textiles from the island of Sumba. The large, bold patterns and rich dyes have consistently enticed Western buyers, and hundreds of the textiles have found their way into Dutch homes as curtains and bedspreads, and more recently, into the ownership of civil servants, textile collectors, and fabric designers all over the world.

The appeal derives from the immediate visual impact of the large forms and their engaging variety. These very qualities place them in contrast to other textiles woven in Indonesia, and also pose unanswerable questions. Within the matrix of the identical technique of warp ikat, using the same basic blue and red dyes, how was this group of weavers able to break the confines of warp stripe patterning that dominate so much textile design in Indonesia? What was the stimulus that gave rise to such a dramatically different expression? How did these weavers escape the suffocating confines of the patola, adapting from that Indian source only a few features for their own needs?

The great numbers of these textiles still circulating speak for the prodigious work of relatively few women, because most Sumba textiles have been and still are produced only in the coastal districts of the eastern part of the island.[1] Many cloths were made for export, but an even greater number were made for use in the continual exchange of goods with people from the interior of the island, where by custom the process of ikat was forbidden. The exchanges were of two kinds: those that bartered textiles, metal imports, salt, fish, and luxury items from the coast for agricultural products of the interior, and those in which the representatives of bride-givers and -takers met to exchange the adat-prescribed gifts of textiles for precious ornaments and horses. Textiles were the economic counters on these occasions, and sizeable quantities were always needed. However, the main sources of these decorated cloths were the households of noble rulers. Only they could command the resources of materials and labor to produce the vast stores that were necessary to dress their families and retainers for great occasions and to meet the inevitable adat commitment that demanded an exchange of

116 *A man from Kodi, West Sumba, wears the paired blue and white hinggi or hanggi as the cloths are called in that region. One cloth is wrapped about the loins and another about the shoulders. (Museum für Völkerkunde und Schweizerisches Museum für Volkskunde Basel, Basel)*

117 Hinggi (man's mantle)
Sumba
Warp ikat
Cotton
Warp 264 cm, weft 128 cm
Museum voor Land- en Volkenkunde,
Rotterdam 19892
(Approximately one-half illustrated)

This is one of the many textiles collected by the first Christian missionary to the Sumbanese, G. K. Wielenga. Because of the certainty of the collecting dates, between 1904 and 1912, his material, now in the ethnographic museum in Rotterdam, is an important research source. This example is typical of textiles from this period, which are characterized by the limited number of horizontal bands, the use of the same design in the first and third bands, and the woven border.[9] The figures in the main design band are marine shrimp, viewed from above, which alternate with living tree forms. It is possible that the tree is the kapok, because "kapok has horizontal branches and flowers similar to this design, with a floral envelope on a little leafless stem. In bloom the plant is leafless."[10] Several types of birds appear in the bands above and below these major motifs. In the center field there are short bands filled with stripes, an unusual selection for this area, since much more complex elements are common. Within this composition, however, these vertical stripes, echoed by the stripes in the body of the shrimp, pleasingly contrast with the static quality of the horizontal bands.

The entire cloth is extremely colorful, with red from the khombu dye, deep blue, and an unusual amount of tan surface staining in the bodies of the shrimp and the flowers of the tree.

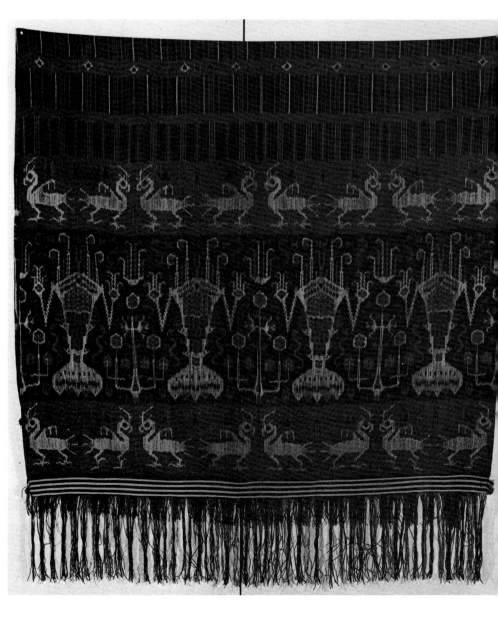

textiles and goods at all meetings and festivals. Nobles were also faced with the need to lay up great stores of textiles; indeed the finest examples were for their funerals, when quantities of fifty to one hundred might be interred with the corpse, and others given to many of the hundreds of guests who would attend.[2]

Figures 117-121
Figures 122-124

The textiles used in the adat exchanges and rituals are the man's *hinggi* and the woman's *lau*. Hinggi are large warp ikat-decorated mantles made in identical pairs. One of the textiles is wrapped about the hips, and the other goes over the shoulder. For commoners' textiles, only a blue dye is used, leaving great white figures in bold relief on the dark ground. These cloths tend to lack complex forms and composition. When destined for the nobility, the textiles are larger and use a range of deep colors, including a red dye, and complex patterning arranged in horizontal bands. This may include a selection of motifs traditionally

reserved for the ruling class. The ends of these more luxurious textiles are often finished by a decorative twined or woven border and with plied and twisted fringes. The woman's lau of parallel rank is a tube with designs worked by supplementary warp, or figures outlined by beads and shells. In the former, the tubular form may have a band of ikat designs.

While many designs used on these textiles are also subjects found in other media in Indonesia, their Sumba rendering often seems to have a local referent. There are horses, deer, snakes, fish, inkfish, turtles, scorpions, shrimp, and plants, as well as birds such as the heron, cock, wild chicken, cockatoo, and hawk. All these elements may be found in the Sumbanese environment. Other forms specific to Sumba culture are gold ornaments worn in ceremonies, and the skull tree—a specially cut tree on which the heads of those captured in war were hung. Forms of living trees and humans are also present on the cloths.[3]

Foreign sources appear in configurations of dragons taken from Chinese ceramic ware and Western motifs such as cupids or bicycle riders. Also recognizable are rampant lions derived from the Dutch coat-of-arms. This heraldic sign appeared on medals and flags that Dutch traders gave to Sumbanese rulers as objects of prestige and marks of trading-partner status. Design features from these were then incorporated into hinggi as evidence of this privilege.

The significance of these designs and the textiles themselves can only be understood in the context of traditional Sumbanese life. At one time decorated textiles were solely the right of the nobility. They were seen only at great festivals, where they were worn by nobles, their families, and their retainers as a sign of the prosperity of the ruler, which was concomitant with the wealth of the total society.[4] The motifs are a visual statement of images that relate to a "universe of concern," and these are the integers in the sum that constitutes the physical and social world of the Sumbanese. Important ceremonial occasions reaffirm the working of this universe by the wealth and vitality that are displayed.[5]

Sumbanese textiles have many of the same ritual properties as local textiles elsewhere in the archipelago. For example, they create totally new symbols when combined with other objects; thus the great stone dragged to mark the grave of an important noble becomes a ship conveyance when two large hinggi are mounted on it as sails.[6] A newly completed house temple is consecrated, and its ship image completed with the aid of textiles.[7]

The role of textiles in symbolic costume is most striking on this island. When a great noble dies, a slave dressed in the deceased's decorated garments rides his horse to the gravesite. In the ceremony he represents the dead man beginning his journey to the other world. After the ceremony, the slave is considered a free man. On a quite different occasion, a royal wedding, the name-servant of the bride, called for the occasion *ana mamoha*, "the decorated one," is dressed as the bride. It is she who is captured by the groom's party and made to endure the long hours of sitting in state during the ceremony in the groom's village, while the actual bride is free to come and go.[8] In both these instances the investiture is the enabling instrument. It is because they wear the

Figure 120

118 **Hinggi** (man's mantle)
Sumba
Warp ikat
Cotton
Warp 289.5 cm, weft 142 cm
Textile Museum, Washington, D.C. 68.1
(Color plate)

This is an excellent example of Sumbanese design and composition, with closely spaced, intricate forms. Human figures alternate with trees in the first major design band, and deer eat from a plant in the second. In between are confronting bird figures. The rhythmic interplay of arching limbs and arms, as well as the echoed forms of deer antlers and curving branches, create pleasing sympathetic motion. These figures are a light color, contrasted by either a rust or deep purplish brown ground, while the geometric netting in the center band is built up from rust, blue, and the natural tan of the cotton.

Designs like the complex netting of the center are called patola ratu. *They probably originate in Indian textiles. In certain regions of Sumba they were reserved for the use of the ruler.[11]*

The significance of the other design elements is subject to speculation. Possibly the human forms refer to royal slaves, and the deer to sacred hunts, which only wealthy men could sponsor. All the designs, however, have their referents in the world controlled by the nobility, and originally these multiple colored cloths were theirs alone to wear or loan.[12]

159

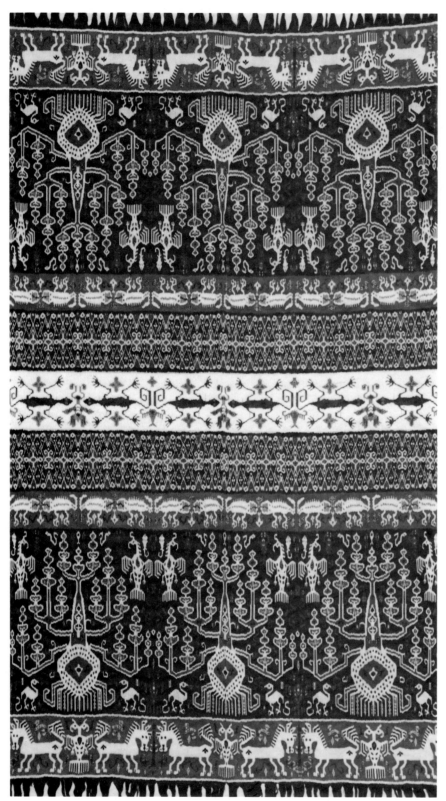

119 Hinggi (man's mantle)
Sumba, Kanatang region
Warp ikat
Cotton
Warp 243 cm, weft 136 cm
Museum für Völkerkunde und
Schweizerisches Museum für Volkskunde
Basel, Basel IIc 8696

Comparison of this textile with the two preceding examples of hinggi illustrates how some textile types changed character in the first half of the century. The two major design bands in each half of the cloth have given way to a single large field, here filled with graceful arching trees. The flanking bands carry different designs, and three bands occupy the center. The most obvious change has occurred in the spatial organization, but there is also an alteration of traditional forms. For instance, horses (lower band) now carry a brand on the flank, and their other details are more realistic. The introduction of colored design elements on a white ground, as in the center band, is also a feature of later cloths. This is done by tying off the background, not the figures, and dyeing the remaining form.[13]

This is a textile of great visual delight. Among the arching tree limbs are birds, snakes, shrimp, and omega-shaped earrings (mamuli) rendered in blue, which have a startling vibrancy on the dark ground. The trees themselves are a brilliant rust outlined in white.

The cloth was collected on Sumba in 1949 by the Indonesian textile expert Alfred Bühler. According to his notes it was made in the Kanatang district, on the commission of a wealthy Chinese merchant in the port of Waingapu for the marriage of his daughter. It is a fine example of the expert craftsmanship that still existed at mid-century.

120 Hinggi (man's mantle)
Sumba
Warp ikat
Cotton
Warp 317 cm, weft 120 cm
Ken Albright and Greg Della Stua,
Toronto
(Not exhibited, one-half illustrated)

In following the course of Sumba hinggi design, this textile provides a recent benchmark. It was made in 1977.[14] The tendency toward a single large field in each half is increasingly pronounced, as well as the use of fewer but larger motifs. As this half of the textile illustrates, the many fine interlocking forms have largely

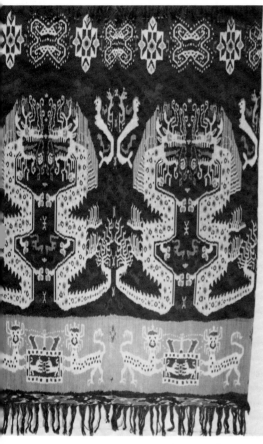

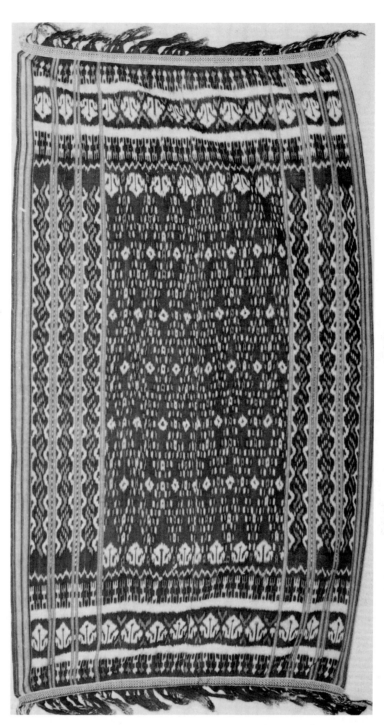

been replaced by a few elements that swirl across the field. All the rest has been correspondingly simplified. In the lowest band two pairs of rampant lions confront a crown, in imitation of the Dutch coat-of-arms—a common motif in Sumba hinggi. Above this are pairs of curling dragons, probably derived from Chinese ceramics, flanked by mermaids and shadowy blue forms of prancing animals. In the center is a row of geometric designs. Among these, the dotted, hooked bar is the karihu design—formerly a royal pattern. Its basic shape has been repeated in the negative space between the paired dragons and again in a modified rendering in the central area between the pairs, giving the whole a complementary harmony. The half of the textile not illustrated is a mirror image of the half shown. Traditionally, a hinggi required more than a year to make because of the time involved in the dye sequence. Using commercial yarns and dyes, this example was completed in six months.

121 **Hinggi or hanggi** (man's mantle)
Sumba, Kodi region
Warp ikat
Warp 251 cm, weft 129 cm
Textile Museum, Washington, D.C. 68.5

The far western tip of Sumba, the area called Kodi, is the other region of the island where ikat-patterned textiles are woven. Here the organization of the design surface is totally different than in the east, being more controlled by the horizontal and lateral framing elements com-

mon to Indian imported textiles. Also these cloths use small design features almost totally of a geometric nature and not large representational forms. An exception to this, though still rendered in a diminutive manner, is the omega-shaped ear ornament, commonly repeated in the borders or in the center field. Here, as is consistent with all Kodi pieces, the ikat figures are white on a lively blue ground, with occasional areas of brown.

162

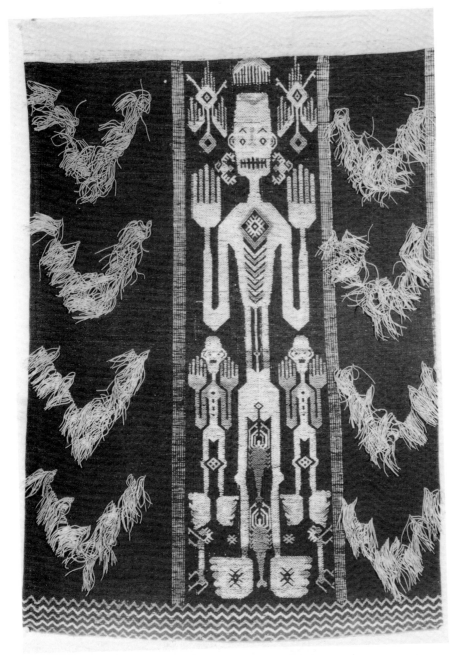

122 **Lau pahudu** (woman's skirt)
Sumba
Supplementary warp, tufted embroidery,
surface staining
Cotton
Warp 114 cm, weft 164 cm
Tropenmuseum, Amsterdam A5244

Many of the same motifs that occur in
the man's hinggi reappear in the woman's
skirt, or lau. The range of decorative tech-
niques in the skirts, however, is greater
than ikat alone. It includes designs
worked by a supplementary warp, em-
broidery, application of beads and shells,
and exotic tufting with supplementary
yarns. Occasionally these are coupled
with bands of warp ikat, but in most in-
stances the dominant designs are carried
in the other techniques. There are, in
addition, lau with only narrow ikat-
patterned stripes.

Supplementary warp patterning is
rarely made in Indonesia, because it is a
complicated task to execute on a back-
tension loom. Not only must means exist
to raise the proper combination of warp
yarns to make the pattern, but the ten-
sion on these supplementary fibers must
be adjustable in a manner independent
of the foundation yarns.[15] Sumba weavers
solved these problems, obviously to great
effect, and created a design inventory of
trees, birds, and humans. These figures
appear in light yarns on a dark back-
ground of blue or black. Details on the
surface are stained with tan after comple-
tion of the weaving. Such skirts, worked
with supplementary warps, are called
lau pahudu.

Lau hada is the name for skirts
worked with shells and beads. They are
important parts of the bride's dowry.
These skirts are also known as pakiri
mbola, which means "at the bottom of
the basket," and refers to the way these
cloths are carried when brought as part
of the marriage gifts.[16] The skirt shown
here is a remarkably fine example, with
a large male or female figure in imported
nassa shells on the front and back. Rust
and ochre beads accentuate the head, rib
cage, and genitals, and also build some
of the small accompanying figures. Be-
tween the shells on the sides of the skirt
are large lizards, defined in tufted em-
broidery. Their rendering in loose black
yarns on the black surface of the cloth
lends them a shadowy impermanence, in
juxtaposition to the bold reality of the
shell forms. Relatively few of these skirts
enter Western collections, because in
addition to being marriage gifts, they are
also used as grave gifts and buried with
their owner.

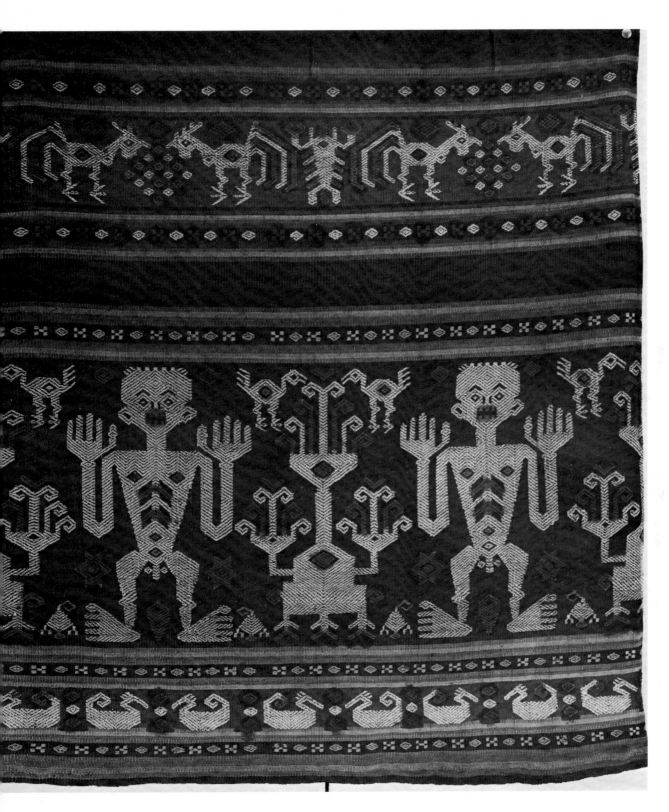

123 **Lau pahudu** (woman's skirt)
Sumba
Supplementary warp, surface staining
Cotton
Warp 130 cm, weft 121 cm
Museum voor Land- en Volkenkunde,
Rotterdam 19806

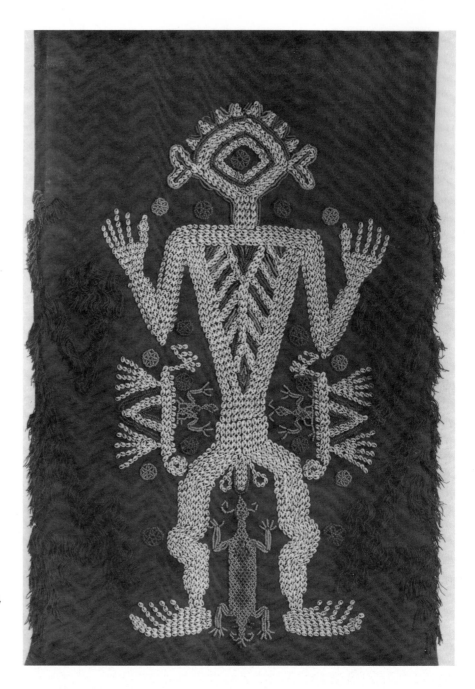

124a and b **Lau hada** (woman's skirt)
Sumba
Plain weave, shell and bead embroidery,
tufted embroidery
Cotton, shell, bead, cording
Warp 112 cm, weft 158 cm
Anita Spertus and Robert J. Holmgren,
New York

decorated textiles so closely bound to the noble class that the substitutes
are able to become the ritual surrogates.

Sumbanese textiles are still woven today, using commercially spun
yarns and synthetic dyes. Commercial yarns were being imported to
stimulate export production even before the turn of the century, al-
though up to World War II Sumbanese society itself largely demanded
textiles with a prescribed color range, traditional organization of design
elements, and a familiar iconography. Since that time, however,
changes in Sumbanese society have introduced new standards for the
textiles, and these items now mirror a culture in the process of restruc-
turing its forms and values.

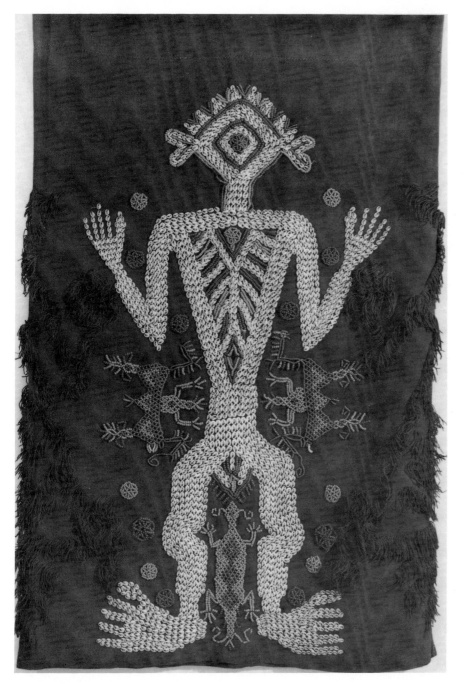

NOTES

1. Many scholars and missionaries have been attracted to Sumba, with its exotic and colorful culture, and most have mentioned the textiles woven there. Dr. Marie Jeanne Adams did research on the island for two years, and has addressed the problem of Sumba textiles in all its complexity. The following essay derives from her work in this region, as listed in the bibliography.
2. Nieuwenkamp 1922-23:308
3. Adams 1969:129ff
4. Adams 1972:14-15
5. Ibid.
6. Adams 1974:344
7. Ibid.:336
8. Roo van Alderwerelt 1890:584; Nooteboom 1940:32, 111; and Adams 1973:273
9. Adams 1969:108
10. Ibid:132
11. Ibid.:145
12. Ibid.:129ff
13. Ibid.:93ff discusses these changes.
14. Personal communication Ken Albright, Toronto, 1978
15. Bolland 1956

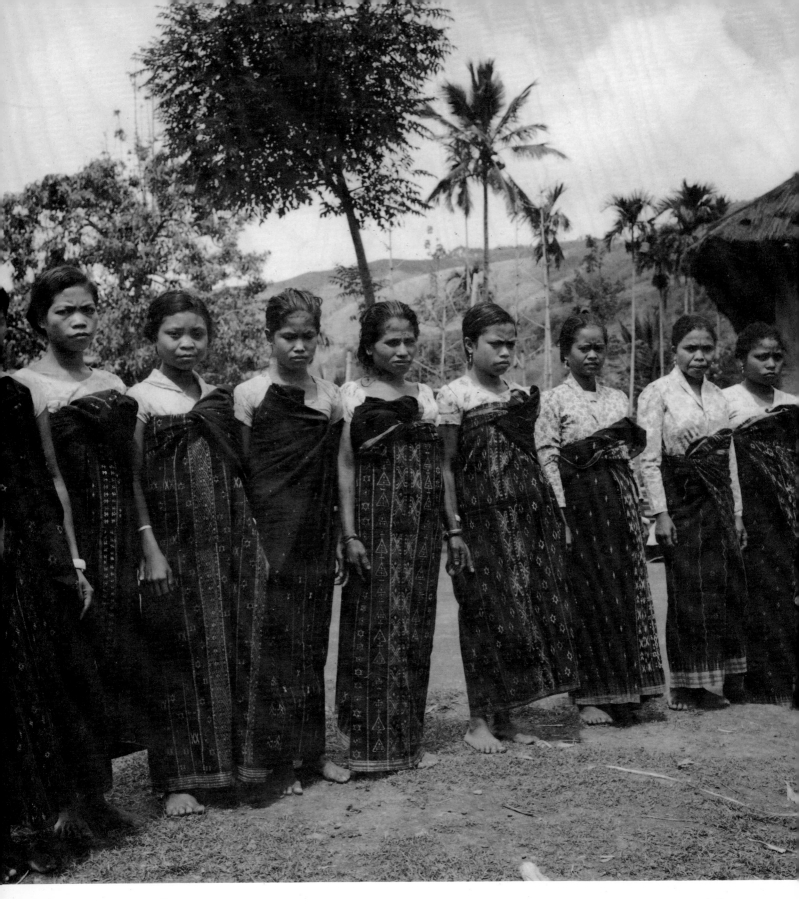

125 Women of Manggarai wear their sarong knotted over the breast. Blouses are a recent addition to the dress in West Flores. (Mattiebelle Gittinger, Washington, D.C.)

FLORES, SOLOR, AND LOMBLEN (Lembata)

The mountains and volcanoes of Flores, abetted by history, have created distinct textile areas on this large island. In the broadest of terms, three may be defined: the west, where the Manggarai people live; the center, home of the Ngada people; and the eastern half of the island, where the peoples of Endeh, Lio, Sika, and Larantuka are found. The extreme eastern area has had traditional contacts, through trade and intermarriage, with the smaller offshore islands of Solor and Lomblen, so the textile arts of these islands will be considered here as well.

Figure 125

Figure 126

There is little similarity in the textiles produced by the three mainland Flores regions. The most distinctly different are the sarong of the Manggarai region. This part of the island was subject to the Bima kingdom of East Sumbawa in the early seventeenth century. The influence of these overlords and that of the Makassarese of the South Celebes has produced basic differences in decorative techniques, design elements, and spatial ordering of the cloth surface. The Manggarai themselves distinguish at least four distinct types of kain according to the area of their manufacture, but for the outsider it is easier simply to identify the two fundamentally different types. One is a plaid cotton sarong that is rendered in forms that range from great bold crossings to minutely hatched grids. The colors are predominantly red, blue, or green. The textile is woven on a loom with a continuous warp, using a reed, which suggests influences from the South Celebes, where this type of loom is also known. The other is a deep indigo blue cotton sarong, woven on a loom with a discontinuous warp and worked with supplementary weft designs in a rainbow of colors. These designs appear in weft-oriented bands that are clustered together to create the heavily patterned kepala, or design center, of the sarong. Other elements may be scattered across the remaining field. All these designs are simple geometric forms that exist as isolated features rather than being interlocked into larger, more encompassing forms. Distinguishing the highest quality of sarong is a row of tumpal along each selvage. In contrast to the designs in the center of the cloth, which are worked by discontinuous supplementary wefts, the tumpal along the edge are of a tapestry weave that dovetails and inter-

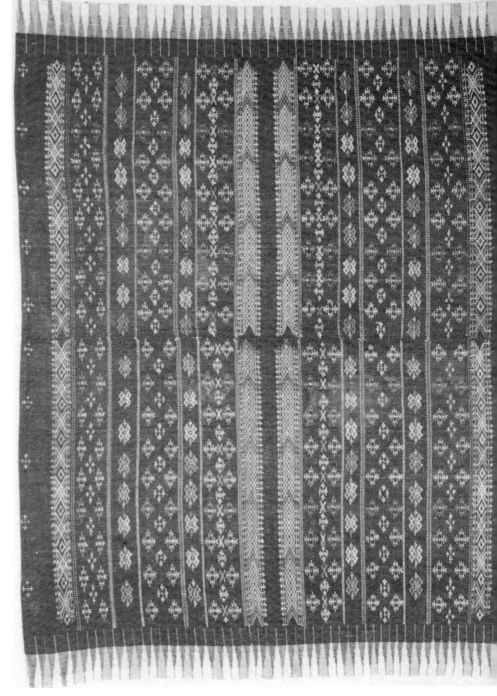

126 Sarong
Flores, Reo, Manggarai region
Supplementary weft, tapestry weave
Cotton
Warp 175 cm, weft 113 cm
Textile Museum, Washington, D.C. 1978.4

*In the western end of Flores, sarong such
as this are called* songket cok. *"Songket"
refers to the supplementary weft tech-
nique used to make the designs, and
"cok" to the tumpal that line the top and
bottom of the sarong. These are worked
by a tapestry weave that dovetails and
interlocks with the adjoining blue weft.
The tumpal along the margins are
characteristic of the most highly prized
sarong of the Manggarai.*

locks with the adjoining blue weft. This suggests interlocking tapestry
found on textiles from Sumbawa, and possibly this detail or even this
type of Manggarai cloth dates from the time the Bima kingdom held
control of this part of Flores.

Textile designs from the western areas are achieved by weaving,
while elsewhere on Flores textiles are patterned almost totally by the use
of dye in the warp ikat process. Here too foreign contact, or the lack of it,
becomes apparent. In the more isolated central region, the textiles of the
Ngada show little outside influence. They are blue-black, with simply

organized geometric figures such as ragged tumpal, squares, and zigzag lines. On the man's selimut, the blue field with its blue-gray figures is crossed in the weft direction in one or two areas by broad brown bands. The woman's sarong is virtually a solid black tube, worn knotted over one shoulder. The highly valued textile called kain kudu, so named after the barely visible images of horses arranged in narrow warp stripes, is of this same somber quality. The faintness of the design occurs because the color prized most highly is a deeply saturated blue-black that requires days of steeping: ultimately some of this solution penetrates the ikat resist. Some kain kudu have a narrow orange stripe near the edge, which gives them even greater value. The tying and dyeing of all these textiles was limited to certain clans at certain times, but unfortunately, details of these limitations have never been studied.[1] While modest in design, the textiles of this central region employ traditionally handspun yarns and natural dyes that lend them a pleasing quality.

Figures 127, 128 The textiles of the Endeh region and the area to the east reveal a range of external influences. In certain cases European patterns have been adopted, or Sumbanese compositional arrangements imitated. The impact of the Indian patola textiles was decisive, leading to the adoption of new design elements and spatial arrangements or even, as in the case of the Lio weavers, to a direct copying of the entire patola cloth. More restrained borrowing incorporated single motifs like the interlocking scrolls or heart design found in Solor textiles and the eight-pointed star of the Lomblen sarong.

The integration of foreign elements is not surprising, considering the great value placed on Indian silk cloths. One type of double ikat in particular was held in highest regard—a four-meter-long textile called *ketipa*, which was used as a shroud. The finest ketipa had designs of elephants, which may be an allusion to the elephant tusks from India that were used in bride-price payments.[2]

Figure 129 Another major foreign influence was the process of Turkey red dyeing. Textiles dyed by this complex process generally carry patola designs, which suggests that the introduction of the dye may have occurred in tandem with the Indian trade. Weavers using this red-brown dye were not confined to borrowed designs. Their own intricate netting of stick-figured men, lizards, animals, and sacred earrings, as worked on Lio sarong, prove far more entertaining. These textiles employ a deep blue in small areas, around which a broad range of red-brown is used that may have required up to eight years of dyeing.[3] Such textiles were reserved by the Lio for festival use, while more quickly patterned and dyed blue textiles served for everyday wear.

Figure 130 In the eastern region, different customs are associated with various designs. On Solor, not the designs themselves but the arrangement of them was the property of an individual clan.[4] There were four major types of arrangements, which related in hierarchical pairs.[5] A person who wore a textile belonging to another group would be considered a "thief." If such proscriptions controlled textile design elsewhere in the east, it is forgotten today. Textiles are, however, still categorized in terms of their arrangements, even though they consistently utilize the same design elements.[6]

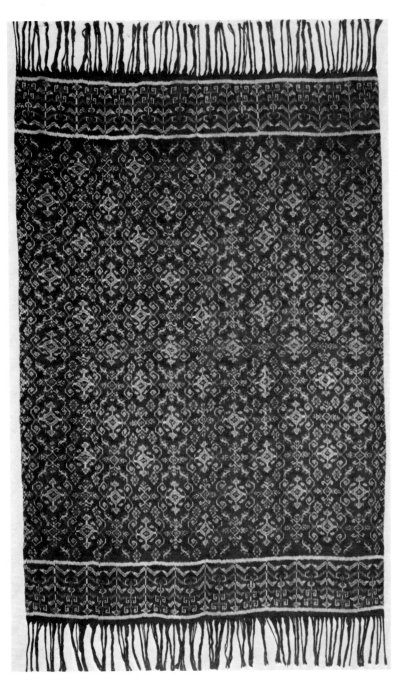

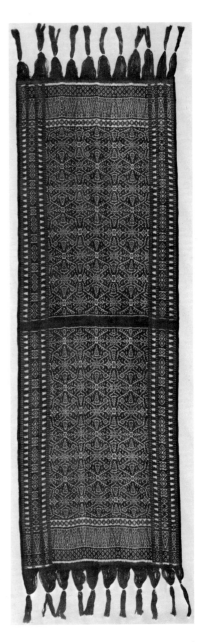

127 Man's mantle
Flores, Endeh region
Warp ikat
Cotton
Warp 241.5 cm, weft 139.8 cm
Textile Museum, Washington, D.C. 68.25

Although the Endeh culture on the south coast of Flores derives from the same roots as that of its neighbors the Sikanese, Lionese, and Ngadanese, exposure to the sea trade has brought in a number of influences. This is apparent in the red-brown ikat textiles, which lack all figural representation. They usually have a large central area covered with a single repeated pattern, and end bands near the fringe with tumpal designs or elements that conform to a similar triangular shape, as in this example. Imitations of patola details may appear in the patterning. The red-brown dyes used on festival wear in this region are similar to the dyes known in Lio, but the coastal groups never achieved the great range of coloration seen on the textiles in the interior. Weavers on the coast also made ikat textiles for everyday use, and these were dyed with indigo. In the blue textiles the designs are often large, crude shapes lacking all organization.

128 Slendang
Flores, Lio people
Warp ikat
Cotton
Warp 223.5 cm, weft 61 cm
Textile Museum, Washington, D.C.
1976.8.2. Gift of Jerome and Mary Jane Straka, New York

These shoulder cloths, which are virtual copies of Indian textiles in design and arrangement, are used by men in dances at yearly ceremonies. These four-day festivals may be the only times the cloths are seen. They are not uncommon, however, and one or more is buried with each man.[9]

The figures are in ecru on a reddish-brown ground. A brilliant light blue accents small details.

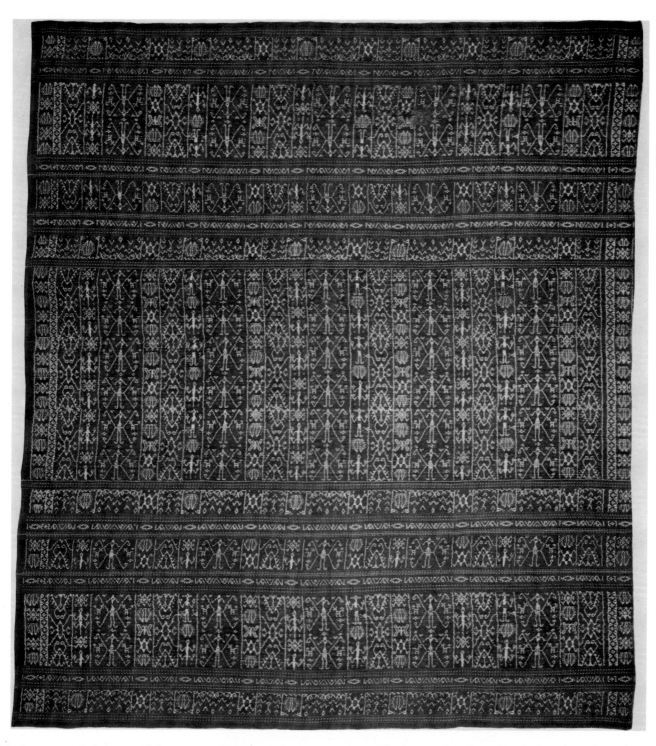

129 **Lavo manusia** (sarong with human figures)
Flores, Lio people
Warp ikat
Cotton
Warp 161.5 cm, weft 155.6 cm
Textile Museum, Washington, D.C. 1977.4.
Gift of Gilbert H. Kinney, Washington, D.C. and P. J. Maveety, Palo Alto

This woman's sarong carries a web of forms. Most unusual are the human figures that give the textile its name. Accompanying them is a tracery of lizards, insect-like forms, birds, dogs, and representations of sacred gold earrings. These ornaments in the shape of the female vulva were part of the objects exchanged at the time of marriage. They were made by the Lio people, who were known for their metal casting of large ornamental bracelets, rings, and earrings; the craft continued down through the first half of this century.

In addition to its varied iconography, the sarong has a broad range of dye tones, achieved through a laborious sequence of dye-baths and by tying and untying the resist elements. The colors range from deep blue-black, through a spectrum of reddish brown, to the light ecru of the figures.

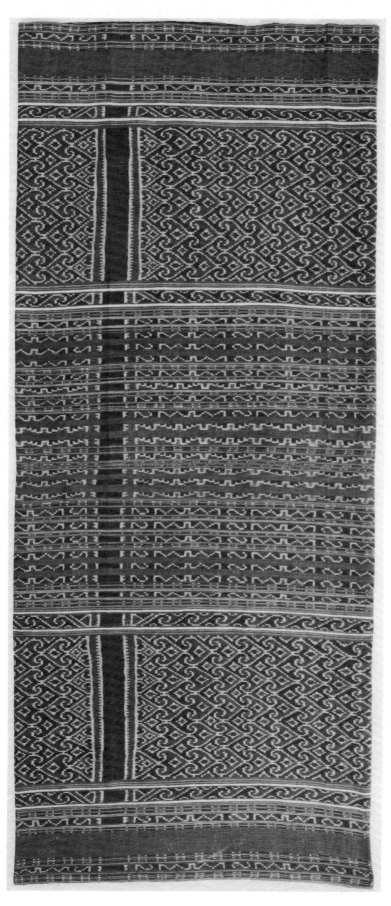

130 Sarong
Solor, Lewolein region
Warp ikat
Cotton
Warp 137 cm, weft 149 cm
Museum für Völkerkunde, Frankfurt NS
27895

*This remarkable sarong from South Solor
was collected by the missionary Vatter
in the early part of this century. It is an
example of fine craftsmanship, and illus-
trates how precisely certain patola pat-
terns were copied in this area. The inter-
locking scrolls that form the heart-shaped
figures are traceable directly to Indian
textiles, while the stepped elements of the
center panel are local in origin. According
to Vatter, the Solorese interpret the de-
signs thus: The heart-shaped forms in
the large end panels are crocodile tracks.
When divided in half into their interlock-
ing S-shaped components and placed in
the narrow flanking borders, the con-
figurations are seen as harpoon points.
The meandering lines of the center band
refer to the nodes of the rattan plant,
knee bends, and a large gourd.*[10]

*This is one of the four basic design
arrangements in South Solor. Each was
the distinctive property of a clan and
could be worn by no other. The colors
of this example, are a glowing reddish
brown, the soft ecru of the natural cotton,
and blue-black detail.*

131 Sarong
Lomblen (Lembata)
Warp ikat
Cotton
Warp 137 cm, weft 142 cm
Textile Museum, Washington, D.C. 68.19
(Color plate)

*Ikat, termed bofak on the island of Lomb-
len, was worked in two principal areas
of this island, Lama Lerap and Gunung
Api. Elsewhere little or no textile work
was done except in recent times in the
eastern Kedang area, where weaving was
introduced, but never involves ikat pat-
terning. The ikat textiles from the tradi-
tional areas, as this example, have a re-
markably gentle dye range of harmonious*

blues and brown. The colors form simple geometric shapes that are arranged in highly sophisticated compositions.

Most of these sarong are composed of three or more panels sewn to form a tube. When they were worn, part of the excess material was doubled back to give the impression of two layers. Today these are never worn on this island, but are still made to be given by women in marriage exchanges. They become the property of the husband and will be buried with him unless he elects to sell them before his death.[11] Few of the present examples can match the beauty of this sarong, made before the turn of the century.

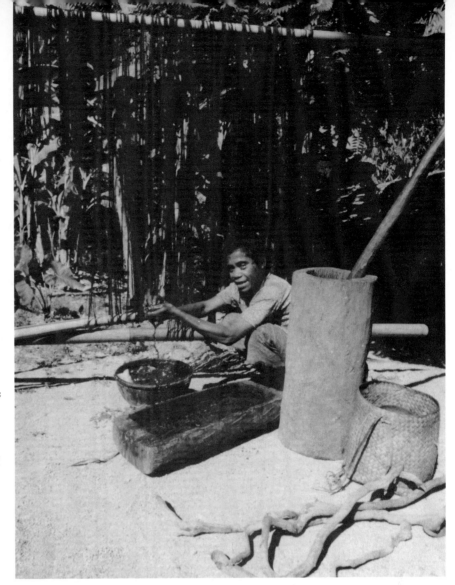

132 *A Sika woman in Flores prepares the red dye called khombu. To make the rich red-brown dye for which the region is known, material from the* Morinda citrifolia *roots in the foreground is scraped, then beaten in the mortar, and additional substances are added. Traditionally, the deepest colors require five to eight years of dyeing before the weaving begins. In this picture yarns previously dyed may be seen drying over bamboo poles in the background. Some natural dyes are still used in east Flores, although weavers increasingly turn to synthetic products. (Kent Watters, Los Angeles)*

Figure 131

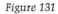

Size was also a telling factor in the value of some of these textiles. On Lomblen, certain sarong had as many as sixteen panels, sewn together to form a tube.[7] These sarong became objects of exchange used at marriage negotiations. On Flores, among the Lio, a single textile length was used for an adat shoulder cloth, but long, fringed two-panel textiles were symbols of prestige and status allotted only to village elders of high rank.[8]

Today ikat textiles are still made in much of the eastern part of Flores. While many of the traditional forms are repeated, the laborious dyeing with natural substances is quickly giving way to the use of faster synthetic dyes, and finer, commercially spun yarns have replaced the warmly textured handspun cotton. These substitutes produce a relatively uninteresting result. Nevertheless, the craft of weaving remains an important part of village life.

NOTES

1. Arndt 1954:457
2. Vatter 1932:76
3. Bühler 1943:108
4. Vatter 1932:223
5. Ibid.:224
6. Watters 1977:88
7. Personal communication Kent Watters, Los Angeles, January 1977
8. Watters 1977:88
9. Ibid.:89
10. Vatter 1932:223
11. Personal communication Kent Watters, Los Angeles, January 1977

TIMOR

The people of Timor weave bright, boldly colored and patterned textiles notable for their direct visual appeal. In a land of rolling hills and mountains browned for more than half the year by dry winds, the brilliant red bands and stripes or large blue ikat patterns are welcome accents in a low-keyed background. These are the characteristics of the textiles of the Atoni, the people who inhabit the interior of western or Indonesian Timor. Extending into the eastern half of the island are the Belu, or Tetum, and other ethnic groups who weave textiles as well; however, the present discussion deals primarily with the work of the Atoni.

The principal Atoni textile is a broad cotton rectangle consisting of two or more bands sewn together in the warp direction. The women sew the rectangle along one side to form a tube-shaped sarong, which they wear knotted over the breast. Men use the rectangle as a fringed flat piece, which they wrap about the hips. In the cold of the mountain morning, men use a second textile around their shoulders; later in the day, this may be secured in a large bulky knot around the waist over the first cloth, held simply by rolling or secured by a belt. In some areas women too wear a second cloth, or, more commonly today, a Javanese-styled blouse.

Figures 134, 135, 136

The designs of these textiles are worked in many techniques: warp ikat, warp-faced alternating float weave, two types of supplementary weft, tapestry weave, twining, and warp stripe patterning. While all the techniques are not pervasive, the Timorese weaver does have a remarkably versatile range of skills at her command.

The various designs and the manner in which they are used in the organization of the cloth surface are distinctive to each of the ten princedoms that once formed the political affiliations of the Atoni. Some of the more subtle characteristics turn on dye tones and slightly different design band arrangements that are barely perceptible to the untutored eye. To the Timorese, however, local textiles are clear indications of the area of one's birth and one's traditional allegiance.

The weavers of Amanuban and Miomafo in particular produce tex-

133 *Two hunters in central Timor wear typical draped and knotted textiles. The ikat patterns in the central band are flanked by numerous red and yellow stripes. (Museum für Völkerkunde und Schweizerisches Museum für Volkskunde Basel, Basel)*

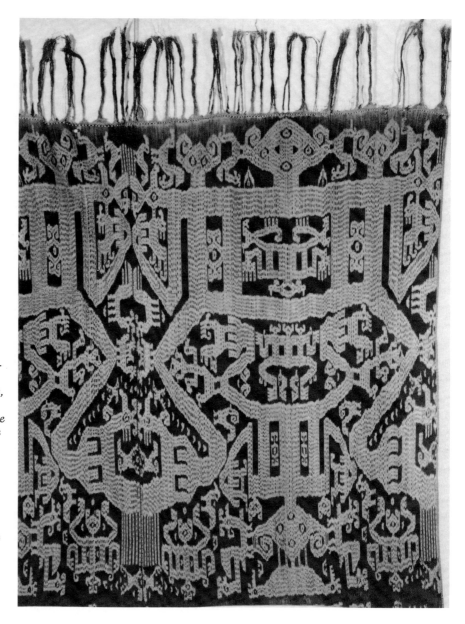

134 Selimut (man's textile)
Timor, Amanuban, Niki Niki region
Warp ikat
Cotton
Warp 218 cm, weft 133 cm
Tropenmuseum, Amsterdam 2071-14
(Approximately one-fourth illustrated)

Great angular figures dominate each quadrant of this man's textile. Here a detail from a section of the textile shows how the extremities—the fingers, elbows, shoulders, ears, and toes of these great forms—deliquesce and reconstitute in the forms of birds. All intervening spaces are filled with similar, but smaller figures. The disjointed patterning of the figures themselves and a few strong warp-directed lines give the figures an almost organic vibrancy.

These figures probably mirror Atoni beliefs that the dead metamorphose into birds after the final funeral celebration.[18] On the other hand, this may be a textile made by a group that honored a bird totem. Whatever the significance, it is a delightful example of both ikat work and design.

Figure 134

Figure 136

tiles that delight the Western eye with their anthropomorphic images and bird forms. These figures are worked in warp ikat and appear as white forms on a blue ground. They are arranged in a central broad band flanked by red, white, and yellow stripes; or there may be three equal ikat bands that alternate with the multicolor stripes. Most spectacular are the textiles completely patterned with great, angular figures. Usually these textiles are assigned to the princedom of Amanuban, but certain textiles from Miomafo share the same characteristics.

In obvious contrast to the blue ikat textiles from Timor are the red and white weavings from the princedoms of Molo, Amfoan, Ambenu, Amanatun, and parts of Miomafo. These are usually constructed of three panels, of which the central length is white and the flanking members are patterned in red or red-brown. A warp-faced alternating float weave, turned, is used to create the designs of crocodiles, lizards, or hooked diamond forms in the lateral red or blue stripes. The result

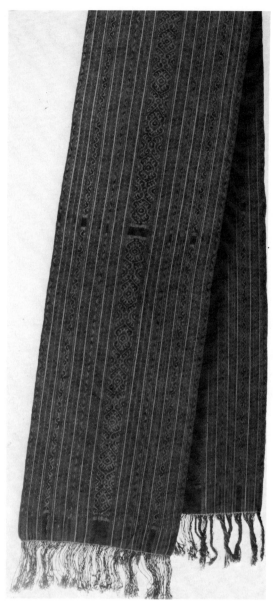

135 Man's sash
Timor, Beboki area
Warp ikat
Cotton
Warp 234 cm, weft 29 cm
Rijksmuseum voor Volkenkunde, Leiden
2769-11

It is rare to see two-color warp ikat in Timor. This piece originated in the north-central princedom of Beboki, which has both Atoni and Tetum (Belu) peoples, and it may have been made by either. The cloth is dependent for its beauty on the interplay of rich shades of red-brown in contrast to the deep saturated blue tones. The narrow warp stripes are a reddish rust, with flecks of natural color left by simple ikat patterning. Wider ikat stripes combine blue and rust in a gentle interplay of curved forms.

is a pattern that appears in the alternate color on the reverse.[1] The center of these complex textiles may be left plain white, or broad design blocks may be worked near the ends in twining and tapestry weave. Still another variation patterns the central white area between the tapestry zones with figures of lizards and birds or geometric forms, worked by a discontinuous supplementary weft.

A major variation of this type occurs in Amarassi, where the lateral panels are often red-brown ikat designs, rather than woven configurations. The latter do exist as well, but the majority of textiles are worked by ikat. The ikat designs are geometric or, more rarely, a bird motif, and all closely resemble the designs of local basketry.

Women's sarong have characteristics similar to the men's garments. For instance, in Amarassi the sarong is four joined panels with ikat designs like those on a man's textile: this woman's garment, however, lacks the white area. In the princedom of Insana in the north, there is a

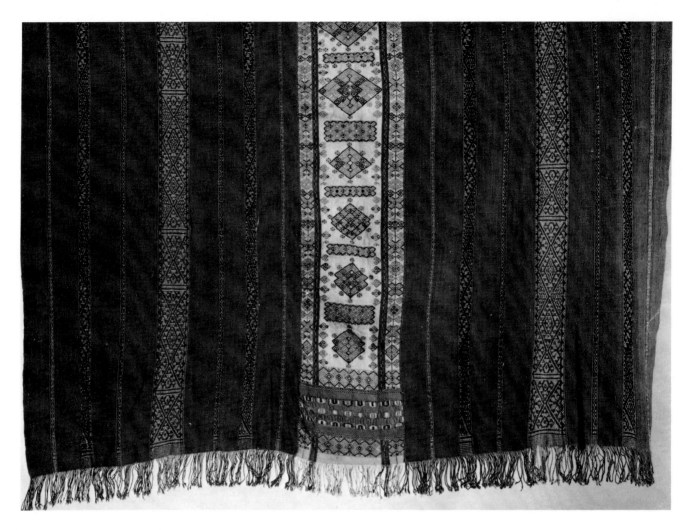

136 **Selimut** (man's cloth)
Timor, Miomafo area
Warp-faced alternating float weave,
turned; supplementary weft; tapestry
weave; twining
Cotton
Warp 191 cm, weft 132 cm
Rijksmuseum voor Volkenkunde, Leiden
2769-13

*In Miomafo two types of textile designing
are practiced—a warp ikat in blue, and
a red or blue alternating float-weave pat-
terning such as this example. This textile
has three panels joined in the warp direc-
tion. The side panels are a rich, brilliant
red, with designs worked in the stripes
by groups of alternating floats. The
amount of supplementary weft pattern-
ing in the central white panel varies
from fabric to fabric. Elaborate textiles
such as this one were used by men of
noble rank.*

Figures 137, 138, 139

different style: the original two-panel blue sarong has a modest narrow
ikat band, flanked by a few stripes at the top and bottom. In between
the ikat is a striped or plain field. For the affluent, this two-panel sarong
can be extended by the addition of a third or even a fourth loom width
at the top and bottom. These panels may be designed in ikat, but are
more frequently patterned by supplementary wefts, both continuous
and discontinuous, sometimes in riotous color combinations.

Because there are proscriptions that apply to the wearing of ikat by
certain people, and strong associations with colors, it is thought that
possibly some all-encompassing system unites the designs of the Atoni
textiles. There probably is a system of complementary opposites based
on red and blue dichotomies, but to date the workings of such a scheme
are not clear.[2]

It is known, however, that color is an important symbolic factor for
the Atoni. Red in particular is associated with headhunting, war, cour-
age, and victory.[3] It is not surprising, therefore, to find red the predomi-
nant dye color of the headhunter's, or meo's, costume.

The meo's garments are curious for a variety of reasons. First, they
employ twining and tapestry weave, and although these are techniques
used in warrior's wear elsewhere in Indonesia, here the yarns are too
light to make them effective for protective wear, like the heavy coat

of the Borneo warrior. In addition, the style of the Timor pieces alone would preclude any defensive function. They are fringed or deeply beribboned, apron-like forms called *pilu saluf,* which were worn over the shoulders and around the waist. Smaller versions covered the upper half of the face. The headgear was the glory of the costume. It consisted of several short bands and a long tapestry-weave strip that trailed down the back. Great silver disks and a large, sickle-shaped ornament were attached to the front. A new meo was ritually dressed in this costume in a ceremony following the taking of his first head.[4] After the Dutch gained control of the interior of Timor in 1910 and ended headhunting, these costume pieces were worn by descendants of great meo to commemorate their ancestors.[5]

These unusual garments appeared on a few other ritual occasions as well. Women wore the costume at life-crisis rites. When a new mother emerged from the house for the first time after giving birth to a child, in the ceremony called "touching the ground,"[6] she was garbed as a headhunter. At the funeral of a great headhunter, his daughter would dance in his meo garments. There are other reports that pieces were hung from tall poles at funerals, and that some were used as the head decoration of the horse central to the last rites of an important person. It is thought that the horse both represented the deceased and served as his final mount.[7]

The origin and significance of this attire are still in question, and the name of the pieces, pilu saluf, suggests rather unsatisfying answers. *Pilu* refers to headcloth, and *saluf* means "to tear into rags," giving rise to one Timor scholar's interpretation: "Having the quality of being torn in rags hanging down from the forehead on shoulders and breast. . . . It seems to be symbolical of the result of the headhunting action."[8] Perhaps the symbolism of "tearing into rags" is more closely related to the total role of costume as an expression of the typical versus the atypical. The deliberately torn garment style removes the occasion from the realm of normalcy. In this regard it may be significant that formerly widows often tore rents in their textiles as a sign of mourning.[9]

Figure 140 Men's purses are made by this same technique of tapestry weave and twining. These intensely personal objects, carried by all men in the mountains of Timor, are woven by their wives. Tucked inside are the items necessary for betel chewing,[10] tobacco, and a bit of money. A man receives one of these bags from his prospective bride in the course of the marriage gift exchange. Whether this same bag lasts a lifetime is not known, but the bag in use at the time of his death is subsequently hung on the main pole of the house, where it remains to commemorate him.

The bag is made from a rectangular twined and tapestry-woven piece, folded and sewn up the sides. Fringes of wrapped yarns, strings of beads, or coins may be added to the margins or upper lip. The strap is either a narrow woven band, or a thin strip with a structure that resembles twining. It is actually worked by the hands of two people in a novel procedure that almost resembles a string game. The straps are long enough to allow the bags to be carried on the shoulder, hung around the neck, or more informally draped about the waist over the bulky, knotted accumulation of the selimut. The designs worked in the twin-

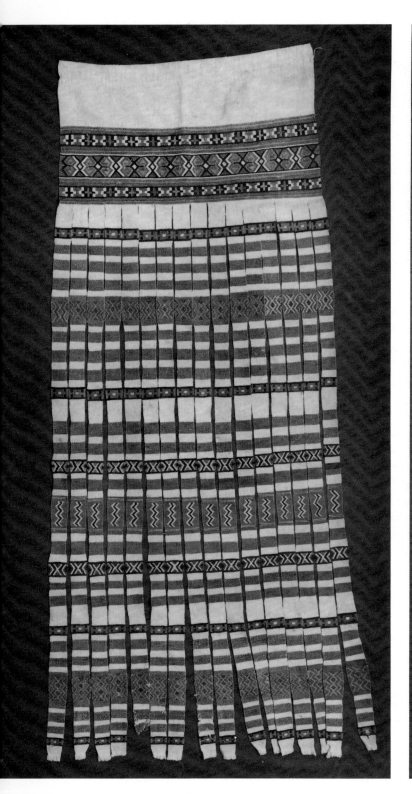

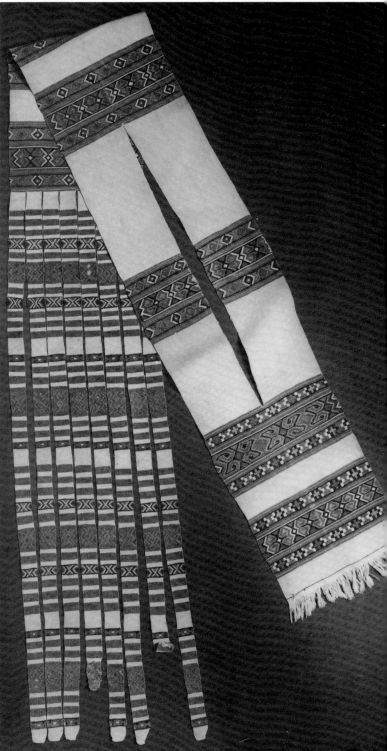

137 **Pilu saluf** (meo, or headhunter's
costume piece)
Timor
Tapestry weave, twining and plain weave
Cotton
Warp 82 cm, weft 31 cm; warp
Rijksmuseum voor Volkenkunde, Leiden
300-1768

138 **Pilu saluf** (meo, or headhunter's
costume piece)
Timor
Tapestry weave, twining, plain weave
Cotton
Warp 175 cm, weft 19 cm
Rijksmuseum voor Volkenkunde, Leiden
300-1761

139 Pilu saluf (detail of field photograph, Mattiebelle Gittinger, Washington, D.C.)

Garments such as these were tied across the shoulder or around the wearer's waist as part of the headhunter's costume. Traditionally these were reserved for warriors who had taken at least one head, and for women at certain rites. After the Dutch gained control in 1910, the pieces became heirlooms and were worn in commemoration of famous ancestors. More recently, they have been used as dance costumes.

The ribbon-like elements are in tapestry weave worked on the warp ends of the apron body. In the latter, a plain weave predominates, but the designs in red and black are a tapestry weave combined with twining. Small versions of this type of garment were made to cover the face, and long, narrow pieces were hung from the back of the headgear. These pieces were collected in 1878.

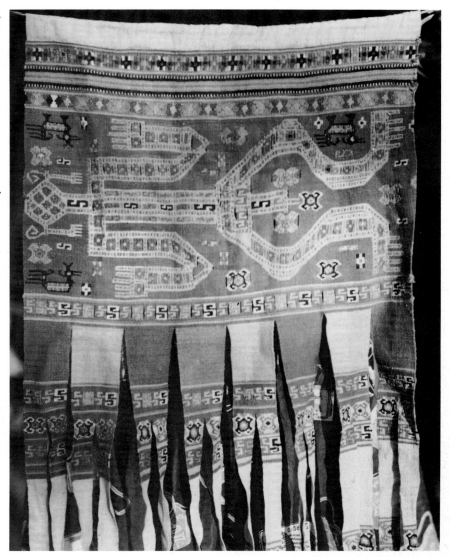

ing and tapestry weave center on the diamond and hooked diamond motifs and a tendril or scroll. The latter is particularly common to the twined bags, and almost always appears in red and yellow. These colors, with small amounts of blue and black, were favored until recently, when more brilliant manmade dyes were adopted.

All of these Timorese textiles, with the possible exception of the meo garments, enter into the traditional patterns of gift exchange between bride-givers and bride-takers. Heijmering, writing in the mid-nineteenth century, reported that a wealthy bride's family would give not less than a hundred textiles and sixteen to twenty large pigs at the beginning of the engagement, in return for twenty-five units of silver and gold and seventy to eighty buffalo.[11] He was recording customs in the port area of Kupang, where gift textiles included imported cloths, but even in the interior, large numbers of textiles were customarily given at the weddings and funerals of important families. Both the early report of Heijmering and that of Kruyt, writing seventy-five years later, record the novel way this payment of the bride-price was accomplished in at least two areas. Textiles were hung before the doors that led to the

140 Aluk (betel bag)
Timor, Molo
Twining; tapestry weave
Cotton, beads
Width 15.9 cm, height 16.5 cm
Museum für Völkerkunde und
Schweizerisches Museum für Volkskunde
Basel, Basel IIc 5609

The traditional Atoni man's costume always includes a twined and tapestry-woven bag. They are usually made by women, on small portable frames, using a passive warp structure. The major design on this example is a series of small scrolls or tendrils worked by twining red and yellow yarns; the result is a red design on a yellow ground. Simple red and blue stepped forms in a tapestry weave are seen in the center stripe. A strip of red commercial cloth marked with white beads lines the lip of the bag, while short fringes of white beads bristle at the sides.

141 Woman's sarong
Eastern Timor (Los Palos)
Supplementary warp
Cotton
Warp 100 cm, weft 78 cm
Jack Lenor Larsen, New York

Sarong such as this are as interesting for the research problems they pose as for their inherent properties. They seem to have been made in a small region at the far eastern tip of Timor, and are extremely few in number. Most, like this example, are of bright commercial dyes—predominantly red—and machine-spun yarns. Their patterning technique—supplementary warp—is of major interest because it is a complex procedure that also occurs on Sumba. On that island, it is used on the woman's sarong, the lau, to form highly stylized human, plant, and animal forms, as well as tightly interlocked geometric patterns. Only small details in the Timor textile designs suggest a relationship between the two phenomena. Many of the designs on these cloths seem to have been copied from European lace or embroidery patterns: confronting arrangements of swans, roosters, squirrels, and small birds, as well as floral meanders. These are interspersed with indigenous subjects like horned buffalo accompanied by egrets or men on horseback. Although such patterns seem radically different from the Sumba lau designs, there is a tenuous affinity, including that lent by the technique itself. Supplementary warp patterning is a taxing procedure on a backstrap loom, and would hardly have arisen independently in these two areas.

The technique is not restricted to these particular sarong. It was also used in the

bride's room, and as the groom advanced from the courtyard through the house, he had to "buy away" the barriers.[12] It is not known how extensive this colorful ceremony may have been.

Almost every ceremony of significance, from house-roofing and rice-harvesting[13] to funerals, employed local textiles as significant ritual objects.[14] Kruyt mentions a hundred and fifty textiles being used at one funeral ceremony. Depending on the ethnic group, these cloths were either all buried with the body or distributed to the living.[15] Here, as in marriage, textiles were the obligatory gift of the bride-giving family segment.

From early reports of these extensive gift exchanges, it is known that patola, or patola-like textiles, were part of the gifts exchanged in at least the Kupang area. For centuries, Timor had been open to trade, as merchants sought the island's wealth of sandalwood, beeswax, honey, slaves, and dyestuffs.[16] It is somewhat surprising that foreign trade influences seem to have left no mark on the local textile traditions. Weavers in the interior retained their design independence, and until fairly re-

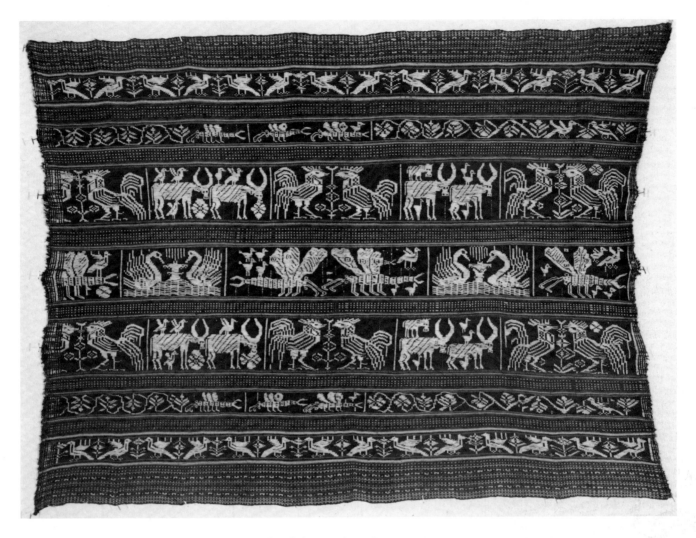

Baguia area of eastern Timor for a narrow decorative border within groups of warp stripes, and to make decorative belts or headbands. The designs on these textiles are simple single figures of bird or human forms, or geometric shapes such as the hooked diamond.

cently, did not alter their traditions. They grew their own short staple cotton and utilized dyes based on local plants: indigo, *bakunu (Morinda citrifolia)*, *hukil (Curcuma longa)*, and *kayu kuning (Cudrania javanensis)*.[17] Commercially spun cotton yarns were traded inland in the early part of the century, to be used primarily as color variations in the lateral stripes. This trade disappeared during the Japanese occupation in World War II, when local cotton and looms supplied what clothing was available. Even as late as 1964, some textiles were woven without imported yarns, although commercial dyes have been extensively used throughout most of this century.

NOTES

1. Rowe 1977:53
2. Schulte Nordholt 1971:45, 418, 419
3. Ibid.:416-417
4. Middlekoop 1963:193-195
5. Nieuwenkamp 1920:249
6. Middlekoop 1949:30
7. Ibid.:8, 9, 159
8. Middlekoop 1963-24
9. Heijmering 1844:299; Middlekoop 1949:111
10. Betel or sirih refers to the quid made of the small nut of the pinang palm
(Areca catechu), leaves from the betel pepper vine, and other substances, which is chewed as a stimulant.
11. Heijmering 1844:128
12. Ibid.:129; Kruyt 1923:359
13. Kruyt 1923:452, 484
14. Ibid.:401-406
15. Middlekoop 1949:103
16. Schulte Nordholt 1971:50
17. Ibid.:44, 45; Ormeling 1956:58
18. Middlekoop 1949:4

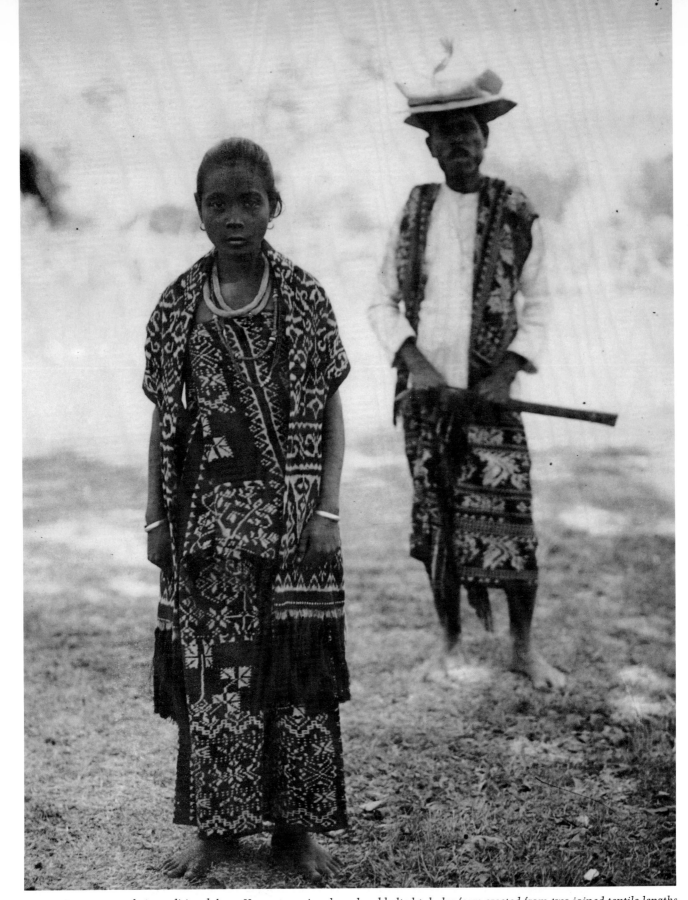

142 *A Rotinese couple in traditional dress. Her costume is a draped and belted tubular form created from two joined textile lengths. This is supplemented by an elegant, long fringed shoulder cloth and heirloom jewelry. The Rotinese man's costume, as illustrated here, still uses a shoulder cloth even though a Western shirt is worn. Tied about the hips is a second fringed cloth. His hat, made from lontar palm leaves, is a distinctive part of the traditional costume. (Museum für Völkerkunde und Schweizerisches Museum für Volkskunde Basel, Basel)*

ROTI, SAVU, AND NDAO

Roti, Savu, and Ndao are three small, arid islands, located between Sumba and Timor, whose textiles have long appealed to foreign eyes. The ikat textiles of Roti and Savu in particular, with their subdued colors and floral forms, were readily appreciated by the Europeans who had early access to them. Technically they were of a superb standard, and for this reason claimed the attention of the ethnographic textile specialist Alfred Bühler. He selected Roti as an area of investigation in 1935 and wrote some of the earliest detailed reports of the process of warp ikat, based on material he collected there. More recently these textiles have received another form of attention in the extensive field investigations of the anthropologist James J. Fox. His inquiries into the role of design have added another dimension to our understanding of the textile traditions of these islands. Almost all of the following is based on his work.[1]

The textiles of the three islands are not the same, but they are similar in their use of warp ikat, a muted dye range, and a moderate design scale. They also share the design impact of the Indian patola textiles that were once used as tokens of alliance by the Dutch. In an effort to monopolize trade in this region, the Dutch East India Company recognized and dealt exclusively with particular leaders, giving them the precious cloths as symbols of their favor. Thus the Dutch in effect created an elite, and the patola they gave in exchange for slaves, beeswax, and other products became synonymous with high social rank. When patola elements were subsequently adopted into local textile traditions, important families claimed particular design elements as their prerogative. The most important design borrowed from the Indian model is the eight-rayed flower, called the "black motif" on Roti, and elsewhere in Indonesia, the jelamprang motif.

Figures 143, 144 The Rotinese in particular adapted characteristics of the patola textiles. They tempered their predilection for warp stripe composition by incorporating the zoned and bordered matrix found on the Indian model. This created an open center field that could be filled with large motifs or interlocking networks, all freed from the warp-directed stripes.

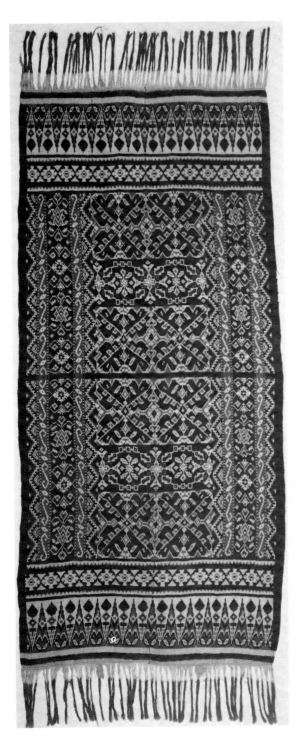
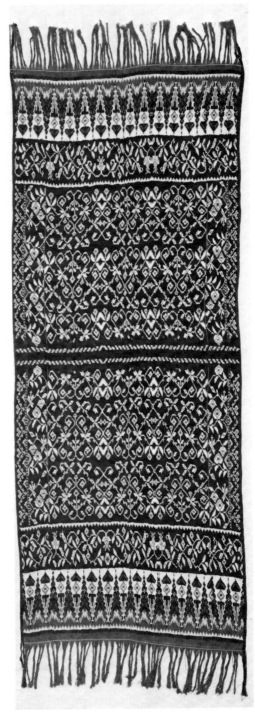

143 **Lafa dula penis no dula nggeo**
(man's textile)
Roti
Warp ikat
Cotton
Warp 202 cm, weft 80 cm
Mary Jane Leland, Los Angeles

These two textiles are both illustrations of Indian patola design borrowing. Most evident is the framed composition and terminal rows of triangles, or the tumpal

144 **Dula bunga** (man's textile)
Roti
Warp ikat
Cotton
Warp 220 cm, weft 76.5 cm
Friend of the Textile Museum,
Washington, D.C.

motif. In addition, the first textile has a center field area filled with paired, eight-rayed flower renderings. The so-called "black motif" or dula nggeo is the cen-

ter pair of flowers in each of the identical halves. While it is here rendered in a somewhat unusual style, it is this motif that identifies the textile as a nobleman's cloth.[6] In the second textile, the center field is filled with a simple floral grid-work, which betrays its commoner status. Both textiles would have been used as men's hip wrappers or shoulder cloths. They are both blue-black, rust and the natural ecru of the cotton yarns.

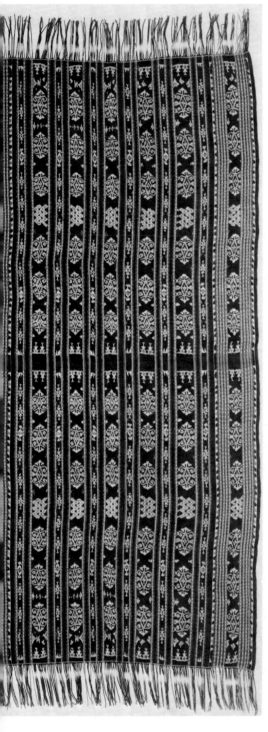

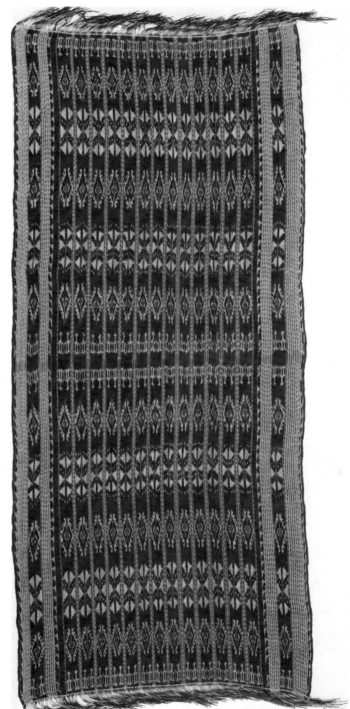

145 **Selimut** (man's textile)
Savu, Greater Blossom group
Warp ikat
Cotton
Warp 198 cm, weft 84 cm
James J. Fox, Canberra

These textiles are representative of the Greater and Lesser Blossom on Savu. Peculiar to the former group, the Hubi Ae,

146 **Selimut** (man's textile)
Savu, Lesser Blossom group
Warp ikat
Cotton
Warp 183 cm, weft 74 cm
The Brooklyn Museum, Brooklyn
45.183.113

are the warp stripes showing star or moto *motifs, alternated with other geometric forms, as well as a preponderance*

of red-dyed yarns. Lesser Blossom textiles, those of the Hubi Iki, are dominantly blue and white, and have neatly ordered rows of parallel diamond shapes.

Both selimut are constructed of two panels sewn together in the warp direction. These panels differ in width to allow an uneven number of major warp stripes —a characteristic feature of Savunese textiles.

147 Sarong
Savu
Warp ikat
Cotton
Warp 122 cm, weft 169 cm
Textile Museum, Washington, D.C.
1976-13.1. Gift of Miss Gladys O. Visel

*The large ikat design band, counterbal-
anced by a plain area and numerous sub-
sidiary bands carrying smaller ikat de-
signs, is the typical composition of the
Savunese women's sarong. Characteristic
also is the very narrow "ribbing" that
divides many of the lesser bands. Techni-
cally this is made by paired white warps,
which alternate with a single colored
warp yarn in a series of warp floats. The
detail is always done in white and is a
feature that helps to identify Savunese
sarong when the designs themselves are
slightly unusual. This sarong as illus-
trated is a flat rectangle made from two
pieces of cloth. When used, it would be
folded and sewn into a tube. Only the
lower of the two large design bands
would be entirely visible when worn,
because the upper half would be folded
in a manner that would obscure some of
the upper part.*

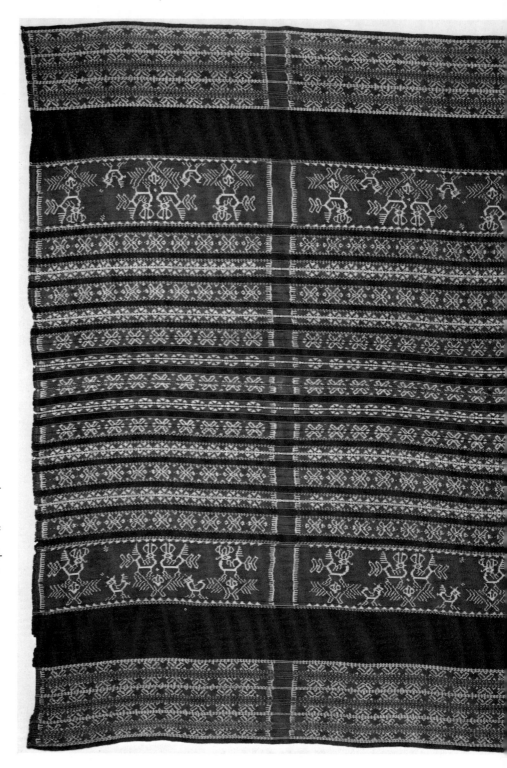

Thus the Indian textiles provided a new format that could be used by commoners and nobles alike, and introduced specific motifs that were claimed by the elite. Of the latter, the "black motif" was the most important, but other designs also carried class connotations. These were often identified as such only in a particular district, and were not always easily recognized as class signs by outsiders.

Figures 145, 146, 147 On Savu, a much more conservative island in all respects, designs have a slightly different function. As explained elsewhere in this catalogue, they signify membership in one of two female aligned groups that control life-crisis rituals. These groups, called "Greater and Lesser Blossoms," are further subdivided into divisions termed "Seeds." Membership in these divisions is never referred to verbally. Rather, it is revealed through use of specific textile designs. The knowledge of these designs is controlled by women, who pass the lore on to their daughters as they learn to weave. The textile designs are, therefore, specific to island-wide groups, and are their exclusive property. They are essentially signs, communicating what the society has chosen not to verbalize.

In an unadulterated form, the designs are restricted to specific blossom divisions and carry an aura of exclusive prerogative. When supplemented by nonrestricted design elements, however, the textiles become neutral and easier to wear, for they indicate a refusal to make a social claim. Thus the Savunese have textiles that are reserved for ceremonial use, and everyday textiles. This custom is more liberally interpreted on Roti.

The exact meaning of individual designs has yet to be investigated; however, there are rich metaphorical traditions in the local ritual and languages, and it is probable that these are mirrored in the visual imagery of the textiles.

The items woven are fringed cotton rectangular forms, used by men as hip wrappers or folded to serve as shoulder cloths. Larger flat cloths are used as sleeping blankets and shrouds to wrap the dead and cover the coffin (Roti).[2] A tubular form, or sarong, made by sewing a rectangle along one side, is the woman's major garment; on Roti this is accompanied by a narrow fringed shoulder cloth. The Rotinese also weave a token handkerchief-sized textile, which is used as an offering to the ancestral spirits. These textiles are all cotton, but Rotinese weavers also make *gewang* palm fiber (*Corypha elata* Roxb.) into undecorated or simply dyed garments used as work clothes.

Most cotton items are decorated by warp ikat, which on Roti once involved the use of the natural dyes of indigo for blue-black, *Morinda citrifolia* for red, and *Curcuma domestica* for yellow. The yellow was colorfast, but the red was used with an incomplete mordant, and faded with washing or exposure to light.[3] Dyeing was traditionally fraught with supernatural dangers, and the word for indigo dye, *tau*, is associated with the root *tau*, meaning "to terrify."[4] *Tifa tau*, meaning "to pay [for] the indigo dye," is the term used to denote blood money paid for killing a person; in such a case, a pot of indigo dye would be poured on the victim's grave. It is interesting to note that the repeated immersions and overdyeing with other colors make the indigo appear black— a color the Rotinese associate with protection and benevolent spirits.

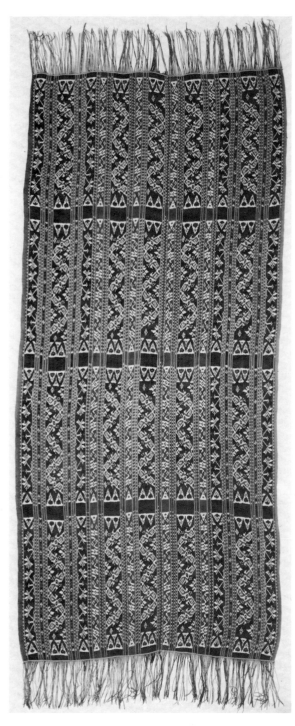

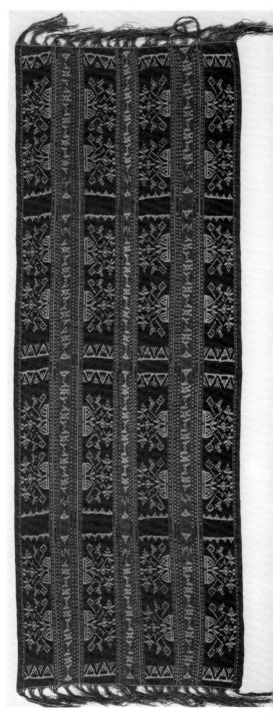

148 **Selimut**
Ndao, clan Londo
Warp ikat
Cotton
Warp 206 cm, weft 86 cm
James J. Fox, Canberra

*These textiles were woven on the small
island of Ndao, located between Roti and
Savu, and reflect design affinities with
both neighbors. Most notable are resem-
blances to Savu textiles. The first textile*

*is constructed of two panels of unequal
width, and shows an uneven number of
major warp stripes—here five—in the
manner of Savunese textiles. (A similar
Rotinese textile would be constructed of
a single panel and have an even number
of major design stripes.) The second tex-
tile carries wide bands, with groups of
tree-like forms. Such clusters, the spatial
allotment, and design size are more char-
acteristic of Savunese woman's sarong.
The designs on the textiles of the*

149 **Selimut**
Ndao (?)
Warp ikat
Cotton
Warp 211 cm, weft 66 cm
The Brooklyn Museum, Brooklyn
60.108.13 Gift of Adelaide Goan

*Ndaoese no longer carry class distinc-
tions. Both of these textiles would have
been worn by men as hip wrappers or
shoulder cloths.*

Surely these are qualities they associate with their textiles as well.[5]

Today Rotinese women are largely abandoning the weaving arts, because their textile needs are met by Ndao weavers. This is an ironic twist, for by legend the Rotinese originally acquired their weaving skills from the Ndao people. The extreme poverty of this island between Roti and Savu has for centuries caused the men of Ndao to seek seasonal work on Roti or Timor, where they function as itinerant gold- and silversmiths. In more recent times, they have returned bringing orders *Figures 148, 149* for weaving and examples from which to pattern the products. This in turn has influenced the locally utilized textiles of the Ndaoese themselves. Their fabrics were formerly similar to the products of Savu, especially the women's sarong, but now they incorporate Rotinese designs as well.

NOTES

1. Fox 1977a and 1977b
2. Bühler 1938-39:82
3. Ibid.:84
4. Fox 1973:360
5. Ibid.:363-364
6. Fox 1977b:102

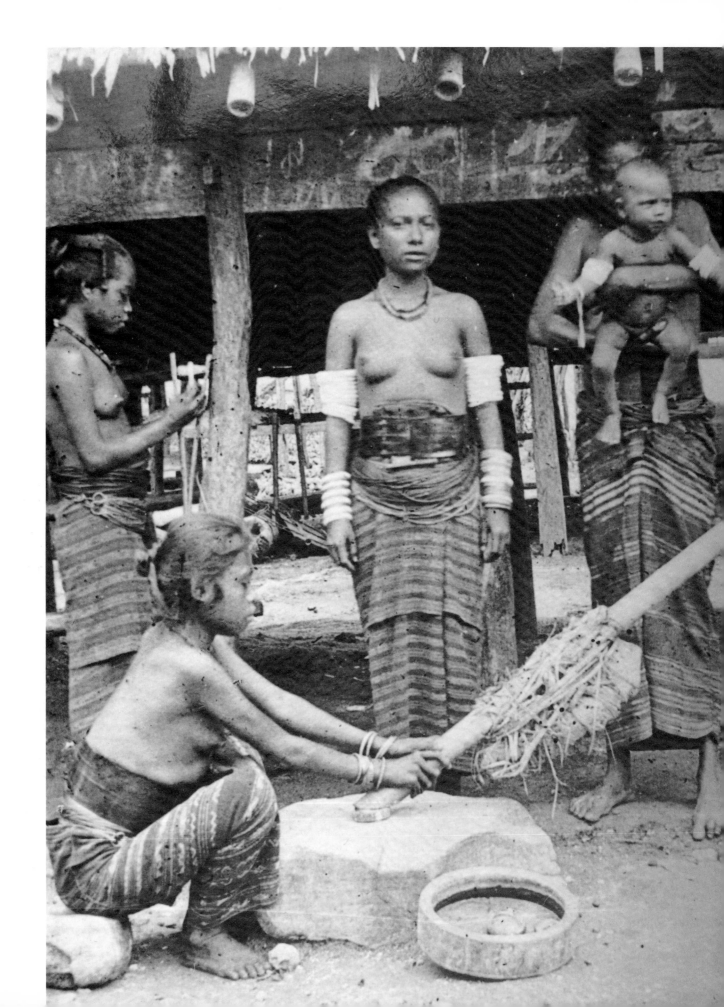

SOUTHERN MOLUCCAS

The Southern Moluccas are groups of islands that dot the sea between Timor and New Guinea. The land is mostly hilly, and inhabited by peoples once notorious for their ferocity. It has been the traditional trading grounds of Buginese and Makassarese, but in the seventeenth century, the Dutch secured several islands in an attempt to protect their spice trade, centered on Banda. Since the late nineteenth century, however, this region has received little attention except from a few missionaries and minor commercial interests.

With the exception of textiles from Tanimbar and Kisar, few examples of weaving from these islands exist in Western collections. Even fabrics from these two areas are rare; those that do exist are accompanied by written records that report on the weaving. The major forms woven are the tubular sarong, the loincloth, and, on Kisar, a slendang used as a belt or carrying band.[1] On this island they also wove a special loincloth called *warpitare*, which was reserved to important leaders for festival occasions. Designs worked by decorative wefts seem to have been its distinguishing trait.[2] This is in contrast to warp ikat, which has traditionally been the major decorative technique in the entire area, and is used to create simple figures of humans, more schematic renderings of figures defined as canoes, combs, and centipedes, and a web-like covering of geometric forms.[3]

Kisar sarong in particular have an attractive inventory of humans with raised arms, birds, bird-and-rider figures, and animals that may be dogs or pigs. These are arranged in 7- to 8-centimeter bands near the top and bottom of the garment. While a few similar, but narrower design widths may be arranged between these, most of the sarong is built from simple stripes. Within the stripes may be yarns ikatted with spots. These alternate with solid colored yarns, giving the entire surface a subtle visual interest not possible with plain stripes alone. This effect of surface reticulation through careful manipulation of the warp stripes is a dominant characteristic of the region, also appearing on more simply patterned sarong from Tanimbar. It was a way to introduce brilliantly dyed commercial yarns in conjunction with locally dyed and ikatted yarns that lacked hard colors.

150 *This old photograph illustrates the manner in which Tanimbar women wore their cotton sarong. The long, tubular form is doubled back upon itself and secured at the waist by a thick copper chain belt. There were many different types of sarong, each defined by a certain color of stripe, the presence of ikat designs, and similar traits. The textiles worn here would probably be considered festival wear, because work sarong were extremely short and made from palm fibers. The woman in the foreground is making a shell armband similar to the ones worn by the woman behind her. Such bands, as well as the sarong, were important in gift exchanges and ritual. (Koninklijk Instituut voor de Tropen, Amsterdam)*

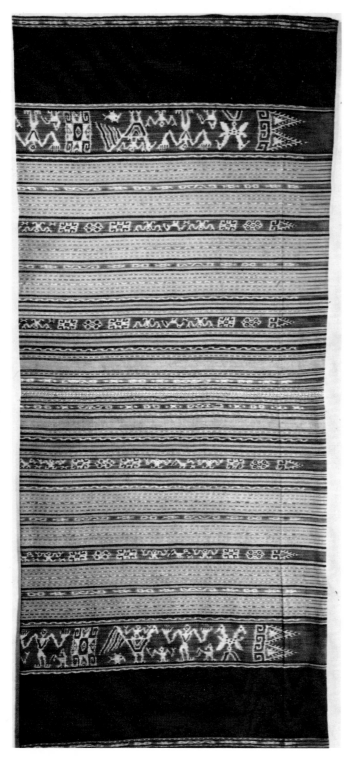

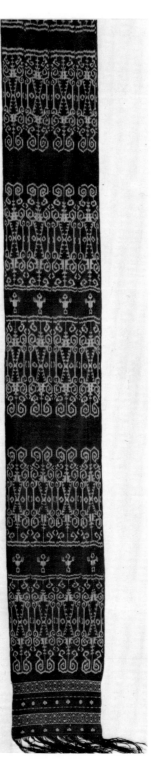

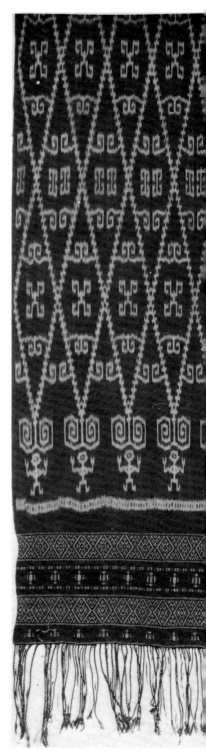

151 **Sarong**
Kisar
Warp ikat
Cotton
Warp 137 cm, weft 152 cm
Textile Museum, Washington, D.C. 68.7

152 **Loincloth**
Tanimbar
Warp ikat, supplementary weft
Cotton
Warp 261:6 cm, weft 25.4 cm
The Brooklyn Museum,
Brooklyn 45.183-8

153 **Loincloth**
Tanimbar
Warp ikat, supplementary weft
Cotton
Warp 383 cm, weft 30 cm
Tropenmuseum, Amsterdam 1970-2

Figure 150 Tanimbar sarong may be cotton, or a combination of cotton and fibers from the lontar palm *(Borassus flabelliformis).* The palm fibers were ikatted in the same manner as the cotton, and then woven to produce a stiff sarong that served as a work garment. Cotton, used to make clothing for festive occasions, was either imported or collected in the local forests, where it grew wild.[4] Beaten bark cloth was also used to make clothing such as jackets and loincloths for men.

Sarong and loincloths were important real and symbolic goods in local gift exchanges, being counterbalanced by earhangers and palm wine.[5] Tanimbar weavings were traded to other islands in the Southern Moluccas and Timor chains; and this added distribution is probably the reason that a few eventually entered museum collections.

The Kisar example shown here is a sarong of two joined cotton panels. In the center are bright red and magenta stripes filled with narrow widths of dappled ikat work. Within the center, and at the top and bottom, are brown bands of ikat figures, which have been outlined with surface painting in black. The end borders are a solid blue-black that provides a contrasting frame for the entire arrangement. The loincloths

Figures 152, 153 from Tanimbar are an indigo blue with ikat figures in the natural cotton color. The geometric designs in the border are worked by supplementary wefts that extend the entire width of the cloth. Between these rows, small shapes created by discontinuous wefts are laid-in with the regular wefts. The ends are finished with a single row of twining and fringes that are plied and twisted.

NOTES

1. Jasper and Pirngadie 1912:274
2. Ibid.
3. Drabbe 1940:120
4. Geurtjens 1920:365
5. Drabbe 1940:187ff

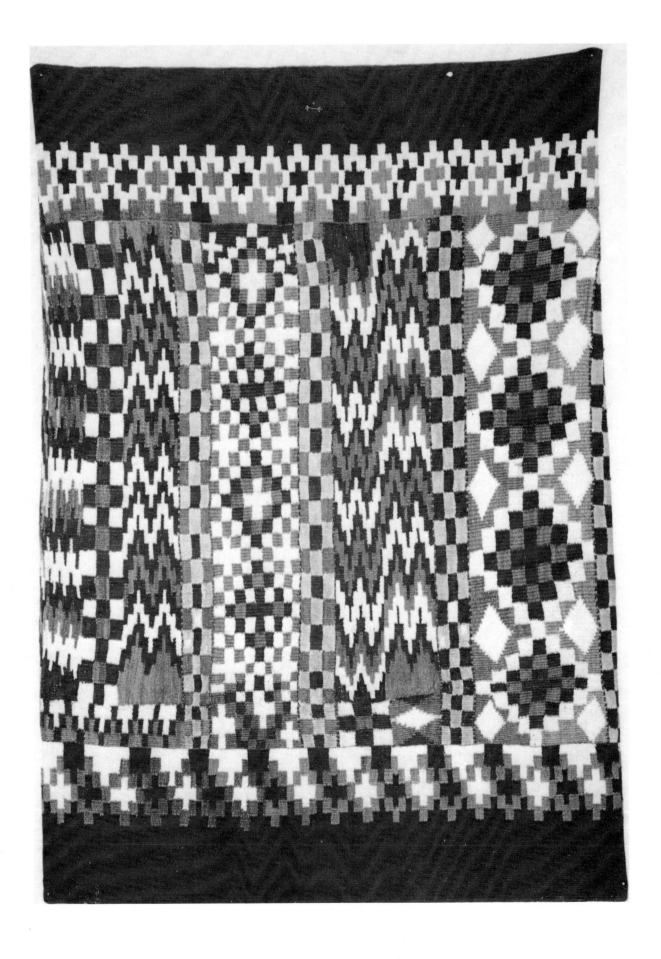

CERAM

The people on the south coast of Ceram, an island in the far eastern part of Indonesia, produced extremely unusual sarong characterized by a sampler-like array of decorative techniques. The present example is relatively modest, with a structure made entirely of tapestry weave. This restraint is balanced by the exuberance of its colors, which are bright blue, red, and white. To make the sarong, three discrete pieces— a large central band, and two narrower bands (top and bottom)—were sewn together.

This unique piece was collected by the Frobenius Institute's expedition to Indonesia in 1937-38, along with records that say such sarong were women's festival dress.[1]

A more usual sarong from this island would have both decorative warp- and weft-oriented patterns. In the warp direction might be supplementary warp and warp ikat figures, as well as alternating colors of red, blue, and white. At the same time, the weft stripe designs would be worked by supplementary wefts, twining, tapestry weave, and even sprang. Though the designs carried in all these techniques are geometric forms, the visual activity of pattern, color, and orientation on the usual Ceram sarong proves somewhat disconcerting, albeit remarkable.

154 **Sarong**
Ceram, Tamilau region
Tapestry weave
Cotton
Warp 160 cm, weft 109 cm
Museum für Völkerkunde, Frankfurt NS
31649

NOTE
1. Niggemeyer 1952:3895

CELEBES (Sulawesi)

The island of the Celebes has a rough, mountainous central area and four peninsulas flung like distorted arms into the sea. History has treated each of these areas differently, and this is reflected in the textile arts. In some the skills have disappeared entirely, in others they have merely been modified; but a century or more ago, the whole island was producing an amazing array of textiles notable for their varied decorative techniques.

In the far northeastern peninsula, the area of Minahassa, the women once made garments from beaten bark cloth and textiles woven from *Musa textilis* (a variety of banana), bamboo, pineapple, and cotton.[1] Of these, their cotton weavings excelled, and come to us today under the general name of *kain bentenan*, probably after the general area in which they were woven. They are basically of three types: an ikat sarong; a striped textile; and a textile with zigzag lines, diamond shapes, and honeycombs, produced by warp floats.[2] The designs in warp ikat recall details in the textiles from Kisar in their muted colors, simple geometric forms aligned in warp stripes, and human figures with raised arms.[3]

From the information that remains, those with woven designs seem to have been the most sacred. Some were used in curing rites and others, according to mid-nineteenth century reports, were "a symbol of wealth and served to bedeck the thrones of leaders and priests."[4] The report goes on to say that formerly a series of ceremonies had to be held before the weaving of the pieces could begin.

In a recent study, Bolland of the Tropenmuseum has been able to reconstruct how the warp pattern weaving of diamond forms, zigzags, and honeycomb patterns was done. Like all textiles in the region, this type of cloth, called *pinatikan*, was woven on a back-tension loom with a continuous warp. To make the designs, an intricate combination of pattern sticks and laze rods was used in a manner not commonly employed in Indonesia.[5] Another unusual feature, common to all three types of textiles, is that those destined to become sarong were completed on the loom as seamless tubes, whereas elsewhere flat rectangles were sewn along one side to make the tubular form. Strong foreign

Figure 156

155 *Among the Toradja wooden dolls, or tau-tau, representing the dead are normally placed near the grave, high in rock walls. Periodically they are brought down and dressed in new clothing. This tau-tau of a high-ranking royal man is in the process of being refurbished. Its headgear is fashioned from one of the holy sarita textiles. (Koninklijk Instituut voor de Tropen, Amsterdam. C. H. M. Nooy-Palm)*

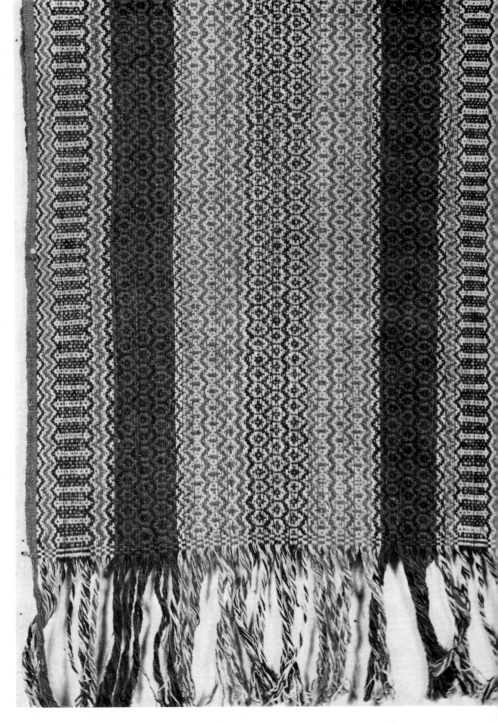

156 Kain bentenan or **pinatikan** (sacred textile)
Celebes, Minahassa region
Warp-faced alternate float weave
Cotton
Warp 146 cm, weft 32 cm
Museum für Völkerkunde, Frankfurt
NS 24258

The term kain bentenan refers to a group of textiles once woven in the far northeastern peninsula of the Celebes. This includes textiles called pinatikan, which had an unusual type of warp-faced alternate float weave. The patterning was a taxing procedure requiring several months of work for each kain. Though they were highly valued and used in religious rites, their very complexity probably brought about their demise. Their manufacture ceased at the turn of the century, and only a rare handful exist in museum collections today.

Cotton and leaf fiber skirts with this particular float weave were once also made on Ceram, to the east of the Minahassa. Here the technique was used in narrow stripes and not overall patterning.[30]

influences in this northeastern peninsula, with the usual accompanying importation of manufactured textiles and different concepts of religion and status, brought an end to all these forms of weaving in the nineteenth century. They are now rare items in a few museums.

At the opposite end of the island, in the far southwest, foreign contacts had quite another effect. They introduced new fibers, caused a breakdown in color proscriptions, and fostered the concept of change for reasons of "style," but never killed the local craft by means of cheap

157 Kampua (cloth money pieces)
Buton
Plain weave with paired warps and wefts,
occasionally tripled
Cotton
Warp 19 cm, weft 18.5 cm (left)
Warp 16.5 cm, weft 15 cm
Tropenmuseum, Amsterdam 1894-3a
(left); 1894-3b

These modest bits of cloth once circulated on the island of Buton and limited parts of the Celebes as coinage. Their colors and stripes were distinctive to the high official who issued and backed them with coin. Originally their manufacture and distribution were the prerogative of nobles, but in the course of time, lesser administrators also issued pieces. They were first noted in use in the seventeenth century, and continued well into the twentieth. The first example has a blue plaid on a natural beige cotton base; the second, fine red stripes on a natural beige background. Both are made from handspun yarns, and seem to have been woven on a loom that utilized a reed.

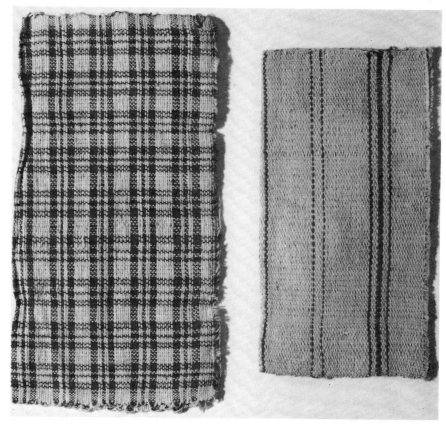

imports. This is the region of the Bugis and Makassarese, traders and notorious sea rovers. By the sixteenth century, they had managed to divert enough of the spice and sandalwood trade from the Moluccas, Timor, and Solor to anger the Dutch, who were trying to create a trade monopoly. Finally, in 1669, the Dutch captured their port of Makassar and as a result of the restrictions imposed there, caused the diaspora of the Bugis throughout much of Southeast Asia. While the Bugis had always been traders before, this displacement involved entire families, who established settlements in Malaya, Borneo, and the Riouw archipelago.[6] The influence of their textile traditions, primarily in silks and plaids, has never been studied, but it must surely have been absorbed into the basic coastal complex that manifests itself in many of the *pasisir* or coastal cultures of the archipelago.

In their homeland, the Bugis' textiles, called *lipa bannang*, were originally dark cotton plaid sarong, dyed in red, black, or brown in a motif called *cura' caddi*, meaning "small squares." Reserved for the nobility was the *lipa garrusu*, a cotton sarong that had been starched and rubbed with a seashell to produce an extremely high glaze. These textiles are still made in the Bulukumba and Sidenreng-Rappang areas today, and are worn by conservative people at weddings and circumcision ceremonies. The plaid designs were translated into silk when these trade yarns were introduced. Later, ikat and supplementary weft patterning altered the silk and cotton even more.

Accompanying the sarong was a red cotton blouse that had been dyed after the weaving of the fabric. Other colored blouses were indicative

Figure 157

158 Sarita (ceremonial banner)
Celebes, Toradja people
Batik
Cotton
Warp 225 cm, weft 26 cm
Textile Museum, Washington, D.C. 1976.
43. Gift of Ernest H. Roberts and Near
Eastern Art Research Center

*The designs on the sarita usually mirror
the carved and painted wooden decora-
tions found on the Toradja houses. One
of these dwellings, called tongkonan, is
depicted on this textile. They are great
pile-supported structures with dramati-
cally projecting gables. Their details, in-
cluding the types of designs carved on the
wooden panels, reflect the social rank of
the family. It is not known whether the
designs on the sarita had a similar func-
tion, but ownership of one of these
sacred cloths was indicative of high
status. The textiles were flown from tall
poles set before the great houses at fu-
neral ceremonies, or used in the head-
gear of a shaman or that of the wooden
figure carved to represent a dead person.
They were considered to be sacred in
origin.*

of particular status: black for older women, green for high nobility,
white for elderly women or women who wet-nursed royal babies, purple
for widows, and yellow for young girls. These associations largely dis-
appeared in the late 1950's when the blouse, called *baju bodo*, blos-
somed in a rainbow of colors in the more liberal circles of Jakarta. This
innovation was adopted in the south Celebes, and "traditional" gar-
ments entered into the game of changing style and "fashion."[7]

Although the Celebes has a rich tradition of visually interesting tex-
tiles, those with the least visual interest involve some of the most curi-
ous customs. An example is a group of extremely plain small cotton
rectangles *(kampua)* marked only by a few stripes or a simple plaid.
These once circulated as currency in a limited area of the Celebes and
the adjacent small island of Buton. It is from the latter island that early
information originates, and it was here that Apollonius Schot saw them
in use as a monetary form in 1612.[8] Weaving the pieces was the preroga-
tive of women of the royal families, and the different sultans' issues
were recognized by particular combinations of stripes and colors. Each
of them was backed by coins. In time, lesser administrators also issued
their versions, and more colors and types came into circulation. Cloth
money continued in use and was still issued by sultans of the island
well into the twentieth century.[9]

Apart from the island of Buton, on Çelebes itself, among the eastern
Toradja, the To Mori, and neighboring groups, a similar phenomenon
occurred, involving sarong that can only be considered as token textiles
because of their size and manner of manufacture. Most are a plain
weave with a simple blue stripe, and have a loose consistency that is
often accentuated by a torn and frayed condition. They are approxi-
mately 80 centimeters long and 35 centimeters wide, and were made on
a loom with a continuous warp. This circular form is retained in some
examples. The textiles were endowed with mystical powers and were
an extremely important element of marriage gift exchanges. Later, when
they were no longer woven, they were often torn into pieces, and these
fragments circulated in the exchanges. Certain pieces were even "rented
out" to be used in rituals.[10] In some areas they were believed to increase
the prosperity of their owners, and were viewed as a direct link with the
ancestors. Among some groups the textiles were used in a ritual context
at funerals, girls' initiation rites, and feasts for metal workers. In other
areas they served primarily as a means to pay fines; for engagement pur-
poses;[11] or as a representation of one's counter-spirit, which had to be
carefully tended in times of peril.[12]

The concept of sacred textiles extended to the interior, but in con-
trast to the former modest cloths, those of the inland are often of great
visual interest. Some have historical significance because of their tech-

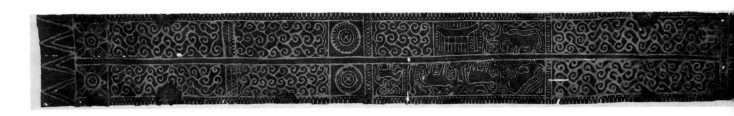

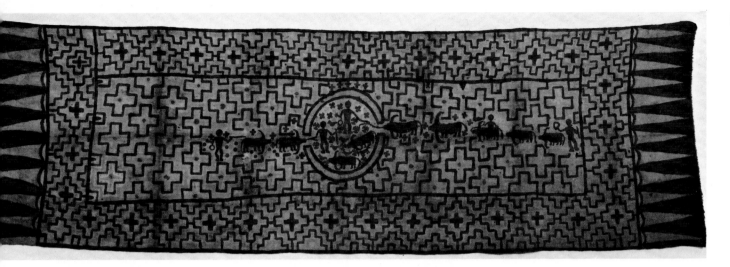

159 **Maa'** or **mawa'** (sacred ceremonial textiles)
Celebes, Ronkong region ?
Painting (and stamping ?)
Cotton
Warp 220 cm, weft 66 cm
Anita Spertus and Robert J. Holmgren, New York

The sheer delight caused by the visual interplay of forms as well as the subject matter of this textile are virtually unparalleled in the textile arts of Indonesia. Here herders drive their long-horned buffalo through the gates of a corral, where they are joined by birds and other small forms. The general tempo of the scene is increased as the animals approach the enclosure, by the proliferation of small solid crosses that echo the open, *irregular, pulsing crosses of the background.*

While such a literal scene is unusual, the subject matter has great meaning for the Toradja. Buffalo are a major component of ritual and real wealth, and the child who sacrifices the largest number of these great beasts at the death ceremonies for his parents receives the largest share of the inheritance.[31] The figures on the textile are brown, against a sepia-toned ground.

Figure 158 nical features. Of these, the most important was the type called sarita, the designs of which were worked by a resist process that must have resembled batik. This evidence of a wax-resist technique on an island not heavily subjected to Hindu-Buddhist cultural influences provides a rallying point for those who claim that batik was indigenous to the archipelago, and not just an imported craft from India. Physically the cloth is a long, narrow textile with designs of scrolls, tendril-like forms, circles, and even buffalo, the animal so crucial to Toradja ritual. Often these images are delightful conceptions utilizing the animal's horns and bulky mass in imaginative stylized renderings.

Figure 8 According to the Toradja, the sarita and their other sacred cloths, all called maa' or mawa', were made from divinely given yarns.[13] Thus sanctified, they were prized ritual accouterments used in a number of ways. They could be flown from tall bamboo poles set before the house of a dead person, or wrapped around the head of the wooden effigy *Figure 155* representing the dead. The long narrow cloth might also be part of a shaman's headgear, although at one time only headhunters could use them in this way.[14]

In the nineteenth century the sarita were imitated by the Dutch in the Netherlands and exported to the Celebes. In these imitations, the resist was applied by means of wooden blocks, and then the cloth was dyed indigo. The imprecise register of the blocks is often discernible on these textiles. Of the sarita that were apparently made in the Celebes, some have stippled lines, suggesting that a blunt tool was used to apply the resist; others have designs with continuous contours, implying the

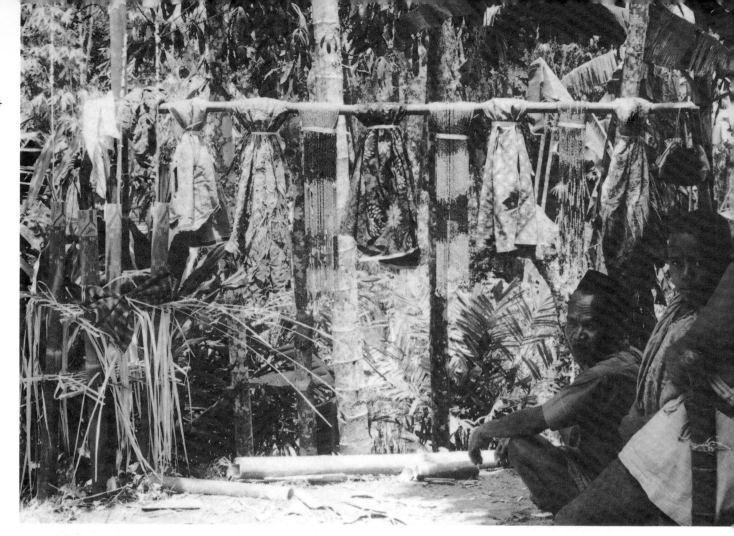

160 *These are sacred maa' textiles and a beaded ornament, the kandaure. They have been set out near a small shrine to the gods on the occasion of a Merok celebration in the Toradja village of Buntao. The celebration, while part of a larger cycle of rites, has the aspect of a feast of merit, because it both expresses thanksgiving for prosperity and promotes* the well-being of the family.[32] *The maa' textiles consist of imported and locally made fabrics, most of which originated in the nineteenth century or before. Over time, many of them acquired specific names and even specific attributes. (Koninklijk Instituut voor de Tropen, Amsterdam, C. H. M. Nooy-Palm 1969)*

use of another type of instrument. In these pieces beeswax was used as the resist substance, whereas the Dutch apparently used a combination of other substances.

The Toradja, and in particular the Sa'dan, had other types of sacred textiles in the mawa' category. These encompassed a broad spectrum of textiles, some locally made and others imported, e.g., Javanese batik, Indian patola and patola imitations, and Indian painted textiles. Of *Figure 159* their own design were stamped and painted fabrics and boldly patterned plangi cloths. The designs on the former depict the buffalo and other animals symbolic of ritual wealth. These textiles show the artists' superb sense of patterning, and their pictorial aspects are quite unmatched in the textile arts of Indonesia. Toradja plangi-dyed textiles are also *Figure 161* unusual in comparison with the others worked in the archipelago by this resist technique. Normally small resist areas are used to build large design elements, and these all directly recall Indian models. The Toradja, in contrast, use great brilliant color masses in designs more reminiscent of the African application of the technique.

161 Poritutu roto (ceremonial banner)
Celebes, Rongkong region
Plangi
Cotton
Warp 340 cm, weft 64 cm
Museum voor Land- en Volkenkunde,
Rotterdam 26055A
(Approximately one-third illustrated)

*The large scale and dynamic qualities of
this textile's design make it a striking
banner. Great splashes of reddish rust and
beige mark a bluish-black field. In areas
not illustrated, smaller circles and tumpal
complete the cloth. They are all made by
plangi, a resist-dye process known else-
where in the archipelago but rarely ap-
plied with such verve.*

*In some villages, such textiles were re-
garded as sacred cloths and were hung on
poles before the house of a dead person
to announce the death. Elsewhere, they
were used as clothing pieces by both men
and women.*

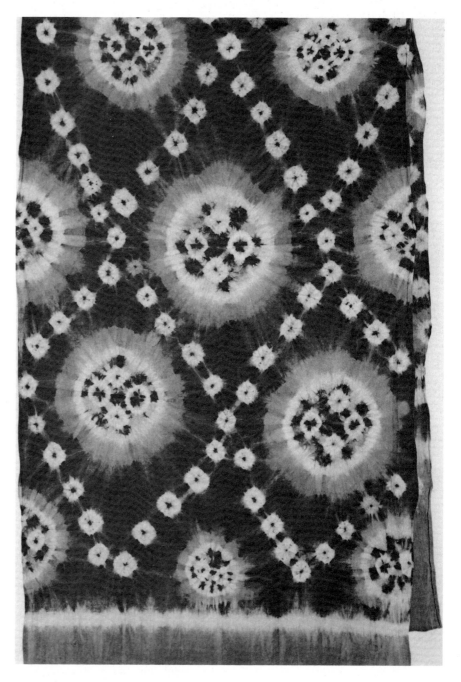

Again, these textiles and certain imported ones were considered
sacred, and entered into ritual in many different ways. Some were worn
by shamans in the course of their rites; at the deaths of important peo-
ple they might form a canopy over the body.[15] Others covered the drums
at great ceremonies.[16] Some had specific properties and names, for ex-
ample, a cloth called "the highest point of the sky" was efficacious in
the cure of sick animals.[17] All the functions and properties of these
textiles have yet to be documented, but it is evident that they were
important in the ritual life of the Toradja.

Figure 162 The most striking of the Toradja textiles, both in size and design,
are the warp ikat funeral shrouds. They have great, vivid forms that
hammer home a single visual statement. Usually this is a hooked dia-

mond, called a *sekong* or *sekon,* or a series of arrow-like forms. These designs flood the two central panels of the textile. Flanking each central area is often another textile width, which is only striped, not ikatted. A third type, up to three meters long, has ikat designs arranged in horizontal bands flanked by striped borders. One interpreter of the major sekong motif sees these tiers of hooked diamonds as a series of interlocking human bodies.[18] These textiles were dyed and woven in the Rongkong and Karataun valleys,[19] and traded to other Toradja groups for various uses. By their makers they are used as funeral shrouds, but elsewhere they are worn as clothing or displayed as wall hangings at important funeral feasts.[20] Strangely enough, these great textiles seem to have escaped the notice of the foreigners who worked or traveled in the area until the 1920's.[21]

Not only did the Toradja weave cotton, but also fibers from the fan leaf palm *(Corypha gewang* or *elata),* pineapple, and a rush *(Fimbristylis globus* Kth.). They still weave pineapple-fiber ritual clothing and screens for partitioning sleeping areas for guests.[22]

A Toradja textile skill that did not go unnoticed was the making of small bands, which was reported as early as 1874[23] and later described in detail by the great early chronicler of Indonesian weaving, J. E. Jasper.[24] This weaving was done with the help of small tortoise-shell tablets, not unlike playing cards in size, which had a hole in each corner. Warp yarn stretched through the holes could be manipulated by raising and lowering certain cards and turning particular combinations to yield designs. These patterns might be simple repeats of geometric forms or unimaginably complex bands with Arabic writing. Up to 182 tablets were used to make certain combinations.[25] At one time, this skill was practiced all through the South Celebes. The tablet-woven bands served a number of functions: as sword and trouser belts, decorative *Figure 163* edgings for clothing, sashes and headbands for funeral dolls, and trim for loincloths and mourning hoods. Tablet-woven bands were also cut into segments and sewn together vertically to form bags for betel. These, as well as a woven variety, were carried by men.[26]

Figure 164a, b Not all Toradja groups wove textiles; some beat them from bark. Called *fuya* in the Celebes, this is the tapa cloth of ethnographic literature. Nine varieties of trees provided the bast, and of these the paper mulberry *(Broussonetia papyrifera)* and *Trema amboinensis* were most important. The bark was stripped from the trees and then the inner layer of bast separated from the hard outer bark. This softer layer was then retted and finally beaten with stone-headed beaters.[27] Smaller strips were felted together to create the desired sizes.

Fuya served just as a woven fabric might for headwrappers, ponchos, loincloths, bags, sarong, and women's tailored blouses. If these garments were to be for daily wear, the bark cloth bore little ornament. If destined for festival garments, it was decorated by immersion in dye, or by freehand painting, or more rarely, by stamping with wooden stamps. Blouses were either painted with designs or had barkcloth or cotton pieces appliquéd as decoration, often in combination with embroidery. The designs and colors on the men's headcloths were linked to the number of headhunting expeditions in which the wearer had partici-

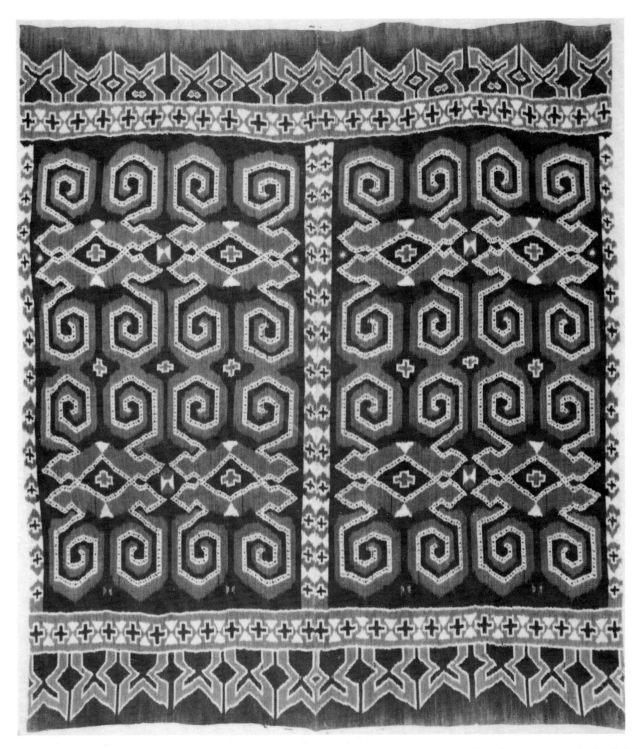

162 **Paporitonoling** (death shroud or hanging for ceremonies)
Celebes, Tonoling region
Warp ikat
Cotton
Warp 145 cm, weft 178 cm
Museum für Völkerkunde und Schweizerisches Museum für Volkskunde Basel, Basel 95162 (*Color plate*)
The name of this great textile, *paporitonoling, derives from the area in which*

it was made, Tonoling, and the root word pori, meaning to tie or to bind.[33] *This is in reference to the tying process involved in warp ikat, the method used to create the designs. Here ikat has been used to create a deep red and blue-black patterned textile of striking visual power. The large forms appear to be geometric shapes, but one analysis of similar forms interprets the scrolls as arching legs and arms of a figure. In this interpretation, the diamond*

above these is seen as the head of the figure.[34]

Such textiles were used as death shrouds in the Rongkong and Karataun river valleys and traded elsewhere to be used as hangings at funerals or as clothing. Very few of the textiles are made today, and those that are utilize commercially spun yarns and are more attuned to the increasing tourist trade in this region of south central Celebes.

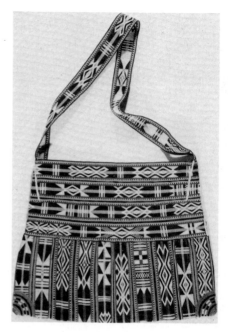

163 Betel bag
Celebes, Mamasa region
Tablet weaving
Cotton
Width at top 33 cm, height 30.5 cm
Tropenmuseum, Amsterdam 46-52

This bag, a type carried by men in the central Celebes to hold the ingredients for betel or sirih chewing, is constructed from narrow bands. They were woven with a series of pierced tortoise-shell tablets, through which the warp was threaded. The tablets were raised and turned in complex combinations to acplish the weaving and the designing. Bolland of the Tropenmuseum has investigated this technique in Indonesia and elsewhere and gives the following analysis of this example.

To make the bag: "Three long bands were cut into pieces. The first band, 11 feet [3.35m] long and woven with forty tablets, was used for the strap and the horizontal strips. For the vertical strips, two bands of 4 feet [1.22 m] and 6 feet [183 cm], respectively, were woven, one with forty-six tablets, the other with forty tablets. All three bands have narrow stripes along the selvedges in white, red, yellow or orange and black or dark blue. The middle strip with a white geometrical ornament has a black background with a red or orange strip in the middle. The weft is black or orange. The places where the edges meet, as well as the fastening of the strap, have been strengthened by embroidery in a kind of blanket stitch. The bag is lined with white cotton." [35]

pated. Sarong designs often featured sun symbols, and blouse decoration shared both this motif and patterns from the man's head cloth.[28]

The making of bark cloth in the Celebes continued long enough into the historical period for pieces to be collected and manufacturing processes described by early missionaries and travelers in the area.[29] Unfortunately, it now shares the fate of bark cloth making elsewhere in the archipelago. Not only has the making of fuya passed from the Celebes scene, but with few exceptions, the other great textile traditions as well. It should be noted, however, that this island once made an extremely diverse range of textiles, often with design features reflecting great imagination.

NOTES

1. Palm 1958:10. From the Minahassa word *wujang,* the name for their bark cloth sarong, came the Dutch corruption "fuja," which has been the name applied to bark cloth in Dutch ethnographic literature.
2. Bolland 1977:1
3. Examples may be found in Palm 1958: 59; Langewis 1964:Figures 6, 7, 8
4. Bolland 1977:12
5. Ibid.
6. Additional material on this aspect of Buginese history is summarized in Lineton 1975.
7. Most of the Bugis-Makassar material is from Sapada 1977
8. Netscher and van der Chijs 1863:189
9. Accession records No. 668.133a, Tropenmuseum, Amsterdam.
10. Kruyt 1933:175-176
11. Ibid.:178-179
12. Ibid.:80
13. Veen 1965:92-93
14. Nouhuys 1925-26:112
15. Ibid.:4
16. Nooy-Palm 1975:52
17. Ibid.:69
18. Jager Gerlings 1952:110-111
19. Nouhuys 1921-22:239; Spertus and Holmgren 1977:53
20. Nouhuys 1921-22:239; Nooy-Palm 1975:75 Item 200, Photo 18
21. Nouhuys 1921-22:237
22. Nooy-Palm 1975-37
23. Matthes 1874:334
24. Jasper and Pirngadie 1912:201
25. Bolland 1970:176
26. Nooy-Palm 1975:43
27. Kooijman 1963:57
28. Ibid.:19-28, 92 discusses headhunting symbolism and other interpretations of these designs.
29. Adriani and Kruyt 1901-04
30. Most information concerning the pinatikan was taken from Bolland 1977.
31. Nooy-Palm 1975:58
32. Ibid.:81
33. Personal communication Robert J. Holmgren, New York, 1978
34. Jager Gerlings 1952:110-111
35. Bolland 1970:175

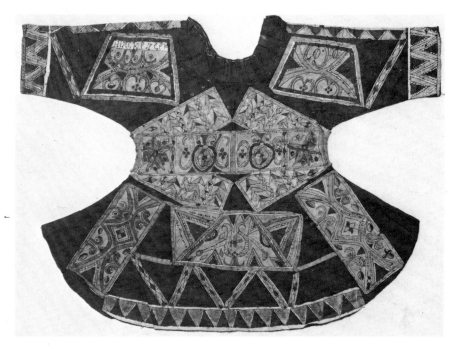

164a and b **Lemba** (woman's blouse)
Celebes, Toradja people
Painting, appliqué
Fuya (beaten bark cloth); applied mica
Width at shoulder (a) 84.7 cm; (b) 84 cm
Rijksmuseum voor Volkenkunde, Leiden
(a) 2140-1 and (b) 2746-5 (Color plate)

Certain Toradja groups did not weave, but did excel in the making and patterning of beaten bark cloth. These gaily designed and painted blouses are just one style of garment made from this material. Brilliant magenta, yellow, and black are the usual colors. Sometimes, as in the second example, the bark cloth was dyed black, then brightly painted rectangles were appliquéd to the surface. Less common are the small mica pieces glued to the surface of this lemba to provide sparkling detail.

A blouse is constructed from a single large, cutout piece of fuya that is folded at the shoulder line and seamed at the underarm and side. Cloth or fuya gussets provide the arms with more flexibility. The ruffled collar sewn to the neck opening is common. For added strength, the whole blouse is lined with another piece of bark cloth. These blouses were traditionally worn with sarong and cylindrical head ornaments of the same material on great ceremonial occasions.

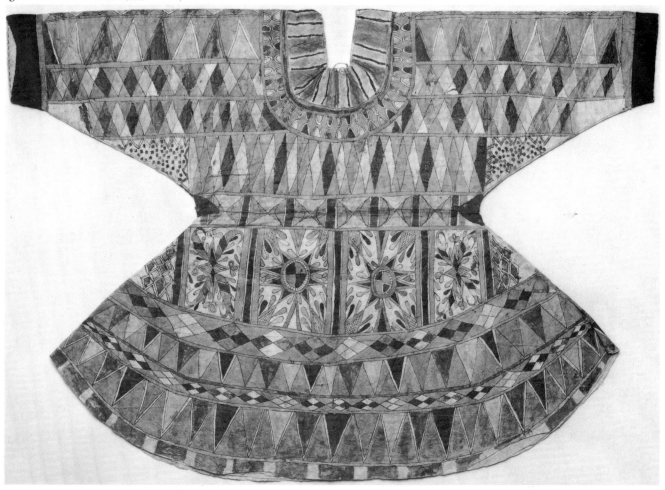

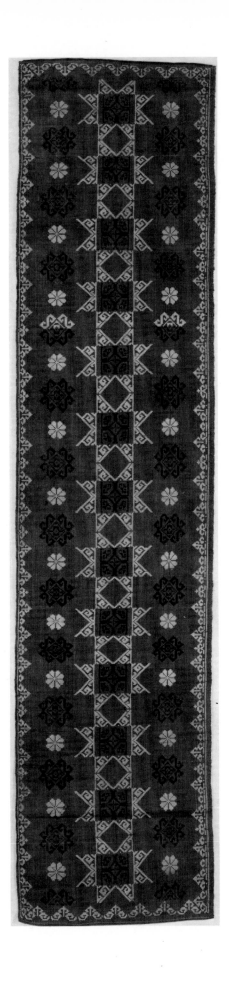

SANGIR AND TALAUD

The weavers of Sangir and Talaud traditionally made use of the fibers from a variety of banana tree. These fibers, commonly known as Manila hemp, are called in Indonesia by the Minahassa term *koffo*. They were cleaned, dyed, and woven on back-tension looms just as cotton was elsewhere. One difference, however, was in the finishing: a completed koffo cloth was waxed and polished on one or both sides.[1]

Koffo items woven were curtains, sarong, and fabric for tunics and smocks. Most pieces that remain today were parts of curtains or screens that served as room dividers or decorations for special occasions. They were composed of three ranks of narrow, decorative panels, sewn together to give lengths of seven meters or more.[2]

As late as the 1930's, koffo tunics were worn in the interior of Sangir on special occasions. Their length depended on the rank of the wearer, some being so long they trailed on the ground.[3] These garments were also worn at dances described by one early writer as occasions of an "immoral character."[4]

The example shown here was probably part of a large curtain. It has a rust ground, with geometric figures worked in blue and beige discontinuous supplementary wefts. While other examples may use a continuous supplementary weft, all show designs based on geometric patterns. Often these are diamond shapes combined with angular scrolls or an eight-pointed star.

165 **Curtain section**
Sangir
Supplementary weft
Koffo (*Musa textilis*)
Warp 132 cm, weft 30.5 cm
The Brooklyn Museum, Brooklyn 45.183.99

NOTES

1. Tonnet 1905:170
2. Ibid.:172
3. Kennedy 1935:643
4. Tonnet 1905:172

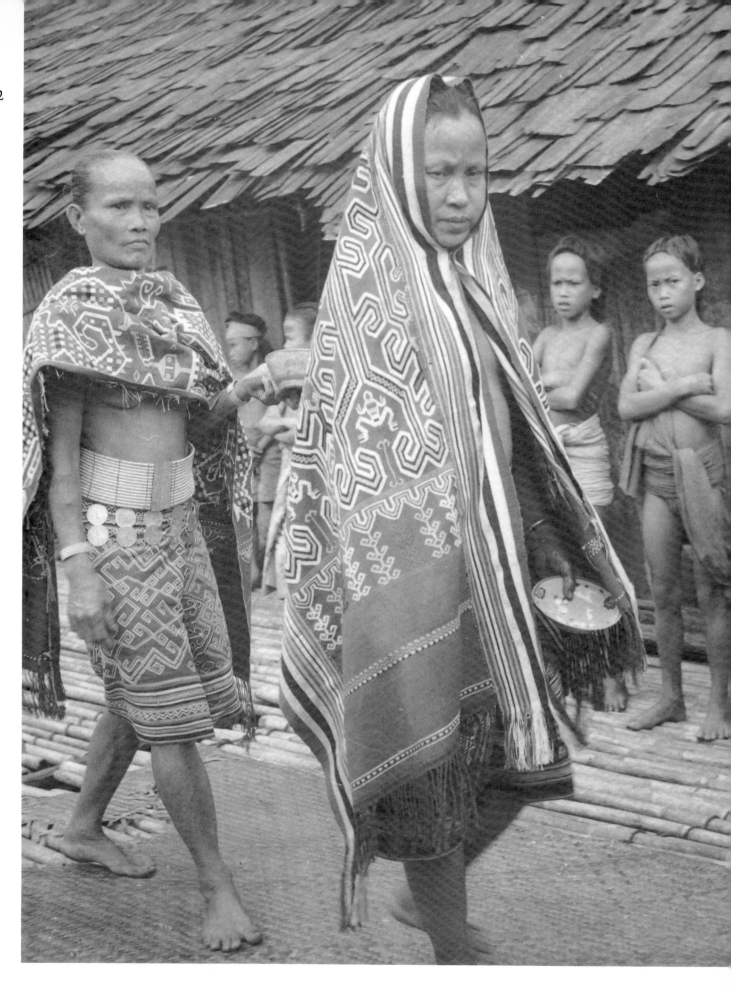

BORNEO (Kalimantan)

The peoples of Borneo have a rich decorative legacy of intricate carving, painted bark cloth, elaborate beadwork, exuberant tattooing, and lavish woven textiles. Not all Borneo groups produce all these expressions; rather it is as though each had elected to specialize in one or two.

The character of the island itself has fostered selective artistic development. Hill ranges and extensive coastal swamps prevent communication or settlement except along isolated river valleys or in coastal enclaves. In the latter live Malays, Buginese, Javanese, and Chinese who came long ago to create minor areas of entrepôt and settlement. Indigenous peoples remained inland near the main waterways and tributaries.

The people collectively called the Iban, most of whom now live in Sarawak, developed the greatest weaving traditions. They make intricately patterned textiles in the form of skirts, loincloths, jackets, shoulder cloths, and large hangings or blankets called pua. Those cloths decorated by warp ikat are the most famous, but the Iban also work designs in supplementary wefts, tapestry weave, and embroidery.[1] The Ot Danum, Bahau, and Apo Kayan, other ethnic groups that live in the river valleys in the southwest and east of Borneo, also have weaving traditions.

Textiles are central to the traditional Iban manner of life—although interestingly enough, almost exclusively on ceremonial occasions. For centuries these proto-Malay people have practiced shifting agriculture, primarily to cultivate rice, cotton, and occasionally dye stuffs. They live adjacent to rivers in longhouses which are a series of walled individual family compartments that share a common gallery. Beyond the gallery is an open veranda where yarns are prepared for dyeing and rice is dried and winnowed.[2] The gallery, which may be 300 meters long, is a general gathering place and the location of colorful ceremonies called *gawai*, at which great displays of textiles are seen. Some gawai may be geared to individual concerns, but others are part of the great cycle of ceremonies that ensures the continued well-being of the society. These

166 *This procession in a Gawai Kenyalang or Hornbill Feast vividly illustrates the use of important textiles among the Iban of Borneo. The woman in the lead is enclosed in a great pua, while her companion wears the woman's shoulder cloth and a short skirt, the bidang. Skirts are normal clothing, but the pua and shoulder cloths are indicative of the festival occasion. This event is in honor of Singalang Burong, the god of heaven, who at one time was associated with headhunting and war. (Hedda Morrison, Canberra)*

167 Pua (blanket)
Borneo, Sarawak region, Iban people
Warp ikat
Cotton
Warp 208 cm, weft 92 cm
University Museum of Archaeology and
Anthropology, Cambridge, Haddon-Hose
Collection 35.923

*Almost all Western knowledge of Iban
designs rests on the collection built by
Charles Hose, who was a civil servant on
Borneo in the latter half of the nineteenth
century. He identified the design ele-
ments on approximately a hundred tex-
tiles, and this classification became the
basis for the major existing work on Iban
design done by A. C. Haddon and Laura
Start at the turn of the century. Eighty-
four of the Hose textiles form the core of
the Iban collection at the University Mu-
seum of Archaeology and Anthropology
at Cambridge, England, and another fifty-
nine are in the British Museum in London.*

*A seemingly endless wealth of detail
combined with masterful execution make
this one of the most interesting pua in
the Haddon-Hose Collection. Nine rows
of anthropomorphic forms share the cen-
ter field in a quick-step interlock of or-
nate headgear, legs, and hands. The
interstices are filled with small design
elements, both geometric and anthropo-
morphic. Within each group of three
rows there are variations in headgear,
body markings, and body shape, and it is
this subtle difference that teases the eye.*

*According to Hose, these figures are all
called engkaramba, which may refer to
some kind of man or to a wooden talis-
man used to protect crops.[21] It can at least
be said that engkaramba were viewed as
protective and beneficent motifs. At the
top of the cloth are designs identified as
blades of paddles with W-shaped handles.
In the side borders are narrow ikat stripes
with patterns of lizards and birds.[22]*

*The figures, beige with occasional ac-
cents of dark brown, are set on a brick red
ground. The dyes for this red are made by
a complex process from Morinda citri-
folia, and an early investigator speculated
that only one in fifty women could do
such work. These expert dyemakers, well
paid for their work, were called "she who
knows the secret of measuring out the
drugs in order to obtain the rich colour."[23]
The skills were often attributed to divine
endowment, and supernatural aid was
customarily sought by offerings made be-
fore beginning the dye work. At this time
also the woman dyer strengthened her soul
by biting a piece of iron. How the Iban ac-
quired this complex skill, which evidently
reached the Indonesian archipelago
relatively late,[24] raises unsolved problems.*

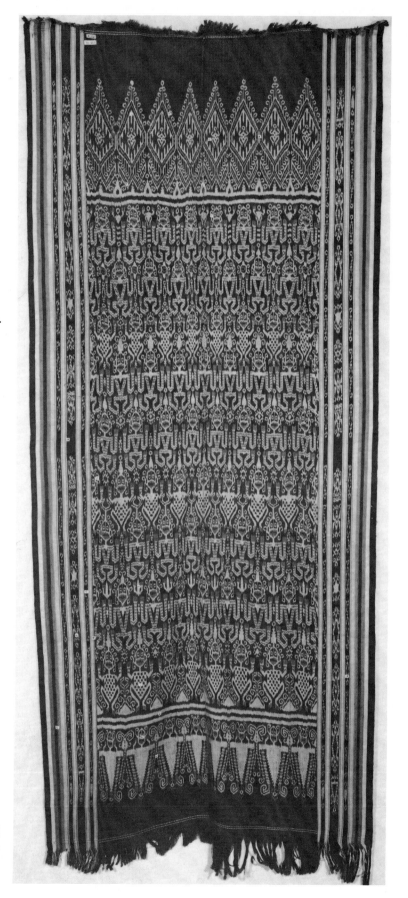

168 Pua (blanket)
Borneo, Sarawak region, Iban people
Warp ikat
Cotton
Warp 203 cm, weft 86 cm
University Museum of Archaeology and
Anthropology, Cambridge, Haddon-Hose
Collection 35.922

*The visual beauty of this pua is matched
by Haddon's imaginative explanation of
its details. The three central forms that
arch across the textile are trees whose
branches join to form "elongated poly-
gonal spaces which are filled with leaves
and pendant branches with blossoms."* [25]
*These forms are all spotted and outlined
in a light buff color, seen to represent the
light from a covering of fireflies, which
in parts of the tropics may envelop entire
trees and emit regular pulsations that
make the trees appear to be on fire.* [26]

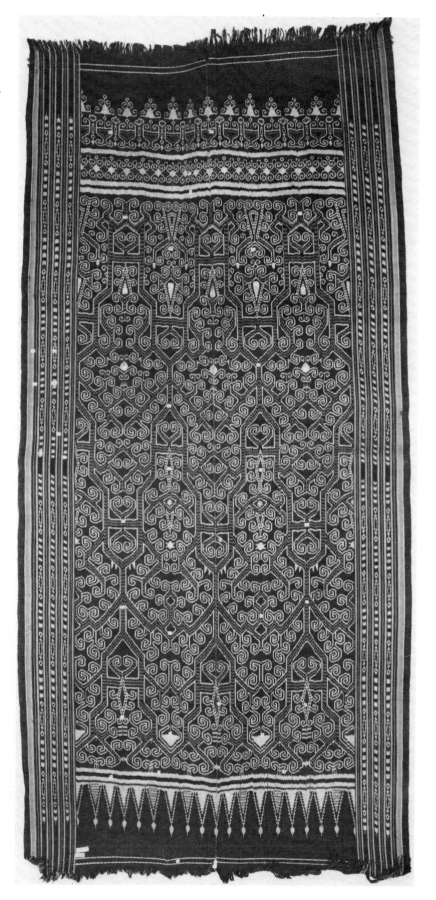

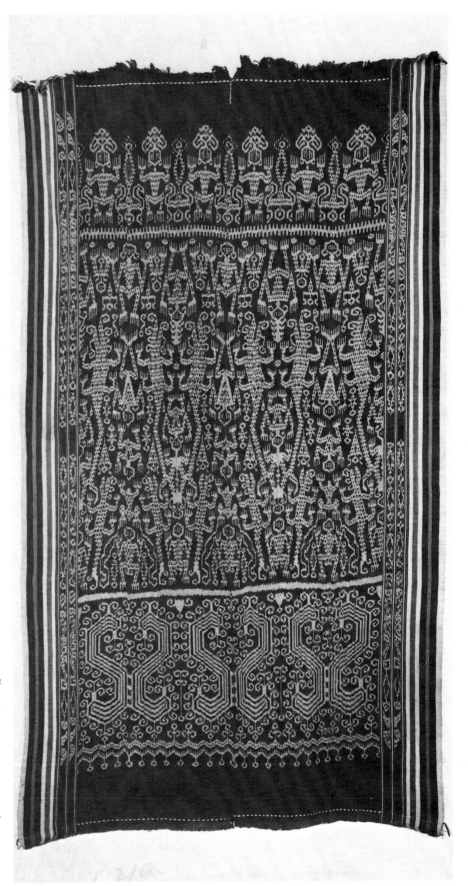

169 Pua (blanket)
Borneo, Sarawak region, Iban people
Warp ikat
Cotton
Warp 201 cm, weft 112 cm
University Museum of Archaeology and
Anthropology, Cambridge, Haddon-Hose
Collection 35.929

*The most striking pua are made from
handspun yarns, which have a slightly
irregular character that lends a pleasing
texture to the cloth. These yarns are
coarse and are almost always paired in
the warp, which precludes finely detailed
designs. When finespun commercial yarns
became available near the turn of the
century, more precision was possible. The
results were technically impressive but
often self-conscious, lacking the robust
qualities of early textiles such as this pua.
Here the yarns participate in the designs,
especially in the nubby skin of the snub-
nosed crocodiles and the costume of the
figures.*

*The designs of this pua are also remark-
able for their subject matter: in addition
to the crocodiles and figures with elabo-
rate headgear, there are headless corpses.
This explicit reference to headhunting is
rarely seen on pua.*

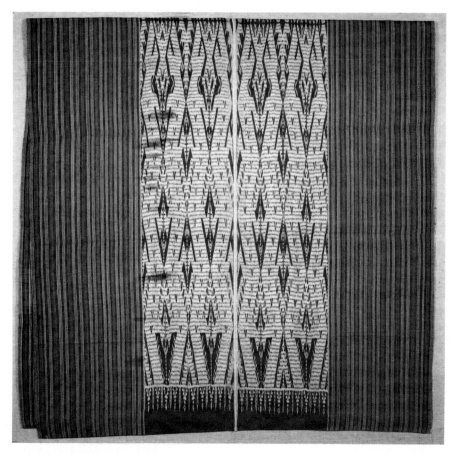

170 **Pua** (blanket)
Borneo, Mahakam River region, Bahau
people
Warp ikat
Bast fiber, cotton
Warp 218 cm, weft 110 cm
Textile Museum, Washington, D.C. 66.16
(one-half illustrated)

*Far to the east of the Iban, in the area of
the Mahakam River, the Bahau peoples
do ikat work on large blanket-sized items
and smaller bidang. Rather than cotton,*
*however, they use a bast fiber taken from
the leaves of the lemba plant (Curculigo
latifolia). When used at all, cotton ap-
pears as brightly dyed yarns in stripes that
flank the warp designs. These are
stretched, angular forms with sharp
bristles or spines. As in this example,
multiple images of crocodiles are a fa-
vored subject, with startling accents of
bright pink, green, or yellow against a
more somber brown background. This
pua is thought to have been collected
about 1910.*

gawai are connected with agriculture, warfare, and the Festival of the
Dead. Decorated textiles appear only on these occasions, and their use
has the same ritual and symbolic complexity as the ceremonies them-
selves. These are occasions for great merrymaking, when finely dressed
young people fraternize and elders flaunt their wealth. But the backdrop
for these activities is a solemn ritual in which decorative textiles are
used not for display, but as integral parts of a sacred pattern.

Figures 167, 168, 169 The large cloths called pua are sometimes used to define a ritual area.
At the Feast of the Whetstones, pua are used as an awning over the
elder who sits below the eaves of the roof to make sacrifices to the
Figure 5 stones,[3] or they are hung about the stones themselves. On other occa-
sions, a pua serves as a blanket for someone sleeping in a "dream house"
on the roof of the longhouse, seeking a spirit helper from beyond.[4] The

pua may also form a small room or enclosure on the gallery, built to contain the dead and his mourners[5] or a new mother and her child.[6] This cloth is used too in adoption proceedings.[7]

The function of the textile in these rituals is twofold. It at once becomes the means for transcendent experience and provides the protection needed at dangerous times. This is apparent in the gifts given to the shaman who conducts the soul of the dead to the beyond. They must include a bidang, for this is to "screen her from the dangers of Hades." "Unless these gifts are given for her protection, she will not be able to return from Hades."[8]

Figures 171, 172, 173, 174

The reason textiles can carry this ritual burden is locked in a ring of cause and effect. If there is a source for this protective quality, it may be in the sanctification conferred by myth, which assigns distinctive powers to particular textiles and enhances all Iban cloth with a special aura. A myth recorded at the turn of the century by the missionary Howell illustrates this:

> One day an Iban hunter shot a bird and as he went to retrieve it, it became a woman's skirt, the bidang. Concealing the garment in his arrow case, the hunter hurried home. Soon a beautiful girl who was, in reality, the daughter of the major god, Singalang Burong, appeared to inquire about her skirt. After a time she consented to become the mortal's wife, and later bore him a son. But soon she tired of mortals and prepared to return to more amorous affairs in heaven. Before leaving she wove two coats for her husband and son that were called "jackets of the birds" because of their pattern. These were capable of transporting her husband and son to heaven should they wish to join her. Eventually, after the mother had returned to heaven in the form of a bird, the son donned his jacket and followed her. In heaven it was a time of mourning for a deceased warrior, and the son was taught to observe the omen birds, to take heads to avenge the dead, how the newly taken head was to be received into the great blankets, the pua, and the details of the Festival of the Dead. The boy returned to the world and taught these culture traits to all the Iban.[9]

Figure 175

Myth thus defines the major Iban textiles: the jacket (especially the *kalambi burong*), the woman's skirt (bidang), and the pua. It also gives a sacred source to the major cultural practices. The textiles, therefore, come from the same mythical font as the Iban's most sacred traditions, and it is this joint origin that qualifies them for use in the ceremonial context.

The myth also juxtaposes these textiles to headhunting practices. The equation of these two activities is an inherent part of the Iban value system; even into this century no man's prowess was confirmed until he had taken the head of an enemy, and no woman was fully recognized until she had woven a pua.[10] As Howell noted in 1912, "As students of Dayak [Iban] life know well, the Sea-Dayak [Iban] bachelor in order to win the affections of a maiden must needs get a head first; similarly the Sea-Dayak maiden to win the affection of a bachelor must needs be accomplished in the arts of weaving and dyeing."[11]

Beyond myth it is not clear why textiles have such power for the Iban, but it is apparent even in the earliest stages of production. During the preparation of the yarns with mordants before dyeing, the same taboos apply to the longhouse community as when a woman gives birth;[12] and

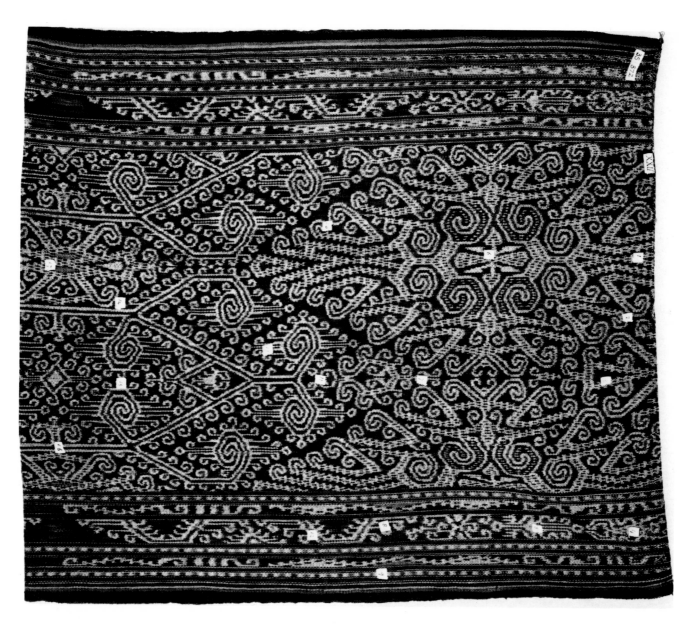

171 **Bidang** (woman's skirt)
Borneo, Sarawak region, Iban people
Warp ikat
Cotton
Warp 114 cm, weft 50 cm
University Museum of Archaeology and
Anthropology, Cambridge, Haddon-Hose
Collection 35.872

*When Hose collected his Iban textiles
near the turn of the century he had local
informants identify the individual design
elements. The small white patches on this*

*bidang are the number labels originally
sewn onto the textile to mark the name
tags applied by Hose.*

*According to these labels, the figures in
the broadest of the bottom borders are
centipedes and bird designs.*[27] *In the cen-
ter field, upper left hand corner, Hose
identified slightly over half a rice husking
box containing a shrew, and below that
a larger rice husking box. Such identifica-
tions seem to be highly interpretative.*

*Many carefully defined tendrils and
scrolls elaborate the major forms of this*

*skirt. The detailed quality is possible be-
cause of the controlled spin, the fineness
of the yarns, and the large number of
warp elements, which allow greater defi-
nition in the tying of the designs. The
dye range also contributes to the excel-
lence of this textile. Light buff forms con-
trast with a multicolored background of
deep brown and reddish brown. The
gradation in the background tones lends
a pleasing illusion of relief perspective to
the cloth surface. A few spots of blue act
as highlights.*

the very laying out of the yarns is compared with headhunting and
called "the warpath of the women."[13] The relationship of the designs to
the qualities of the textile is poorly documented by field investigation.
Haddon, the first to publish on this aspect, thought that the motifs in
the *kalambi* were related to the "omen birds" that once controlled so

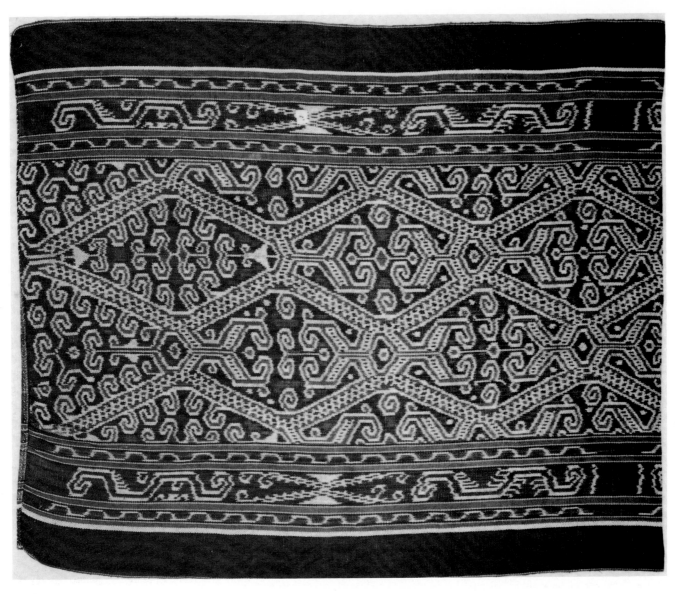

172 Bidang (woman's skirt)
Borneo, Sarawak region, Iban people
Warp ikat
Cotton
Warp 119 cm, weft 47 cm
University Museum of Archaeology and
Anthropology, Cambridge, Haddon-Hose
Collection 35.887

The designs on Iban women's skirts are almost always intricate patterns of whole or partial diamond forms with elaborations of tendrils, hooks, and scrolls. At no time do truly representational figures occur on the bidang, either in the ikat, sungkit, or pilih techniques. Variations do occur through the application of borders of commercial cloth, a hemline decoration of bells, or, more rarely, a supplementary margin of shell or beadwork.

Hose's information concerning the designs of this bidang is somewhat limited. The undulating line in the lower border is called "crossing the river." In the band above, from the left side, are a hand spinning wheel, a spear with one barb, and a centipede. In the centerfield is a climbing jungle plant.[28] The yarns in this example, as well as in the other two bidang shown, are handspun cotton.

many Iban decisions.[14] In the light of the origin myth, this seems probable.

Because of the Iban preoccupation with headhunting, it might be supposed that certain designs would refer to that practice. In the *sungkit,* anthropomorphic forms, including figures holding trophy heads [15] and images identified with headhunting customs, are favorite subjects. In ikat designs, these motifs are not so apparent. Here humanoid, croco-

Figures 179, 180

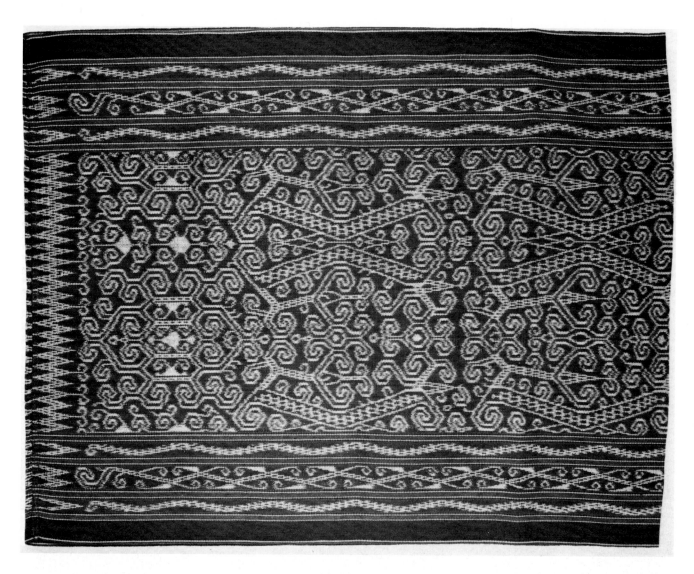

173 Bidang (woman's skirt)
Borneo, Sarawak region, Iban people
Warp ikat
Cotton
Warp 122 cm, weft 47 cm
University Museum of Archaeology and
Anthropology, Cambridge, Haddon-Hose
Collection 35.890

Iban designs in general, but in particular the designs of the Iban woman's skirt, are some of the few Indonesian textile compositions not arranged on the principle of bilateral symmetry. A design axis usually does exist in the warp direction, but it serves as the turning point for only two-thirds of the design. The remaining third repeats half of the first design, and thus creates an asymmetrical field.

The scroll design in the borders at the top and bottom of this skirt represents the arenga palm and rattan. According to Hose, the bent bar motifs in the center, with their projecting angular scrolls, are stylized deer.[29] All the designs are worked in light beige on a ground formed by a single shade of brown. The clear lines of the design and the lack of color gradations give the composition a simple clarity.

dile, and frog forms are easily identified, as well as abstract figures. Concerning human representations Haddon wrote in 1894, "Only women belonging to ancient and honourable families may make *engkaramba* [human forms] and even then they must begin by making other patterns." [16] The abstractions are a welter of hooks, scrolls, and diamond patterns. For the Iban these too have identities, but it is difficult to know whether so-called lizards, crossed poles, heads of birds, and spiders are meant to be specific or metaphorical images, and what concepts they illustrate. At one time the designs were the property of the individual weaver and could be sold or, more commonly, handed on from

174 Bidang (woman's skirt)
Borneo, Apo Kayan region
Beads, cut shells, buttons, sequins
Commercial cotton
Warp 81 cm, weft 53 cm
Textile Museum, Washington, D.C. 66.8

*The motif worked in beads in the center
band of this skirt is called* aso. *Literally
this means "dog," but the design itself
bears little relation to so mundane an ani-
mal. It probably derives from mythical
animal motifs found on the Chinese
ceramics that have been greatly prized
in Borneo. More commonly the motif is
found in bone or wood carving, and the
designs for the skirt were probably first
lightly incised or painted on a wooden
board by a man for a woman to copy in
beads.*

*The skirt is a sequence of decorative
layers supported on a foundation of com-
mercial cotton textile, a dark blue diag-
onal twill, which has been lined for
added strength. Circling the top and bot-
tom, as well as forming narrow decorative
plackets in front, are appliquéd strips of
red and yellow cotton. Superimposed on
the front strips are bead borders. These in
turn are lined with buttons that march
down the front and around the hem. Out-
side these are a few sequins and some
light embroidery. In the large central
beaded band the aso figures are worked in
yellow and tan beads, with outlines of
red and blue. Clusters of cut shells frame
the beaded band.*

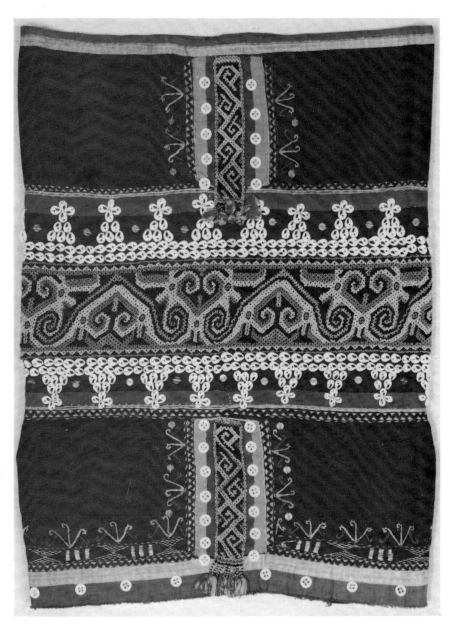

Figure 176

mother to daughter. An inventory of a hundred designs was not unusual.[17]

Bark cloth, used well into this century in much of Borneo and revived during World War II, was employed for pua and clothing, particularly jackets. In these felted cloths the fibers were darned across the grain, which not only strengthened the tissue but also yielded stitched patterns on the surface. Designs were also painted on or applied by stencil. The Kenyah people in particular stenciled exotic representations of human figures and a dragon-like creature called the *aso*. These were favorite subjects also in media other than bark cloth, such as bead and shell appliqué.[18]

Both beadwork and bark cloth ornamentation seem to have stemmed from the crafts of men. They created both the stencils and the painted boards or cloth masters used by the women as guides for the beadwork.[19]

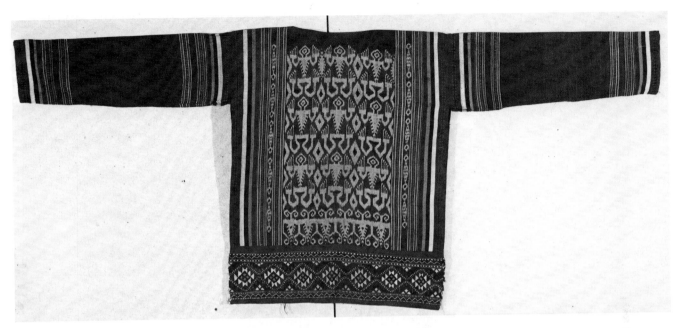

175 Kalambi (jacket)
Borneo, Sarawak region, Iban people
Warp ikat, twining, tapestry
Cotton
Height 60 cm
Museum voor Land- en Volkenkunde,
Rotterdam 19476

On Borneo, jackets of similar style and size were worn by both men and women, especially on ceremonial occasions. The majority of Iban examples are patterned by ikat, as in this example, but sungkit and pilih techniques were also used, as

well as elaborate designs worked in shells and beads. The Kenyah, Kajan, and Bahau groups once wove impressive twill and twill-striped fabrics for kalambi on their back-tension looms.

Supplementing the ikat patterns on the jacket is a twined and tapestry-woven badge at the bottom edge of the back. This example includes the unusual feature of an identical border on the bodice front. Such badges were made while the textile was still on the loom, and almost always consisted of tightly zoned diamond-shaped figures. The material

used was bright yellow, blue, red, or white cotton yarn supplemented with bits of metallic yarns. This piece from the Rotterdam collection is said to date from 1894; it is interesting to note that metallic yarns were being traded upriver at that time. The significance of these badges, if any, is not known.

According to Haddon, the ikat designs in the main body of the jacket are frog figures; the smaller flanking stripes carry lizard forms. The figures are light beige on a dark brown background.

Figure 177

Many Borneo groups used beads, shells, and buttons to adorn skirts, jackets, sword hilts, and baby carriers. The Kelabit, Maloh, Kenyah, and Kayan in particular excelled at this decoration, creating intricate networks of human, animal, and abstract patterns.[20]

In the beaded work as well as in the woven cotton textiles, it is the interlocking nature of the design that distinguishes Borneo work from other Indonesian patterning. The design components rarely exist as isolated elements, but are joined as parts of a unified whole. The asymmetrical organization of most Borneo ikat is also distinctive. In bidang and pua, the designs are rarely mirrored on a horizontal axis. The variation in features lends pleasing visual interest, yet because of the interlocking nature of the pattern the diversity never breaks the rhythm of the design.

In spite of the incursions of the modern world, textiles and decorative arts still persist in Borneo. Although the subject matter may now include vivid colors and modern, often quite amusing, forms, the style remains distinctive. It seems inevitable, however, that in a few years weaving will have become an art of the past.

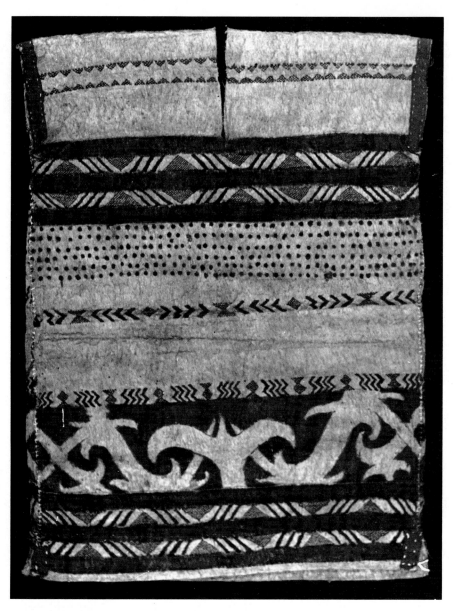

176 Kalambi (jacket)
Borneo, Kayan people
Paint, embroidery, appliqué
Beaten bark cloth
Width at shoulder, 43 cm, height 58 cm
Textile Museum, Washington, D.C. 66.7

Bark cloth has been used for a variety of garments in Borneo, from loin cloths to blanket-sized sheets. Some items were for everyday use, but others were reserved for particular rituals.[31] *For these latter articles, a fibrous white bark cloth was used, whereas other items were made from a bark cloth with a looser texture and a reddish brown color. Darning stitches, worked originally with bone or thorn needles, strengthened the material and added pleasing patterns to the surface. The yarns used were pineapple fibers and, more recently, imported cotton threads.*

This festival jacket of the Kayan shows a combination of painted and needle-worked designs on a light tan bark cloth foundation. Rows of running stitch embroidery in blue yarns build simple geometric patterns that are further accented with painted lines. The major design feature is the silhouetted aso motif in the broad lower border. Random rows of dots mediate the contrast of the geometric and curvilinear forms.

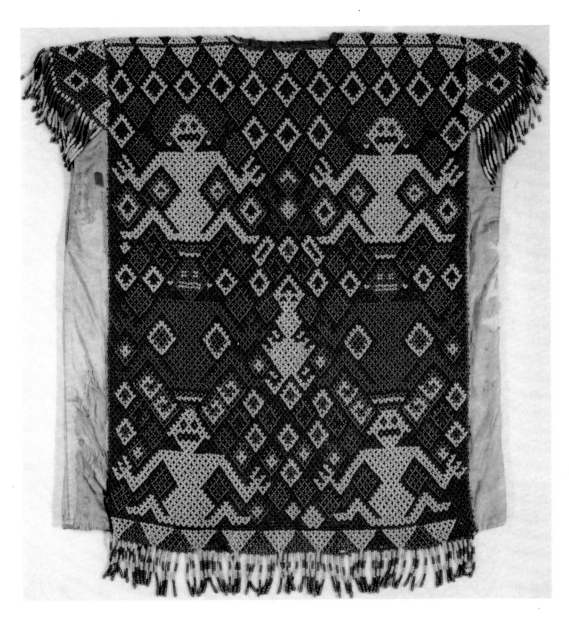

177 Kalambi (jacket)
Borneo, probably Upper Kapuas region,
Maloh people
Beads
Commercial cotton
Width at shoulder 58 cm, height 60 cm
Textile Museum, Washington, D.C. 66.26

*The Kelabit, Kenyah, and Kayan peoples
of Borneo are noted for their beadwork,
but the Iban are less so. This jacket made
by the Maloh, an Iban group, is therefore
of particular interest. The Maloh them-
selves say they learned the art of bead-
work from their neighbors, the Kayan, so
a similarity in technique and design is
certainly to be expected. This jacket is
made of large, imported beads strung in
an open-net binding, then attached to a
cloth foundation. On both the back and
front there are two green and four yellow
figures framed by a grid of small diamond
shapes. This particular splayed figure is
also common to Kenyah and Kayan bead-
work, but the diamond filling is charac-
teristic of the Maloh. Jackets such as this
one were worn by women on festival
occasions.*[32]

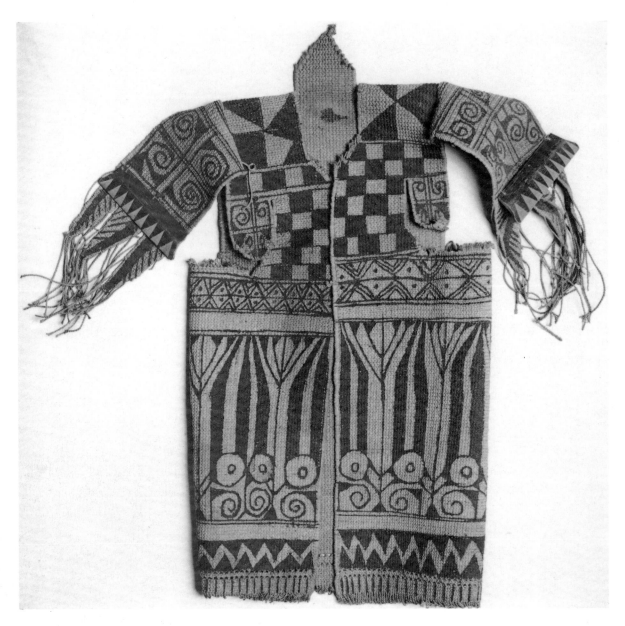

178 War jacket
Borneo, Southeast region
Paint on twined surface
Bast fiber
Height 73 cm
Rijksmuseum voor Volkenkunde, Leiden
1239-144

Both the technique of manufacture and the stylistic details of this war jacket are interesting. It was made by twining, a process of concurrently utilizing two weft elements, one above and one below a given warp. These wefts cross between the warps and exchange positions around each succeeding warp. For scholars of weaving this is a very primitive technique, placed in a nebulous category between basketry and weaving. This is because the warp yarns do not have to be separated into odd and even elements by some mechanism. In twining, the warp is completely passive and need not be strung on a loom.[33] The structure used to hold the warp elements of this jacket is not known, but the bodice is one continuous piece folded at the shoulder. The epaulettes were made separately and lashed to the bodice. Twining was once used to make war jackets on Flores and the Celebes, and headhunters' costumes on Timor. It is still employed in parts of the archipelago for making purses and finishing cloth edges.

Details of the Borneo jacket construction are completely inexplicable in terms of twining. First, a large tab that replicates the shape of the neck opening is always present at the back of the neck hole. And second, a smaller tab falls freely from the bodice over the breast near each armpit. These seem to be completely extraneous; however, if the twined work is seen as a skeomorph for a jacket made from an animal skin, the tabs become the logical parts remaining when the neckline was cut and parts of the original animal pelt—such as forelegs—were left hanging. These details were faithfully translated into the twined forms.

The designs painted on the twined surface of such jackets are characteristic: gyronny and/or checkerboard renderings on the upper front and scrolls on the lower front and back. The epaulettes, twined or carved from wood, carry pointed triangles and either scrolls or gyronny pattern. Some twined war jackets have no painted designs, but are ornamented with shell discs.

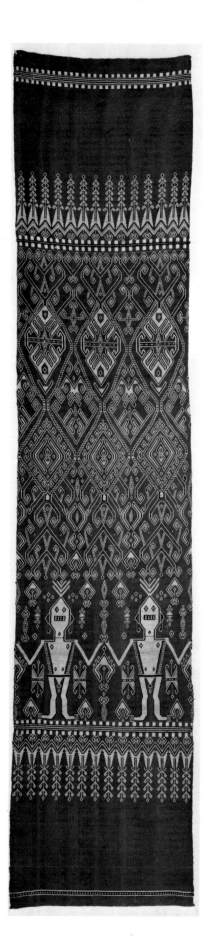

179 Shoulder cloth
Borneo, Sarawak region, Iban people
Sungkit (supplementary weft)
Cotton
Warp 241 cm, weft 51 cm
Textile Museum, Washington, D.C. 66.15

This shoulder cloth displays a delightful composition of anthropomorphic and geometric forms rendered with great skill. The background color is a rich brick red, and the figures are white with minor features in black, yellow, and green. They wear feathered headgear and many represent headhunters. Between them are flat, winged forms that have been identified elsewhere as bird figures;[34] these probably refer to the omen birds that guided Iban decisions on important matters. The precise craftsmanship is accentuated by finely spun commercial yarns. The lively colors keep the subject matter from seeming too threatening.

180 Shoulder cloth
Borneo, Ngemah River in the Rejang River basin, Iban people
Sungkit
Cotton
Warp 195 cm, weft 56.5 cm
Kent Watters, Los Angeles

Shoulder cloths like this are worn by women at feasts such as the Gawai Kenyalang, or Hornbill Feast, Figure 166 Formerly they were used on these occasions by the women as slings to carry the trophy heads that were essential to the success of rites in honor of Singalang Burong, the god of war and head-hunting.

This particular example, possibly made before the turn of the century, was recently collected and interpreted in Borneo. According to the Iban, the first four rows in the center field contain figures of Singalang Burong. Small ovals to his side are explained as skulls. Below these rows are stylized representations of a spirit figure placed over an abstract version of Kenyalang, or the Hornbill. In the bottom row are spirit figures, possibly those of people killed in headhunting.[35]

The foundation yarns are handspun and dyed a warm, reddish brown. The figures are worked in dark blue-black and natural buff colors.

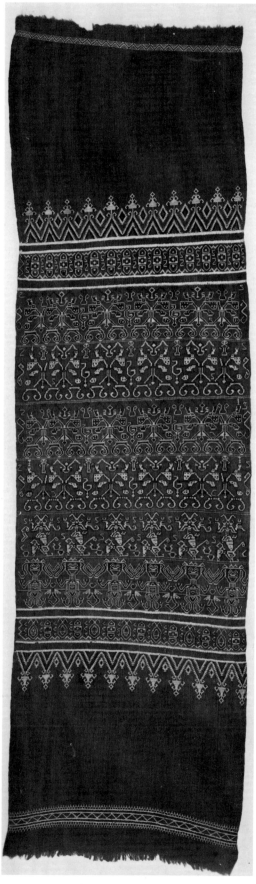

181 Sirat (loincloth)
Borneo, Sakarang people
Sungkit, pilih (supplementary weft),
embroidery
Cotton
Warp 325 cm, weft 24 cm
Textile Museum, Washington, D.C., 66.10

*Individual loincloth design, the manner
in which each was wrapped, and the
length were once characteristics of spe-
cific groups on Borneo. The skill em-
ployed in decorating these pieces was
recognized by early observers who also,
in an ironically inconsistent approach,
complained of the excessive (eleven-
meter) length of some loincloths, yet ad-
monished women for the brevity of their
skirts.*[36]

*These are the two decorative ends of a
loincloth of the Sakarang people. In the
bottom panel the designs are worked by a
supplementary weft wrapping alternating
with regular paired wefts. This technique,
called sungkit, yields a double-faced cloth.
Here the designs are red, outlined in black
and accompanied by minor details in
light blue and yellow. The cut warp end
is overcast with braid stitch embroidery.
At the opposite end of the loincloth (top
panel) the designs are worked in a pilih
technique. This too is a supplementary
weft technique, but the designs on the
two faces are reciprocal. This example
shows the reverse side: on the obverse,
the meander design appears as a light
figure on a red- and black-striped ground.
The warp fringes are grouped and bound
with red, black, and gold yarns that also
secure the cotton ball tassels.*

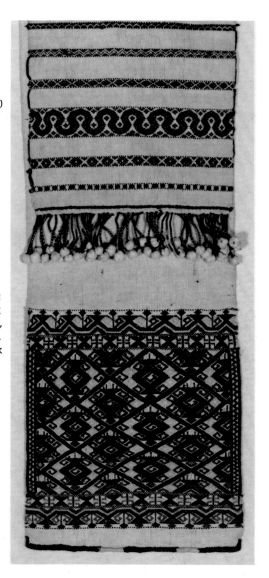

NOTES

1. Haddon and Start 1936:10-11 and Jager Gerlings 1952:25ff
2. Freeman 1970:3
3. Howell 1909b:124
4. Freeman 1975:284
5. Howell 1909a:75
6. Gomes 1911:101
7. Freeman 1970:21
8. Howell 1911:7
9. Howell 1909c:186-187.
10. Pringle 1970:24
11. Howell 1912:63
12. Freeman 1970:125
13. Howell 1912:64
14. Haddon and Start 1936:145
15. Ibid.:43
16. Ibid.:44
17. Gill 1968:165
18. Kooijman 1963:7
19. Hose and McDougall 1912:1; 236
20. Personal communication J. B. Avé, Rijksmuseum voor Volkenkunde, Leiden, June 1976
21. Haddon and Start 1936:124
22. Ibid.:112
23. Howell 1912:63
24. Bühler 1941:1423
25. Haddon and Start 1936:116
26. Ibid.:117
27. Ibid.:Plates 16 and 7
28. Ibid.:84
29. Ibid.:85
30. Ibid.:Plate 13
31. Kooijman 1963:9ff
32. Personal communication J. B. Avé, Rijksmuseum voor Volkenkunde, Leiden, June 1976
33. Jager Gerlings 1952:32
33. Haddon and Start 1936:Plate 9b
35. Personal communication Kent Watters, Los Angeles, September 1978
36. Ling Roth 1968:53, 55

APPENDIX

Three types of looms are the major instruments used to create the woven textiles of Indonesia. All are back-tension looms, so named because a belt structure (**a**) attached to the breast beam passes around the waist of the seated weaver. By leaning backward or forward the weaver can maintain the appropriate tension on the warp yarns stretched before her. The far end of the warp encircles a bar (**f**) or board that is anchored to posts of the house or, in the case of the board, rides in its own foot braces. On certain looms this bar, called the warp beam, may be a piece of bamboo or a flat board with inset tongues of wood. As the weaver beats each new weft into place, these tongues hit against the board with a "clack." The bamboo has its own particular hollow beat as it hits the supporting poles. Thus the weaver proclaims her diligence throughout the village by the rhythmic sound of her loom.

In front of the warp beam are either two laze rods or a single coil rod [1], which help maintain the proper ordering of the warp yarns. Preceding these is a shed stick (**d**), which holds down half the warp elements. The string heddles (**c**) in front loop around these same elements and are used to raise them to create an alternate shed, or opening in the warp, into which each new weft is inserted. Alternate sheds are created by the alternate action of the heddles and the shed stick. The other two components of the loom are the breast beam (**b**), which rides in the weaver's lap, held there by the back strap, and the sword (**h**). This is a smooth, narrow wooden slat, which the weaver uses to beat down each newly inserted weft.

Looms B and C also have a reed (**g**), or "comb," made up of fine bamboo slivers lashed to an upper and lower bar. It is used as a warp spacer and located in the yarns directly in front of the newly woven cloth. The weaver uses the sword as a beater, striking back of the reed after each new weft.

The significantly different element among these looms is the warp structure. In type A, the warp is continuous, that is, it makes a continuous circle between the breast beam and the warp beam. As new unwoven yarns are required, the weaver merely shifts the woven material

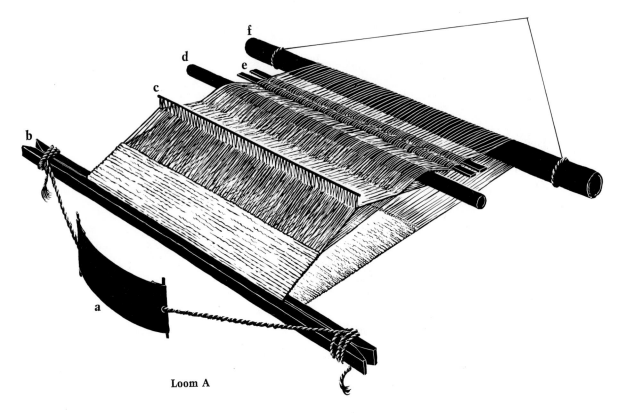

Loom A

around and under the breast beam, which brings new yarns in front of her. When the completed weaving is removed from this loom, it has a tubular shape. A small section remains unwoven, and it is here that the tube is cut across, creating fringes at the two ends of the resulting rectangle. Because of the distribution of this type of loom among people in the interior such as the Batak and the Iban, it is thought to be one of the first looms used in the archipelago. Another possible indication of its antiquity is its use in the weaving of sacred textiles by groups with access to other types of looms as well.[2]

Loom B has a discontinuous warp; in other words, the warp elements are in theory separate yarns wrapped on the warp beam. Unwoven yarns are unrolled from the warp beam as newly woven cloth is rolled up on the breast beam. Because the weaver need not support the entire weight of the yarns with her back while weaving, as in the case with Loom A, textiles of any length may be woven on this loom.

The type B loom is used for weaving both cotton and silk. It appears in coastal regions, high culture areas, and regions directly subject to the influence of central courts. Such textiles as the gold and silk kain songket and weft ikat of Sumatra and Bali are woven on this loom. When it is used for cotton, simple stripes and plaids are produced.[3]

In the type C loom, the warp as it appears on the loom looks and functions like a continuous warp, but the inclusion of the reed means that in the warping process, the warp is mounted in a manner similar to that of a discontinuous warp. In the warping the yarns pass about a common stick which acts like a linchpin to hold the great loops of yarn. When on the loom, this allows the warp to have a circular structure. The stick is seen at (**i**).[4] This loom is used to weave a range of fibers such as cotton, silk, banana, and pineapple. It occurs in a relatively

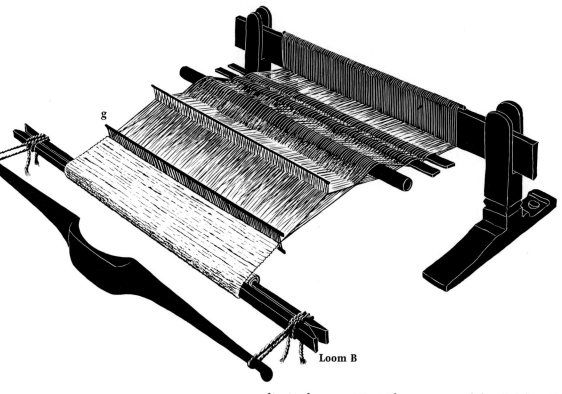

Loom B

limited area—West Flores, parts of the Celebes, Sangir, and the southern Philippines.

There are many variations in the details of these three types of loom, but the basic structural principles are usually similar to those described. While extremely simple in operation, in the hands of a master weaver these looms are capable of producing a remarkable range of textiles, as the present exhibition bears witness.

Loom C

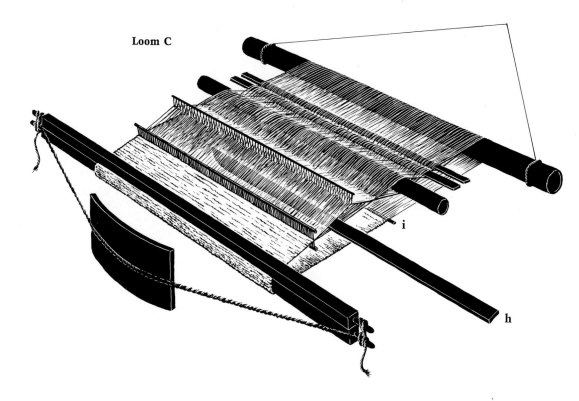

232 182 *A woman uses the canting tool to apply wax to the cloth surface of a batik textile. Here she is covering some of the existing design in preparation for a new dye sequence. The small spout on the reservoir gives the artist precise control of the molten substance and thus enables her to produce intricate details. (Koninklijk Instituut voor de Tropen, Amsterdam)*

183 *A man applies the wax resist to the cloth surface by means of a metal stamp called a cap. This process enables him to make twenty times or more the number of batik that a person working with the canting could. The designs, however, lack the creative vitality of the freely drawn forms. (Koninklijk Instituut voor de Tropen, Amsterdam)*

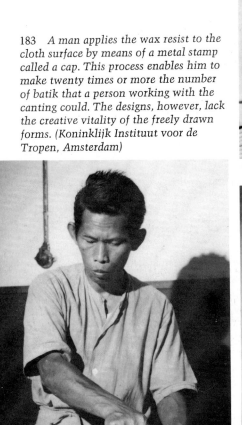

184 *The batik surface may be elaborated with gold. This is done by applying an adhesive to the surface and then layering on the gold foil or dust. (Koninklijk Instituut voor de Tropen, Amsterdam)*

NOTES

1. Bolland 1971
2. Ibid.; Goslings 1922-23:277
3. Pelras 1972 shows maps illustrating the distribution of these looms
4. Goslings 1922-23:165, 171 illustrates this warping.

GLOSSARY

Adat Custom and traditions that govern much of social and religious life.

Batik Resist-dye process in which wax is applied to cloth surface. When dyed, patterns are reserved in color of foundation. For more than one color, sequences of waxing and dyeing are used.

Betel Refers to quid made of small nut of pinang palm *(Areca catechu)*, leaves from betel pepper vines, and other substances, which is chewed as stimulant.

Bidang Iban woman's skirt (Borneo).

Cermuk Small mirror pieces, usually attached to surface of cloth by embroidery. Some are mirrored lead, others glass.

Complementary weft Fabric structure in which two sets of yarn elements in weft are coequal.

Couched Method of embroidery in which decorative yarns are laid on surface of cloth and tacked in position with small stitches.

Fuja Bark cloth.

Geringsing Sacred double ikat textile woven only in one village, Tenganan Pageringsingan, Bali.

Hinggi Man's ikat textile on Sumba.

Ikat "String" or "band," in verb form, *mengikat,* "to tie" or "to bind." Term applied to resist dye process in which designs are reserved in warp or weft yarns by tying off small bundles of yarns with palm leaf strips or similar material to prevent penetration of dye. Resists are cut away and/or new ones added for each color. After dyeing, all resists are cut away, leaving patterned yarns ready for weaving. Process may be applied to either warp or weft yarns, or, as on Bali, to both. Latter process is called "double ikat."

Kain "Cloth," generally denotes flat rectangle used as wrapper. Is most often combined with descriptive word, e.g., kain songket, kain kembangan.

Kain panjang "Long cloth," refers to batik rectangular textile that is wrapped about hips. Length approximately two and a half times width.

Kebaya Woman's blouse.

Kepala "Head," refers to visual center of sarong; this may be area of contrasting pattern. Usually two rows of confronting triangles spanning width of cloth.

Khombu Or *Kombu.* Red or rust dye from *Morinda citrifolia.*

Kraton Royal palace, adjoining courts and gardens, all within walled area.

Kris Indonesian weapon resembling dagger or short sword, with supernatural attributes.

Laid-in Term used when supplementary yarn is interlaced in unison with corresponding elements of ground weave.

Lamak Long narrow cloth or palm decoration hung from temple entrances or tall poles on Bali.

Lau Sumbanese woman's tubular garment. When decorated by supplementary warp it is called lau pahudu; when by shells and beads, lau hada.

Lembe Sacred shoulder cloth on Nias.

Naga Serpent, snake, or dragon of supernatural character.

Nitik Batik designs built from dots and bars in imitation of designs in woven textiles.

Pagi-sore "Morning-evening," batik textile divided in half by two different patterns, often contrasting dark and light backgrounds.

Patola Indian double ikat textile traded in Southeast Asia, especially at peak of spice trade in sixteenth and seventeenth centuries.

Pilih "To choose," decorative technique in which continuous supplementary wefts are inserted between the regular wefts with a shuttle.

Plangi "Rainbow," resist-dye process in which small areas of textile are bound off by cord or palm strip that reserves area from dye. Patterns are generally built up from small circular forms. Name probably originates in colorful nature of these textiles.

Prada Application of gold leaf or dust to cloth surface.

Pua Iban (Borneo) ceremonial blanket.

Ragidup Batak (Sumatra) prestige textile with white end panels.

Sarong Tubular garment worn around body. Will have kepala.

Selimut "Blanket," general term applied to large mantles and wrappers.

Siger Large gilded ship-shaped crown worn by unmarried women in southern part of Sumatra.

Singa "Lion," visually hybrid, mythological animal with features of tiger, lion, and dragon.

Slendang Shawl, usually narrow rectangular cloth worn over shoulder.

Soga From soga tree *(Peltophorum ferrugineum)*. Bark is major ingredient in brown dye common to batik of Central Java.

Songket Supplementary weft patterning. Used as "kain songket" to denote silk and metallic textiles from Palembang.

Sungkit "Needle." Decorative technique in which discontinuous supplementary wefts are worked with needle on passive warp between two regular wefts.

Supplementary warp or weft Decorative technique in weaving, in which pattern yarn is added between two regular foundation yarns. Has decorative function only.

Tampan Small, square ceremonial cloth once woven in South Sumatra.

Tapestry weave Patterning with discontinuous wefts that entirely conceals the warp.

Tapis Woman's sarong; used here to denote those worn in South Sumatra.

Tatibin Narrow ceremonial cloth used in limited area of South Sumatra.

Tritik Resist process in which designs are reserved by sewing and gathering textile before dyeing. Characteristic of kain kembangan.

Tumpal Triangle motif, usually in row at fringe end of textile or in confronting rows in kepala of sarong.

Twill weave Progressive successions of floats in diagonal alignment.

Ulos "Cloth," generic term for locally woven textiles among Batak (Sumatra).

Warp Parallel elements that run longitudinally in loom or fabric (Emery 1966:74).

Warp faced Fabric structure in which warp yarns conceal weft. Warp ikat fabrics usually have warp-faced weave so design will ride clearly on surface.

Wayang "Puppet," refers here to flat shadow puppets used in classic theater of Java and Bali.

Weft Traverse elements in fabric that cross and interwork with warp (Emery 1966:74).

BIBLIOGRAPHY

Abdurrachman, Paramits 1977 "Introduction," *Batik Exhibition of Chinese Designs*, June 6-16, Museum Tekstil and Himpunan Wastraprema. Jakarta.

Achjadi, Judi 1976a *Indonesian Women's Costumes.* Penerbit Djambatan. Jakarta.

 1976b "Traditional costumes of Indonesia," *Arts of Asia*, 6(5):57-63.

Adam, Tassilo 1934 "The art of batik in Java," *Bulletin of the Needle and Bobbin Club*, 18:2-79.

Adams, Marie Jeanne 1969 *System and Meaning in East Sumba Textile Design: A Study in Traditional Indonesian Art.* Southeast Asia Studies Cultural Report Series No. 16. Yale University. New Haven.

 1970 "Symbolic scenes in Javanese batik," *Textile Museum Journal*, 3:25-40.

 1971 "Work patterns and symbolic structures in a village culture, East Sumba, Indonesia," *Southeast Asia*, 1:321-334.

 1972 "Classic and eccentric elements in East Sumba textiles. A field report," *Bulletin of the Needle and Bobbin Club*, 55:3-40.

 1973 "Structural aspects of a village art," *American Anthropologist*, 75:265- 279.

 1974 "Symbols of the organized community in East Sumba, Indonesia," *Bijdragen tot de Taal-, Land- en Volkenkunde*, 130:324-347.

Adriani, N. 1894 "Sangireesche teksten," *Bijdragen tot de Taal-, Land- en Volkenkunde*, 44:1-168.

Adriani, N. and A. C. Kruijt 1901-04 "Geklopte boomschors als kleedingstof op Midden-Celebes, en hare geographische verspreiding in Indonesië," *Internationales Archiv für Ethnographie*, 14:139-191; 16:180-193.

 1912 *Bare'e-Sprekende Toradja's van Midden-Celebes.* Vol. I. Landsdrukkerij. Batavia.

Arndt, Paul 1954 *Gesellschaftliche Verhaltnisse der Ngadha.* St. Gabriel, Vienna.

Avé, J. B. 1976 Personal communication.

Bartlett, Harley Harris 1973 *The Labors of the Datoe and Other Essays on the Asahan (North Sumatra).* Michigan Papers on South and Southeast Asia No. 5. The University of Michigan. Ann Arbor. Articles originally published from 1929 to 1952.

Bolland, Rita 1956 "Weaving a Sumba woman's skirt," in *Lamak and Malat in Bali and a Sumba Loom* by Th. P. Galestin, L. Langewis and Rita Bolland, pp. 49-56. Royal Tropical Institute. Amsterdam.

 1970 "Three looms for tablet weaving," *Tropical Man*, 3:160-189.

 1971 "A comparison between the looms used in Bali and Lombok for weaving sacred cloths," *Tropical Man*, 4:171-182.

 1977 "Weaving the pinatikan, a warp-patterned kain bentenan from North

236

Celebes," in *Studies in Textile History*, edited by Veronika Gervers, pp. 1-17. Royal Ontario Museum. Toronto.

Bolland, Rita, J. H. Jager Gerlings
and L. Langewis 1960 *Batiks from Java*. Royal Tropical Institute. Amsterdam.

Bolland, Rita and A. Polak 1971 "Manufacture and use of some sacred woven fabrics in a North-Lombok community," *Tropical Man*, 4:149-170.

Bühler, Alfred 1938-39 "Die Herstellung von Ikattüchern auf der Insel Rote," *Verhandlungen der Naturforschenden Gesellschaft von Basel*, 50:32-97.

1941 "Turkey red dyeing in South and Southeast Asia," *Ciba Review*, 39:1423-1426.

1943 "Materialien zur Kenntnis der Ikattechnik," *Internationales Archiv für Ethnographie*, Supplement 43.

1954 "Plangi. The tie and dye work," *Ciba Review*, 104:3722-3748.

1959 "Patola influences in Southeast Asia," *Journal of Indian Textile History*, 4:4-46.

1975 "Patola," in *Patola und Geringsing* by Alfred Bühler, Urs Ramseyer, and Nicole Ramseyer-Gygi, pp. 8-22. Museum für Völkerkunde und Schweizerisches Museum für Volkskunde Basel. Basel.

Coedès, G. 1968 *The Indianized States of Southeast Asia*. East-West Center Press. Honolulu. First published in French in 1964.

Covarrubias, Miguel 1965 *Island of Bali*. Alfred A. Knopf. New York. Originally published in 1937.

Dames, Mansel Longworth 1921 *The Book of Duarte Barbosa*. Vol. 2. Bedford Press. London.

de Zoete, Beryl and Walter Spies 1973 *Dance and Drama in Bali*. Oxford University Press. Kuala Lumpur.

Drabbe, M. S. C. 1940 *Het Leven van den Tanimbarees. Ethnografische Studie over het Tanimbaresche Volk*. E. J. Brill. Leiden.

Elmberg, John-Erik 1968 *Balance and Circulation. Aspects of Tradition and Change among the Mejprat of Irian Barat*. Monograph Series Publication No. 12. The Ethnographical Museum (Ethnografiska Museet). Stockholm.

Emery, Irene 1966 *The Primary Structures of Fabrics*. The Textile Museum. Washington, D.C.

Fiedler, Hermann 1929 *Die Insel Timor*. Folkwang Auriga. Friedrichssegen.

Fox, James J. 1973 "On bad death and the left hand: a study of Rotinese symbolic inversions," in *Right and Left, Essays on Dual Symbolic Classification*, edited by Rodney Needham, pp. 342-368. The University of Chicago Press. Chicago.

1977a *Harvest of the Palm*. Harvard University Press. Cambridge.

1977b "Roti, Ndao, and Savu," in *Textile Traditions of Indonesia*, edited by Mary Hunt Kahlenberg, pp. 97-104. Los Angeles County Museum of Art. Los Angeles.

Freeman, Derek 1970 *Report on the Iban*. London School of Economics Monographs on Social Anthropology No. 41. Humanities Press. New York. First published in 1955.

1975 "The Iban of Sarawak and their religion, a review article," *Sarawak Museum Journal*, 23:275-288.

Geurtjens, H. 1920 "Tanimbareesche weverij," *Tijdschrift voor Indische Taal-, Land- en Volkenkunde*, 59:364-379.

Gill, Sarah Hall Sharples 1968 *Selected Aspects of Sarawak Art*. Doctoral dissertation (unpublished). Columbia University. New York.

Gittinger, Mattiebelle 1972 *A Study of the Ship Cloths of South Sumatra: Their Design and Usage*. Doctoral dissertation (unpublished). Columbia University. New York.

1975 "Selected Batak textiles," *Textile Museum Journal*, 4(2):13-29.

1976 "The ship textiles of South Sumatra: functions and design system," *Bijdragen tot de Taal-, Land- en Volkenkunde*, 132:207-227.

1977 "Sumatra," in *Textile Traditions of Indonesia*, edited by Mary Hunt Kahlenberg, pp. 25-40. Los Angeles County Museum of Art. Los Angeles.

Gomes, E. H. 1911 *Seventeen Years among the Sea Dayaks of Borneo*. J. B. Lippincott Co. London.

Goslings, B. M. 1920-21 "Scheringtechniek in Indische weefzels," *Nederlandsch-Indië Oud en*

Nieuw, 5:209-222, 228-240, 283-288.

1922-23 "De betekenis der invoering van den kam in het Indonesische weefgetouw," *Nederlandsch-Indië Oud en Nieuw,* 7:163-180, 243-256, 275-291.

1929-30 "Het batikken in het gebied der hoofdplaats Djambi," *Nederlandsch- Indië Oud en Nieuw,* 14:141-152, 175-185, 217-223.

Haddon, Alfred C. and Laura E. Start 1936 *Iban or Sea Dayak Fabrics and Their Patterns.* The University Press. Cambridge.

Heijmering, G. 1844 "Zeden en gewoonten op het eiland Timor," *Tijdschrift voor Nederlandsch-Indië,* 7(3):121-146, 272-313.

Heine-Geldern, Robert 1966 "Some tribal art styles of Southeast Asia: an experiment in art history," in *The Many Faces of Primitive Art,* edited by Douglas Fraser, pp. 165- 221. Prentice-Hall. Englewood Cliffs.

Holt, Claire 1970 " 'Bandit Island,' a short exploration trip to Nusa Penida," in *Traditional Balinese Culture* by Jane Belo, pp. 67-84. Columbia University Press. New York.

Hoop, A. N. J. Th. à Th. van der 1949 *Indonesische Siermotieven.* Koninklijk Bataviaasch Genootschap van Kunsten en Wetenschappen. Bandoeng.

Hose, Charles and William McDougall 1912 *The Pagan Tribes of Borneo.* 2 vols. Macmillan. London.

Howell, William 1909a "Dyak burial custom," *Sarawak Gazette,* 39:75-76.

1909b "Gawai Batu, or the Feast of the Whetstones," *Sarawak Gazette,* 39:124-125.

1909c "The Hornbill or Tenyelang," *Sarawak Gazette,* 39:185-187.

1911 "A Sea-Dayak dirge," *Sarawak Museum Journal,* 1(1):5-73.

1912 "The Sea-Dayak method of making and dyeing thread from their home grown cotton," *Sarawak Museum Journal,* 1(2):61-64.

Jager Gerlings, J. H. 1952 *Sprekende Weefsels.* Koninklijk Instituut voor de Tropen, Amsterdam.

Jasper, J. E. and Mas Pirngadie 1912 *De Weefkunst,* volume 2 of *De inlandsche kunstnijverheid in Nederlandsch Indie.* Mouton and Co. The Hague.

1916 *De Batikkunst,* volume 3 of *De inlandsche kunstnijverheid in Nederlandsch Indie.* Mouton and Co. The Hague.

Kat Angelino, P. de 1930-31 *Batik Rapport.* 3 vols. Lands Drukkerij. Weltevreden.

Kats, J. 1922 "De achteruitgang van de Batikkunst," *Djawa,* 2:92-98.

Kennedy, Raymond 1935 *The Ethnology of the Greater Sunda Islands.* Doctoral dissertation (unpublished). Yale University. New Haven.

Kern, R. A. 1926 "Tjinden en plangi in Gresik," *Djawa,* 6:193-194.

Kooijman, S. 1963 *Ornamented Bark-Cloth in Indonesia.* Mededelingen van het Rijksmuseum voor Volkenkunde No. 16. E. J. Brill. Leiden.

Koperberg, S. 1922 "De Javaansche batikindustrie," *Djawa,* 2:147-156.

Korn, Victor Emmanuel 1933 *De dorpsrepubliek Tenganan Pagringsingan* (Bali). Santpoort.

Kraijer van Aalst, H. 1924-25 "Het dooden-feest te Niki-Niki Mei 1922," *De Timor Bode,* 104:60-64; 105:69-72; 106:75-79; 107:86-88.

Krulfeld, Ruth 1978 Personal communication.

Kruyt, A. C. 1923 De Timoreezen. *Bijdragen tot de Taal-, Land- en Volkenkunde,* 79:347-490.

1933 "Lapjesgeld op Celebes," *Tijdschrift voor Taal-, Land- en Volkenkunde,* 73:172-183.

Langewis, Laurens 1956 "A woven Balinese lamak," in *Lamak and Malat in Bali and a Sumba Loom* by Th. P. Galestin, L. Langewis and Rita Bolland, pp. 31-47. Royal Tropical Institute. Amsterdam.

Langewis, Laurens and Frits A. Wagner 1964 *Decorative Art in Indonesian Textiles.* van der Peet. Amsterdam.

Leur, J. C. van 1960 *Indonesian Trade and Society.* Second edition. Sumur Bandung. Bandung.

Lineton, Jacqueline 1975 "Pasompe' ugi': Bugis migrants and wanderers," *Archipel,* 10:173-224.

Ling Roth, Henry 1950 *Studies in Primitive Looms.* Third edition. Bankfield Museum. Halifax. First edition published in 1918.

238

 1968 *The Natives of Sarawak and British North Borneo.* Vol. II. University of Malaya Press. Kuala Lumpur. First published in London in 1896.

Loebèr, J. A. 1914 *Textiele Versieringen in Nederlandsch-Indie.* Koloniaal Instituut. Amsterdam.

 1926 *Das Batiken. Eine Blute indonesischen Kunstlebens.* O. G. Stalling. Oldenburg.

 1927 "De evolutie in de Javannsche batikkunst," *Djawa*, 7:55-59.

Lookeren Campagne, C. J. van 1899 "Indigo," *Encyclopaedie van Nederlandsche-Indië*, 2:78-86. Martinus Nijhoff. 's Gravenhage.

Matthes, B. F. 1874 *Boegineesch-Hollandsch Woordenboek.* Amsterdam. Cited in Bolland 1970.

Middelkoop, P. 1949 "Een studie van het Timoreesche doodenritueel," *Verhandelingen Koninklijk Bataviaasch Genootschap van Kunsten en Wetenschappen*, 76.

 1963 *Head Hunting in Timor and Its Historical Implications,* Part 1, 2. Oceania Linguistic Monographs No. 8(b). University of Sidney. Sidney.

Moerdowo, R. 1973 *Ceremonies in Bali.* Bhratara Publishers. Jakarta.

Netscher, E. and J. A. van der Chijs 1863 *De Munten van Nederlandsch Indie.* Lange and Co. Batavia.

Nevermann, Hans 1938 "Die Indo-Ozeanische Weberei," *Mitteilungen aus dem Museum für Völkerkunde in Hamburg*, 20.

Nieuwenkamp, W. O. J. 1906-1910 *Bali en Lombok.* Edam.

 1920 "Het kostuum van een Meo of koppensneller op Timor," *Tijdschrift van het Nederlandsch Aardrijkskundig Genootschap*, 37:249-252.

 1922-23 "Iets over Soemba en de Soembaweefsels," *Nederlandsch-Indië Oud en Neiuw*, 7:294-313.

Niggemeyer, H. 1952 "Baumwollweberei auf Ceram," *Ciba-Rundschau*, 106:3868-3897.

Nooteboom, C. 1940 *Oost-Soemba: een Volkenkundige Studie.* Martinus Nijhoff. The Hague.

Nooy-Palm, C. H. M. 1969 "Dress and adornment of the Sa'dan-Toraja (Celebes, Indonesia)," *Tropical Man*, 2:162-194.

 1975 *De Karbouw en de Kandaure.* Indonesisch Ethnografisch Museum. Delft.

Nouhuys, J. van 1921 *Jaarverslag over 1921.* Museum voor Land- en Volkenkunde. Rotterdam.

 1921-22 "Een autochthoon weefgebied in Midden-Celebes," *Nederlandsch- Indië Oud en Nieuw*, 6:237-243.

 1925-26 "Was-batik in Midden-Celebes," *Nederlandsch Indië Oud en Nieuw*, 10:110-122.

Obdeyn, V. 1929 "Indragirische weefkunst," *Tijdschrift van het Koninklijk Bataviaasch Genootschap van Kunsten en Wetenschappen*, 68:92-124.

op't Land, C. 1968-69 "Een merkwaardige 'tampan pengantar' van Zuid-Sumatra," *Kultuurpatronen*, 10:100-117.

Ormeling, F. J. 1956 *The Timor Problem: A Geographical Interpretation of an Undeveloped Island.* J. B. Wolters. Groningen and Jakarta.

Palm, C. H. M. 1958 "Ancient art of the Minahassa," *Madjala untuk Ilmu Bahasa, Ilmu Bumi dan Kebudajaan Indonesia*, 1958: 3-59.

 1965 "De cultuur en kunst van de Lampung, Sumatra," *Kultuurpatronen*, 7:40-79.

Palmer, Ingrid 1972 *Textiles in Indonesia. Problems of Import Substitution.* Praeger. New York.

Pauw, J. 1923 "De Kekombong Oemba' (heilige draagdoek) in het gebruik bij de Sasaks van Oost-Lombok," *Tijdschrift voor Indische Taal-, Land- en Volkenkunde*, 63:183-197.

Pelras, Christian 1962 "Tissage balinais," *Objets et Mondes*, 2(4):215-40.

 1967 "Lamak et tissus sacrés de Bali," *Objets et Mondes*, 7(4):255-278.

 1972 "Contribution à la géographie et à l'éthnologie du métier à tisser en indonésie," in *Langues et Techniques, Nature et Société*, Vol. II, *Approche Ethnologique, Approche Naturaliste*, pp. 81-97. Klincksieck. Paris.

Pigeaud, Theodore G. Th. 1938 *Javaanse Volksvertoningen. Bijdrage tot de Beschrijving van Land en Volk.* Volkslectuur. Batavia.

 1962 *Java in the 14th Century.* Vol. IV. Martinus Nijhoff. The Hague.

Pleyte, C. M.　1912　*De Inlandsche Nijverheid in West-Java.* Batavia.

Poensen, C.　1876-77　"Iets over de kleeding der Javanen," *Mededeelingen van wege het Nederlandsche Zendeling-genootschap,* 20:257-294, 377-420; 21:1-21.

Poeroebojo, B. P. H.　1939　"Rondom de huwelijken in de kraton te Jogjakarta," *Djawa,* 19:295-329.

Praetorius, C. F. E.　1843　*Eenige Bijzonderheden Omtrent Palembang.* H. W. Hazenberg en Comp. Leyden.

Pringle, Robert　1970　*Rajahs and Rebels. The Iban of Sarawak under Brooke Rule 1841-1941.* Cornell University Press. Ithaca.

Raffles, Thomas Stamford　1817　*The History of Java.* Black Parbury and Allen. London.

Ramseyer, Urs　1975　"Geringsing," in *Patola und Geringsing* by Alfred Bühler, Urs Ramseyer, and Nicole Ramseyer-Gygi, pp. 48-72. Museum für Völkerkunde und Schweizerisches Museum für Volkskunde Basel. Basel.

　　　1977　*The Art and Culture of Bali.* Oxford University Press. Oxford.

Roo van Alderwerelt, J. de　1890　"Eenige mededeelingen over Soemba," *Tijdschrift voor Indische Taal-, Land- en Volkenkunde,* 33:565-595.

Rouffaer, G. P. and H. H. Juynboll　1900　*Die Indische Batikkunst und ihre Geschichte.* H. Kleinmann. Haarlem.

　　　1917　"Batikken," in *Encyclopaedia van Nederlandsche-Indie,* Vol. 1, pp. 192-203. Martinus Nijhoff. 's Gravenhage.

Rowe, Ann Pollard　1977　*Warp-Patterned Weaves of the Andes.* Textile Museum. Washington, D.C.

Sapada, Andi Nurhani　1977　"Traditional textiles of South Sulawesi," paper presented to the Wastraprema (Society of the Friends of Textiles), Jakarta, Indonesia, August 4.

Schärer, Hans　1963　*Ngaju Religion. The Conception of God among a South Borneo People.* Koninklijk Instituut voor Taal-, Land- en Volkenkunde Translation Series No. 6. Martinus Nijhoff. The Hague. Originally published as *Die Gottesidee der Ngadju Dajak in Süd-Borneo* in 1946.

Schulte Nordholt, H. G.　1971　*The Political System of the Atoni of Timor.* Verhandelingen van het Koninklijk Instituut voor Taal-, Land- en Volkenkunde No. 60. Martinus Nijhoff. The Hague.

Soekawati, Tjokorde Gde Rake　1926　*Hoe de Baliër Zich Kleedt.* G. Kloff and Co. Weltevreden.

Solyom, Bronwen and Garrett　1977　"Java," in *Textile Traditions of Indonesia,* edited by Mary Hunt Kahlenberg, pp. 59-72. Los Angeles County Museum of Art. Los Angeles.

Spertus, Anita and Jeff Holmgren　1977　"Celebes," in *Textile Traditions of Indonesia,* edited by Mary Hunt Kahlenberg, pp. 53-58. Los Angeles County Museum of Art. Los Angeles.

Steinmann, Alfred　1937　"Les tissus à jonques de Sud de Sumatra," *Revue des Arts Asiatiques,* 11:131-143.

　　　1946　"The ship of the dead in textile art," *Ciba Review,* 52:1870-1896.

　　　1958　*Batik. A Survey of Batik Design.* F. Lewis. Leigh-on-Sea.

Swellengrebel, J. L.　1960　"Introduction," in *Bali: Studies in Life, Thought, and Ritual.* W. van Hoeve. The Hague.

Tirtaamidjaja, N.　1967　"A bedaja ketawang dance performance at the court of Surakarta," *Indonesia,* 1:31-61.

Tirtaamidjaja, N., Jazir Marzuki and Benedict R .O. G. Anderson　1966　*Batik: Pola and Tjorak—Pattern and Motif.* Djambatan. Jakarta.

Tonnet, Martine　1905　"Sangireesche kofo-weefsels." Reference collection. Koninklijk Instituut voor de Tropen. Amsterdam.

Toorn, J. L. van der　1881　"Aanteekeningen uit het familieleven bij den Maleiers in de Padangsche boven-landen," *Tijdschrift van Indische Taal-, Land- en Volkenkunde,* 26:205-228, 514-528.

Vatter, E.　1932　*Ata Kiwan.* Bibliographisches Institut. Leipzig.

Veen, H. van der　1965　"The Merok feast of the Sa'dan Toradja," *Verhandelingen Koninklijk Instituut voor Taal-, Land- en Volkenkunde.*

Veldhuisen-Djajasoebrata, Alit　1972　*Batik op Java.* Museum voor Land- en Volkenkunde. Rotterdam.

Veltman, Th. J.　1912　"De Atjehsche zijde-industrie," *Internationales Archiv für Ethnographie,* 20:16-58.

Vergouwen, J. C.　1964　*The Social Organisation and Customary Law of the Toba-Batak of Northern Sumatra.* Martinus Nijhoff. The Hague. Originally published in 1933.

240

Vollmer, John E. 1977 "Archaeological and ethnological considerations of the foot-braced body-tension loom," in *Studies in Textile History*, edited by Veronika Gervers, pp. 343-354. Royal Ontario Museum. Toronto.

Vroklage, B. A. G. 1953 *Ethnographie der Belu in Zentral-Timor*, Vol. I. E. J. Brill. Leiden.

Watters, Kent 1977 "Flores," in *Textile Traditions of Indonesia*, edited by Mary Hunt Kahlenberg, pp. 87-93. Los Angeles County Museum of Art. Los Angeles.

Werff, J. van der and R. Wassing-Visser 1974 *Sumatraanse Schoonheid Tentoonstelling*. Indonesisch Ethnografisch Museum. Delft.

Wetering, F. H. van de 1925 "Het huwelijk op Roti," *Tijdschrift voor Indische Taal-, Land- en Volkenkunde*, 65:1-37, 589-667.

1927 "Huwelijksgebruiken van Timor-Koepang," *Mededeelingen van wege het Nederlandsch Zendeling-genootschap*, 71:341-370.

SUPPLEMENTARY BIBLIOGRAPHY

Adams, M. J. 1981 *Threads of Life. A Private Collection of Textiles from Indonesia and Sarawak*. The Katonah Gallery, June 7–July 26. Katonah. New York.

Bühler, Alfred 1972 *Ikat Batik Plangi*. 3 vols. Pharos-Verlag Hansrudolf Schwabe AG. Basle. (While this work does not deal with Indonesian textiles directly, the information is essential for an understanding of textiles of the archipelago.)

Bühler, Alfred and Eberhard Fischer 1979 *The Patola of Gujarat*. 2 vols. Krebs AG. Basle.

Bullough, Nigel 1981 *Woven Treasures from Insular Southeast Asia*. Auckland Institute and Museum. Auckland.

Dijk, Toos van and Nico de Jonge 1980 *Ship Cloths of the Lampung, South Sumatera. A Research of Their Design, Meaning and Use in Their Cultural Context*. Galerie Mabuhay. Amsterdam.

Elliott, Inger McCabe 1984 *Batik. Fabled Cloth of Java*. Clarkson Potter, Inc. New York City.

Gittinger, Mattiebelle 1979 "Conversations with a batik master," *Textile Museum Journal*, 18:25–32.

 1980 "Indonesian textiles," *Arts of Asia*, 10(5):108–123.

Hamzuri 1981 *Batik Klasik*. Djambatan. Jakarta.

Holmgren, R. J. (*in press*) "Fresh Indonesian evidence of lost Indian textiles," *Irene Emery Roundtable on Museum Textiles. 1983 Proceedings. Eastern Hemisphere Textile Trade*. Indianapolis Museum of Art. Indianapolis.

Irene Emery Roundtable on Museum Textiles. 1979 Proceedings. Indonesian Textiles. Edited by Mattiebelle Gittinger. The Textile Museum. Washington, D.C. Contents: Rita Bolland, "Twill weaving by the Angkola Batak," and "Advice to advisors." Joseph Fischer, "The character and study of Indonesian textiles." James J. Fox, "Figure shark and pattern crocodile: the foundations of the textile traditions of Roti and Ndao." Peggy S. Gilfoy, "Textiles in Africa and Indonesia: a connection?" K. R. T. Hardjonagoro (translated by R. J. Holmgren), "The place of batik in the history and philosophy of Javanese textiles." Robert J. Holmgren and Anita E. Spertus, "Tampan pasisir: pictorial documents of an ancient Indonesian coastal culture." Mary Hunt Kahlenberg, "The influence of the European herbal on Indonesian batik." Nobuko Kajitani, "Traditional Dyes in Indonesia." Suwati Kartiwa, "The social functions of the kain songket Minangkabau." Mary Elizabeth King, "Possible Indonesian or Southeast Asian influences in New World textile industries." Angela Lakwete, "Identification and preservation of dyes." John Maxwell, "Textiles of the Kapuas Basin—with special reference to Maloh beadwork." Robyn J. Maxwell, "Textile and ethnic configurations in Flores and the Solor Archipelago." Hetty Nooy-Palm, "The role of the sacred cloths in the mythology and ritual of the Sa'dan-Toraja of Sulawesi, Indonesia." Susan Rodgers-Siregar, "Blessing shawls: the social meaning of Sipirok Batak ulos." Garrett and Bronwen Solyom, "Cosmic symbolism in semen and alasalasan patterns in Javanese textiles," and "A note on some rare Central Javanese court textiles." Alit Veldhuisen-Djajasoebrata, "On the origin and nature of Larangan:

forbidden batik patterns from the Central Javanese principalities." Cornelia Vogelsanger, "A sight for the gods. Notes on the social and religious meaning of Iban ritual fabrics." Hiram Woodward, "Indonesian textile patterns from a historical point of view." Olga Yogi, "Lurik, a traditional textile in Central Java," and "An introductory survey to Indonesian textile collections in North America."

Kahlenberg, Mary Hunt 1979 *Rites of Passage*. Mingei International Museum of World Folk Art. La Jolla.

Kartiwa, Suwati 1982 *Songket Indonesia*. Museum Nasional. Jakarta.

1983 *Kain Tenun Donggala*. Donggala Press C. V.

Kaudern, Walter 1944 *Ethnographical Studies in Celebes VI: Art in Central Celebes*. Edited by Teres Kaudern and Henry Wassen. Elanders Boktryckeri. Goteborg.

Klokke, Marujke 1981 *Ikat-Weefsels uit Oost Nusa Tenggara*. Volkenkundig Museum Nusantara. Delft.

Loebèr, J. A. 1903 "Het weven in Nederlandsch-Indie," *Bulletin van het Koloniaal Museum te Haarlem*, No. 29. de Bussy. Amsterdam.

Maxwell, Robyn 1981 "Textiles and tusks: some observations on the social dimensions of weaving in East Flores," *Five Essays on the Indonesian Arts*. Monash University. Melbourne.

Maxwell, John R. and Robyn J. Mazwell 1976 *Textiles of Indonesia*. Indonesian Arts Society. Melbourne.

Puspita Warni 1980 Himpunan Pencinta Kain Tenun dan Batik "Wastraprema", Jakarta.

de Raadt-Apell, M. J. 1980 *De Batikkerij Van Zuylen te Pekalongan*. Terra-Zutphen.

1980–81 "Van Zuylen batik, Pekalongan, Central Java (1890–1946)," *Textile Museum Journal*, 19,20:75–92.

Real, Daniel n.d. *La Decoration Primitive II: Oceanie*. Librairie des Arts Decoratifs. Paris.

1924 *The Batiks of Java*. Ernest Benn. London.

n.d. *Tissus des Indes Neerlandaises*. Librairie des Arts Decoratifs. Paris.

Sheares, Constance 1983 "The ikat technique of textile-patterning in Southeast Asia," *Heritage*, 4:30–41. Singapore.

Solyom, Garrett and Bronwen Solyom' 1973 *Textiles of the Indonesian Archipelago*. The University Press of Hawaii. Honolulu.

1979 *Threads of Tradition: Textiles of Indonesia and Sarawak*. Edited by Joseph Fischer. Lowie Museum of Anthropology, University Art Museum. Berkeley.
Contents: Eric Crystal, "Mountain ikats and coastal silks: traditional textiles in south Sulawesi." Joseph Fischer, "The value of tradition: an essay on Indonesian textiles." Lydia van Gelder, "Indonesian ikat fabrics and their techniques." Beverly Lavin, "Batik traditions in the life of the Javanese." Laurence A. G. Moss, "Cloths in the cultures of the Lesser Sunda Islands." Michael Palmieri and Fatima Ferentinos, "The Iban textiles of Sarawak." Bronwen and Garrett Solyom, "Notes and observations on Indonesian textiles."

Tilmann, Georg 1938 "Iets over de weefsels van de Kroe districten in Zuid-Sumatra," *Maandblad voor Beeldende Kunsten*, 15 (1):10–16, 30–31. Amsterdam.

1938 "Iets over de weefsels van de Lampong'sche districten in Zuid-Sumatra," *Maanblad voor Beeldende Kunsten*, 15 (5):130–143. Amsterdam.

1939 "De metalen bakken van Zuid-Sumatra en de dierenvoorstellingen op de z.g. Kroe-doeken," *Cultureel Indie*, 1:16–19.

1939 "De schepen- en wajangmotieven der Zuid-Sumatrasche weefsels," *Cultureel Indie*, 1:332–333.

Veldhuisen, Harmen 1983 "Ontwikkelingen in de batik van Java. 1: Batiks van Java; Javaanse batiks?" *Handwerken Zonder Grenzen* No. 4: 26–35.

1983 "Ontwikkelingen in de batik van Java. 2: Traditionele batiks van de Noordkust," *Hanwerken Zonder Grenzen* No. 5: 27–33.

1984 "Ontwikkelingen in de batik van Java. 3: Europese invloed in de batik van Java," *Handwerken Zonder Grenzen* No. 1: 52–59.

1984 "Ontwikkelingen in de batik van Java. 4: Nederlandse invloed in de batik van Java," *Handwerken Zonder Grenzen* No. 2:26–33.

Veldhuisen-Djajasoebrata, Alit 1984 *Bloemen van het Heelal. De Kleurrijke Wereld van de Textiel op Java*. Sijthoff. Amsterdam.

Warming, Wanda and Michael Gaworski 1981 *The World of Indonesian Textiles*. Kodansha International, Ltd. Tokyo.

Wassing-Visser, Rita n.d. *Weefsels en Adatkostuums uit Indonesie*. Volkenkundig Museum Nusantara. Delft.

Wenner-Gren Foundation for Anthropological Research: an International Symposium. 1983 "Cloth and the Organization of Human Experience." Troutbeck, Amenia, New York September 28–October 5. Organized by Jane Schneider and Annette Weiner. Many of the papers presented at the symposium are in preparation for publication in a volume tentatively titled *Cloth in Society and History*.

Yoshimoto, Shinobu 1977–78 *Indonesia Senshoku Taikei*. (Survey of Indonesian Dyeing and Weaving). 2 vols. Shikosha Publishing Co. Kyoto.

Yoshioka Tsuneo and Shinobu Yoshimoto 1980 *Sarasa no Sekai*. (Sarasa of the World.) Kyoto Shoin. Kyoto.

Zerner, Charles 1982 "Silks from southern Sulawesi," *Orientations*, 13 (2):46–55.

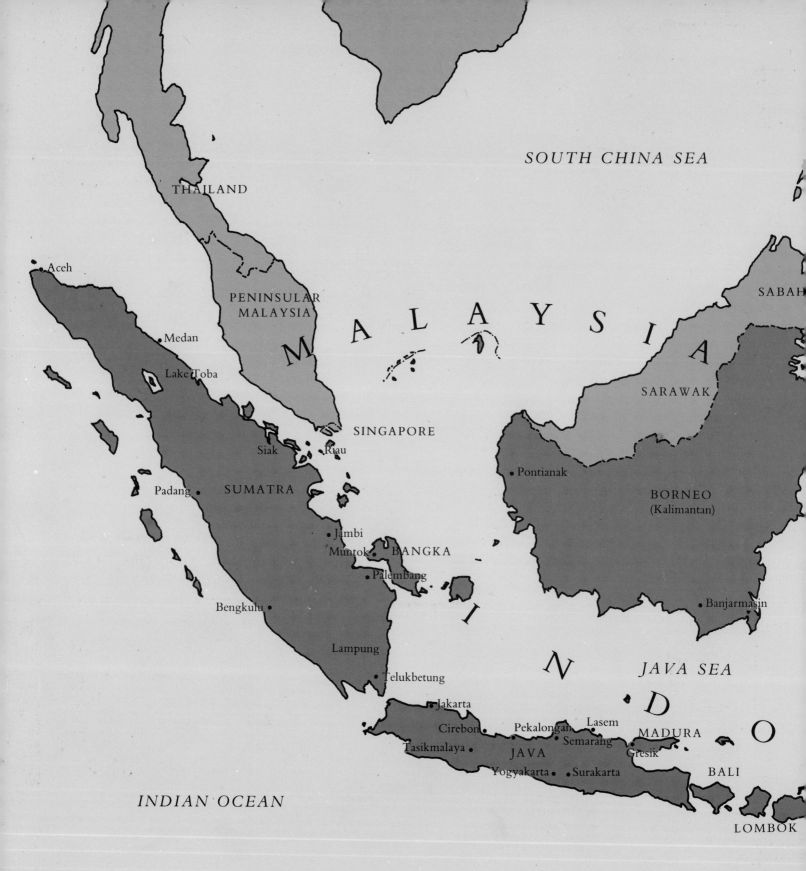